Paris

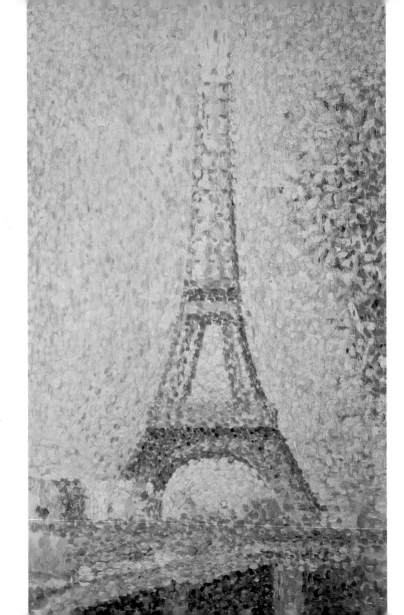

Art & Architecture

PARIS

MARTINA PADBERG

With contributions by Oliver Burgard, Nicole Colin,
Rita Degenhard, Eva Leistenschneider,
Jeannine Fiedler, Hans-Joachim Kuke, Günter Liehr,
Stephan Padberg, Birgit Sander, Charlotte Seeling,
Hagen Schulz-Forberg, Jörg Völlnagel

h.f.ullmann

Notes on this edition:
Information regarding the location of the works in museums and churches,
as well as opening times may be subject to change.

© 2007 Tandem Verlag GmbH
h.f.ullmann is an imprint of Tandem Verlag GmbH
For this English edition © Tandem Verlag GmbH
h.f.ullmann is an imprint of Tandem Verlag GmbH

Art direction: Peter Feierabend
Project management: Kerstin Ludolph, Swetlana Dadaschewa
Project assistant: Brita Köhler
Translation into English: Ann Drummond in association with First Edition Translations Ltd, Cambridge, UK
Editing: Sally Heavens in association with First Edition Translations Ltd, Cambridge, UK
Typesetting: The WriteIdea in association with First Edition Translations Ltd, Cambridge, UK
Picture editing: Lucas Lüdemann, Barbara Linz, Eva Wenzel, Kerstin Dahnken, Petra Ahke, Matthias Teufel
Cartography: Ingenieurbüro für Kartographie Dr. Hans-Joachim Kämmer, Berlin

Printed in China

ISBN: 978-3-8331-4304-5

10 9 8 7 6 5 4 3 2 1
X IX VIII VII VI V IV III II I

Frontispiece
Georges Seurat
The Eiffel Tower, 1889
The Fine Arts Museums of San Francisco

Contents

The heart of the city—
View over Île de la Cité

Past and present—The glass
pyramid in front of the Louvre

Shakespeare & Company bookshop— in the Latin Quarter

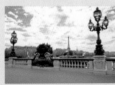

View from Pont Alexandre III to the Eiffel Tower

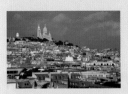
A topographical checkpoint—Montmartre and the Sacré Coeur

The Géode—a futuristic cinema in Parc de la Villette

The colonnades in the palace grounds of Versailles

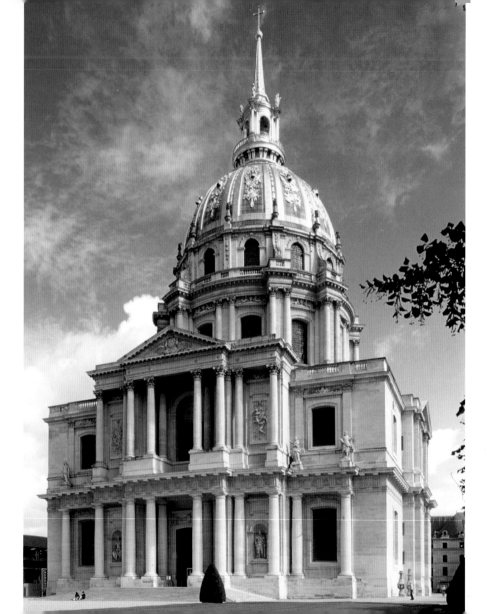

A voyage in time—from Lutetia to La Défense

As the French author and avowed Parisian Julien Green observed, with all its secrets and contradictions, the city of Paris should actually be talked of in plural terms. Paris was, and is, a rich stage for world history—the undisputed capital of France, a Baroque center where the royal court flourished in splendor, the focal point for conflict-ridden revolutions, a sumptuous backdrop for the growth of bourgeois consciousness, a metropolis with all its social and ethnic struggles, but also a place where individual and collective dreams are inspired and expressed in literature and art like nowhere else. Behind the city streetscape with its boulevards, avenues, squares, and junctions lies an equally well-developed world of images, concepts, dreams, and myths that defines the sense of Paris just as much as the architecture. The ensuing literary conventions of a city of love, an artistic mecca, a center of scholars and intellectuals, or a stage for "flâneurs" (strollers) have now become firmly embedded in our consciousness. So a trip to Paris always becomes a search for

the "inner city," with a desire not only to explore the city, but to "think Paris"—"penser Paris," as the writer Paul Valéry expressed it in his essay "Présence de Paris" (1937).

The city on the river

History and the present blend together in the day-to-day life of Paris. Irrespective of the desire to understand the names of Metro stations, streets, and squares, or the significance of individual buildings, it is impossible to imagine Paris without its past. It gives both the city and its nation their identity and self-confidence. The present structure of the city center —the Île de la Cité as the historical core, and the north–south axis of the Via Superior (Rue St-Jacques/Rue St-Martin) leading off from it—dates back to the period when Paris was still known as Lutetia. Inhabited by the Gauls and occupied by the Romans following the campaigns of Julius Caesar, it was one of the many conquest

Dome of Les Invalides (Église du Dôme), south facade

Gold coin of the Parisii tribe, 1st century BC, Musée de Cluny, Paris

cities of the Roman Empire characterized by the grid layout of its streets. The only architectural monuments preserved from this epoch are the thermal baths and the amphitheater. Life in Paris would seem to have been very pleasant even then: as Emperor Julian Apostata (358 AD) remarked shortly before the fall of the Roman Empire: "I spent a winter in my beloved Lutetia, the name given by the Gauls to the town of the Parisii. It includes an island in the middle of the river. Wooden bridges link the banks. Winter is very mild for the inhabitants of this land. The earth bears good vines and the Parisii even have the skills to grow fig trees…"

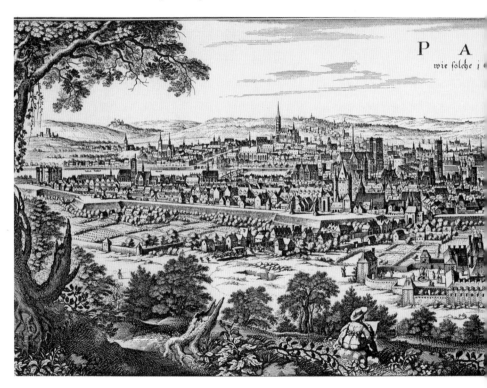

P A
wie solche i

The city of kings

Only after the Christian king of the Franconians, Clovis I (481/82–511), relocated his residence from Soisson to Paris in 508 did the latter achieve capital status for the first time. From then on, the process of developing Paris was closely intertwined with the progressive centralization and consolidation of royal power. The city did not exactly enjoy municipal autonomy: it was ruled by a "prévôt royal" (royal provost) and its inhabitants had the feudal status of "bourgeois du roi" (bourgeois of the king). The growth of the city was determined by the sovereign. The numerous fortifications and city walls

Matthäus Merian the Elder, view of the city of "Parys," 1620, copper engraving, 23.7 x 66.7 cm, Bibliothèque Nationale de France, Paris

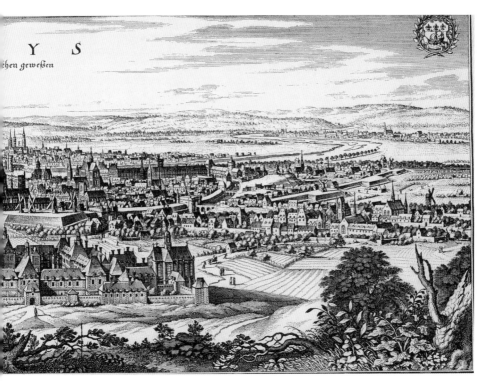

erected during the following centuries are proof of this restrictive policy, and it is hardly surprising that they attracted the wrath of insurrectionists at the start of the French Revolution. When rebellion broke out in the summer of 1789, 40 of the 57 customhouses in the city were set on fire and destroyed, even before the storming of the Bastille. Up to this point, the monarchy had taken great pains to ensure the security and layout of Paris as the seat of governance. This was a very difficult undertaking, as the balance of

Plan of Paris, known as a "gouache map," 1576, Bibliothèque Historique de la Ville de Paris (City of Paris Historical Library)

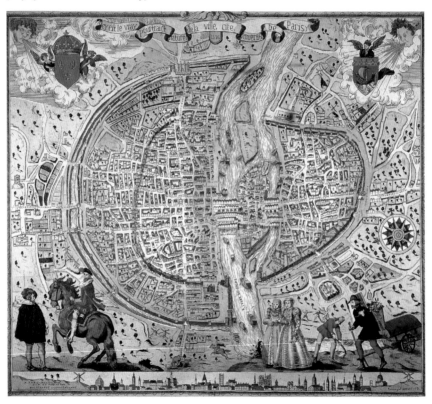

power between crown and community was subject to constant political fluctuations. Medieval bastions such as the Tour de Nesle on the "Rive Gauche" (Left Bank) of the Seine and even the Bastille served, not only as protection against foreign invaders like the Vikings and, later, the English, but also as a means of controlling the Paris populace, who were perceived as rebellious and volatile. Indeed, the revolt of the Estates-General under Étienne Marcel (ca. 1356–1358) had already instilled fear into Charles V, then heir to the throne and later king. After the insurgents managed, albeit temporarily, to hold the young Dauphin prisoner on the Île de la Cité, the old royal palace, evidently not secure enough, was abandoned in favor of the Louvre, which was extended to become the new official residence. When the Paris mob penetrated the private chamber of the young Dauphin (who later became Louis XIV) in the Palais Royal during the Fronde rebellion of 1651, the king was galvanized into tackling the development of Versailles; within a decade, he had turned his back on Paris forever. His grandfather, Henri IV (1589–1610), had been unable even to set foot in the capital of his country for five years, due to the undisguised aggression of the Parisians towards their Protestant king. Under his regency however, the city went on to develop into the political, cultural, and economic center of France. The regulatory hand of the king became the expression of a rationalist concept of power, while the capital of his kingdom became the embodiment of his power

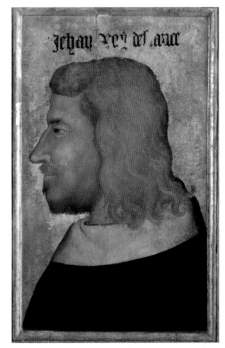

Parisian artist, Jean II "John the Good," King of France, before 1350, wood, 60 x 44.5 cm, Musée du Louvre, Paris

and greatness. Subsequent regents perpetuated this tradition with their ambitious projects for developing the city. In particular, the numerous statues of French rulers erected on open squares—most of which were newly laid out for this purpose—served as prominent reminders of their authority. During the Baroque period especially, architecture and urban development

were seen as projects involving both aesthetic design and rhetorical powers of persuasion. Through the interplay between architectural sculpture and artisan craftsmanship, a monumental style developed under Louis XIV that acted as a mirror of the absolute might of the monarch. "Nothing distinguishes the greatness and spirit of a ruler better than his buildings," wrote Colbert, the powerful minister of finance at that time; and thus, as a symbol of his sovereignty, the king opened up the city walls that had been erected and nervously guarded by his predecessors, and laid out the first "grand boulevards" atop the old bastions—wide, magnificent streets forming the central axes of the city structure. Paris became the screen onto which the image of the monarchy was projected. The subsequent staging of the city—planned, although only partially realized by Napoleon I (1804–1815)—was the obvious successor to the Roman empire of antiquity in terms of this tradition. Even the "grand works" of François Mitterrand demonstrate the powerful, political resonance of town planning and urban development in Paris. The city was, and is, conceptualized as the center of the nation.

Charles Marville, Opening in Avenue de l'Opéra and Butte des Moulins, ca. 1877, photograph, Musée Carnavalet, Paris

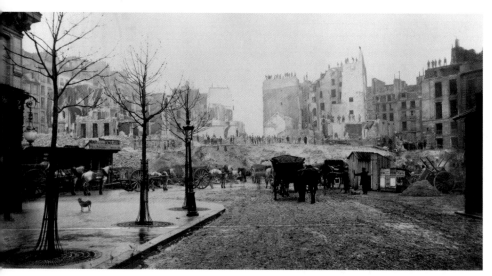

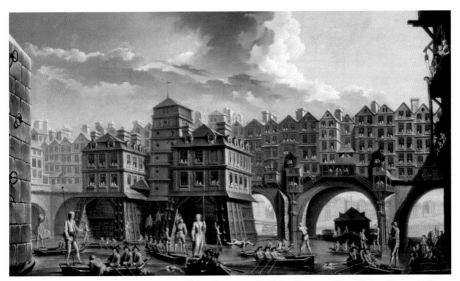

Nicolas and Jean-Baptiste Raguenet, "Tilting boats on the Seine between Pont Notre-Dame and Pont au Change," 1751, oil on canvas, 60 x 97 cm, Musée Carnavalet, Paris

The city of the intellect

From the 11th century onwards, the city began to expand on both sides of the river. Differences emerged between the left and the right banks that are still in evidence today. Alongside the political and ecclesiastical center of La Cité, the Right Bank developed into a location for crafts and trade, while the university dominated the Left Bank. Practical issues were the deciding factors in this: as boats on the Seine could only dock on the Right Bank and traders went from there on the footpath to Flanders, a harbor and marketplace grew up on Place de Grève (now Place de l'Hôtel de Ville) around which numerous guilds became established. Several street names today give an indication of the craft that was practiced there, such as Rue de la Coutellerie (cutlers), Rue de la Verrerie (glassworks), and Quai de la Mégisserie (tanners) right next to the river. Moneylenders and goldsmiths were based on the Pont au Change, which at that time was densely developed, while the influential slaughterhouses were situated around St-Jacques-de-la-Boucherie (now Place du Châtelet). Italian merchants and bankers had their business establishments in Rue

des Lombards. The settlement of the Left Bank was driven above all by religious orders that founded their own schools there in order to free themselves from dependence on the bishop's chancellor: the latter resided on La Cité and took advantage of his right of abode to put a high price on the teaching permit in the Notre Dame cathedral school. The mendicant orders in particular could not afford, and did not want to pay for, such expenses. In the power struggle between the Bishop of Paris and the new schools, the

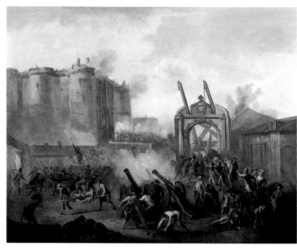

Artist unknown, "Storming the Bastille on July 14, 1789," 18th century, oil on canvas, 80 x 104 cm, Musée Carnavalet, Paris

King and the Pope took the side of the colleges: the cooperative institutions on the Left Bank were recognized as early as 1219 by Pope Honorius III as autonomous bodies—as the "universitas." Thus a tradition was founded that allowed Paris to establish itself as a European center of scholarship. Study at the Sorbonne has continued to imply a springboard for careers right up to the present day, with great minds being developed in the elite schools in Paris rather than in the provinces. The public libraries and museums with their vast treasures and numerous specializations, mainly established in the wake of the French Revolution, made Paris a place where it seemed possible to see and learn about the whole universe. Whether one wanted to understand how the steam engine was developed or learn about the peoples of Oceania, evolutionary theory, or the Egyptian cult of the dead, all human knowledge appeared concentrated in one location: Paris.

The city of revolutions

To the same degree that the crown had stamped its mark on the development of Paris, the city became the setting for its reversal of fortune and eventual downfall. The enforced return of Louis XVI from Versailles to Paris on October 6, 1789 as a prisoner of the French people and his public

execution on Place de la Révolution on January 21, 1793 had not only political ramifications, but also symbolic value. Paris became the capital of a revolutionary nation and was to remain the scene of revolts and revolution throughout the 19th century. Time and time again, the political destiny of France was decided anew here. After the revolutions of 1830 and 1848, defeat in the Franco-Prussian War (1870/71) led to the fall of the Second Empire. The revolt of the Communes in February 1871 and the bloody clashes with government troops had devastating consequences: 4,000 communards killed, nearly 20,000 executed, and around 9,000 deported; whole streets of houses razed to the ground; and the Tuilerie Palace, Hôtel de Ville, Palais Royal, and many other buildings in flames. Yet the legacy of the Second Empire endured in the form of the fundamental restructuring of the city that was carried out under Napoleon III (1853–1870) and his administrator, Haussmann (1809–1891). The Paris that was built under their supervision became the spectacular backdrop for the cultural life of the Belle Époque. The

city had changed radically, not only in terms of its appearance, but also inwardly, and had turned into a modern metropolis. The following decades saw the boom of the "Myth of Paris."

The Tuileries in ruins, following the great fire, 1871, Musée Carnavalet, Paris

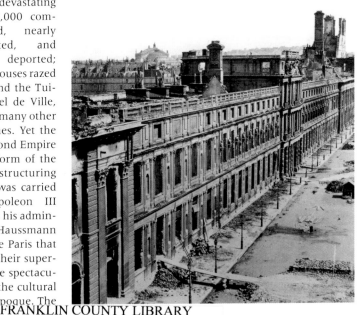

The capital of Europe

The spirit of the age, "La Belle Époque," manifested itself around 1900 in art, theater, and opera; in fashion; in ordinary street life; and in the cafes and salons. Paris became a magnet for artists and intellectuals: the cultural capital of Europe and place where success brought fame and fortune.

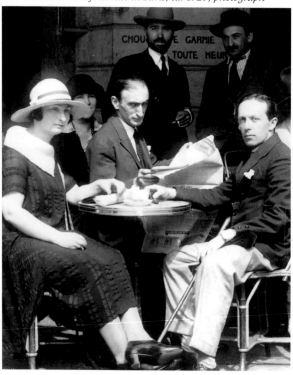

Two women on a café terrace in Paris, ca. 1925, photograph

Before long, a lengthy stay in the French capital became part of the educational canon in affluent, upper-class circles. Against the background of both the shaky political situation of the Third Republic, which had seen 95 changes in government during its 70-year history, and the global political conflicts that culminated in World War I, an apparently carefree bohemian society in Paris lived for the day. Big city life pulsated in the "passages" (covered arcades), on the boulevards, and especially at night in Montmartre—public entertainment places of all kinds banished the destructive feelings of alienation that the modern world engendered in a surprising number of people. At the same time, there began a process of reflection on Paris that was to become just as symptomatic of the age as the urban reality itself. Both the outer shell and inner core of the city were depicted in literature, painting, photography, and film. These media displayed grand panoramas, penetrated the darkest corners of the city, and portrayed protagonists who embodied the fate of a whole generation or class. The city acted as both a res-

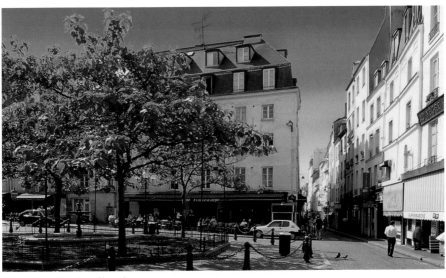

View down Rue Mouffetard

onator of, and stimulant for, unfolding events. Thus an original body of Parisian art and literature evolved that extended far into the European cultural landscape of modernity. Novels, poetry, songs, paintings, and photographs created an imaginary topography of the city. Images of decadent bourgeois society around 1900, the impoverished artistic genius, sophisticated ladies, happy-go-lucky whores of Montmartre, and unrecognized writers and thinkers drew their strength from the everyday life of the metropolis, and live on in the image and perception of everyone who visits Paris.

The city of the 21st century

Paris has always been in a state of flux. As for the direction this movement is taking, the debate has for a long time focused on how the historical legacy of the city—comprising not only the buildings worthy of preservation, but also a distinctive consciousness—can be safeguarded in the face of massive technical and social upheaval. The extreme positions in this argument were originally set out by the architects Le Corbusier and Charles Garnier: if the former demanded the complete demolition of Paris, in order to replace once and for all the heterogeneous form that had developed

with a new type of architecture befitting the age of constructivism, the architect of the old Paris Opera advocated total conservation—in his opinion, modern times should kindly present elsewhere.

In the middle of the 20th century, migration on a large scale from the provinces and the former colonies outside Europe created new statistics. Paris was threatening to collapse under the weight of overpopulation. An attempt was made to solve the problem "extra muros" (outside the walls): the chaotic, unregulated growth of satellite towns began in the suburbs on the edges of the city. In the absence of a coherent urban development plan, high-rise housing was built outside the Périphérique in the 1960s and 1970s, which meant lengthy and unavoidable commuting time between their homes and workplaces for the inhabitants. "Métro–Boulot–Dodo" (Metro—Work—Bed) was the formula describing the daily pattern of life for those who existed in the Paris suburbs. Bleak living conditions without any infrastructure, high unemployment, and social as well as ethnic conflicts made the suburbs a terrain riddled with problems and tensions as well as a high crime rate. Over 11 million people now live in the "Paris region" and, of these, 8 million live in one of the "new towns." So the life of a Parisian is not necessarily based in one of Haussmann's town houses with wrought iron balcony, a concierge on the ground floor and a bistro on the next corner, but instead, and more usually, in

Chinese stores in Belleville

accommodation units fitted out with Formica sheets on the 16th floor of a high-rise building. The political powers must make it their job in future to win back and organize what has become a virtually lawless space ruled by violence.

La Défense, whose high towers are visible far into the city center, has become the expression of an inescapable second transformation of Paris. The "Grands Travaux" (great works) sponsored by François Mitterrand have made Paris into a center for contemporary architecture. Spectacular individual buildings have set a trend far beyond the city boundaries. Structural measures have breathed new life into individual areas and the regeneration of urban space in Paris has won back new areas for employment, living, and relaxing. Not everything works, not everything is high quality, but these initiatives are helping Paris develop into a landscape of historical and modern architectural monuments, into a city with both a past and a future. It has always been a living metropolis. "To be the sole center and capital of a great country in terms of politics, literature, science, finance, trade, pleasure, and extravagance, to represent its whole history, to attract and provide a focus for all its intellect and influence as well as nearly all of its earning potential and gold reserves, all of which is for the better and worse of the nation of which it is the crowning achievement—this is what differentiates Paris from all other cities with over a million inhabitants." Paul Valéry expressed it thus in his earlier cited

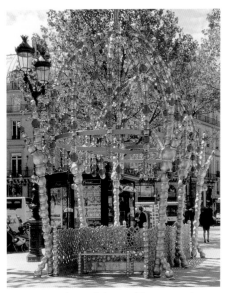

Entrance to the "Palais Royal" metro station on Place Colette. Designed by Jean-Michel Othoniel

essay, "Paris, the function of a city." A trip to Paris means discovering a collective masterpiece in which all the hopes, aims, and dreams of generations have been invested. The histories and images through which Paris is articulated are addictive. In searching them out, the visitor will return again and again.

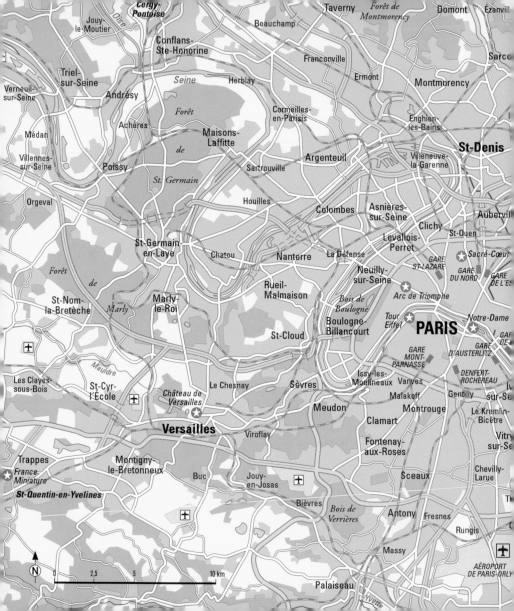

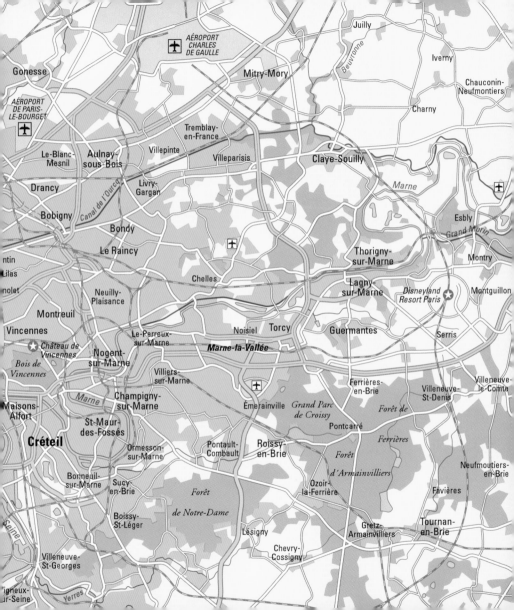

Paris—facts and figures

Geography
- Capital of the French Republic and the Île-de-France region
- Situated in a valley on the northern course of the Seine, surrounded to the north, east, and south by hill country. The highest point is the butte of Montmartre on the north side at 413 ft. (126 m).
- The heart of the city today (the Paris département, or administrative unit) is demarcated by a circulatory ring road (the Périphérique) and two green lungs: the Bois de Boulogne to the west and the Bois de Vincennes to the east.
- The Île-de-France region is made up of the Paris département, the three départements known as the "small crown" (Hauts-de-Seine, Seine-St-Denis, and Val de Marne) and the four départements of the "large crown" (Essone, Seine-et-Marne, Val d'Oise, and Yvelines).

Area
- Urban area (Paris département): 40 sq. miles (105 km^2)
- Île-de-France: 4,660 sq. miles (12,072 km^2)

Population
- Approximately 2.2 million in Paris
- Approximately 11 million in the whole of Île-de-France (18 percent of the total French population)

Administration
- President of the Republic with official residence in the Élysée Palace
- Prime Minister with official residence in the Hôtel Matignon
- Parliament (Assemblée Nationale) in the Palais Bourbon
- Senate in the Palais du Luxembourg
- Mayor with official residence in the Hôtel de Ville. The mayor is also President of the Regional Council, whose 163 members represent the 20 administrative districts (arrondissements) of the city.
- 20 arrondissements, each with its own mayor and administrative council (conseil d'arrondissement)

Economy
- About 23 percent of French businesses are concentrated in the Paris agglomeration; the region generates just under one-third of the national GDP.
- The national center of the services sector is La Défense, where over 1,500 companies with around 150,000 staff are based.
- 36 million visitors each year make tourism one of the most important economic factors in the region; 130,000 jobs are directly dependent on it.

- With a farmed area of approximately 1.5 million acres (600,000 hectares), agriculture represents a frequently underestimated pillar of the economy, particularly in terms of flowers, trees, and garden plants.

Climate and When to go

- Because of its geographical location, Paris is influenced by both the ocean and the continent: cool winter months with occasional frost, mild transitions, and hot, mostly dry summers are typical features of the weather. Even though the annual rainfall is below the national average, visitors always have to be prepared for rain.
- July 15 through August 31 is the holiday season in France. During these weeks, many Parisians leave the capital and many businesses and restaurants are closed. It is mainly the facilities whose survival depends on tourism that remain open; along with museums and other sights, these are overrun with visitors throughout the summer months.

Festivals and Public Holidays

- End of January/beginning of February: Chinese New Year (13th arrondissement)
- February: International Agricultural Show
- March: Book Fair
- March/April: Music Fair
- April: Paris Marathon
- May: French Open Tennis at the Roland Garros stadium
- June 21: Fête de la Musique
- June: Gay Pride Parade
- June/July: Café waiters and waitresses race
- July/August: Finish of the Tour de France
- September: Techno Parade
- October: International Contemporary Art Fair (FIAC)
- Public holidays: New Year (January 1), Epiphany (January 6), Easter, May Day (May 1), VE Day (May 8), Ascension Day, Whitsun, National Holiday (July 14), Assumption Day (August 15), All Saints' Day (November 1), Armistice Day (November 11), Christmas (December 25/26)

Climate details

Average temperature in °C	Jan.	Feb.	Mar.	April	May	June	July	Aug.	Sept.	Oct.	Nov.	Dec.
Day	6,0	7,4	12,2	15,8	19,7	22,9	24,6	24,0	21,1	15,6	10,0	6,6
Night	0,9	1,3	3,6	6,3	9,5	12,7	14,5	14,3	11,9	7,2	4,5	2,0
Hours of sunshine per day	2,0	2,9	4,9	6,6	7,3	7,2	7,3	6,6	6,0	4,0	2,1	1,5
Days of rain	17	14	12	13	12	12	12	13	13	13	15	16

Important addresses for planning your trip

- In Germany:
 Maison de la France, Zeppelinallee 37,
 60325 Frankfurt a. M., Tel. 0900/157 00 25,
 Fax 0900/159 90 61,
 info.de@franceguide.com
- In Austria:
 Maison de la France, Lugeck 1–2/Stg. 1/Top 7,
 1010 Vienna, Tel. 0900/25 00 15, Fax 01/503 28 72,
 info.at@franceguide.com
- In Switzerland:
 Maison de la France, Rennweg 42,
 Postfach 72 26, 8023 Zürich,
 Tel. 0 44/2 17 46 00, Fax 0 44/2 17 46 17,
 info.ch@franceguide.com
- In France:
 Office de Tourisme et des Congrès,
 Bureau d'accueil Pyramides,
 25, rue des Pyramides, 75001 Paris,
 Tel. 08 92 68 30 00,
 info@paris-touristoffice.com

Paris on the Internet

- www.parisinfo.com
- www.paris.fr
- www.paris.org

What's On

Three current events guides for the city appear every Wednesday containing up-to-date information about exhibitions, concerts, movies, and theater productions in and around Paris (available in all newspaper kiosks):

- L'officiel des spectacles
- Pariscope
- Zurban

Opening times (subject to change):

As part of the Journées du Patrimoine (Heritage Days) that take place on a weekend in September every year, buildings and institutions that would normally be inaccessible are open to visitors, including many government offices and ministries. Further details can be found on the websites of the Ministry of Culture and the City of Paris (www.paris.fr).

Arc de Triomphe de l'Étoile: 10.00–22.30 (Oct.–March), 10–23.00 (April–Sept.)

Château de Versailles: Tues.–Sun. 9.00–17.30 (Nov. 1–April 2), 9.00–18.30 (April 3–Oct. 31)

Château de Vincennes: daily 10.00–12.00, 13.15–17.00 (Sept. 1–April 30); 10.00–12.00, 13.15–18.00 (May 2–August 31)

Cité de la Musique – Parc de la Villette: Tues.–Sat. 12.00–18.00, Sun. 10.00–18.00

Cité des Sciences et de L'Industrie – Parc de la Villette: Tues.–Sat. 10.00–18.00, Sun. 10.00–19.00

Conciergerie: daily 9.30–18.30 (March 1–Oct. 31), 9.00–17.00 (Nov. 1–Feb 28)

Église de la Madeleine: Mon.–Sat. 7.00–19.00, Sun. 7.00–13.30, 15.30–19.00. Access limited during church services.

Église du Dôme: daily 10.00–18.00 (April 1–Sept. 30), 10.00–17.00 (Oct 1–March 31), 10.00–19.00 (June 15–Sept. 15)

Fondation Cartier pour l'Art Contemporain: Tues.–Sun. 12.00–20.00, Tues. 12.00–22.00

Fondation le Corbusier: Mon.–Thurs. 10.00–12.30, 13.30–18.00, Fri. 10.00–12.30, 13.30–17.00, Sat. 10.00–17.00

Hôtel de Soubise—Musée de l'Histoire de France (National Archives): Wed.–Fri., Mon. 12.00–17.45, Sat. & Sun. 13.45–17.45, Tues. closed

Hôtel de Sully: building closed to visitors, but gardens are open.

Institut du Monde Arabe: Tues.–Sun. 10.00–18.00

Jardin des Plantes: daily 8.00–20.00

Jardin des Tuileries: daily 7.30–19.00

Musée Carnavalet: Tues.–Sun. 10.00–18.00

Musée Cernuschi: Tues.–Sun. 10.00–18.00

Musée Cognacq-Jay: Tues.–Sun. 10.00–18.00

Musée d'Art Moderne de la Ville de Paris: Tues.–Sun. 10.00–18.00

Musée de la Mode et du Textile: Tues.–Fri. 11.00–18.00, Thurs. 11.00–21.00, Sat.–Sun. 10.00–18.00

Musée de l'art et d'Histoire du Judaisme: Mon.–Fri. 11.00–18.00, Sun. 10.00–18.00

Musée de la Vie Romantique: Tues.–Sun. 10.00–18.00

Musée de l'Homme: Mon., Wed.–Fri. 10.00–17.00, Sat. & Sun. 10.00–18.00, Tues. closed

Musée de l'Orangerie: Wed.–Mon. 9.00–12.30 (pre-booked groups only), Wed. & Thurs., Sat.–Mon. 12.30–19.00, Fri. 12.30–21.00

Musée des Arts Décoratifs: Tues.–Fri. 11.00–18.00, Thurs. 11.00–21.00, Sat.–Sun. 10.00–18.00

Musée des Arts et Métiers: Tues.–Sun. 10.00–18.00, Thurs. 10.00–21.30

Musée d'Orsay: Tues. & Wed., Fri.–Sun. 9.30–18.00, Thurs. 9.30–21.45

Musée du Louvre: Mon., Thurs., Sat. & Sun. 9.00–18.00, Wed. & Fri. 9.00–22.00, Tues. closed

Musée du Quai Branly: Tues., Wed., Fri. & Sat. 10.00–18.30, Thurs. 10.00–21.30

Musée Gustave Moreau: Wed.–Mon. 10.00–12.45, 14.00–17.15

Musée Jacquemart-André: daily 10.00–18.00

Musée Maillol–Fondation Dina Vierny: Wed.–Mon. 11.00–18.00

Musée Marmottan: Tues.–Sun. 10.00–18.00

Musée National d'Art Moderne—Centre Georges Pompidou: Wed.–Mon. 11.00–21.00

Musée National des Arts Asiatiques—Guimet: Wed.–Mon. 10.00–18.00

Musée National du Moyen Age: Wed.–Mon. 9.15–17.45

Musée National Eugène Delacroix: Wed.–Mon. 9.30–17.00

Musée National Picasso: Wed.–Mon. 9.30–18.00 (April–Sept.) 9.30–17.30 (Oct.–March)

Musée Nissim de Camondo: Tues. & Wed., Fri. 11.00–18.00, Thurs. 11.00–21.00, Sat. & Sun. 10.00–18.00

Musée Rodin: Tues.–Sun. 9.30–17.45 (April–Sept.), 9.30–16.45 (Oct.–March)

Musée Zadkine: Tues.–Sun. 10.00–18.00

Notre Dame: daily 7.45–18.45. Access limited during church services.

Panthéon: daily 10.00–18.30 (April–Sept.), 10.00–18.00 (Oct.–March)

Petit Palais: Wed.–Sun. 10.00–18.00, Tues. 10.00–22.00

Saint Denis: Mon.–Sat. 10.00–18.15, Sun. 12.00–18.15 (April–Sept.), Mon.–Sat. 10.00–17.15, Sun. 12.00–17.15 (Oct.–March)

Sainte Chapelle: daily 9.30–18.00 (March–Oct.), 9.00–17.00 (Nov.–Feb.)

Saint Etienne du Mont: Tues.–Fri. 8.45–19.30, Sat. & Sun. 8.45–12.00, 14.30–19.45, Mon. 14.30–19.45

Saint Eustache: Mon.–Fri. 9.30–19.00, Sat. 10.00–19.00, Sun. 9.00–19.15

Saint Germain l'Auxerrois: daily 8.00–20.00

Saint Séverin: Mon.–Sat. 11.00–19.30, Sun. 9.00–20.30

Tour Eiffel (Eiffel Tower): daily 9.00–23.45, 9.00–0.45 (June 15–Sept. 1)

Strolling through other museums

Musée Balzac

47, rue Raynouard

This tiny house, where Honoré de Balzac lived and worked from 1840 through 1847, sits on the sloping bank of the Seine in Passy. On display are original documents, memorabilia, and the author's small writing chamber. In his work "La Comédie humaine" (The Human Comedy), the founder of the realist novel represents ideal types of the bourgeoisie, and human passions and weaknesses under Louis-Phillippe.

Musée Cernuschi – Musée des Arts de l'Asie de la Ville de Paris

7, avenue Velázquez

The museum contains the comprehensive collection of Asian art acquired by Henri Cernuschi (1821–1896) on his voyages and bequeathed by him to the city of Paris, along with his private residence in Avenue Velázquez. The main focus of the exhibition today is Chinese art. The museum has displays of bronzes, porcelain, and stone sculpture from the time of the Chinese empire as well as contemporary Asian art.

Musée Cognacq-Jay – Musée du XVIIIe Siècle de la Ville de Paris

8, rue Elzévir

This rich collection of art objects and everyday items from the 18th century was left to the city of Paris by Ernest Cognacq-Jay, the founder of the Samaritaine department store, and his wife. They are now housed in the former Hôtel Donon in the Marais, dating back to the 17th and 18th centuries. As well as paintings by important artists like Boucher, Watteau, and Greuze, visitors can admire precious furniture, porcelain from Meissen and Sèvres, tapestries, and an exquisite collection of miniatures, tobacco boxes, and fans.

Musée de la Mode et du Textile

107, rue de Rivoli

In the fashion capital of Paris, the Musée de la Mode et du Textile showcases clothes, fabrics, and fashion accessories from the 17th century through to the great French couturiers of the present day. The exhibition has an unusual layout, not displayed as a chronological development of fashion trends, but instead taking textiles and factors such as the color, sheen, or texture of a material as the basis for a voyage of discovery into the fashion world of different epochs.

Musée de la Vie Romantique

16, rue Chaptal

The villa-style building that now houses the Musée de la Vie Romantique was originally the home of the artist Ary Scheffer (1795–1858). During his lifetime, the intellectual and artistic elite of Paris met here, including Franz Liszt, Frédéric Chopin, and Eugène Delacroix. The first floor of the exhi-

bition is dedicated to the female writer George Sand. The second floor contains paintings by Scheffer and his contemporaries, while the studio in the courtyard houses temporary exhibitions.

Musée Maillol – Fondation Dina-Vierny
56-61, rue de Grenelle
This museum originated from an endowment by the model and lifelong companion of Maillol, Dina Vierny. It displays the famous sculptures of Aristide Maillol (1861–1944) along with his lesser-known works in other media such as paintings, drawings, woodcuts, and ceramics. The visitor is also given an insight into the wider artistic context of his oeuvre from the rich collection of works by contemporary sculptors and artists such as Duchamp-Villon, Matisse, Gauguin, and Kandinsky.

Musée National Eugène Delacroix
6, rue de Furstenberg
The house where Eugène Delacroix (born 1798) spent the last six years of his life and died in 1863 is located in one of the loveliest squares tucked away in Saint-Germain. The rooms of his former apartment contain paintings, sketches, and drawings by Delacroix and artists close to him, as well as some of the artist's personal items. A staircase leads to his studio at the back of the house and a small, quiet garden.

Musée Nissim de Camondo
63, rue Monceau
Moïse de Camondo, heir to a rich Jewish family of bankers from Istanbul and a passionate collector of French art from the 18th and 19th centuries, built this splendid "Hôtel particulier" on Parc Monceau. Today's visitor can not only admire the artistic treasures it holds, but also derive a sense of everyday life in a Parisian townhouse around the time of World War I. Paintings, furniture, porcelain, and tapestries have retained their original roles as functional objects in the living and reception rooms of the house—even the bathrooms, kitchen, and service areas are accessible. It is easy to forget this is a museum.

Musée Zadkine
100, rue d'Assas
Tucked away in a back courtyard is the small house and studio where the sculptor Ossip Zadkine (born 1890) lived and worked from 1928 until his death in 1982. The exhibition shows important works by the Russian-born artist, who made a significant contribution to cubism with his sculptures in bronze, stone, and wood. In the tiny garden full of character in front of the premises, Zadkine incorporated large-size bronzes that have remained where he placed them until the present day. As well as showcasing his oeuvre, the museum also holds exhibitions of the work of young contemporary artists three to four times a year.

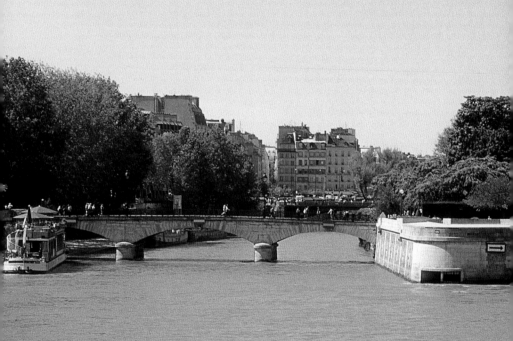

Île de la Cité and

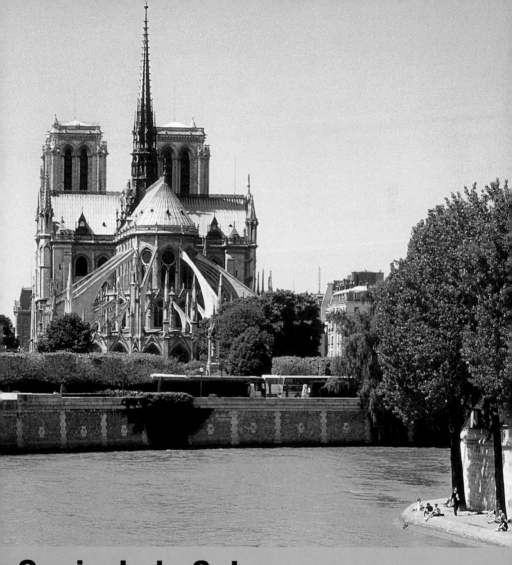

Quais de la Seine

Île de la Cité and Quais de la Seine

For the Gauls, the Romans, and even for people in the Middle Ages, Paris was an island. The Île de la Cité—whose geographical location offered natural protection against the feared attacks of the Vikings, while its banks provided moorings for the ships on the Seine to load and unload goods—remained the densely populated, labyrinthine center of the city for many centuries. The Roman governors lived on the western side of the island and later the Frankish kings built their castle there. In the 12th century, at the opposite end of the island, the Bishop of Paris realized the magnificent cathedral of Notre Dame on the foundations of a Gallic-Roman temple. Secular and ecclesiastical powers thus struck a balanced position from which they determined the future development of the city and the country. Although the medieval character of the island with its narrow alleys disappeared in the 19th century, the royal chapel, Sainte-Chapelle, the well-fortified Conciergerie, and Place Dauphine all convey the history of the city in a lively and impressive way. Île Saint-Louis makes its mark more by way of its quiet charm and general impression of elegance than by towering monuments: the island was created artificially by Louis XIII in the 17th century by joining together two small islets on the Seine. Even today, with its almost exclusively classical, refined architecture, the island seems like a little gem in the middle of Paris. It is not surprising, therefore, that the rents here are astronomical. It would be impossible to live anywhere else in Paris that is more central yet tranquil, free from the hustle and bustle of a big city. From the

View over the Seine on the Île de la Cité, around 1880

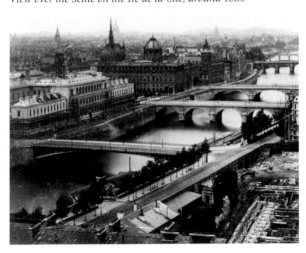

Preceding spread:
View of Notre Dame, from the library of the Institut du Monde Arabe

islands, Paris opens out like any city on a river. The Seine's many bridges looking across to the opposite bank from different perspectives and the quiet quays with booksellers offering their antiquarian books, drawings, and engravings are conducive to long, leisurely walks. Léon-Paul Fargue (1876–1947) a poet and "flâneur" (stroller) in Paris following the turn of the century, maintained in his literary guide to the city entitled "The Pedestrian in Paris" (1939): "As the lyrical masterpiece of Paris, the quays have captivated most poets, tourists, photographers, and strollers in the world. The whole length (this masterpiece) encompasses is unique, a sort of curved ribbon or quixotic peninsula that appears to have been forged by the imagination of a bewitching creature."

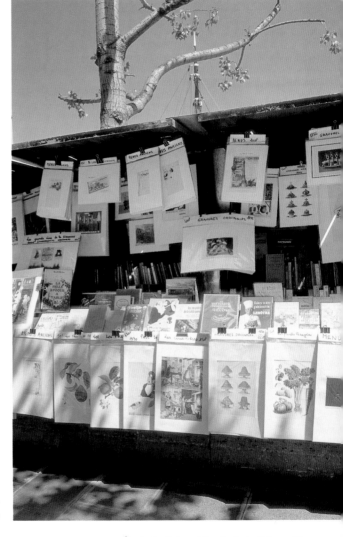

Bookseller's stall on the Quais de la Seine

Île de la Cité and Quais de la Seine

Musée d'Orsay, Rue de
Bellechasse, p. 70 ff.

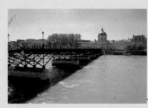

Pont des Arts and Institut de
France, 23, Quai de Conti, p. 64 f.

Pont-Neuf, p. 46 f.

Also worth seeing

1 Palais de Justice, 4, Bd du Palais, p. 36 f.

2 Conciergerie, 1, Quai de l'Horloge, p. 42

3 Place Dauphine, p. 43

4 Tour St-Jacques, Sq de la Tour St-Jacques, p. 63

5 St-Germain-l'Auxerrois, 2, Place du Louvre, p. 64

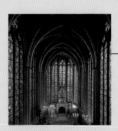

Sainte-Chapelle,
4, Bd du Palais, p. 36 ff.

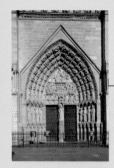

Notre-Dame,
Place du Parvis Notre-Dame,
p. 48 ff.

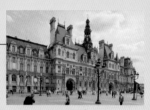

Hôtel de Ville,
Place de l'Hôtel de Ville, p. 62

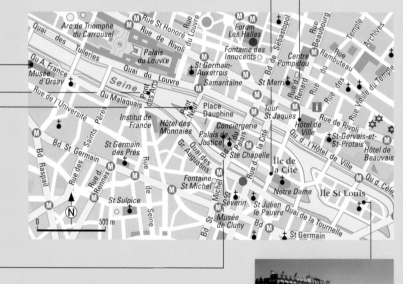

Île St-Louis,
p. 60 f.

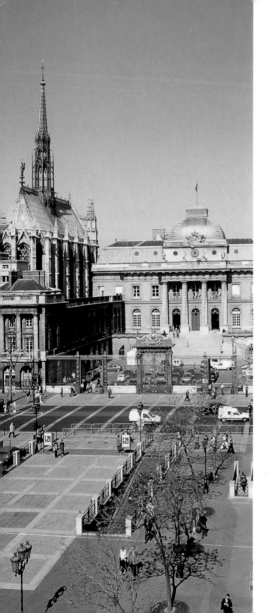

Palais de Justice and Sainte-Chapelle

Philippe Auguste (1180–1223) built a castle on the spot where the Roman governor of antiquity and the Merovingians in the Middle Ages resided, and it served as a palace for French kings until the 14th century. His grandson, Louis IX (1226–1270), or Saint Louis, extended the site and endowed it with the famous Sainte-Chapelle. An architecturally heterogeneous complex developed out of the numerous reconstructions and renovations necessitated by the fires and destruction that occurred until the 20th century: nowadays, it is mainly distinguished by the strong, 18th-century facade and the splendid gate in the Cour de Mai in the style of Louis XVI. After the kings had retreated from La Cité to the Right Bank for reasons of security, they left the royal residence in 1431 to the highest court of justice, the "parlement." Any royal edict could only come into force with the approval of this institution, although in practice there was no formal right of veto.

Sainte-Chapelle is the oldest remaining part of the medieval royal castle. Built within just a few years as a High Gothic double church by a team of outstanding master builders, stonemasons, wrought iron craftsmen, goldsmiths, and stained glass artists, it was consecrated in 1248 and remains even today an architectural masterpiece with a seminal influence in Europe. Louis IX, or

Saint Louis, commissioned this religious building as a monumental shrine for the holy relic he had acquired, the Crown of Thorns of Christ. The king's intention was to turn Paris into a new "locus sanctus" on a par with the Holy City of Rome by purchasing relics of the highest value that would, of course, reinforce his own status in terms of political power.

Palais de la Cité and Sainte-Chapelle at the beginning of the 17th century, after Jean Boisseau and Israël Silvestre
Lithograph

Today Sainte-Chapelle seems as if it is wedged between the buildings of the Palais de Justice, but until the 19th century it was freestanding on the Cour de Mai, the old courtyard of the royal residence. There, on Good Friday, the populace would kneel down when the king displayed the holy relics, which comprised not only the Crown of Thorns, but also other instruments of torture and some drops of Christ's blood. The king alone held the key to the precious shrine in the upper chapel. This part of the church was reserved for the use of the monarch, his confidants, and guests of honor, and could be directly accessed from the royal apartments by a staircase, the Galerie des Merciers. The lower chapel served as a parish church for the rest of the royal court: that is to say courtiers, servants, and soldiers. The two-story composition of the church took account therefore of the complex functions of Sainte-Chapelle. The unknown master builder decided, however, on a unified exterior facade with narrow buttresses, gargoyles, and decorative pinnacles.

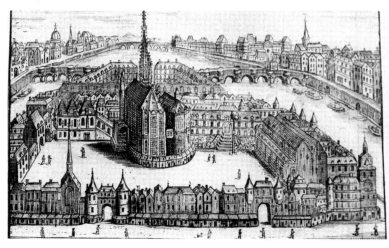

Lower chapel

The crypt-like lower chapel consists of a wide central nave and two very narrow side aisles, which also serve as an ambulatory. The vault, which has to bear the floor of the upper chapel, rests on surprisingly slender columns with an amazingly rich variety of capitals. The enormous thrust of the vault is reduced to fine tracery on the external walls. The underlying metal structure of the vault, which is covered in stucco, has been preserved intact, although the painting is a recent addition from the 19th century: a flood in 1689/90 caused considerable damage.

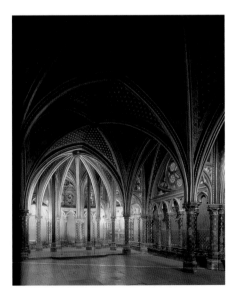

Upper chapel

Originally accessible only to select members of the aristocratic elite, the upper chapel reveals itself as a fascinating space defined by light and color, with an almost ethereal quality. A complex structural system and the insertion of hidden tie and ring beams made it possible to completely do away with walls of any kind. Instead it has a row of high windows that rise up from a socle, evenly structured by blind arcades and intermittently broken up by the engaged columns supporting the vault.

The magnificent overall impression is heightened by the 100 ornately decorated capitals with a variety of patterns taken from the animal and plant kingdoms. The vault painting, which was renewed using old, leftover paint in the 19th century, depicts the firmament. The reliquary is situated in the apse, although it was badly damaged during the Revolution: what is now seen is also a reconstruction. Delicate arcades separate the raised altar from the body of the church. Underneath a dais, which appears to be floating, stands the shrine of the relic. Possibly the most precious work in 13th-century gold, this was melted down in 1793, with the remains of the Crown of Thorns now being located among the treasures of Notre Dame Cathedral. Seats for the king and his family were situated in a niche on the right side of the nave, affording them a clear view of the shrine and allowing them to take part in the service without being seen themselves.

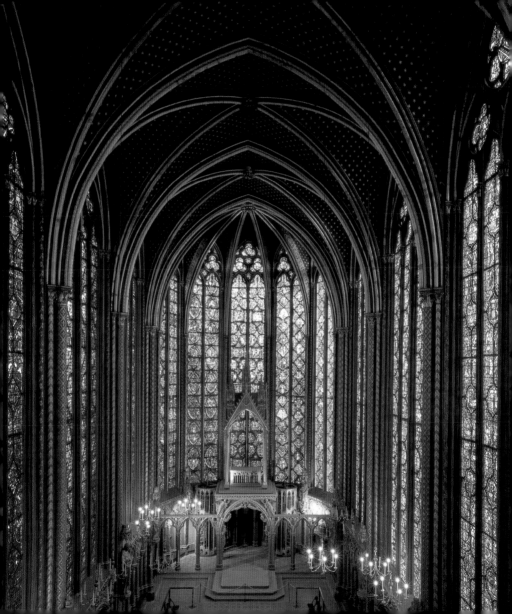

Plan of the iconographic scheme in the upper chapel

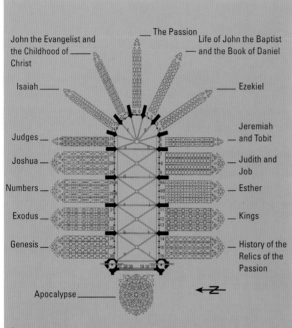

John the Evangelist and the Childhood of ——— Christ

——— The Passion

Life of John the Baptist ——— and the Book of Daniel

Isaiah ———

——— Ezekiel

Judges ———

——— Jeremiah and Tobit

Joshua ———

——— Judith and Job

Numbers ———

——— Esther

Exodus ———

——— Kings

Genesis ———

——— History of the Relics of the Passion

Apocalypse ———

The spatial configuration of the church interior is determined by a quite deliberate iconographic scheme that refers to the significance of the Passion of Christ and was certainly developed through discussions held between the patron and the advisory theologians. Even the socle area refers to the tradition of Christ's suffering with its 44 depictions of martyrs in the quatrefoils of the blind arcades. Above it stand life-size, fully sculpted figures of the twelve apostles on twelve pillars, as symbolic supports of the church. The windows of the church, which dominate the space,

Statues:

a	St. John
d	St. James the Less
f	St. Peter
g	St. Paul
i	St. James
k	St. Bartholomew
b, c, e, h, j, l	Unidentified apostles

Quatrefoils:

0, 20 Destroyed during the construction of the galleries

2, 9-A–B, 18-19, 21-22, 25, 39 Now illegible

1, 5-7, 14, 27-28 Unidentified, beheaded martyrs

3, 4, 17, 23-24, 29-A–B, 34, 37-38 Suffering of other martyrs who cannot be identified with certainty

8	Torture of St. Quintinus with wool combs
9	Stoning of St. Stephen
10	Beheading of St. Dionysius
11	St. Clement in the sea
12	St. Lawrence in flames
13	Flagellation of St. Vincent
15	Suffering of St. Eugene
16	St. Blaise torn apart by wool combs
29	Beheading of St. Firminus
30	Beheading of St. Margaret
31	Murder of Thomas Becket
32	Beheading of John the Baptist
33	Quartering of St. Hippolytus
35	St. Sebastian shot with arrows
36	Torture of St. Victor

can be read like a pictorial Bible, with over 1,000 scenes unfolding a wealth of artistic and narrative depictions. The Passion of Christ takes central place in the choir, flanked to the right and left by themes on the lives of John the Baptist and John the Evangelist. Down the length of the sides are scenes from the Old Testament that culminate in a rose window depicting the Apocalypse: flamboyant Gothic in style, it was completed between 1490 and 1495.

History of the Passion relics (detail)

These impressive windows together bathe the church interior in a changing light of predominantly red and

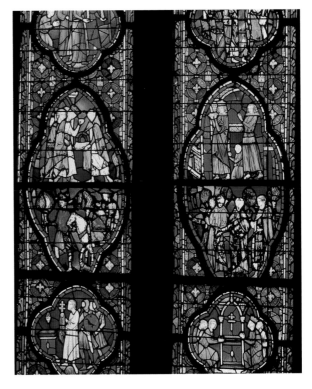

blue tones. Looking at each individual pane of glass emphasizes the density of the overall work, achieved through careful assembly of all these scenes. The sequence of images on the windows always begins at the bottom, on the left. One of the windows refers directly to the history of the relics of Sainte-Chapelle. Below, the discovery of the True Cross by St. Helen is shown, above which are the relics first being acquired by the Byzantine emperor and then being brought to Paris. Finally, at the very top, is the Adoration by Saint Louis and his family. Closer inspection also reveals the old royal palace and the Île de la Cité.

Conciergerie

Salle des Gens d'Armes

From the middle of the 14th century onwards, a chamberlain, or "concierge," administered the unoccupied royal palace. As far back as 1400, part of the building was used as a prison, and during the French Revolution thousands had to await here their transportation to the guillotine. The Salle des Gens d'Armes (1299–1313) was initially used as a dining room for up to 3,000 people and later as a resting place for the armed watch.

Clock on the Tour de l'Horloge

The first public clock in Paris was installed here around 1370, under Charles V "The Wise." In the 16th century it was given a representative Renaissance frame, the ornamentation it still has today. This culminates in two putti bearing the coat of arms of Henri III, the regent at that time and the last Valois king. To the right and left of the clock, two allegorical figures represent justice and the law in direct reference to the function of the courthouse.

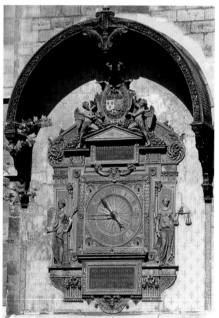

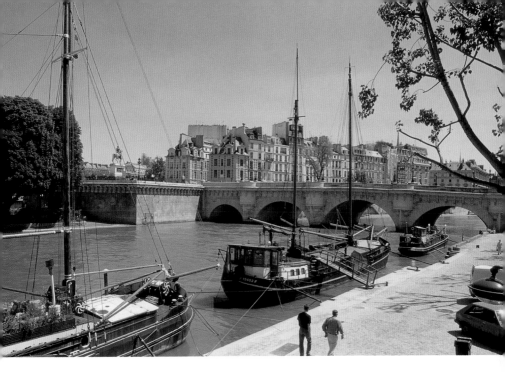

Place Dauphine

The square is one of the urban developments carried out by Henri IV (1589–1610). Building on the site began in 1607, with excellent use being made of the geographic location at the tip of the island. Three enclosed rows of houses with identical facades were built, though variation was achieved by using red brick and white stucco simulating hewn stone. Local stores were accommodated on the ground floor, above which were apartments on two sto-ries. Named after the birth of the long awaited heir to the throne and later king, Louis XIII (1610–1643), Place Dauphine brought a new openness to the densely built Île de la Cité, which mainly favored merchants and traders. This type of layout, radically changed through the interventions by Haussmann in the 19th century, points to the rational principles of urban design that were first formulated during the Renaissance.

Henri IV—"Good King Henry" or "the gallant Green"

by Martina Padberg

On the eve of August 24, 1572, which later went down in history as the St. Bartholomew's Day Massacre, Henri of Navarre, just 18 years of age, witnessed a terrible bloodbath from a window in the Louvre. Over 3,000 French Protestants (Huguenots), many of whom had come to the city for the recent wedding of the Protestant Henri to the Catholic Marguerite de Valois, were brutally slaughtered in just a few hours. As the gray morning dawned, the streets of Paris ran with blood.

This situation was not without danger for the young Bourbon from southwest France. A marriage had just taken place between him and the daughter of Henri II and Catherine de Medici—

ostensibly to reconcile the religious sides that had been at war for many years—and now he himself only narrowly escaped murder. He was forced to watch helplessly as his friends and confidants were butchered and found himself back in the Louvre as the prisoner of his brother-in-law, the French king Charles IX.

It is hardly surprising, therefore, that efforts to achieve tolerance and reconciliation were central to his later aims in terms of domestic politics. As he announced to members of the Paris parliament in a speech on February 16, 1599: "We should not make any distinction between Catholics and Huguenots—we should all be good Frenchmen." A politically astute sentence intent on reconciliation, it contained the clear demand to subordinate religious questions to a unifying national identity, thereby valuing the role as subject to a mutual king higher than the matter of confession. This marks the emergence of the notion of an absolute monarch that would be perfected by his son and, more particularly, his grandson Louis XIV.

Yet the road to royal dignity and above all to actually taking over the reins of power was to be a long one. When Henri III died

François Dubois (1529–1584), St. Bartholomew's Day Massacre, 1572–1575, oil on canvas, 94 x 154 cm, Musée Cantonal des Beaux-Arts, Lausanne

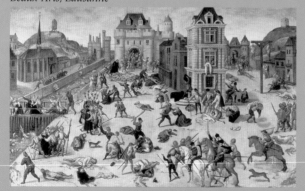

on August 2, 1589 following an assassination attempt, there was no successor to the throne from within the house of Valois. The crown passed to Henri de Navarre, thus introducing the factor feared by so many in France—a Protestant king. He remained, however, a king without a kingdom for a further five long years in a land ravaged by civil wars. Only after Henri IV publicly converted to Catholicism in St-Denis in 1593 was he anointed in Chartres the following year as the first king of the Bourbon dynasty and was able to move to Paris as regent. This conversion for reasons of political expediency was seen by his fellow believers as a betrayal. Yet it allowed him finally to take over the business of governing and led eventually to peace on the domestic political front. "Paris is worth a Mass"—this much-cited, laconic sentence does not do justice to the personal plight of the king and the external pressures of the situation: it was almost certainly not uttered by him, but instead is reputed to have been a rumor spread by deeply disappointed Protestants.

The rebuilding process began after the long-awaited end to the wars of religion and the Edict of Nantes (1598), by which Henri IV gave the Huguenots the right to exercise their religion freely, guaranteeing their physical safety and access to all official posts. As well as developing

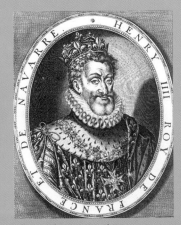

Thomas le Leu, Henri IV, copper engraving after François Quesnel, 1594–1599, Bibliothèque Nationale de France, Paris

the capital, his aims included strengthening the economy and improving the lives of the peasant population who had been badly affected by bands of marauding soldiers. In Paris itself Henri IV initiated large-scale projects with the extension of the Louvre and completion of the Pont-Neuf and Place Dauphine, as well as the Place des Vosges: they would define the development of urban design for centuries to come. No sooner had the process of consolidation begun, however, than a radical lay brother stabbed the 57-year-old king to death on May 14, 1610 as he was entering the Louvre. Although he had made many enemies during his regency, Henri IV went down in French history as "good King Henry." He was the ruler who brought internal peace to the country and promised that even the poorest of his subjects would have a chicken in their pot every Sunday. He is also remembered however, with a mixture of awe and ridicule, as the "gallant Green" skirt chaser, whose countless affairs often put him under a great deal of personal and political pressure.

Pont-Neuf

Quite the opposite of what its name suggests, Pont-Neuf is the oldest bridge in the city, crossing the Seine in two separate spans. Completed in 1604 under Henri IV, it was the first bridge without the customary house building on it. In this way, the view from the Louvre to the old royal palace on the Île de la Cité remained clear, and the bridge soon became a favorite meeting point in the center of Paris, not least because of its link to Place Dauphine.

For the first time, pavements and roads were separated off on two different levels, thus making it easier for pedestrians to stroll out of the way of the traffic. Booths and stalls, fortune tellers and quack doctors, carnival singers and actors set themselves up on the semicircular bays of the bridge's piers. On the bastion beside the Île de la Cité, Maria de Medici erected an equestrian statue of her husband Henri IV, after his murder in 1610. It was the first large-scale, public statue dedicated to a king, establishing a Parisian tradition that was continued throughout all the main squares of the city. The original statue, designed by the Florentine sculptor Giovanni da Bologna, was destroyed in 1792.

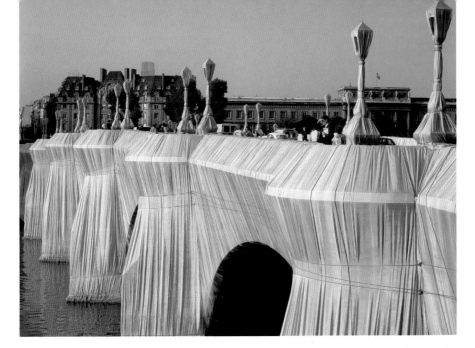

Christo and Jeanne-Claude, The Pont-Neuf Bridge Wrapped, 1975–1985

Revealing a new and strange side to what is old and familiar is a subject that fascinates the artists Christo and Jeanne-Claude when creating their projects: this motivates them time and time again to work with prominent and historically significant buildings. When the two artists wrapped the Pont-Neuf with sand-colored, silky fabric for a few weeks in 1985, it represented the end of a ten-year preparation period. During this time, they had to use all their persuasive powers to win over the authorities in Paris and the relevant politicians to accept this artwork into the heart of the city even temporarily. Over 300 specialists including divers and mountaineers helped to achieve the transformation of the bridge along with its pavements and streetlights. In keeping with the city of Paris they created a stylish, subtle, and astonishing piece, with rich folds and silky surfaces reflecting the sunlight, turning the bridge into a golden vision. Now this temporary miracle has only been preserved in the form of photographs and sketches.

Notre Dame

The Gothic cathedral of Notre Dame is a complete work of art that was almost 150 years in the making and whose religious, architectural, and political significance stretches far beyond Paris. The laying of the foundation stone in 1163, ennobled by the presence of Pope Alexander III, took place during the great era of Gothic architecture in France. There were already prominent role models near to hand in the form of the cathedrals of St-Denis and Chartres. For the newly appointed bishop, Maurice de Sully, and King Louis VII, however, the ambitious project in Paris was closely linked with the agenda of positioning the city as the theological and political center of the kingdom. A huge expanse of ground was freed up for a cathedral on the eastern side of the Île de la Cité by the wide-scale demolition of existing housing and two architectural forerunners. Generous contributions from the king, clergy, and aristocracy as well as a huge investment of labor made the construction of the building possible, which was completed after a few modifications around 1330.

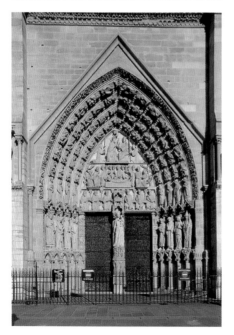

West facade (with detail: Portal to the Virgin)

On the great forecourt, called the parvis, the western facade rises up like a display wall, divided into five horizontal zones. On ground level, three ornately decorated stone portals lead into the interior—the Portal to the Virgin, the Portal of the Last Judgement, and the Portal to Saint Anne (from left to right). Above this, there is an innovative facade design in the form of the King's Gallery with 28 statues: the heads of these were cut off during the French Revolution because they were believed to be portraits of French kings. What is left of the originals, which were presumably the biblical kings of Israel and Judea, can now be found in the Musée de Cluny. Continuing up the facade, there is a clerestory with a central rose, which is followed by the

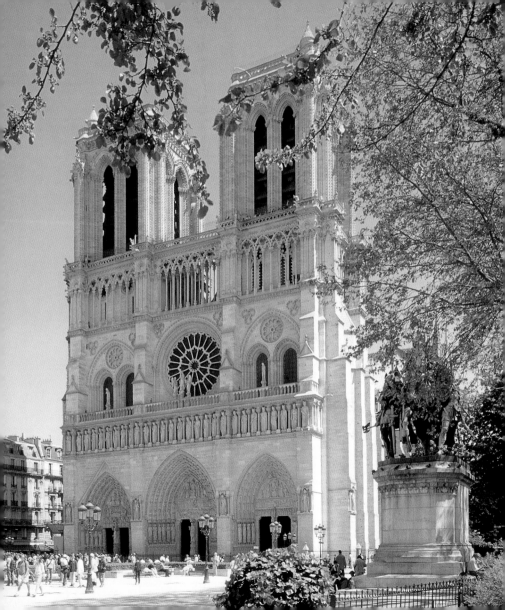

balustrade tracery and finally at the top by two truncated towers.

The famous portals on the west facade have tympanum reliefs with rich, decorative sculpture, which were restored and partially replaced in the 19th century by Eugène Viollet-le-Duc (1814–1879). The Portal to the Virgin is dedicated to the patron of the cathedral. The strong composition of its figures and restrained gestural language became the ideal model in the late Middle Ages.

South facade of the transept

The external view of the nave and choir is characterized by the broad flying buttresses that bear most of the weight of the church. Removing the weight burden from the wall surfaces in this way allowed extensive fenestration of the walls. A well-known master builder, Pierre de Montreuil, was involved in the interior design of the south facade, which is particularly ornate and elegantly divided. The transept portal is dedicated to St. Etienne, patron of the Romanesque basilica torn down to make way for the new building, and shows scenes from his life and works. The small reliefs on each side of the portal are also worthy of notice; they represent student life in the cathedral school.

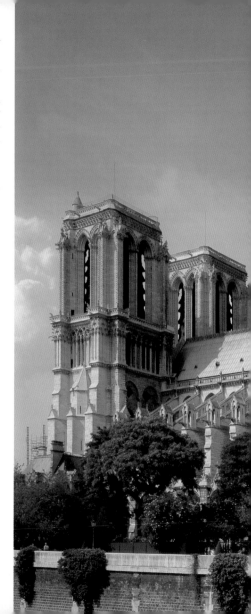

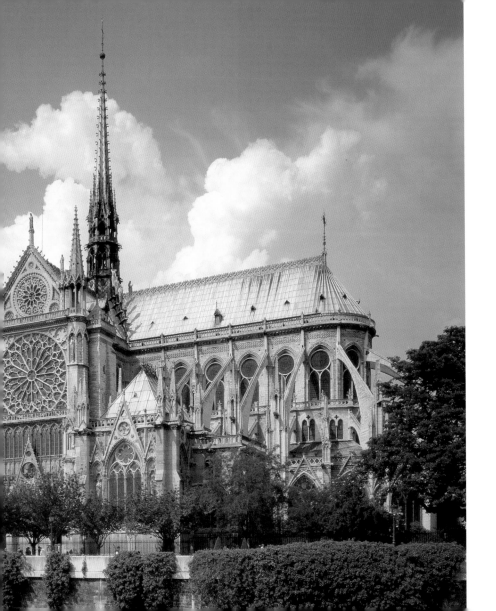

Notre Dame

Antoine Coysevox, Ludwig XIV,
Statue on high altar, 1715

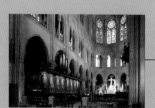

View of the choir and seating after
Robert de Cotte, 1711–1715

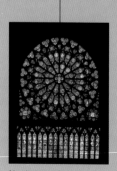

North rose window, p. 56

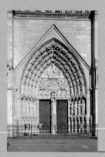

Portal to the Virgin, p. 48 f.

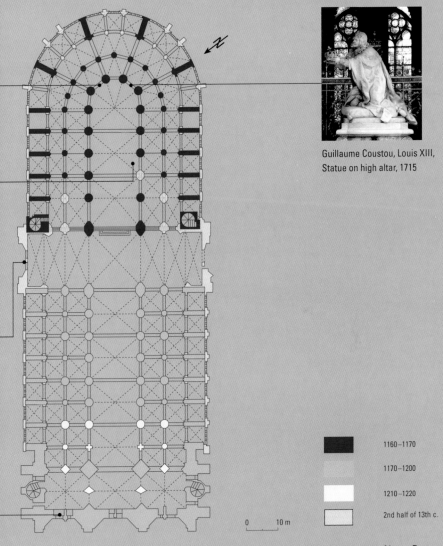

Guillaume Coustou, Louis XIII,
Statue on high altar, 1715

■	1160–1170
	1170–1200
□	1210–1220
	2nd half of 13th c.

0 10 m

Notre Dame **53**

Elevation

The cathedral church of Notre Dame (Our Lady), the last great gallery church in France, underwent a significant change to the vertical division of the interior during construction. The original building had a four-zone elevation typical of the early Gothic style, but around 1220/1230 the upper windows were extended considerably, the small rose windows removed, and the plain lancet windows exchanged for tracery windows. These measures ensured better light in the gloomy main body of the church and were in keeping with the Gothic tendency to break up large wall areas. In the bays around the crossing, Viollet-le-Duc carried out an exemplary restoration to their original state during the 19th century.

Interior

On entering the church through the three-level west facade, the visitor is surprised by a five-part nave. Together with the side chapels, which form a closed crown here for the first time in Gothic church architecture, it constitutes a vast space capable of holding up to 6,500 people. The central nave is divided by massive round pillars and arcades with pointed arches, whose uniformity give this extensive area its visual coherence. Above the capitals, engaged columns rise up 115 ft. (35 m) to meet the six-part, cross-ribbed vault. In the side aisles there is a variation in supports between round columns and round pillars with engaged columns. The wide breadth of the crossing and transept, which are seen as the special achievement of the renowned architects Jean de Chelles and Pierre de Montreuil, heighten the impression of space still further—the idea of the cathedral as a celestial Jerusalem built in stone as a monument to the power of the church and monarchy is given emphatic expression by the difference in size between man and architecture.

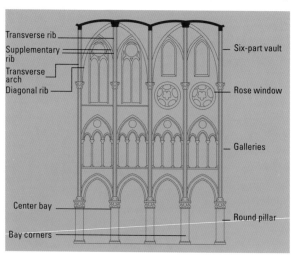

Transverse rib
Supplementary rib
Transverse arch
Diagonal rib
Six-part vault
Rose window
Galleries
Center bay
Round pillar
Bay corners

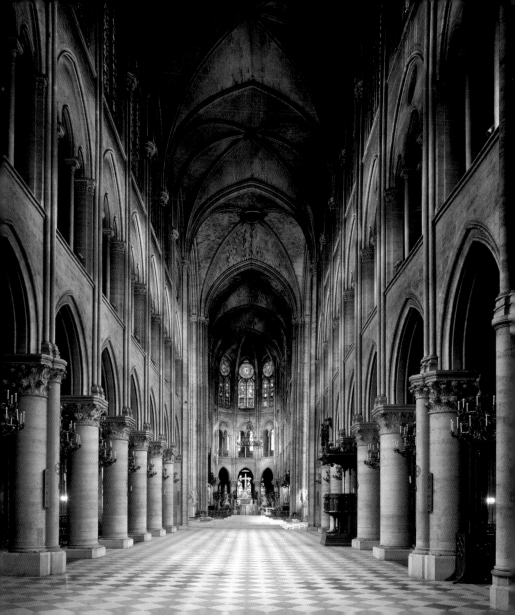

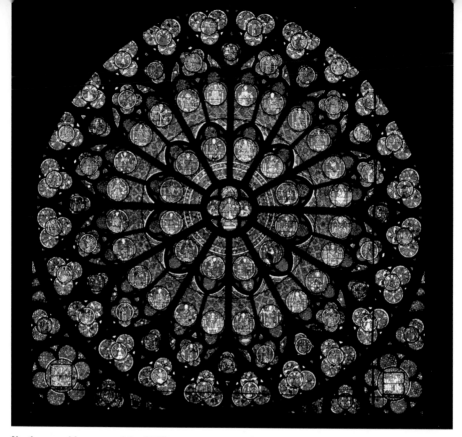

North rose with scenes of the Old Testament, ca. 1250

The three huge rose windows in the transept and western facade are particularly impressive: they are each 43 ft. (13 m) in diameter and bathe the main body of the church in a violet-red light. The rose on the north wall has been preserved in its origi-nal condition and depicts scenes from the Old Testament that are grouped around the central figure of the Madonna and Child. The effect of the round windows is meant to convey a metaphysical experience of light rather than create recognizable repre-sentations: the window seems to exude a glow of light from within like a precious stone.

Quasimodo lives—Victor Hugo and the rebirth of the Middle Ages

by Martina Padberg

As the whole nation—with the exception of the aristocracy—rose against the outdated and repressive regime of Charles X (1824–1830) in "the three glorious days" from July 28–30, 1830, and the old revolutionary spirit seemed to rise up in Paris once more with the bourgeoisie, workers and intellectuals setting up barricades side by side, Victor Hugo was working in single-minded seclusion on a great historical novel. Just a few months later, in February 1831, the 500-page work was published under the title "Notre-Dame de Paris," and very quickly went on to become an unprecedented success with the public. Within a year it was in its eighth reprint and had three additional chapters. In his book, Hugo tells the tragic story of the hunchbacked bell ringer, Quasimodo, set in Paris at the end of the 15th century when the Middle Ages were giving way to the Renaissance. It is a tale everyone is now familiar with, not least due to the incredible number of film versions (even a Disney cartoon)

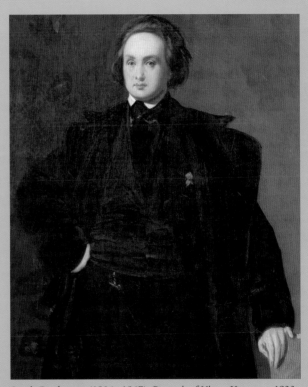

Louis Boulanger (1806–1867), Portrait of Victor Hugo, ca. 1833, oil on canvas, 26 x 21 cm, Maison Victor Hugo, Paris

and various musicals all produced with the erroneous title "The bell ringer of Notre Dame." For the most part these are very commercial

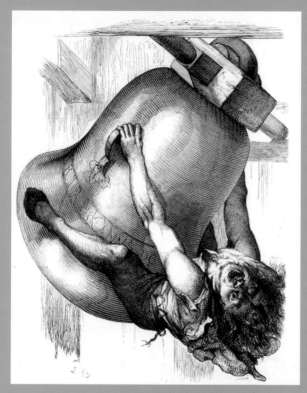

Quasimodo—The Bellringer of Notre-Dame, 1844, copper engraving by Laisné, presumed to be after Steinheil

romanticism, aspiring to bring to life a lost era in its entirety and in a readable form. It leads us back into the labyrinth of narrow, treacherous alleys in Paris in a time long before Haussmann created a city of boulevards.

The Gothic cathedral is the central point, geographically as well as spiritually, as the incarnation of a value system that was both authoritative and unifying. Hugo's problematic relationship with Catholicism is expressed through the narrative in numerous ways. Notre Dame acts at one and the same time as a shelter and a prison, a place of both freedom and oppression. This is where Quasimodo lives, a one-eyed hunchback and freak of nature who serves as a bell ringer. Like a mythical creature, a cross between man and beast, terrible to look at and moving in his simpleheartedness, he lives in the towers of the cathedral protected from a society that punishes any deviation from the norm with bitter scorn and harsh cruelty. The body of the church itself is the domain of the sinister archdeacon Claude Frollo, whose passionate love for the beautiful Esmeralda turns him into a murderer and wicked schemer, resulting in the eventual death of the gypsy girl. Having pledged her

adaptations, which always focus on the tragic love story between the cripple and the beautiful gypsy girl and almost completely obliterate the complex narrative structure and true meaning of Hugo's work.

"Notre-Dame de Paris" is a novel marking the culmination of the historical novel of French

unconditional love to the young, impulsive, and superficial Captain Phoebus—who certainly does not deserve it—she is condemned as a witch and murderess, tortured, and, though innocent, hanged on the Place de Grève. Quasimodo tries in vain to rescue her. He is bound to her in immense gratitude and tender affection, ever since she showed compassion by offering him a sip of water when he was pilloried and whipped by a jeering, salivating crowd. The helplessness of the individual before an inevitable fate, being at the mercy of one's own uncontrollable feelings and the capricious forces of the church, the law, and the mob— these are the main themes of this Romantic melodrama, which portrays the lives of the protagonists in a wealth of cleverly interwoven detail. The purity and innocence embodied in equal measure by the ugly figure of Quasimodo and the beautiful Esmeralda cannot prevail in the face of scheming evil: yet in their goodness they remain at the very heart of humanity, the inviolable guarantee of individual freedom against the claims of society. The highly topical political dimension of the historical novel was combined throughout Hugo's life with the hope for a culture of freedom, a hope that for a short time seemed to be reflected in the uprisings of July 1830, but were rapidly dashed after the appointment of Louis-Philippe, the so-called "roi bourgeois" (bourgeois king). Victor Hugo was ready to take up arms for his political convictions and had to flee into exile to Great Britain. He did not return to Paris until after the collapse of the monarchy in 1870. Not long afterwards, he wrote as an old man of 70 in "Choses vues" (Things Seen): "My life can be summed up in a few words—in solidarity and in solitude."

Charles Meryon (1821–1868), "Le Stryge" (The Vampire), 1853, etching, 11.6 x 15.5 cm, Bibliothèque Nationale de France, Paris

59

Île St-Louis

A creation of the 17th century, the Île St-Louis can be reached from Notre Dame via Pont St-Louis. It was reclaimed from two smaller islands in 1609 by filling in an arm of the Seine with gravel that separated them. Louis XIII linked the islands to both banks of the river by two bridges and leased out the parcels of building land. As in the Marais, lavish palaces were built here, mainly by the aristocracy, but also by prosperous representatives of the bourgeoisie such as bankers and judicial officers. A homogenous form of Classical architecture emerged that concealed its luxurious interior design behind very plain, unadorned, yet elegant facades. Île St-Louis remained unaffected by the large-scale reconstruction work during the 19th century, which among other things radically changed the structure of the neighboring island. For this reason, the narrow streets, the quiet quais,

Île Saint-Louis, view from Pont Saint-Louis to Quai d'Orléans and Quai de Béthune

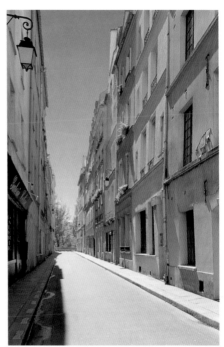

Quai d'Orléans at Rue Jean-du-Bellay

Rue Budé

and the old villas with their lovely portals partially decorated with woodcarvings and wrought-iron balconies convey the impression of the time in which they were built even today. A walk along Quai de Bourbon and Quai d'Anjou offers beautiful views across to the opposite bank when passing by the former studios and apartments of Camille Claudel (19, Quai de Bourbon), Théophile Gautier (17, Quai de Bourbon), and Honoré Daumier (9, Quai d'Anjou).

Also on the Quai d'Anjou are the two most famous palaces built by the architect Louis Le Vau in the mid-17th century: the Hôtel de Lauzun and Hôtel Lambert. Le Vau, a respected and successful architect who lived on the island himself and supervised many of its building projects, was also involved in the construction of the St-Louis-en-l'Île church, which was, however, not completed until 1725.

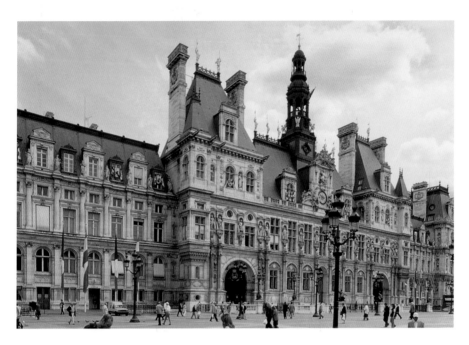

Hôtel de Ville

The town hall, built in the style of the Early Renaissance and richly decorated with around 150 statues and medallions of famous men in the city's history, is rather surprisingly a creation of the 19th century. It is a historical replica very much in the style of the building erected by François I in 1533, though it was far bigger than its original model, which was destroyed during the suppression of the Commune (1871). The location for the administration of the communes is an historical one: ever since the Middle Ages, the ships of the Seine have docked at the former Place de Grève. This is where trading and dealing took place, as well as folk festivals and even public hangings. From 1357, the residence of the "prévôt des marchands" (provost of the merchants), who represented the interests of the guilds with the king, was on this square. After ongoing problems of authority with the crown, the office of mayor was abolished once more under Napoleon I (1804–1814/15) who instead installed a "préfet de la Seine" (prefect of the Seine) in its place. The Hôtel de Ville did not have an elected mayor until Jacques Chirac was in office in 1977.

Tour St-Jacques

Tour St-Jacques-de-la-Boucherie, 1853,
Musée Carnavalet, Paris

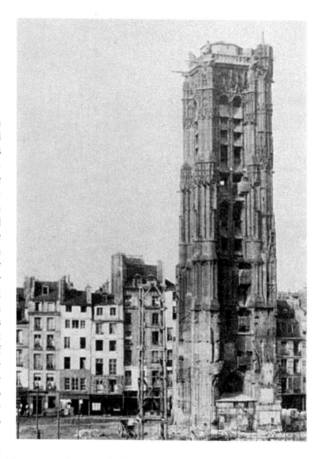

In the busy commercial area between the Rue de Rivoli and Place du Châtelet stands a strangely isolated tower, which is all that is left of the Gothic church of St-Jacques-de-la-Boucherie. The parish church of the butcher's guild that was formerly based here was sold for demolition in the wake of revolutionary secularization in 1797. Only the tower stayed where it was: built by Jean de Félin between 1508 and 1522, its spire was never finished, but it gives an indication of church architecture in the Flamboyant style. In the 19th century a socle had to be added for stability. The arcades in the basement also date back to this conservation work, which was instigated by Baron Haussmann. The statues in the baldachins are replicas, as the originals were destroyed during the Revolution. On the corners of the platform can be seen the symbols (eagle, lion, and bull) of the three Evangelists, Mark, Luke, and John, along with the patron, St. James. Since the Middle Ages, pilgrims had been passing by on their way to Santiago de Compostela in the south. For this reason, a predecessor to the building had been previously consecrated to this saint in the 13th century.

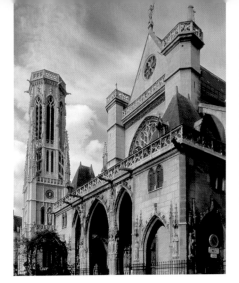

Antoine Coysevox. Of architectural note is the Late Gothic narthex, which was built as a separate structure with three portals between 1435 and 1439. The Portal of the Last Judgement in the center has ornate figures. On the right side is St. Genevieve, the patron saint of Paris: she can be identified by her usual attribute—the candle blown out by the Devil but always relit by an angel. The Bishop of Auxerre, St. Germain, met her as a child, and it is to him that the church is consecrated.

Pont des Arts and Institut de France

St-Germain-l'Auxerrois

The chimes of this church were the secret signal that unleashed the terrible St. Bartholomew's Day massacre of the Huguenots in 1572. St-Germain-l'Auxerrois was built on the foundations of an earlier building in a prominent position opposite the Louvre and had just been completed at that time, following a construction period of over 300 years. It served as parish church to the royal court and then, later, when the king moved to Versailles in 1682, it was mainly used as a burial place for artists who had their studios in the Louvre. Some of those buried here are the architects Louis Le Vau and Robert de Cotte, the painters François Boucher and Jean-Baptiste Chardin, and the sculptor

Built in 1803 during the reign of Napoleon I, the Pont des Arts is the oldest iron bridge in France. Supported by cast-iron arches on stone piers, this delicate-looking footbridge connects the Louvre and the Institut de France. This latter building was originally home to the Collège des Quatre-Nations, a foundation established by Cardinal Mazarin (1602–1661) offering a free education to 60 students. Beneficiaries of the college were supposed to come from the four regions that had fallen to France at the end of the 30 Years War, in the wake of the peace treaties of Münster (1648) and the Pyrenees (1659). In so doing, the college was actively promoting a form of scholarship that fitted perfectly with political and integrative aims. Mazarin had commissioned the architect Louis Le Vau for the

new building; he designed a curved ground plan with clear influences from Roman baroque architecture. The site opens out onto the riverbank in an oval shape: the college chapel with its high dome forms the central point. The two-story wings adjoin it on each side; this is where the teaching took place. The facade is inspired by a Roman column order with pilasters, pillars and columns. The tomb of Cardinal Mazarin is located in the chapel, based on a design by Jules Hardouin-Mansart and completed by Antoine Coysevox in 1692. The Cardinal's college was closed down by revolutionaries in 1793. Under Napoleon I, the building became home to the Institut de France, an amalgamation of the old royal academies. Today, the Institute is made up of the five most important national academies: the Académie Française (est. 1635); the Académie des Inscriptions et Belles-Lettres (1664); the Académie des Sciences (1666); the Académie des Beaux-Arts (1816); and the Académie des Sciences Morales et Politiques (1832). The annual inauguration of new members still takes place in the traditional assembly hall underneath the cupola.

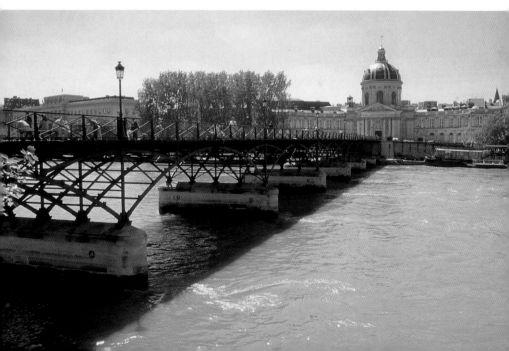

The Académie Française—the language police on the Seine

by Oliver Burgard

"The language of the Republic is French." This is stated in Article 2 of the Constitution. As the intellectual basis of state and society, the national language in France is afforded the protection of the highest law. The history of state custodianship of the language can be traced back to the year 1635, when Cardinal Richelieu created the Académie Française. Right up to the present day, the sole task of the Academy has been to guard the form of communication of the populace. Not the content, but the words. It is a question of "la

Cardinal Richelieu and the members of the Academy represented as the center of the sun, 1635, copper engraving by unknown artist, Bibliothèque Nationale de France, Paris

pureté"—the purity of expression. The official dictionary of the Academy, which first appeared in eight volumes in 1694, lays down the guidelines for the proper use of the French language. The Academy's 40 members, whose numbers include several writers and leading intellectuals, are respectfully referred to by the French as "les Immortels" (the Immortal Ones). The reason for this is that anyone appointed to this illustrious circle remains an "académicien" for life, with membership being regarded as the pinnacle of any intellectual career. Members meet every Thursday to work on the new edition of the dictionary, which is now in its ninth incarnation. The decision rests with them as to which new words should belong to the official vocabulary and how they should be written. Increasingly, it is about translations of English and American expressions, which to the great annoyance of the language guardians have slipped into everyday French in recent years, mainly through advertising and television. Combating the hated "franglais" has become one of the Academy's most important tasks.

The Internet in the 21st century has also become a source of contamination of French through Anglicized terminology. While in the land of Victor Hugo and Voltaire, two former Academicians, the reference is not to "computers" and "software," but instead to "ordinateur" and "logiciel," the spread of multimedia and the Internet is bringing with it a flood of new expressions, all of which

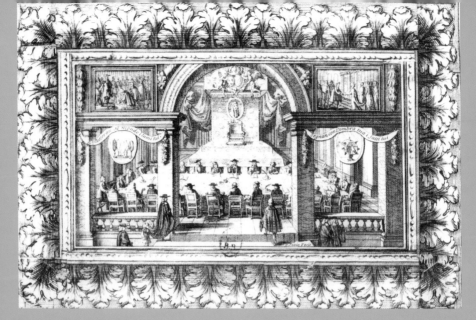

P. Sevin, The Academy in session, copper engraving

are American in origin. The Academy provides a guide to the correct form of expression on its website, where it lists English expressions and their French translations. In doing so, the Immortals do not shrink from content-related interventions into the language, replacing the symbolic abbreviation "www" with a neutral "tam" and degrading the "World Wide Web" unceremoniously with the term "Toile d'araignée mondiale"—a worldwide spider's web. The Immortals see it as their reward that the French language has reached such a high quality in 200 years, thereby making it the language of elites the world over. So it is only logical that the linguistic custodians on the Seine look not to the mouths of the

people, but to those of the upper echelons of society, particularly from the worlds of politics and the media. In the summer of 1998, however, they were forced to acknowledge in indignation that the Jospin government had arbitrarily invented new words. The six female cabinet ministers decided to feminize their titles and use the term "Madame la Ministre" in official communications. In the eyes of the Academicians, this was a forbidden attack on the linguistic supremacy of their institution; it gave rise to an impassioned public debate.

This dispute about words may be surprising, but the maintenance of the national language among the elite in France is a concern shared by everyone

DICTIONNAIRE

DE

L'ACADÉMIE FRANÇOISE.

[Dictionary text in columns]

Gerard Edelinck, The King as Patron and Protector of the Académie Française, Frontispiece of the "Dictionnaire de l'Académie Françoise," 1694, copper engraving after Jean-Baptiste Corneille

Jean Mariette, First page of the "Dictionnaire de l'Académie Françoise," 18th c., copper engraving after Jean-Baptiste Corneille, both in Bibliothèque Nationale de France, Paris

and seldom causes argument. Whether it is in the spoken language, music, or the moving image, the state uses a combination of subsidies and quotas to make sure that radios play French music, televisions put on home-grown programs, and cinemas show French films. In 1994 the Culture Minister, Jacques Toubon, personally enacted a law on language which was called the "loi Toubon" after its author. It bans the use of English expressions and slogans in advertising, radio, and television if there are existing French words with the same meaning. Since then, there has officially been no more "fast food," "walkman," or "aftershave" in France: instead they are called "restauration rapide," "balladeur," and "lotion après rasage" respectively. Infringements are punished in the courts. The Body Shop was taken to court in 1996 after a consumer protection inspector found various soaps and shampoos in a branch of the cosmetics chain that had English labels.

"Lus" not "Salut"

There are, however, no legal repercussions for the everyday corruption of the French language heard among young people. Many of them speak "le verlan" in French cities: their own, made-up slang of reversed syllables that practically no one can understand except them. In the way that the word "verlan" was made up by inverting the word "'l'envers" (meaning "the wrong way round"), a stream of new words is being created in the language of the subcultures, especially among the children of immigrants, by constantly inverting syllables and parts of words. The cool

way to greet friends is with "lus" instead of "salut" while smoking "garettecis." Syntax and grammar also become garbled, when the twisted and abbreviated words are made into sentences in a new sequence.

Verlan developed as a linguistic fad on the fringes of large cities in France. When French artists discovered the word contortions of social outsiders, it became the topic of all the arts feature pages. Pop stars like the rapper MC Solaar have written songs in verlan, while directors such as Matthieu Kassowitz and Jacques Doillon have cast in their socially critical feature films actors who speak the jargon of the periphery. In these films and songs, verlan is understood as a genuine expression of the social reality of France. They have raised the anarchic artificial language to the level of a French cultural artifact, once more documenting the fact that a living language cannot be bound by the regulatory efforts of its guardians.

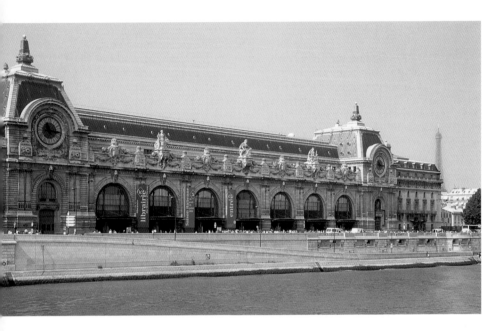

Musée d'Orsay in the Gare d'Orsay

The Gare d'Orsay, built in just three years and one of the largest central railway stations in Paris, was put into operation just in time for the World Exhibition in 1900. The architect Victor Laloux (1850–1937) had concealed the modern glass and iron structure of the huge station concourse behind the elaborate ornamentation of an historical stone facade. This led even contemporaries to imagine it more as a "palace of the fine arts" when they approached the Gare d'Orsay. The decision to turn it into a museum in 1979 saved the station, which had been abandoned for 40 years, from demolition and was particularly appropriate for its eclectic architectural language. The ensuing renovation work took twice as long as the original building period: the Musée d'Orsay was opened in 1986, with a collection that represents 19th-century art in all its diversity. Through painting, sculpture, the decorative arts, photography, and architecture it is possible to engage with an artistic period that was incredibly productive, through its struggle to become reconciled with the upheavals of industrialization.

The Great Hall and Sculpture Walkway

Sculptural works from around 1850 are on display in a central aisle in the massive station concourse. Adjoining halls of the museum exhibit paintings also dating from the same time. The chronological display of artworks continues on the upper and middle floors: standing together on an equal footing are the Salon paintings of the Academy alongside the Impressionists, and the monumental sculptures of the Second Empire alongside the works of Rodin and Maillol. In this way, the themes and techniques of the epoch are clearly and vividly conveyed to the visitor. Most importantly, only then do the innovations of progressive artists become truly understood against their historical background.

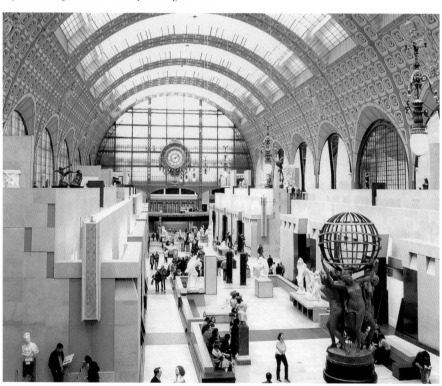

Musée d'Orsay

The most recent renovation work in the Musée d'Orsay involved restructuring the entrance and cash desk area in order to speed up access to the museum. Till then, the long queues of waiting visitors on the drafty platform had been an annoying permanent feature. More space was also given over to the museum's ambitious temporary exhibitions and the museum shop.

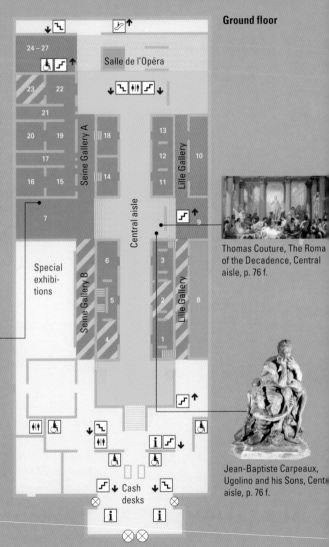

Ground floor

Gustave Courbet, Burial at Ornans, Room 7, p. 75

Thomas Couture, The Roma of the Decadence, Central aisle, p. 76 f.

Jean-Baptiste Carpeaux, Ugolino and his Sons, Cent aisle, p. 76 f.

Second floor

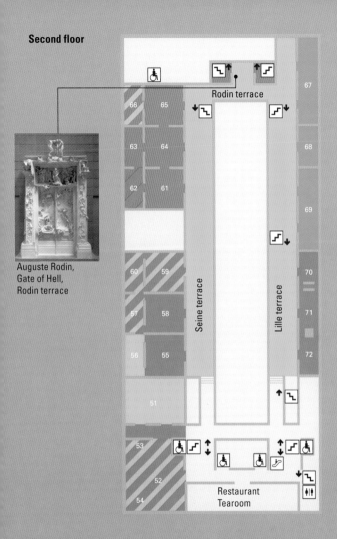

67

66 65

Rodin terrace

63 64

68

62 61

69

60 59

70

Seine terrace

Lille terrace

57 58

71

56 55

72

51

53

52

54

Restaurant
Tearoom

Auguste Rodin,
Gate of Hell,
Rodin terrace

Sculpture

Painting

Architecture

Decorative Arts

Temporary exhibitions

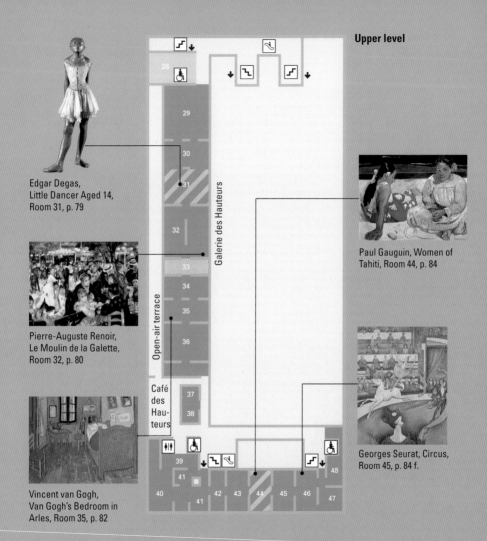

Edgar Degas,
Little Dancer Aged 14,
Room 31, p. 79

Pierre-Auguste Renoir,
Le Moulin de la Galette,
Room 32, p. 80

Vincent van Gogh,
Van Gogh's Bedroom in
Arles, Room 35, p. 82

Galerie des Hauteurs

Open-air terrace

Café
des
Hau-
teurs

Paul Gauguin, Women of
Tahiti, Room 44, p. 84

Georges Seurat, Circus,
Room 45, p. 84 f.

28
29
30
31
32
33
34
35
36
37
38
39
40
41
41
42 43 44 45 46
47
48

Gustave Courbet (1819–1877), Burial at Ornans (detail), 1849/50
Oil on canvas, 315 x 668 cm

When Courbet exhibited his massive painting in the 1851 Paris Salon, it met with a negative and perplexed response from the public. This monumental size painting depicts around 40 people, portrayed in minute detail, gathered together for the burial of an anonymous citizen of the small town of Ornans in the Franche-Comté region. The contemporaries of Courbet could not understand how such an insignificant event could become the subject for a picture format normally reserved for historical painting. They were also irritated by the drab brown and green colors and the funereal black of the clothing appropriate to the occasion. The bleak tedium of provincial life was conveyed directly by both the subject matter and the style of painting, which in the context of the Paris Salon was seen as impertinent. The radical realist vision of Courbet did indeed contradict the prevailing concepts about art: neither the past nor elevated subjects, but unadorned reality in all its triteness was being monumentalized within the format of a contemporary history painting.

The sculptural group "Ugolino and his Sons," on which Carpeaux worked for about three years, was a direct result of the artist's stay in Rome (1858) as a fellow of Villa Medici: while there, he encountered the sculptures of antiquity and the High Renaissance. Carpeaux chose a classical pyramid composition for the depiction of Ugolino, a tragic figure from Dante's "Divine Comedy" who is forced to starve to death with his sons and, while in a state of agony, eats of the flesh of his children. Exhaustion, despair, and madness are reflected in the faces, while instances of physical pain and spiritual loneliness are expressed in a multitude of physiological details. The precise anatomical rendition of the old and young bodies and the subtle finish give this work its exceptional quality: by order of the state, it was cast in 1862 and erected in the Tuileries Gardens.

Thomas Couture (1815–1879), The Decadence of the Romans, 1847
Oil on canvas, 472 x 772 cm

Jean-Baptiste Carpeaux (1827–1875), Ugolino and his Sons, 1862
Bronze, 194 x 148 x 119 cm

Jean-Baptiste Carpeaux, one of the most successful sculptors of his generation, was commissioned by the Emperor to create several major groups of figures as ornamentation for facades in Paris, among which was the Opéra Garnier building.

A teacher of Édouard Manet and Anselm Feuerbach among others, Thomas Couture belonged to the last generation of great historical artists in France, and achieved considerable acclaim with this monumental painting in the Salon exhibition of 1847. His picture illustrates a text from Roman antiquity, which bemoans the decadence of society in times of peace and prosperity—according to the Roman author and satirist,

Decimus Iunius Juvenal, if there is no external foe, then egoism, anarchy, and immorality soon take over. As if on a stage fitted with replicas of the auditorium architecture of antiquity, Couture orchestrates a veritable orgy with around 30 participatory figures under the watchful eyes of gods of stone and emperors. Contemporary viewers would certainly have been compelled to see parallels in this to their own situation. Internal social disintegration and social tensions could be felt everywhere in the year before the outbreak of the 1848 Revolution. The constitutional monarchy under the bourgeois king, Louis-Philippe, who together with the upper classes had bled the country dry at the expense of the ordinary people and the new industrial proletariat, had failed miserably in living up to initial expectations. In addition, large sections of French society were unsettled by the onset of industrialization and its far-reaching social consequences. Couture's monumental painting could well be read as a cautious, if politically neutral, allegory of that time. With its representational form lacking in innovation and harking back to baroque models, it marked the end of classical historical painting.

Édouard Manet (1832–1883), Le déjeuner sur l'herbe, 1863
Oil on canvas, 208 x 264 cm

When Manet showed this picture in the "Salon des Refusés" (the exhibition for those refused entry to the official Salon by the selectors), it unleashed guffaws of laughter on the part of the public. There was an outpouring of ridicule and derision for a painting that shows a strange group of two well-dressed gentlemen and a naked woman sitting in a clearing in a wood. It is not, however, actually about a picnic on the grass, as the title suggests—instead, it deals with the subject of prostitution in the Bois de Boulogne, of which everyone in Paris was aware, but did not speak. Manet turned this taboo topic into the subject matter of the painting, even giving it a classical composition, positioning his figures in the manner of the Italian Renaissance.

Edgar Degas (1834–1917), Little Dancer Aged 14 (profile and front view), 1880/81
Polychrome bronze and fabric, 98 x 35.2 x 24.5 cm (without base)

Edgar Degas, who was in fact a painter and illustrator, began working around 1880 with small sculptures, most of which were of a purely personal nature. The figure of the 14-year-old dancer, relatively tall at almost a meter in height, was shown in the year of its creation in the sixth group exhibition of the Impressionists. Rather than the bronze-cast figure on display here, it was a wax model dressed in a tutu and wearing artificial hair, silk ribbons, stockings, and ballet shoes. The critics reacted in negative fashion, as the representation of the young girl was considered offensive. The simple, almost coarse face and posture that reflect a moment of relaxation during rehearsals convey an idea of the social and physical hardship these young dancers had to endure. Degas, who for years had moved in opera circles and found his models there, expressed something in his realistic portrayal that Parisian society refused to see. Members of the elite Jockey Club used the poorly paid young girls of the corps de ballet as prostitutes, gaining free access to their dressing rooms. The rather surprising inclusion of ballet sequences in the works of many composers for the Opéra Garnier can no doubt be attributed to the influence of these "patrons of the arts."

Pierre-Auguste Renoir (1841–1919),
Le Moulin de la Galette, 1876
Oil on canvas, 131 x 175 cm

In 1875, Renoir rented a small house with a garden in Rue Cortot in Montmartre, with the financial support of the wealthy publisher Georges Charpentier. This was the beginning of an exceptionally creative phase for the artist. The complex portrayal of the Sunday dance at the nearby Moulin de la Galette open-air restaurant presented him with the challenge of composing a figure-studded scene that was characterized by constant movement and the ever-changing light. Some of his friends acted as models for the picture, which was painted in situ and at a rapid rate. Renoir captured and conveyed the relaxed atmosphere of a warm summer's afternoon with his characteristic dissolving forms and subtle dashes of color.

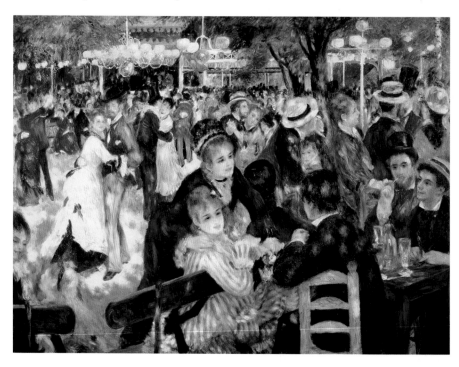

Claude Monet (1840–1926), The Cathedral at Rouen
Left: Harmony in Blue and Gold, 1893
Oil on canvas, 107 x 73 cm
Right: Harmony in Gray, 1892
Oil on canvas, 100 x 65 cm

In the late 1880s, Claude Monet began his series of works that involved painting the same subject—here it is the Gothic cathedral in Rouen—at different times of day and in varying light and weather conditions. This concept demanded extremely fast and spontaneous painting in order to capture a fleeting instance of light. Monet managed to achieve a fascinating balancing act between completing the subject of the picture in his characteristically shimmering, vibrant style and focusing on a precise rendition of the architecture.

**Vincent van Gogh (1853–1890), Van Gogh's
Bedroom in Arles, 1889**
Oil on canvas, 57 x 74 cm

Just before the eagerly awaited arrival of his
friend Paul Gauguin in October 1888, Van
Gogh was working on "Bedroom in Arles"—
the Musée d'Orsay has one of the smaller ver-
sions he produced the following year. The first
painting was intended for the studio in the
Yellow House that Van Gogh was hoping to
turn into accommodation for an artists' col-
lective in the near future. His collaboration
with Gauguin ended in a mental breakdown
after only two months. When he came out of

hospital, Van Gogh was so pleased with the
interior that he completed two replicas as
replacements for the original, which had been
damaged by dampness. "The color must do all
the work here and give the impression of rest
or sleep, if I simplify it (...)" he wrote in a let-
ter to his brother on October 16, 1888, refer-
ring to this work. By using complementary,
yet contrasting, colors—red and green, yellow
and violet, blue and orange—he creates the
sensation of a quiet, private room, whose
humble nature reveals a great deal about the
artist's desire for authenticity in his life and
work.

Paul Cézanne (1839–1906), The Bridge at Maincy, 1879/80
Oil on canvas, 58.5 x 72.5 cm

By 1877, Cézanne had retreated to the provinces away from the art scene in Paris, after his works had been unequivocally rejected there. This landscape, which he painted during a stay in Melun, marks his final break with Impressionism. Whereas Monet and his circle were concerned with capturing a fleeting visual impression in painting, Cézanne was busy working on a universal, timeless formulation. Crystalline forms and strictly controlled brushwork con-

tribute to a structured, well-organized over-all impression. The object being represented is formed by short, parallel brushstrokes. "Everything in nature is modeled on cones, spheres, and cylinders. You must use these simple shapes as the basis for learning to paint, and then you will be able to do any-thing you want," wrote Cézanne in 1904. His insight was to be decisive in stimulating and marking the development of painting right up to the Cubist period.

Paul Gauguin (1848–1903), Women of Tahiti (On the Beach), 1891
Oil on canvas, 69 x 91.5 cm

Georges Seurat (1859–1891), Circus, 1891
Oil on canvas, 185.5 x 152.2 cm

Paul Gauguin hoped that he would find a new impetus for his painting in Tahiti, as well as an alternative lifestyle—closer to nature and far away from the behavioral norms of civilization. He was soon forced to recognize, however, that French colonialism had inflicted lasting damage on what was supposed to be a South Sea paradise. Nevertheless, the two massive Polynesian women seem like icons of an existence at peace with itself. In terms of composition, Gauguin worked with one of his leitmotifs in this painting: the tension between the two- and the three-dimensional. Thus, the bulky, heavy figures are placed in front of a horizontally structured landscape completely lacking in any spatial depth.

The circus performance is in full swing—a galloping horse, an audacious female artiste, a clown doing somersaults—and yet the scene seems as if frozen, in a strange kind of vacuum. On closer inspection of the picture, the painting technique becomes evident: each part of the image is made up of uniform dots in primary colors and their complementary tones. Seurat developed this technique with Paul Signac around 1886; it was later described as Neo-impressionism, pointillism (from the French "point" meaning "dot"), or divisionism, and represented a strictly systematic approach to painting. The free application of paint of Impressionism was replaced by a decomposition of the subject based on physical rules: instead of a spontaneous act of painting in front of an object, a long period of work in the studio was required. No other style of contemporary painting managed to achieve a comparable purity of color. The approach of Seurat stimulated the development of European art in numerous ways well into the 20th century.

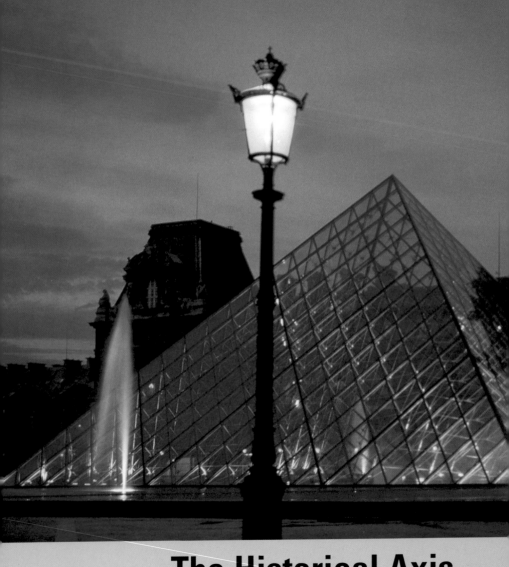

The Historical Axis—

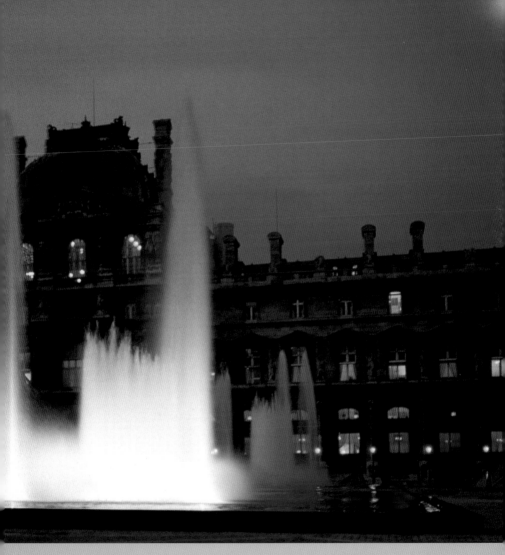

from the Louvre to La Défense

The Historical Axis—from the Louvre to La Défense

When seen from the air, a straight line seems to cut a huge, 5-mile (8-km) swathe through the center of the city, stretching from the Louvre to the Grande Arche in La Défense: this historical axis has occupied the imagination of French rulers across the centuries. All the significant kings of the "Grande Nation" have participated in the development of this extensive perspective in the attempt to stamp their own seal on the capital of France. The Louvre, which formed the central point of departure for the urban developments, remained in effect a huge building site for centuries during the continuous reconstruction and extension works. The architectural concept of the palace underwent several changes—every new design meant an increase in the size of the existing building, and often the demolition of the old structure. So there were only brief periods when Paris actually served as the official residence of the king, with preference usually being given to the chateaux on the Loire and later the one at Versailles. Given this situation, the massive structure takes on an even greater symbolic significance. This is where the thoughts of imperial rulers took their architectural form.

The view from the old palace opens out onto the horizon through the Tuileries Gardens, which were laid out by Catherine de Medici in 1563; across the 18th century Place de la Concorde and the Champs-Élysées; and finally to the Arc de Triomphe, which Napoleon commissioned to be built in honor of his Great Army in the 19th century, on what was then the Place de l'Étoile. Originally the whole area to the west of the Louvre was uninhabitable: a swampy district used into the 16th century by butchers and tanners for the disposal of their stinking waste. What is more, there were ovens in the present day Tuileries in which bricks ("tuiles" in French) were baked for the building trade. So the area was hardly predestined to be the noblest axis in the city—the painstaking improvement and development work was rather an act of the royal will to shape the city, a power capable of ignoring any topographical specifications. The development of these historical stretches has continued into the present day: La Défense, the business and financial quarter dominated by skyscrapers of glass and concrete, is a product of 20th-century urban planning, while the spectacular Grande Arche, an initiative of the French socialist president François Mitterrand built in 1989, once again adopts the architecture of the triumphal arch.

Preceding spread:
The Cour Napoléon in front of the Grand Louvre with Pyramids by Ieoh Ming Pei

The Historical Axis:
Musée du Louvre—Jardin des Tuileries—Champs-Élysées—Grande Arche

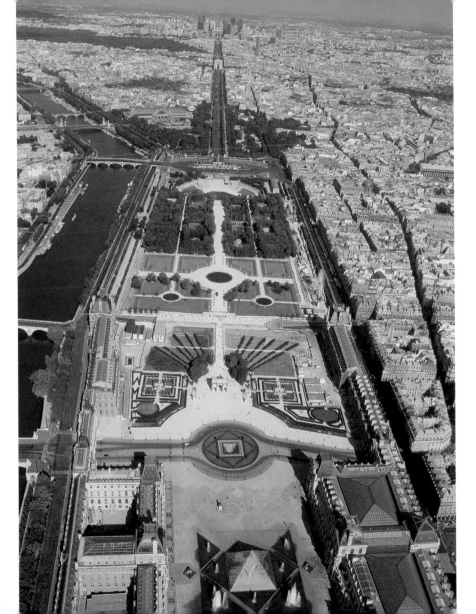

The Historical Axis—from the Louvre to La Défense

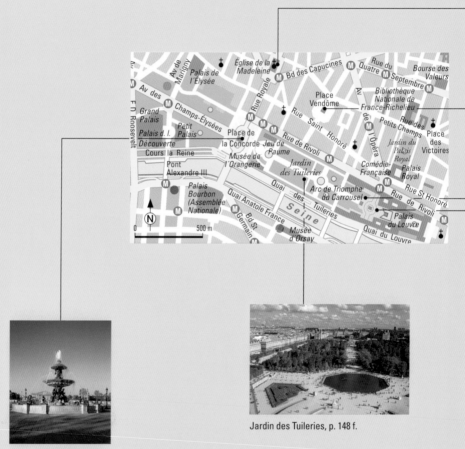

Place de la Concorde, p. 156

Jardin des Tuileries, p. 148 f.

La Madeleine, Place de
la Madeleine, p. 157 f.

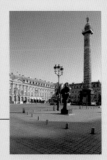

Place Vendôme, p. 152

Arc de Triomphe du Carrousel,
Place du Carrousel, p. 145

Louvre Palace and
Museum, p. 92 ff.

The Historical Axis—from the Louvre to La Défense **91**

The Louvre Palace

Mapping the construction history of the Louvre

The extremely complicated construction history of the palace stretches from the Renaissance to the Neo-Baroque periods, with the final rebuilding works required for its use as a museum only being completed in 1999. The first important architect, Pierre Lescot (ca. 1510–1578), designed a ceremoniously decorated palace in the Italian style for François I which is still preserved in the southwest corner of the Cour Carrée: under Louis XIII, it was extended to four times its

Construction history of the Louvre

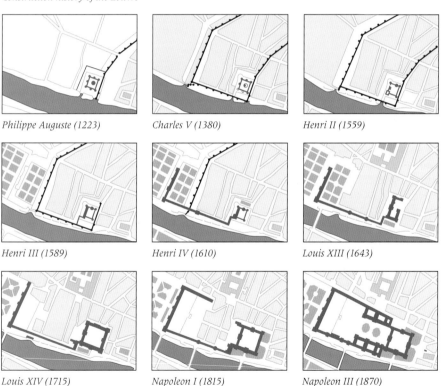

Philippe Auguste (1223)

Charles V (1380)

Henri II (1559)

Henri III (1589)

Henri IV (1610)

Louis XIII (1643)

Louis XIV (1715)

Napoleon I (1815)

Napoleon III (1870)

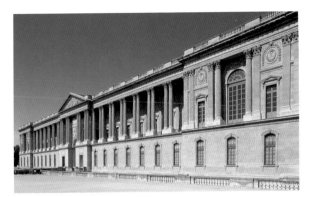

Under Louis XIV, the prestigious entrance to the palace from the east side was designed and completed. The influential figure, Jean-Baptiste Colbert (1619–1683), who was not only Controller-General of finances and Minister of Trade, but also the Superintendent of Royal Buildings, set up an international architecture competition, in which the famous Italian Baroque architect, Gian Lorenzo Bernini (1598–1680), took part. At the last minute, however, the king himself chose a joint design by the French architects Louis Le Vau, Charles Le Brun, and Claude Perrault, which was subsequently completed in 1670 in its present form. This represented the victory of the strict French Classical style—monumental, paired Corinthian columns under a pediment and tympanum in the style of antiquity—over the busier Romanesque design with its dynamically curved structures. The result was an impressive, if rather austere, ornamental facade, whose majestic grandeur set a style that is still used in countless variations for palaces, law courts, and banks.

size after 1624. The architect Jacques Lemercier (ca. 1585–1654) picked up Lescot's facade design in the course of this work in order to ensure consistency in the external form. A decisive factor for the scale of the present palace was Henri IV's idea of connecting the original core structure of the Louvre with Catherine de Medici's Tuileries Palace. Thus the Grande Galerie was built along the bank of the Seine between 1595 and 1608. After Louis XIV moved to Versailles in 1682, the massive, unfinished palace remained derelict until the French Revolution. By 1793 it had been customized as a public museum. Under Napoleon I another connecting gallery was built on the north side, parallel to Rue de Rivoli. This created the spacious inner courtyard opening out onto the Tuileries Gardens. Reconstruction work during the 20th century improved the options for using the Louvre as a museum.

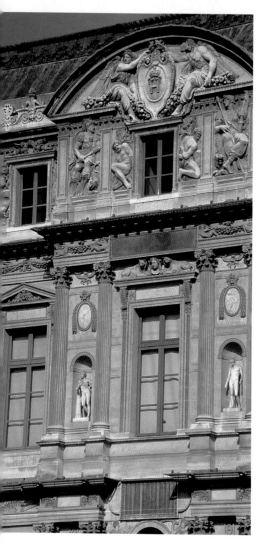

Cour Carrée (facade detail)

One of the most beautiful examples of French Renaissance architecture was built from 1546 through 1549 during the reign of Henri II (1547–1559), following an original plan drawn up by François I. Set on the foundations of the demolished medieval fortress, its ground plan can still be traced in the paving of the courtyard today. The architect Pierre Lescot designed a three-storey corps-de-logis based on the Italian models that were popular at that time. The ornate sculptural work came from the workshop of Jean Goujon (ca. 1510–1568) and his associates. The elevation presents a facade whose regular structure is divided into small elements—the vertical window bays and continuous horizontal cornices create a balance that visually accommodates the richly varied decoration of bas-reliefs, putti, medallions, festoons, and trophy groups.

The Glass Pyramid

Since 1993, most visitors to the museum have accessed the Louvre through a glass pyramid, the new main entrance that makes optimum use of the extensive Cour Napoléon. Its purpose was to receive over 5 million visitors each year, leading them into the three main wings of the 650,000 sq. ft. (60,000 m²) museum. In architectural terms, it achieved a balancing act between the historical structure and the formal language of

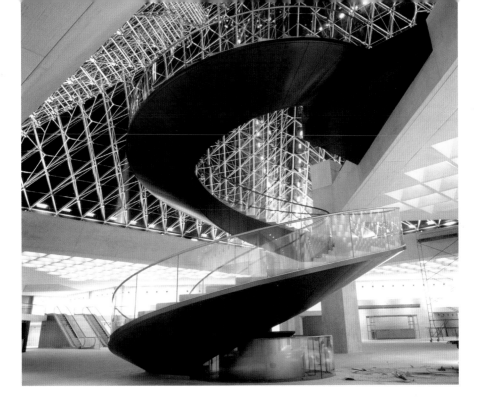

the 20th century. The Chinese-American architect Ieoh Ming Pei, who was responsible for the overall restructuring of the "Grand Louvre," chose the archaic form of a geometric shape for the new entrance, which is also reminiscent of the royal tombs of the Egyptian pharaohs. Ming Pei used transparent material to avoid detracting too much from the appreciation of the old palace. A smaller, counterpart pyramid illuminates the new underground service area with its shop-ping arcade, metro station, and connecting walkways to the Napoleon Hall. A subject of political contention for many years that was finally pushed through personally by François Mitterrand, the ambitious "Grand Louvre" project saw the emergence of the largest museum in the world, with the contemporary architecture providing a convincing context for the museum's witnesses to the past.

Musée du Louvre

Not long after the completion of the extensive "Grand Louvre" project, further reorganization and restoration works were undertaken in the largest museum in the world. The ambitious plan involved the total overhaul of the Galerie d'Apollon, which is definitely worth a visit following its completion in 2004. With the support of a private Japanese television station, what is probably the greatest attraction of the Louvre, the "Mona Lisa" by Leonardo da Vinci, moved to an elaborate new location in Room 13 and is exhibited on a huge wall with an altar-like enclosure and extended

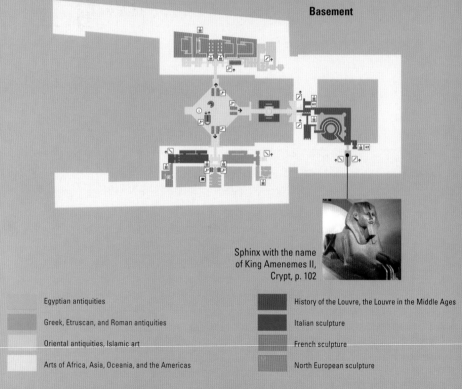

Basement

Sphinx with the name
of King Amenemes II,
Crypt, p. 102

Egyptian antiquities

Greek, Etruscan, and Roman antiquities

Oriental antiquities, Islamic art

Arts of Africa, Asia, Oceania, and the Americas

History of the Louvre, the Louvre in the Middle Ages

Italian sculpture

French sculpture

North European sculpture

railing. The stream of visitors can be kept at a distance while still having an unrestricted view of what is actually a rather small-format portrait. Hanging on the opposite wall is the monumental work "Wedding at Cana" (1563) by Paolo Veronese—the largest picture in the collection. The other paintings by Leonardo in the Louvre are on display further into the Grande Galerie as part of the Italian Renaissance collection.

The Venus de Milo should also be allocated a similar display in the Sully Wing in the near future, along the same lines as for the Mona Lisa, and again financed by a private Japanese sponsor.

Ground floor

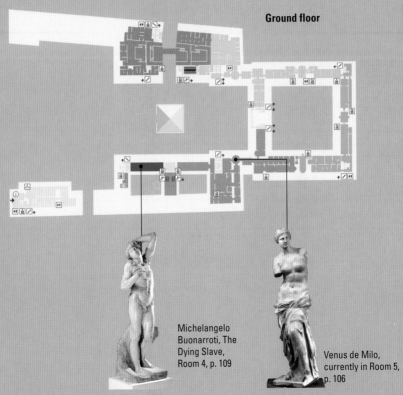

Michelangelo Buonarroti, The Dying Slave, Room 4, p. 109

Venus de Milo, currently in Room 5, p. 106

First floor

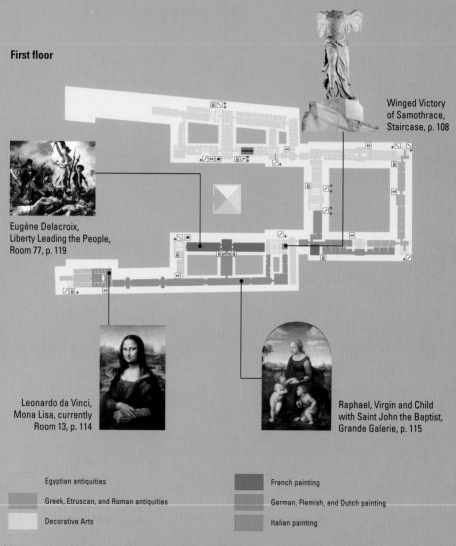

Winged Victory
of Samothrace,
Staircase, p. 108

Eugène Delacroix,
Liberty Leading the People,
Room 77, p. 119

Leonardo da Vinci,
Mona Lisa, currently
Room 13, p. 114

Raphael, Virgin and Child
with Saint John the Baptist,
Grande Galerie, p. 115

Egyptian antiquities

Greek, Etruscan, and Roman antiquities

Decorative Arts

French painting

German, Flemish, and Dutch painting

Italian painting

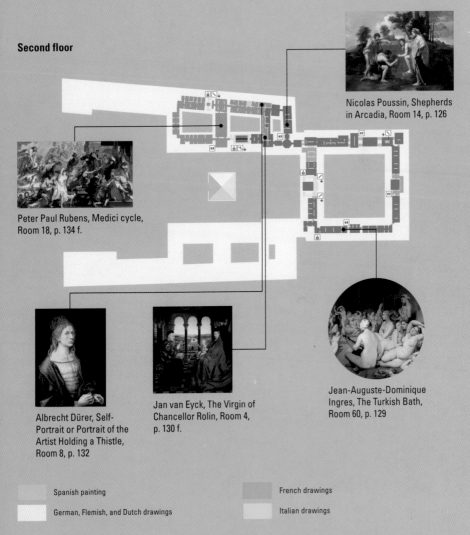

Second floor

Nicolas Poussin, Shepherds in Arcadia, Room 14, p. 126

Peter Paul Rubens, Medici cycle, Room 18, p. 134 f.

Albrecht Dürer, Self-Portrait or Portrait of the Artist Holding a Thistle, Room 8, p. 132

Jan van Eyck, The Virgin of Chancellor Rolin, Room 4, p. 130 f.

Jean-Auguste-Dominique Ingres, The Turkish Bath, Room 60, p. 129

Spanish painting

German, Flemish, and Dutch drawings

French drawings

Italian drawings

Visiting the Louvre—past and present

<div align="right">by Martina Padberg</div>

In its 800 years of existence, the Louvre has gradually opened its doors wider and wider. In the beginning, only members of the royal court were allowed access, but nowadays around 5 million visitors, who come from all corners of the globe for all different reasons, file around it annually. Every trip to Paris must include the Louvre on its itinerary, yet as well as displaying outstanding artistic masterpieces from the 4th century BC to the mid-1800s, the museum also caters for fringe interests and specialist inquiries. The Louvre has a traditional association with art—as far back as the ancien régime, or more precisely from 1699, the Grande Galerie

of the Louvre was used for the annual art exhibition of the royal Académie de Peinture et de Sculpture. The selection of exhibits was based on the strict criteria of the commission and, as well as being riddled with intrigues and corruption scandals, it chose artists who were either already famous or were likely to be so in the future. From 1725, the exhibitions were held in the Salon Carré—the origin of the terms "Salon" and "Salon art," which came in for heavy criticism in the 19th century and were eventually widely discredited. Both for the Salon and the royal collections held by the Louvre, the audience in the 18th century comprised the handpicked elite, who had to produce a written letter of recommendation for entry. The use of the Louvre as the museum is known today, with access for ordinary people, only came about in the course of the French Revolution. The artist Hubert Robert (1733–1808) who had previously been responsible for the royal collection under Louis XVI, undertook the remodeling of the museum in his role as first curator and developed visionary ideas, only some of which could actually be realized. So work on the public exhibition of

Pietro Antonio Martini, Exhibition in the Salon du Louvre in 1787, engraving, 38 x 51.5 cm, Bibliothèque Nationale de France, Paris

art in the Louvre has been underway since 1789, under the auspices of whatever zeitgeist and political situation prevailed, and to a degree not recognized until today.

Artists felt particularly at home in the Louvre right from the start. In the 17th century, many of them had their studios in it, right beside the most powerful patron. After the official residence was turned into a museum, they flocked to study the paintings of the great masters and imitate them. For the sale of first-rate copies represented a secure source of income at a time when there were no technical means of

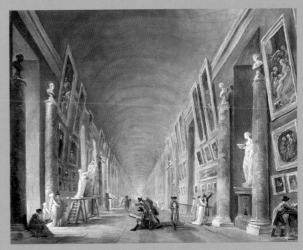

Hubert Robert (1733–1808), Grande Galerie in the Louvre, 1801, oil on canvas, Musée du Louvre, Paris

reproduction—that is, photography and poster printing. Even Henri Matisse (1869–1954) took this opportunity in order to keep his head above water financially when he was a young artist without any marketable value. The study of exemplary art, however, which had always belonged to the teaching canon inside and outside the art academies, was more important in terms of the artist's personal development. This is why nearly every artist's biography contains stories of visits to the greatest museums in the world. Here, it is easy to compare Baroque painting in Italy and the Netherlands and see the great French artists of the 17th and 18th centuries, while one look at the antiquities collection gives a profound understanding of how to represent human anatomy and guarantees the creative

stimulation that is derived from observing far-away cultures.

The Louvre is thus a treasure trove of artistic expressiveness and the discovery of aesthetic forms. Such a receptive approach became discredited, however, in the late 19th and early 20th century: henceforth, the modern artist wanted to create his own original style of imagery without basing it on any kind of role model. Yet many a revolutionary was to revise his attitude before long: "I wanted to burn down the Louvre, idiot that I am!" commented Paul Cézanne (1836–1906) in a conversation. "You have to enter the Louvre on account of nature, and go back to nature because of the Louvre."

101

Musée du Louvre

The Louvre in the Middle Ages

Under Philippe Auguste, a castle was built between 1190 and 1210 in the course of constructing fortifications and a wall around Paris, the aim of which was to protect the city against attacks from the western side of the river. So a fortress based on a simple square floor plan was erected that allowed the Seine to be completely closed off with chains in an emergency, with the aid of the Tour de Nesle which was situated on the left bank. A 105-ft. (32-m)-high, round tower, the Donjon, rose up inside the castle and soon became an emblem of the increasing power of the French monarchy. The royal treasure and archive of all the important state documents were kept in the "Tour de Paris" as it was popularly known. When Charles V (1364–1380)

extended the city boundaries, the fortress lost its significance, and in 1527 the Donjon was pulled down to make way for the new castle buildings. The foundations, which can still be seen today, give a good idea of this huge earlier building.

Sphinx inscribed with the name of the pharaoh Amenemes II, Tanis on the Nile Delta, 12th dynasty (1898–1866 BC), possibly as early as the pharaoh Snofru (2620–2590 BC; beginning of 4th dynasty)
Pink granite, 183 x 154 x 480 cm

This imposing, larger-than-life sphinx was hewn from a single block of stone and originally functioned as the awe-inspiring guardian in front of a tomb or temple. The combination of a pharaoh's head and lion's body goes back to a prehistoric symbolism aimed at giving physical form to the strength and domination of the king of Egypt. The name of the pharaoh is normally the clue to the date, and in the case of Amenemes ll it can be found on the breast of the enigmatic hermaphrodite. As subsequent rulers appropriated the sculpture for themselves and thus made numerous inscriptions over it as well, however, the date remains a matter of debate.

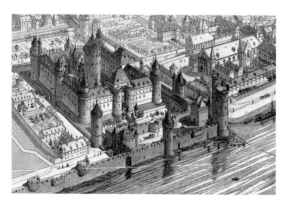

**Seated Scribe, Saqqara, 4th dynasty
(2620–2500 BC)**

Limestone, rock crystal, magnesite, copper,
Ht. 53.7 cm

Not many antiquities inspire such an imme-
diate connection with a lost civilization as
the "Seated Scribe," which was discovered
around 1850 in the necropolis of Saqqara.
Alert and focused, the official appears to be
waiting for the text he is supposed to tran-
scribe onto papyrus. Over 4,000 years old,
the figure seems to come to life as if in the
present day, thanks mainly to the painting
on the limestone and the inlays that form
the eyes. As with all forms of typecasting,
the face has portrait-like features. In addi-
tion, the sculpture is impressive evidence of
the significance of writing as a form of cul-
tural technology, which ordered Egyptian
society along rational lines.

The Law Code of Hammurabis, found in Susa, Babylon or Sippar, ca. 1750 BC
Basalt, 225 x 55 cm

This dark stele, covered in cuneiform script, is an outstanding testimony to early civilization in the Near East. King Hammurabi of Babylon, who succeeded in uniting the warring cities in Lower and Middle Mesopotamia in 1764 BC, thus founding the Kingdom of Babylon, compiled court decisions on this stone that deal with just about every kind of legal dispute. Whether it was a case of theft, divorce, property maintenance, or even assault and murder, this collection of texts offered legally binding judgments sanctioned by the king to the parties to the dispute. This represents the first attempt to replace family feuds and private wars with a judicial system that was universal yet differentiated according to social class. The associated monopoly of power of the king as the legislative and judicial authority is founded in religion. The bas-relief shows Hammurabi meeting a seated god, who was either Schamasch, the sun god of Sippar, or Marduk, the god of the Babylonians. The king, represented as the smaller of the two, stands before the god in the stance of a reverential greeting: this makes it clear that even the mightiest ruler has to bow before the authority of god.

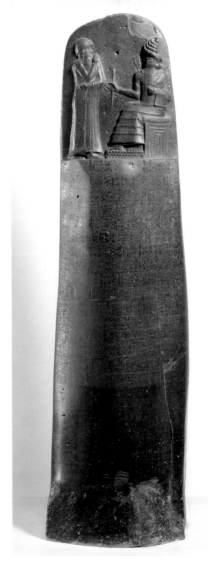

Venus de Milo, Melos, ca. 100 BC
Marble, ht. 202 cm

The statue from the late Hellenic period was discovered in 1820 on Melos, an island in the Cyclades, and brought to Paris that same year as a gift for Louis XVIII, who had acceded to the French throne in 1814 following the revolutionary upheavals and the rule of Napoleon. The half-nude figure representing Aphrodite, the goddess of love, is now considered one of the most famous sculptures of antiquity in the world. The perfect modeling of the body, the well-proportioned face, and especially the classic weightiness of the figure all make the Venus de Milo the epitome of the perfection of antiquity. The fall of the drapery, which seems to be slipping off the hips, cleverly conceals the joining edge of the two blocks of marble from which the larger than life size figure is composed, its dynamic aspect softening the rigid form of the statue.

Salle des Caryatides

The Salle des Caryatides was fitted out as a prestigious festival hall and courtroom under the regency of Henri II (1547–1559). As with the Cour Carrée, the architect Pierre Lescot worked with Jean Goujon and his mason's workshop. The hall was named after the figures made by Goujon as supports for a gallery from which an orchestra struck up the dance. These caryatids—sculpted female figures used as columns—represented a return to the architectural motifs of antiquity in interior design. The caryatids were already familiar from the

Erechtheion, a relatively small temple in Athens from the 5th century BC and handed down in "De architectura," written by the Roman architect Vitruv and published for the first time outside Italy in 1543. This reference signified an innovative association with the great architectural tradition of antiquity that was drawn on so readily during the Renaissance. Opposite the gallery, the king took his place as the supreme judge under an arch formation; this is another reference, but this time to the famous Italian Renaissance architects Andrea Palladio and Sebastiano Serlio, whose work was being adapted at that time throughout Europe. Today, Roman replicas of Greek originals from the Classical and Hellenic periods are on display in the Salle des Caryatides.

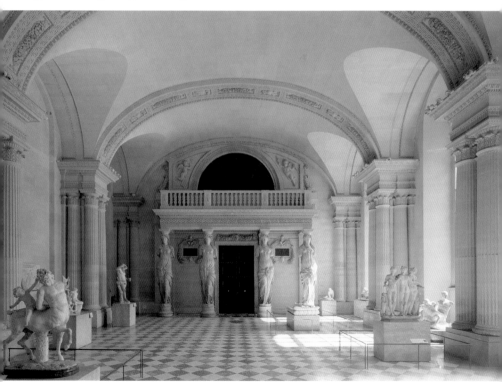

Winged Victory of Samothrace, Samothrace, ca. 190 BC

Gray Lartos marble (ship), light Parian marble (statue), ht. 129 in. (328 cm)

"She stands, up there in a cone of light, at the prow of her ship, the goddess of victory—she does not stand, she strides, she does not stride, she storms towards it. She has no head or arms, but where else in the world is there anything like it, that so intuitively expresses headlong bravery as this mutilated figure?" In Lion Feuchtwanger's novel "Exile" (1939) the "Winged Victory of Samothrace" appears to the émigré Hanns Trautwein, who has fled from Nazi Germany to Paris, as a vivid sign of hope in a completely depressing situation. It must be the special presence of this statue that has ensured its lasting fame. It was probably positioned at the harbor entrance on the northern Aegean island of Samothrace around 190 BC, to mark the victory of Rhodes and Pergamon against the Syrians. She could be seen from far across the sea and the billowing drapery of her garment must have looked unbelievably authentic in the natural wind. Discovered in 1863 in a badly damaged condition, the figure was installed on a pedestal on the great flight of stairs, a position entirely befitting her impact. Thus the winged goddess holding a trumpet continues to radiate her triumphant power even within the context of a museum.

Michelangelo Buonarroti (1475–1564), The Dying Slave, for the tomb of Pope Julius II, 1513/14
Marble, ht. 209 cm

Pope Julius II (1503 –1513) planned his burial place in a personal mausoleum in St Peter's Basilica and commissioned Michelangelo to produce an enormous monument of 40 figures. This was, however, completed only in a distinctly smaller version in San Pietro in Vincoli after the death of the Pope. During the artist's lifetime, the "The Dying Slave" and its counterpart, "The Rebellious Slave," were brought to France as a gift to the court of François I. In spite of its perfect articulation, the sculpture is considered unfinished, as there are clear traces of tool work in the marble that yield a glimpse into the artist's workshop. There is an ongoing debate even now among experts about the meaning of "The Slaves," whose athletic forms appear to stand in complete contrast to death and destruction and whose physical voluptuousness emits a conspicuously erotic aura. Neo-Platonic ideas, which were accepted in the milieu of the Pope and by Michelangelo himself, lend themselves to interpreting the figure as a symbol of the ecstatic liberation of the spiritual within man from the prison of his own body. The enduring modernity of the work can be attributed to the ambivalent tension between this philosophical idea and the sensual presence of the sculpture.

Galerie d'Apollon

Originally commissioned by Louis XIV in 1661 following a devastating fire in the Louvre and designed by Louis Le Vau and Charles Le Brun, the gallery had become a complete synthesis of the arts by the mid 19th century to which French artists from all periods contributed. The mighty barrel vault and walls feature excessive ornamentation of stuccowork, painting, tapestries, and sculptures. The iconographic scheme of 36 figures and 41 paintings reveals itself as the representation of a cosmological ideal, at the center of which the sun god Apollo is celebrated as the universal sovereign and, by association, the Sun King Louis XIV. Grisaille medallions around the hall represent the months with their associated star signs. A skilful combination of painting and stucco, especially at the top ends, produces astonishing trompe l'oeil effects, in which Apollo is celebrated as the ruler over the annual cycle, the seasons, and the forces of nature. The finest tapestries depict portraits of the French kings who had been most important for the construction of the Louvre—Philippe-Auguste, Henri IV, François I, and Louis XIV. Self-confidently, at the same eye-level, are portraits of the most famous architects, sculptors, and artists. At the end of the 18th century the gallery, which was still unfinished at that time, was allocated to the royal Academy of Art, and in the years that followed several new members created designs for the as yet undecorated sections of the ceiling as their inaugural work. During Napoleon's time the suite of rooms was used as exhibition space for the newly founded museum. Under the aegis of Félix Duban, the gallery underwent extensive restoration work between 1849 and 1851, with the central ceiling fresco being finally completed by Eugène Delacroix. In keeping with the lavish décor, the displays in the Galerie d'Apollon now consist of the valuable "Gemmes de la Couronne" collection of Louis XIV, the sensational French crown jewels, as well as precious glass, goblets, and jewelry boxes.

Eugène Delacroix (1798–1863), Apollo Slaying the Python, 1851
Oil on canvas, 800 x 750 cm

This vigorous composition by Delacroix, characterized by a dramatic use of light and dark, adopts the vision of antiquity that depicts the Greek god Apollo on his sun chariot being drawn across the sky each day by four horses. The sun is depicted as his captive, clearly defining his role as the ruler of the heavenly body bestowing light and life. Delacroix combines this traditional form of representation with another legend from antiquity, according to which Apollo vanquishes the python serpent he is said to have slain as a youth. Delphi, where the treacherous beast had till then created havoc, henceforth became the center of the cult of Apollo and site of his deity. In this painting, numerous gods and goddesses from antiquity along with putti and other supporting figures become witnesses to the heroic deed, by which Apollo lays claim to universal sovereignty.

**Giotto di Bondone
(ca. 1266–1337),
St. Francis Receiving the
Stigmata, ca. 1300**
Oil on wood, 313 x 163 cm

Giotto di Bondone took up a very topical theme with this altar panel from the Ughi chapel in the choir of the Church of San Francesco in Pisa. The life and works of St. Francis of Assisi (1182–1226), canonized in 1228, had been documented only a few years earlier in the famous "Legenda aurea," or "Golden Legend" (1297). Francis is depicted on his knees in the center of the painting, receiving the stigmata from Christ in the form of a seraph. The three-dimensional and spatial composition of the figures along with the barely defined mountain landscape show that Giotto was active in the transition from the Middle Ages to the Early Renaissance, Below the main painting, in three scenes from the Legend—the vision of Pope Innocent III, the Pope receiving the statutes of

Domenico Ghirlandaio (1449–1494), Old Man with Grandchild, ca. 1490
Oil on wood, 62 x 46 cm

A fundamental tenet of modern thinking is the discovery and exploration of human individuality. This is also revealed in the genre of portraiture, which developed many variants from the mid 15th century onwards in Europe. In this panel painting, Ghirlandaio, who had become famous primarily as a fresco painter, shows a grandfather sharing a spiritual moment with his grandson. The juxtaposition of the two stages of life is subtly portrayed by the artist: emphasized by his hand gesture, the child's alert gaze is directed with attentive interest to the weary features of the old man, whose gentle smile is imbued with understanding and indulgence. The naturalistic portrayal of the characters and the man's conspicuous nose indicate that the main purpose of the dual portrait was as a memento, which may even have been completed posthumously with the aid of the old man's death mask.

the Order of St. Francis, and St. Francis preaching to the birds—Giotto was experimenting with architectural perspective. For the first time the geometric spaces that were typical of his work reveal a three-dimensional depth that was to prove definitive for the modern understanding of pictorial art.

Leonardo da Vinci (1452–1519), Mona Lisa, or "La Gioconda," 1503–1506
Oil on wood, 77 x 53 cm

Protected by bulletproof glass and in a surprisingly small format, the most famous painting in the world is still sought out by every visitor to the Louvre. The identity of the woman in the painting is still not certain even today. It is generally assumed, however, that she was the second wife of the Florentine merchant, Gioconda. The young woman, who is shown by Leonardo under a shaded loggia with an idealized landscape far in the background, turns to face the viewer. Her upright stance, the elegant way she holds her hands, and the mere hint of a smile indicate the courtly ideal of "temperantia," the deliberate moderation of emotions and feelings.

Symbols of chastity, such as the veil and the proverbial path of virtue in the background landscape, are signs that the woman was a member of the nobility. The "sfumato," the soft, blurred outlines so characteristic of Leonardo's work, and the dim light enshroud the woman being portrayed, lending her appearance the allure of uncertainty that has persisted until the present day.

Raphael, real name Raffaello Santi (1483–1520), Virgin and Child with Saint John the Baptist, known as "La Belle Jardinière," 1507
Oil on canvas, mounted on wood, 122 x 80 cm

There is no account of any meeting between Jesus and John the Baptist as young children in the Bible; instead, it is an invented theme, favored by High Renaissance artists as it particularly lent itself to intimate devotional pictures in the Mannerist style. In his painting, created in Florence in 1507 and clearly influenced by Leonardo, Raphael also values highly the depiction of the ideal of motherhood, tenderness, and purity that was intended to affect all observers and encourage them to worship. The group is accordingly situated in the foreground of the picture, arranged in a pyramid formation to produce calm and balance in the composition. The charming, idealized landscape emphasizes the peaceful overall impression and seemingly locates the holy figures in the world of human beings. This would explain the epithet given to the painting—"the beautiful gardener."

**Michelangelo Merisi da Caravaggio
(ca. 1571–1610), The Fortune Teller, ca. 1594/95**
Oil on canvas, 99 x 131 cm
(originally 89 x 131 cm)

Caravaggio's genre painting tell the story of a betrayal: as the young, rather excessively dandified, nobleman is giving his hand to a gypsy woman to have his fortune told, she takes the opportunity of removing a ring from his finger. This is presumably why she holds his gaze so deliberately rather than looking at the hand of the unsuspecting customer. The half-length double portrait stands in front of a background that in characteristic Caravaggio style is given structure only by light and does not reveal anything about the location of the action. Thus the artist has conceived his picture completely in terms of the composition of the figures. It was primarily the authenticity of the models that characterized Caravaggio's paintings, which met with international approval after the artist's death.

El Greco, real name Dominikos Theotokopoulos (1541–1614), Christ on the Cross Adored by Two Donors, ca. 1585–1590
Oil on canvas, 260 x 171 cm

seeking redemption in death—an expectation of salvation shared by the donors in, and viewers of, the painting.

Though born in Greece, El Greco is classified as a Spanish painter, as he moved permanently to Toledo in 1577 after years of study and apprenticeship in Venice and Rome. It was in Spain that he developed his highly original and inimitable pictorial language, the primary aim of which is to produce an emotional response in the spectator. The crucifixion scene was painted during the most productive phase in his oeuvre. The suffering and death of Christ are reflected in the masterfully painted sky with its masses of dark, stormy clouds and blazes of white light that plunge the whole picture into an unreal, bluish atmosphere. The crucified figure, whose body seems sculpted out of marble in the flickering light, appears to have already broken free from his physical existence. His gaze is directed heavenwards, his wide-open eyes

Jacques-Louis David (1748–1825), The Oath of the Horatii, 1784
Oil on canvas, 330 x 425 cm

David was one of the most successful artists of his generation, as court painter to Louis XVI during the Revolution and finally under Napoleon I. In the rediscovery of ancient themes, his growth as an artist reflects the development of a form of classicism bearing a political stamp. This large-format, histori-cal picture deals with the war between Rome and the town of Alba Longa (ca. 500 BC) that was decided, according to legend, between the three brothers from the ancient Roman patrician house of the Horatii and the three brothers of the Curatii on the side of Alba. Already bound to each other through mar-riage and betrothal, the men put reasons of state above those of family and swore before their father to fight to live or die. Commis-sioned by the king, David turned to this sub-

ject matter from antiquity, choosing a point in the storyline that was eminently suited to representing the irreconcilable conflict between the warring men and the grieving women. The compelling need for political action, which went beyond even personal interests, was a general topic of discussion on the eve of the French Revolution: with his ambitious painting, David made a significant contribution by revealing the potential for conflict of his time.

**Eugène Delacroix
(1798–1863), Liberty
Leading the People, 1830**
Oil on canvas, 260 x 325 cm

No artist has poured the Romantic glorification of revolution and the struggle for freedom into a picture as sensationally as Delacroix. The allegorical figure of freedom strides forcefully and decisively into battle, armed with tricolor and bayonet and followed by the throng of revolutionaries she will lead to victory. The Île de la Cité can be seen burning in the background and the scene is heavy with smoke. Two figures are depicted in portrait form: one is the young boy with two pistols who was killed during the riots in July 1830 and glorified as a hero by the population of Paris; the other is the

artist, who portrays himself here as the citizen commander. The dramatic use of light, the dynamic style, and the richly detailed realism give the painting an allegorical yet authentic character. The picture was

purchased by the French state under the bourgeois king, Louis-Philippe, but was consigned to the storeroom for years, being political dynamite.

Lutetia Parisiorum—the favorite model of photographers and film directors

by Jeannine Fiedler

Paris—the city of insatiable longing to anyone who has ever tasted its delights. Even if you have never been there, you have a sense of it, discovering it as something from a past life you have always known. "Yet why was the joy of returning to Paris so overwhelming that I almost felt as if I were stepping onto the sweet soil of home…? Why does Paris cast such a spell on foreigners who spend a few years in its municipal area?" marveled one of the first Paris addicts, Heinrich Heine. For a century, Paris was the hub of the world—for hedonists, exiles, poets, philosophers, and artists. During the 19th century, its myth was established as a pleasure-loving, sophisticated capital of Europe that no other city in the Old World could match in terms of style, openness to the world, and sensual, charismatic attraction.

It is worth noting that Paris acquired this fame before its glamorous face and fascination had been disseminated through photography and film. Yet it was entirely appropriate that the white city on the Seine was to be the one that gave birth to the mass media of the modern age. On August 19, 1839, the daguerreotype process was unveiled to the Parisian public in the Institut de France. Admittedly, William Henry Fox Talbot would lay the foundation of successful photography in 1840 with the reproducible negative-positive calotype process, but the reward of creating the first lasting images of real life went to Louis-Jacques-Mandé Daguerre (1787–1851)

using his gleaming, silver-coated plates. Although daguerreotypes required an exposure time of three minutes in sunlight, this was long enough to completely remove people from the first photographic views of Paris. It was as if the equipment had banished all life from the streets and squares in order to give precedence to witnesses made of stone. The hectic hustle and bustle of the metropolis and people moving around with their companions were all blotted out, leaving only ghostly shadows. The Boulevard du Temple, taken by Daguerre in 1838 from his apartment, is the very first picture of a city view. On it, the outline of a man is decipherable, who is standing still at a bootblack. Frozen in time on the metal plate, he has no idea that he has left behind the first human trace on a photographic image. The hum of the big city ceases with this lost representative of his species. The "flâneur éternel" (eternal stroller) remains still, spun into a cocoon of timelessness, on the boulevard forever. And perhaps, who knows, the young Baudelaire is just passing by, doffing his top hat to him. For the first time, a moment is distilled to immortalize the photographic image, clearly showing that the presence of the human being creates the "present" of a photograph.

Half a century later, the actor Eugène Atget (1857–1927) began working on a photographic kaleidoscope of Paris. Atget creates a fictional "document" of his city with thousands and thousands of poetic, melancholic views of a disap-

pearing epoch. Only occasionally is his vision of "lost times" animated by staffage figures of rushing tradesmen, minstrels, or prostitutes. Gripping the observer in an emotional distance, this vision creates amazing spaces: compositions of shop fronts and back courts, fountains and bridges, sculptures and parks—floating between dream, reality, and a corresponding future—transforming the familiar to the strange on the threshold of phantasmagoria and allowing the viewer to lose himself in its secrets. Atget's work, like the magical paintings of customs officer Henri Rousseau, represents the rootstock of surrealist flowers.

The child prodigy Jacques-Henri Lartigue (1894–1986), who experimented with his first camera at the tender age of seven, conceived the fin de siècle and advent of the modern age very differently, however. Two- and four-legged beings, the latest means of transportation such

View of the Louvre and the Tuileries, Paris, ca. 1850

as the automobile, airplane, and velocipede, all run and jump, take off and land, sometimes in tragicomic crashes. For Lartigue, the world is a structure of high-speed movement, a perpetual motion machine, and by taking its photographic image he proves that gravity can easily be overcome. For him the snapshot, which brings him closer to producing panoramic images than anyone else, becomes an ingenious way of exhibiting an age bursting with dynamism. Even his "Dames du Bois de Boulogne" stride purposefully into modern times: their hats, turbo-driven and swallow-like, signal an energy that is poised for lift-off. Speed and progress as existential vectors driving the 20th century are channeled here for the last time into the permanent adrenalin rush of a child enthused by all things technical: this was before the fall from grace of technology, for the future still spelled hope, not threat.

Between the World Wars, photographers were the internal occupying force in the city. As members of bohemian society, or onlookers, they had direct access to artists and vaudeville, to the ladies and gentlemen of the demimonde, who abandoned their somewhat embittered selves to the swansong of the Belle Époque in the aftershock of World War I. Prostitutes and their milieu, gin palaces, bars, and artists' studios—all are recorded with an "intimate eye." Man Ray, one of the many American expatriates in Paris, took one of the city's well known whores, Kiki de Montparnasse, as his companion and made her the most famous face (and violin back) of the 1920s. She was followed by Lee Miller, Meret Oppenheim, Dora Maar, and Nusch Eluard among others: the magical, fairy-like figures

Eugène Atget (1857–1927), Le Moulin Rouge, 1921

and fetishist mascots for the surrealists. All of them birds of paradise in exile, they nevertheless helped to forge the cliché of the "Parisian woman." The "real" Paris, however, that unembellished image of the "quartier" and its inhabitants—minus the ancient temples and elitist artistic pretensions—belongs to Brassaï (1899–1984). This Rumanian immigrant approaches the city with the alert and unsentimental eye of a newcomer and compassionate sympathy for the everyday life of the "man on the street." Brassaï lived modestly among ordinary

people and was accepted by them as an equal. This trust allowed him to create an authentic portrait of the "petit bourgeoisie" that is akin to the realism and poetic power of Heinrich Zille's photo-journals. Whether it is the Parisian "quartier" or the Berlin "Kiez," desperate courage in the art of survival looks much the same everywhere—it is black and white, with gaudy splashes of urban humor.

From thereon in, Paris was treated like a coveted film star. "Photographed to death," was how Marlene Dietrich described her mask-like beauty and she refused to have any more photos taken of her, only to die on the banks of the Seine. Yet Lutetia's magnificent body is amenable, refusing no-one—neither the hungry and ambitious photographers (every one of them a little Brassaï or Robert Doisneau) who might only succeed with black-and-white, nostalgic rubbish; nor the greedy opportunists whose lucrative kitsch-art culture has a turnover of millions; nor even the hordes of fathers making amateur family films.

The city center as a film set

Filmmakers, of course, also fell in love with the city and its attractions. Numerous inventors in the 19th century had worked on the moving image—the logical extension of the photographic medium—but it was the Lumière brothers who won the race in 1894 with their cinématographe. Is it possible to imagine a more wonderful correspondence between the name of the inventor, Louis Jean "Lumière" (1864–1948), and his apparatus for casting images and light onto a screen? The first cinematic screening in the world took place the following year, on December 28, 1895, in the basement of the Grand Café on the Boulevard des Capucines. The greatest mass spectacle in human history had glimpsed the darkness of the projection room! Georges Méliès, an early

Cary Grant and Audrey Hepburn in "Charade" by Stanley Donen, 1963

Jean-Pierre Léaud and Dorothée in "L'Amour en fuite" (Love on the run) by François Truffaut, 1978

the clerk in "Le Crime de Monsieur Lange"—both satires on bourgeois morality from Jean Renoir (1894–1979); or the desperate lovers in "Sous les Toits de Paris," 1930, by René Clair and "Hôtel du Nord," 1938, by Marcel Carné (1909–1996). "Les Enfants du Paradis," 1945, Carné's masterpiece, leads the predisposed viewer back to the Boulevard du Temple of Daguerre. The shadow world of early photography is now filled with the adventures of jugglers, showmen, and anarchists in the France of the bourgeois king, Louis-Philippe. In the search for a beautiful woman called "Golden Helmet"

cinema magician, led his audience to the moon and into underwater worlds. Their enthusiasm was not spoiled in the slightest by the fact that everything was made of cardboard, hung on threads, and moved about by voluptuous ladies. Most directors, however, preferred to narrate their stories on the streets or under the roofs of Paris, using the heart of the city as a sumptuous backdrop. In 1913, Louis Feuillade sent his masked villain "Fantômas" through a mysterious urban landscape. The surrealists became intoxicated with this side of Paris as a panopticon of base desires. It was only with poetic realism in the 1930s that the city recovered those irreverent characters in their petit bourgeois microcosms that constantly reinvent and revive it: the tramps in "Boudu Sauvé des Eaux," 1932, and

(the film "Casque d'Or," 1952) Renoir's assistant, Jacques Becker, sent his hoodlums back into the Belle Epoque on Montmartre. But the one who ultimately brings together French film art and Hollywood is Carné's brilliant designer, Alexandre Trauner, who created numerous fictional versions of Paris. In "Irma la Douce" (1963), Billy Wilder's bittersweet romance between a cop and a cute whore, Trauner achieves the perfect representation of Paris in film. In Louis Malle's "Zazie dans le Métro" (1960) the heroine and the "man on the street" set off on a madcap journey through Paris. And in the films of Jacques Tati, the great French comedian, capital is a malevolent battleground where progress is king: Monsieur Hulot experiences it as a human emergency zone among the robot-like workers in "Playtime" (1967).

In "Pickpocket" (1959) and "Le Diable probable-ment" (1977), Robert Bresson creates a version of the city alien to those who live there, a place where the Nouvelle Vague filmmakers reconcile their anti-heroes with Paris, in episodic and random accounts of their fortunes. For at the end of the 1950s, the young rebellious critics of the journal "Cahiers du Cinéma"—including Jean-Luc Godard, François Truffaut (1932–1984), Jacques Rivette, and initially Claude Chabrol and Eric Rohmer—were prepared to reinvent film for their own generation in a practical sense as well. Godard's first feature film kick-started the New Wave in French cinema: in "À bout de souffle" (1960) the leading actors are the streets of Paris. The gang's sprint through the rooms of the Louvre in "Bande à part" (1964) is simply unforgettable.

There would be no Antoine Doinel without Paris; and, without Truffaut's alter ego Jean-Pierre Léaud, the most consistent incarnation of a Parisian in the history of cinema would also be unthinkable. The lovable and eccentric petit bourgeois character gives way to the bohemian and flâneur. The Doinel cycle, produced between 1959 and 1979, together with "La Maman et la Putain" (1972) by Jean Eustache reveal the key to the substance of the city: possession is gained by walking all around and ruminating on it. The conversation—when in the form of a monologue directed at the viewer, as is so often the case with Léaud—is a step-by step reflection on the urban space, or "making one's way through Paris with words."

Jean Seberg and Jean-Paul Belmondo in "À bout de souf-fle" (Breathless), still from the 1960 film by Jean-Luc Godard

Nicolas Poussin (1594–1665), Shepherds in Arcadia, ca. 1638–1640
Oil on canvas, 85 x 121 cm

Until well into the 19th century, Nicolas Poussin was regarded as the great, if somewhat controversial, role model of French art. His painting shows a pastoral idyll familiar to the educated public in the 17th century from the literature of antiquity, especially the "Bucolica" by Virgil (70–19 BC). Life in Arcadia, a landscape in southern Greece, was imagined as carefree and at one with nature, where the only concern was playing the flute or writing love poems. In this mythical paradise ruled by Pan, the group of shepherds depicted by Poussin finds a tomb with the inscription "Et in Arcadia ego" (I am also in Arcadia). As if within a stage set with robes from antiquity, Poussin orchestrates a variety of reactions in the four Arcadians to the presence of death in their mirthful world.

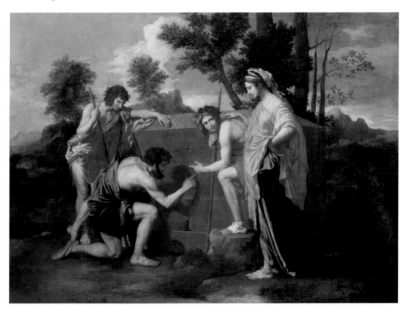

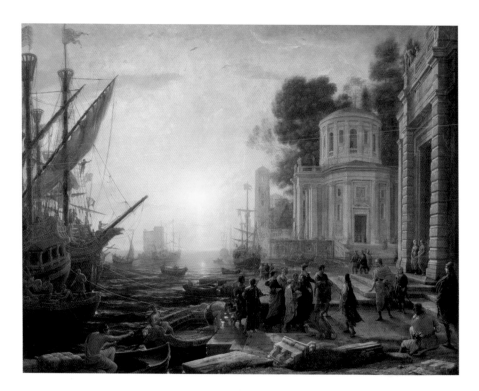

**Claude Lorrain, b. Claude Gellée (1600–1682),
The Disembarkation of Cleopatra at Tarsus,
1642/43**
Oil on canvas, 119 x 168 cm

In 41 BC, Cleopatra met Antony, the ruler of Rome's eastern empire, in Tarsus, the capital of the Roman province of Cilicia, which is now part of southern Anatolia in Turkey. She succeeded in making him her lover and powerful ally—before long he had generously presented the Egyptian queen with the territory of Cilicia, among others, in memory of their first encounter. Lorrain, who had lived and worked in Rome for most of his life, used this historical subject matter to depict a harbor scene atmospherically illuminated by the soft light of the dawning sun. He created the perfect veduta, or panoramic view, packed with a rich narrative and embellished with detail.

Jean-Antoine Watteau (1684–1721), Pierrot, also known as Gilles, 1718/19
Oil on canvas, 184.5 x 149 cm

Scenes from the world of theatre often play an important role in the oeuvre of Watteau, which is considerable in spite of the early death of the artist. In one of his most famous paintings—"Gilles"—he portrays a comic character from the Italian commedia dell'arte, a figure that had crept into many plays in Paris under the name "Pierrot" by the end of the 17th century and is instantly recognizable with his characteristic, white outfit. Other characters from the repertoire of Italian comedy also appear in the middle ground of the painting in front of a landscape backdrop, as if they are in a stage pit:

they are the Doctor; the scholar from Bologna on his donkey; and, on the far right, Capitano Spavento, a self-important braggart. The context of the origin of this painting is still unclear today, but it was possibly made as a decoration for the cafe of a former actor. This portrayal of Pierrot by Watteau has made "Gilles" the epitome of the genre, with his dreamy, slightly melancholic expression and the solitary, curiously stiff, theatrical stance that gives him the air of being lost. The loneliness and existential angst inside him, hiding behind the mask of a clown, has subsequently become a frequently used motif.

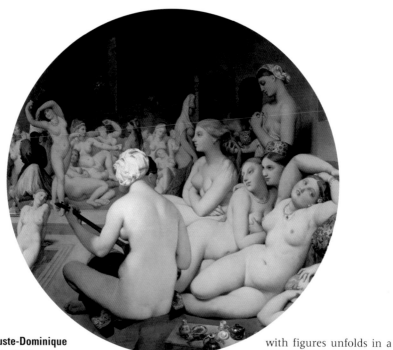

Jean-Auguste-Dominique Ingres (1780–1867), The Turkish Bath, 1862
Oil on canvas, diameter 110 cm

Complex in terms of its composition, this painting was completed by the 82-year-old Ingres in 1862, after long periods of reworking. He himself must have seen "The Turkish Bath" as an artistic legacy, whose many formulations represent decades of grappling with the nude form and are characteristic of his graphic and linear style. As if seen through a keyhole, a scene crammed with figures unfolds in a Turkish bath in this tondo, or circular painting: more than 20 women linger in the bath of a seraglio, apparently unobserved, and are waited on by black servants as they drink tea, play the lute, dance, or lounge languorously on cushions. The picture suggests an authentic image of eroticism in a harem, yet represents a European stereotype that was often expressed during the fashion for Orientalism in French painting in the 19th century.

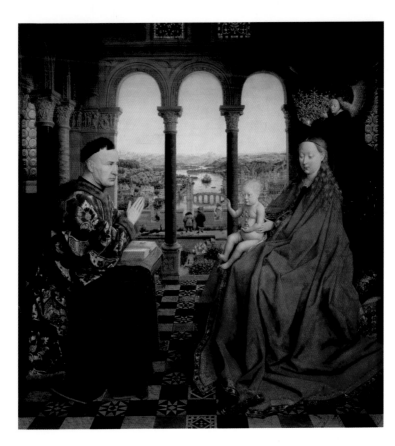

**Jan van Eyck (ca. 1390–1441), The Virgin of
Chancellor Rolin, ca. 1434**
Oil on wood, 65 x 62.3 cm

There was already a long tradition of artists
representing their patrons by the time of
Jan van Eyck. Ever since the Middle Ages,

the person commissioning an expensive
painting could appear in person in the pic-
ture, though usually in lesser proportion to
the holy figures. Jan van Eyck on the other
hand arrived at a completely new and quite
innovative solution: he depicted the adora-
tion of the Virgin and Child by Nicolas Rolin

(1376–1462), the influential chancellor at the court of Philip the Good of Burgundy, as an actual physical meeting. The demeanor and attire of Rolin, who is kneeling in a position of devout worship, are rendered in meticulous detail. His portrait occupies almost the same level of importance as the Mother of God and the infant Jesus, who is blessing Rolin. The apparent verisimilitude of the scene is emphasized by the overwhelming wealth of detail that can be discerned in the architecture and idealized landscape in the background.

Hieronymus Bosch (ca. 1450–1516),
Ship of Fools, ca. 1500
Oil on wood, 58 x 32.5 cm

Since ancient times the ship has been well known as a symbol for man's dangerous and capricious journey through life. In particular, this idea was made enormously popular by the writer and humanist Sebastian Brant (1457–1521) with his moralistic satire "The Ship of Fools," which he completed in 1494. The mortal is not, however, granted a fortunate, speedy passage into the safe harbor in Brant's story—instead, human vices and transgressions cause his ship to tack aimlessly through life's shallows. Hieronymus Bosch, whose allegories mostly have many figures in them with often grotesque and satirical features, translates this written source material into pictorial form. Busy eating, drinking, and womanizing, the fools fail to notice that their ship has long since

run aground in bushes. The spectator, on the other hand, realizes that this journey is not destined to have a happy end and that it is necessary to keep a steady hand on the helm of the ship of life.

Albrecht Dürer (1471–1528),
Portrait of the Artist Holding a Thistle, 1493
Parchment on canvas, 56.5 x 44.5 cm

This self-portrait shows Albrecht Dürer at the age of 22 and was presumably meant as a gift for his fiancée, Agnes Frey, whom he married the following year at the wishes of his parents. The young painter presents himself with a self-conscious gaze and in a strikingly stylish outfit: symbolically, he is holding a thistle in his right hand—commonly known as "Mannstreu" in German, meaning "husband's fidelity." In depicting his own physical appearance, Dürer reveals

himself as an empiricist, with his acute observation of even the shaggy, rather unkempt hair and sparse beard.

Hans Holbein the Younger (1497–1543), Erasmus of Rotterdam, 1523
Oil on wood, 42 x 32 cm

This portrait of the scholar Erasmus (1467–1536), who encouraged Holbein to go to England and arranged for his first commissions there, is one of the outstanding humanist portraits of the 16th century. It is characterized by a radical reduction in the

spatial composition and the artist rehearsing the classical profile of antiquity. In doing so, Holbein puts the subject's concentration on thought and writing at the center of his representation, bringing this further to the fore through the light coloring of face and hands. Looking down introspectively at his work, the scholar's pose nevertheless leaves room for psychological interpretations, seemingly expressing his strong, yet benevolent, character through his physical form.

Pieter Brueghel the Elder (ca. 1525–1569), The Beggars, 1568
Oil on wood,
18.5 x 21.5 cm

the left. On the back of the painting is the motto: "Cripples, take heart, and may your affairs prosper." Produced for an educated and prosperous audience, this genre scene by Brueghel illustrates in a deeper sense

Pieter Brueghel frequently depicted cripples, beggars, and boorish peasants, often giving them allegorical significance as personifying vices and virtues. This small-format painting shows a group of amputees with coarse, simple faces, who are dressed in strange clothing draped with fox brushes. They shuffle about and, after performing a grotesque dance, beg for money, which is collected by the figure in the background to

that those who behave in a curious manner often fool their charitable peers. The other argument is that even the worst human defects can generate possibilities for living, rather than simply existing.

Peter Paul Rubens (1577–1640), Henri IV Receives the Portrait of Maria de' Medici, ca. 1621–1625
Oil on canvas, 394 x 295 cm

In 1620, Maria de' Medici, whose husband Henri IV had been murdered 10 years earlier, commissioned an extensive cycle of paintings that were intended to decorate the Palais du Luxembourg she had just built and also to ennoble and lend allegorical significance to her life's work as the regent and mother of Louis XIII. The Flemish painter, Peter Paul Rubens, produced 24 large-format paintings in just four years, 21 of which are now in the Louvre and 3 in Versailles. The iconographic project was developed through close cooperation between the artist and his client: its aim was to create a powerful and convincing interpretation of the extremely difficult political situation of Maria de' Medici, who had been banished to Blois in 1617 by her own son. Again and again, her struggle for peace and compromise in a country shaken by insurrection, revolts, and wars of religion is highlighted. Thus, Rubens portrays the marriage between Henri IV and the granddaughter of Cosimo I of Florence as a peacemaking union driven by love rather than dynastic and fiscal considerations, thus distracting the French king from the art of warfare.

Peter Paul Rubens, The Apotheosis of Henry IV and the Proclamation of the Regency of Maria de' Medici, ca. 1621–1625
Oil on canvas, 394 x 727 cm

In one of the key paintings in the cycle, the accession of Maria de' Medici to the regency (1610) is portrayed in over-sumptuous pictorial language as an act of humble self-sacrifice for the good of the country: while the murdered king is led by the God of the Dead to Olympus where Jupiter is already waiting for him, Maria de' Medici is coaxed by the country's luminaries into accepting the orb of power from the hands of Gallia, representing France. With Athena, goddess of wisdom, standing supportively behind her, she is handed the reins of state from on high. In fact, the regent did face complex problems of domestic and foreign policy, which she attempted to resolve though not always with success. On the other hand her son, Louis XIII, who was intent above all on preserving his own authority, did not shrink from using war as a political means, establishing a repressive and bloodthirsty regime in his own country. When the dispute between Richelieu and Maria de' Medici escalated in 1631, the king backed his advisor. The erstwhile regent was forced to flee abroad, where she stayed in various places before her eventual death in Cologne in 1642.

Sir Anthony van Dyck (1599–1641), Charles I of England, ca. 1635–1638
Oil on canvas, 266 x 207 cm

Anthony van Dyck, an assistant and colleague of Rubens, was one of the most innovative portraitists of his time; he mastered a fresh, contemporary formulation of the official royal portrait, making it all the more convincing. The expressive force of his portraits gained rapid recognition throughout Europe and, by the age of 33, he had been appointed painter to the court of Charles I in England. His portrait of the king is an outstanding example of subtle representation. Van Dyck gave completely new meaning to the traditional equestrian portrait by showing Charles standing near, rather than, as was usual, sitting astride, his horse. The king is seen enjoying a moment of physical and mental relaxation. As if he has just noticed the viewer, he turns to look beyond the frame. With the regal bearing of the king, his sumptuous costume, and the emphasis on sword and glove as aristocratic emblems, however, the composition does appear carefully posed. The noble beast, which seems to bow before the majesty of its rider, and the attentive pages can be interpreted as allegories of loyalty; given the fate that later befell the king, who was executed under Oliver Cromwell, this has a certain tragic ring to it.

**Jan Davidsz. de Heem (1606–1683/84),
A Table of Desserts, 1640**
Oil on canvas, 149 x 203 cm

De Heem, who was born in Utrecht, but worked in Antwerp from the mid-1630s onwards, combined the Dutch still-life tradition with a typically Flemish flourish of opulence. The lavish arrangement of luscious fruits and pastries among refined jugs, glasses, and dishes is captured in a drapery backcloth that gives way to an architectural set piece. On the left can be seen a large lute and, in the background to the right, a globe and books. For the educated connoisseur of symbolic literature, there were numerous allusions to the transitory nature of worldly things hidden in the represented objects, as well as the masterful reproduction of their different textures: fruits spoil, music fades, and even riches and education are not spared death. The vines are a Christian symbol, reminding viewers of the need to put their individual lives in order.

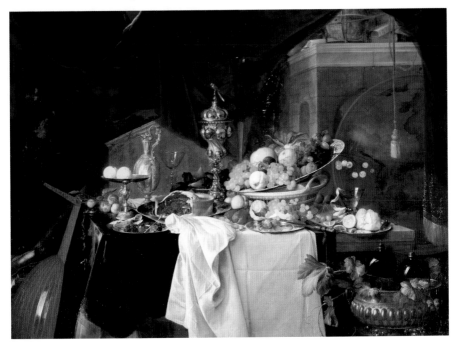

Rembrandt Harmensz. van Rijn (1606–1669),
Bathsheba at her Bath, 1654
Oil on canvas, 142 x 142 cm

The story of Bathsheba, from the second book of Samuel in the Old Testament, is one of adultery and betrayal. King David, who happens to see the beautiful Bathsheba bathing from the balcony of his palace, takes her as his lover, although she is married to one of his soldiers. When she becomes pregnant David sends her husband, Uriah, to the front line of battle, where he is killed; the king then marries

Bathsheba. Biblical stories from the Old Testament form an important subgroup in Rembrandt's oeuvre, and for this complex storyline he selects a moment of intimate reflection when the action has paused: Bathsheba, whose feelings are not divulged in the biblical text, is holding the letter in her hand that forces her to decide whether to commit adultery or refuse David's advances. An elderly maidservant is drying her feet after a bath. It is not the external action, but the internal resolution, which carries the narrative in this scene. Rembrandt concentrates accordingly on a theatrical use of light that carves out the body of the beautiful woman like a sculpture and makes it shine even brighter than the sparkling, golden material in the middle ground. Her slightly bowed head and melancholic expression intimate the outcome of the story. The supreme skill of the artist is revealed in the virtuosity of the brushwork, the uncompromising reduction of content, and the discreet rhetoric of the picture.

Jan Vermeer van Delft (1632–1675), The Lacemaker, ca. 1670/71
Oil on canvas mounted on wood, 24 x 21 cm

As if caught in a snapshot, a woman can be seen attending to her business, oblivious to everything else. The myopic quality emphasized by the image detail and gently controlled lighting engenders a high level of intimacy and a sense of emotional proximity. Vermeer died prematurely, at the age of 43, burdened with financial problems: he left behind 11 children, and painted three or four pictures a year at most. His complete oeuvre thus comprises only about 40 paintings, yet their artistic sophistication and inner harmony remain inspirational to this day.

Pieter de Hooch (1629–1684), Woman Drinking with Soldiers, 1658
Oil on canvas, 68.6 x 60 cm

This inoffensive genre painting made by Pieter de Hooch during his most productive period in Delft, shows a brothel scene: two soldiers, a prostitute, and a madam are in the process of doing business. A picture within the picture in the background sounds a cautionary note, depicting Christ and the adulteress before the imminent Fall of Man. The subtle use of light, the warm color, tones and the skilful composition of interiors that open out deep into the background made the paintings of de Hooch valuable collectors' items even during his lifetime.

Cardillac's "unrivaled" jewelry—
a detective story

by Jörg Völlnagel

"Un amant qui craint les voleurs
n'est point digne d'amour."

"A lover who fears thieves is not worthy of
love." This throwaway comment by the aristo-
crat Mademoiselle de Scuderi, who lived in Rue
St-Honoré, put her at the center of a truly
sparkling detective story. During the reign of
Louis XIV, in the fall of 1680 to be precise, Paris
was plagued by a series of murders and rob-
beries—the culprits were after valuable jewelry.
Under cover of darkness, gentlemen mostly on
their way to trysts with secret lovers were
robbed of the gems they were carrying and
stabbed in the heart with a dagger. Special
investigators appointed by the king failed to
arrest the callous criminals, resulting in wide-
spread unease, even fear, in the city of romance.
A petition from the endangered lovers to the king
led to this rather condescending comment from
Scuderi. Not long afterwards, she became
caught up in the case herself.

The central character in E. T. A. Hoffmann's
novella "Das Fräulein von Scuderi" (1818) was
not the eponymous woman, however, but the
goldsmith René Cardillac. As the master of his
guild in Paris and indeed of his generation, soci-
ety held him in high esteem. His works of gold
exceeded anything ever seen before, while the
way he handled precious gems in particular was
proof of his exceptional talent. Yet it was not
easy to wrestle the pieces from the jeweler. He

certainly worked like one possessed, always
ready to take on a job when he spotted sparkling
stones and agreeing to carry out the work at far
too low a price. But when the eager customer
came to collect his "bijou" in the workshop on
Rue Nicaise, the master craftsman was never
satisfied. He had to change this or rework that,
and refused to part with the precious piece even
when double payment was offered. If the cus-
tomer insisted on his contractual rights, the
mood of the recalcitrant Cardillac hit rock bot-
tom. On occasions when a threat of involving the
police was made, it was not unknown for the
customer to be separated from both the intran-
sigent goldsmith and the piece of jewelry by
hefty punches.

Yet there was a dark secret lurking behind the
eccentric artist—an evil diamond, as he himself
described it. In the first month of her pregnancy
with René, his mother gave herself to a Spanish-
dressed gentleman out of insatiable desire for
the jewels he had. The man died in her arms. His
pregnant mother's sinful behavior sealed a dark
fate for the boy who had barely been conceived.
Cardillac chose to become a goldsmith purely
out of desire for precious gems: the gleam of the
polished stones drove him on and soon made
him the best in his field. Before long, however, he
turned into a thief, in order to regain possession
of the finished pieces, putting them into a jew-
elry cabinet of which no king could ever dream.
But the fiendish voice inside him did not give

him any peace: it taunted him with "Your jewelry adorns a dead man," reminding him of his nightmarish destiny. And so he began to murder his clients, in an unsuccessful attempt to deny them the jewels in advance, believing he was protecting them and himself from misfortune.

Hoffmann leaves it to Fräulein von Scuderi to solve the crime: using diplomatic skills and applying a good measure of maternal feeling, she saves both an innocent man from being condemned and society from a scandal. In the Scuderi character, Hoffmann constructs the human antithesis to the blood-soaked figure of Cardillac. An artist herself, this virtuous young woman devotes herself to writing poetry and recites her verses at the court of the king. Against this, the goldsmith seems almost like a precursor of the "art for art's sake" artist, whose output consists in dabbling in pointless creativity. Of course, it is not within his control—the master craftsman is a man driven by impulses, unable to hand over his pieces for their intended purpose, i.e., to adorn the face or body of a woman. Destiny has chained him to his work; they are forged together, and only death can release him from this curse.

The goldsmith Cardillac in his workshop, illustration by Josef Hegenbarth for "Das Fräulein von Scuderi," the novella by E.T.A. Hoffmann, 1976, ink drawing, 16.3 x 15 cm

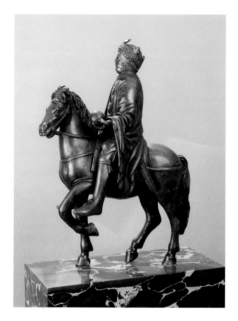

bronze sculpture from the Carolingian period. Charlemagne, the king of the Franconians who was crowned emperor in Rome on December 25, 800, was sure to have connected with this role model from antiquity, ranking himself within the tradition of the Christian rulers of Rome. His political vision, which strived to amalgamate the legacy of antiquity, Christian religion, and Germanic philosophy, is reflected in this mode of representation. The emperor, who personally acts as the promoter and patron of the arts, is shown in an erect pose with the symbols of his rule, the crown and the orb. The sword that he would have held in one hand has been lost. His facial features and garments are elaborated in great detail. Difference in scale and style indicate that the horse itself is a piece from antiquity, taken as a spoil and incorporated with the aim of ensuring a special closeness to the exemplary art of antiquity.

Equestrian statuette of Charlemagne or Charles the Bald, 9th century, horse possibly late Empire
Bronze, formerly gilded, ht. 23.5 cm

A debate about the art of antiquity began for the first time during the Carolingian Renaissance. This small equestrian statuette, presumably depicting Charlemagne, is an outstanding example of the associated trend of adopting and reinterpreting the models of antiquity. The Roman equestrian statue of Marcus Aurelius, which was believed to represent the Christian emperor Constantine even in the Middle Ages, was the direct forerunner of this rare extant full

Tomb of Philippe Pot (1428–1494), Burgundy, Late 15th century
Painted stone, 180 x 265 cm

From the Middle Ages onward, it was common to immortalize the figures of rulers on their tombstones, initially in bas-relief, then later in full sculpture. This led to elaborate formulations that created a more life-like and immediate effect by surrounding a tomb with "pleurants" or mourning figures. The anonymous artist, commissioned to create this monument by Philippe Pot

while still alive, adopted this form of tomb design, but interpreted it in a completely new way: the eight monks, almost life-size, who seem to be in deep mourning from their hidden faces and bowed heads, replace the sarcophagus here, carrying a sculpture of the dead man on their shoulders that is reminiscent of the recumbent figures of a medieval tomb. This was not, however, a burial place, but a memorial for Philippe Pot. The monumental style is emphasized by the coats of arms of the bearers, which signify the domains ruled by Philippe Pot and are therefore supposed to act as reminders to posterity of his terrestrial power.

Marly courtyard in the Richelieu wing with sculptures by Antoine Coysevox (1640–1720) and Guillaume Coustou (1677–1746)

A collection of first-rate Baroque sculptures is on display under a protective glass roof in the Marly courtyard, as if in the open air: they were created for the garden of the Louis XIV chateau of the same name. The horse pond formed the central point in the gardens—a large basin fitted with sculptures by Antoine Coysevox and his nephew, Guillaume Coustou. While Coysevox depicts the goddess of fame, recognizable from the trumpet announcing victory, and Mercury riding on his winged horse Pegasus, Coustou avoided a specifically mythological scheme. His expressive sculptures, which were placed at the entrance to the Champs-Élysées in 1798 by the painter Jacques-Louis David, achieve their impact through the rearing movement of the horses, which are being restrained by humans in spite of their animal strength.

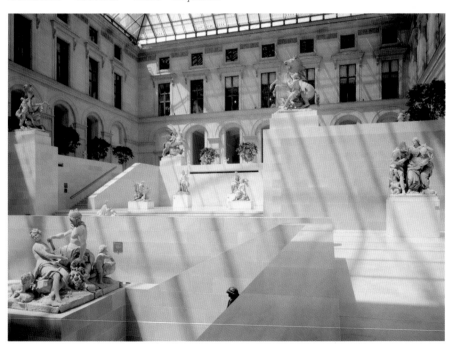

Arc de Triomphe du Carrousel

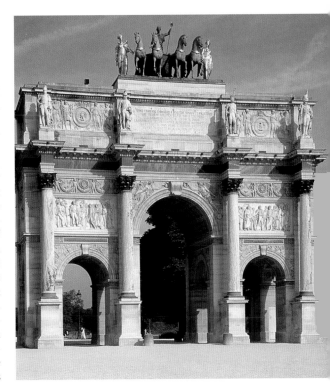

To commemorate his military victory at Austerlitz, Napoleon I commissioned two triumphal arches—the Arc de Triomphe du Carrousel and the Arc de Triomphe de l'Étoile. In designing the Arc de Triomphe du Carrousel, Charles Percier (1764–1838) and Pierre François Léonard Fontaine (1762–1853) took their inspiration from famous models of antiquity, the Severus Arch (203 AD) and the triumphal arch of Emperor Constantine (312 AD), which they had seen while on scholarships in Rome. The dainty, three-portal structure, which was inaugurated in 1808 and now stands in a solitary position following the demolition of the Tuileries Palace and the railings framing it on both sides, has a particularly effective color scheme, achieved through the use of different types of material. The sculptural work shows bas-reliefs illustrating historical events from the wars, with the figure of Napoleon at the center: inside the middle archway, he is being crowned by the goddess of victory. The attic is supported by eight soldiers from the various army units. For the inauguration ceremony, the four ancient horses of Saint Mark's Cathedral—brought from Venice as spoils of war by Napoleon—were placed on top of the triumphal arch. After they were returned in 1815, the sculptor François Joseph Baron Bosio (1769–1845) made the quadriga with the goddess of peace in a chariot.

Musée des Arts Décoratifs

(view into the main hall)

The completely renovated Musée des Arts Decoratifs was re-opened in 2006 and is housed in the north wing of the Louvre in the Pavilion de Marsan on Rue de Rivoli. The Musée de la Mode et du Textile, which also has an impressive jewelry gallery, shares the same building. There are now nine floors providing a comprehensive chronological tour through the history of decorative arts from the Middle Ages to the present day, taking in the incunabula of each period. The collection, built up since the mid 19th century mainly from private donations amounting to around 150,000 exhibits, concentrates on the 17th, 18th, and 19th centuries—the golden age of applied arts in France. The 20th century is also represented by important masterpieces. Representative works are displayed in the form of a study gallery in the impressive architectural setting of the main hall, providing a selective introduction to the "history of taste." Grouping objects with a similar function makes it easier to understand the historical development of their design. The intention is to change the exhibition pieces around each year within this "study gallery" layout. The tastes and lifestyle of an epoch are vividly brought to life by the many objects in showcases and especially by the complete interiors. Thus it is possible to stroll past, for example, the reconstruction of a 15th-century bedchamber; a mid-18th-century boudoir from an elegant townhouse on Place Vendôme, painted with delicate illustrations taken from fables by Jean de La Fontaine; or an Art Deco study from the 1920s, fitted out in a cool, detached style.

Detail
A mountain of 100 chairs

The different conceptual, aesthetic, and functional approaches by designers can be directly understood in graphic terms, especially in their struggle with a common task—the development of a piece of furniture on which to sit. "Mountain of 100 chairs" is impressive from the point of view of its composition; it is nothing other than a small piece of the style history of modern seating, which has evolved at breakneck speed from the beech-wood chairs of Michael Thonet through woven loom chairs and the Bauhaus classics by Mies van der Rohe and Marcel Breuer. New types of material have offered more and more possibilities for shape and color; plastics like polypropylene and a specially developed injection molding technique has enabled almost every design concept since the 1960s to be realized. The chair became ergonomic, in bright jazzy colors. The anti-authoritarian movement introduced the cuddly seating statement, with busy nineties yuppies committed to success in sitting on the dynamic shell chair, the "Tom Vac", capable of accommodating all the rocking and wobbling about. A chair is not just a chair; it is a piece of history, related to a mindset and its time.

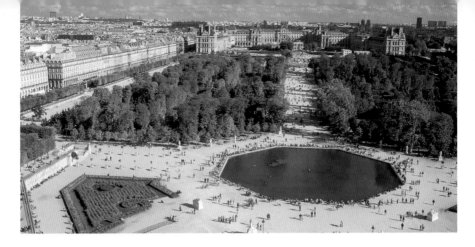

Tuileries Gardens

During the battles between the Communards and government troops in May 1871, the old Tuileries Palace commissioned by Catherine de Medici in 1564 to be built by Philibert Delorme (ca. 1510–1570) went up in flames. For 200 years the palace, which had a strict axial alignment, terminated the western side of the Louvre. With galleries almost 330 ft. (100 m) long, it provided living quarters for well over 1,000 members of the royal household. Today, only its extensive gardens have been preserved, being one of the most popular promenades in Paris since its inception. André Le Nôtre (1613–1700), who came from a family of gardeners, worked on the designs and construction of the park from 1664 and went on to become one of the most famous landscape architects in Europe. He created a symmetri-

cal layout, which is segmented by a wide middle axis and two large water basins at the crossing points. The two curved driveways to the outer terraces bridge the sloping incline. To the west, Le Nôtre extended the axis and terminated it in an open field, where the Champs-Élysées was later located.

Aristide Maillol (1861–1944),
Monument to Cézanne, 1925
Bronze, 140 x 227 x 77 cm

Sculptures and vases, most of which were initially brought from the castle grounds at Marly, were not put in place until the 18th century. Nowadays, modern sculptures by Aristide Maillol, Auguste Rodin, Max Ernst, and Henry Moore are also on display here.

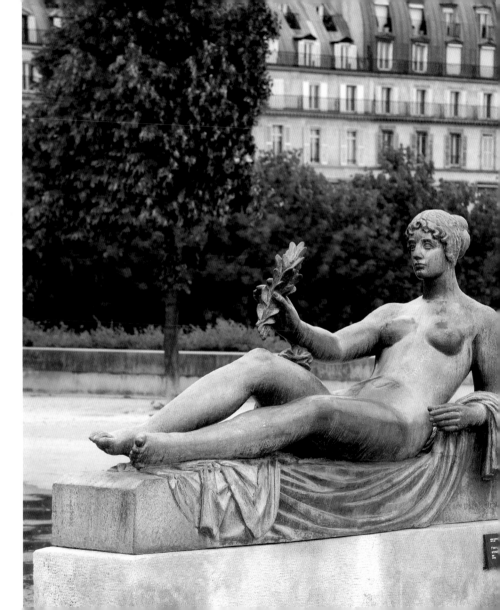

Musée de l'Orangerie

The Tuileries is closed off on the Place de la Concorde side by two buildings that share a long history with French Impressionist painting. The Jeu de Paume, where the first, small-scale exhibition of Impressionist painting once took place, was an obligatory port of call for a generation of young European and American artists during their stay in Paris. The Orangerie opposite has housed the famous "Water Lilies" series by Claude Monet since 1927. To mark the victorious end to the war in 1918, the elderly painter had decided to bequeath two of his "water lilies" canvasses to the French state: these formed part of the extensive series of over 250 paintings he had been working on intensively in his garden in Giverny. The Prime Minister at the time, Georges Clemenceau (1841–1929) offered him the royal orangerie in the Tuileries, built in 1852, to house this artwork. As Monet kept making changes to his paintings, however, the eight enormous compositions that were subdivided into 22 canvasses were not installed in the two oval rooms until after his death. After the opening of the Musée Claude Monet in May 1927, the critics were already raving about an "Impressionist Sistine." Following a six-year renovation period (2000–2006) during which the upper floor added in the 1960s was torn down, the "Water Lilies" can now finally be seen in daylight again. In this coordinated series of rooms, the stunning "painted garden" unfolds as a bright, luminous waterscape that offers a contemplative retreat for visitors.

Paul Cézanne,
Fruit, Tablecloth, and Milk Jug, 1880/81
Oil on canvas, 60 x 73 cm

In the newly refurbished lower floor, visitors can experience an intense encounter with the leading French exponents of classical modern art, in the outstanding collections of the art dealer Paul Guillaume and the architect and dealer Jean Walter. The spectrum ranges from the Impressionists—Auguste Renoir is particularly well represented—to Paul Cézanne and the younger generation of post-Impressionists around Pablo Picasso, Henri Matisse, André Derain, Maurice Utrillo, Chaim Soutine, and Amedeo Modigliani. A sense of the original, upper-class environment of these works is conveyed in the comprehensive reconstruction of the two collections. Today, they have found their place on cool, concrete walls.

Place Vendôme

As is so often the case in Paris, an equestrian statue forms the center of this representative square, which was designed under Louis XIV. Jules Hardouin-Mansart began to realize his synthesis of the arts in 1686.

Due to lack of funds, it was not long before the king was forced to sell the square, but with the proviso that the private buyers had to keep the unified facade design by Hardouin-Mansart. The construction of the two-story townhouses with arcades and a continuous mansard roof dragged on until 1725. The huge column, which is disproportionate to the size of the square, was erected in 1806 as a replacement for the statue of the king, which was melted down in the course of the French Revolution. Napoleon I commissioned the column to be modeled on Trajan's Column in Rome—it is surrounded by a bronze plate of 76 bas-reliefs depicting his victory at the Battle of Austerlitz. Originally, a statue of the emperor stood on top of the column, dressed in a Roman toga. During the Commune in 1871, the 145-ft. (44-m) column was dismantled on the grounds of being a symbol of autocratic monarchy. The courts sentenced Gustav Courbet, the reputed leader of this action, to bear the costs of reinstating the column, resulting in his financial ruin. It was finally restored and the bas-reliefs re-cast using the original molds.

Travel and Wonder—A Showcase of New Worlds in Paris during the Second Empire

by Hagen Schulz-Forberg

Müller: You're a melancholic hypochondriac of the first order.

Schultze: That's what my doctor says as well!

Müller: You need a change of scene, distraction and travel…

Schultze: He said that too. I'm supposed to go to Nice or Bad Ischl.

Müller: God forbid! I'm prescribing Paris!

(Kalisch, "Schultze und Müller in Paris", 1855)

The depressive is only too willing to swallow his medicine, and the two make their way to Paris in the summer of 1855. Schultze, who has just come into money as a result of a successful business deal, and his friend Müller are prototypes of the new type of tourist emerging at that time, who enjoyed travel for its own sake. The "steam revolution" made it all possible. The railways and steam navigation that revolutionized transportation in the 1850s soon began to specialize in passenger services. Cheap prices brought hundreds of thousands of curious and amazed foreigners to Paris; not only aristocrats, as was formerly the case, but also the bourgeoisie and even a few working-class people. The Englishman Thomas Cook organized package tours to the 1855 World Exhibition that were aimed at introducing ladies and working men to the delights of the metropolis. Its hotels, boarding houses, and restaurants were listed in the many travel guides that appeared. Travel writers and publishers soon adapted to the faster, more modern world. They printed simple

Wilhelm Schotz, (1824–1893), street scene in Paris with omnibus in background, woodcarving from D. Kalisch's, "Schulze and Muller in Paris," Berlin 1855, Staatsbibliothek, Berlin

descriptions with illustrations of the travel destinations on a few sheets of paper, in large type that could be easily read as the steamship or carriage rocked from side to side, and sold them at a price that even "third class" passengers could afford. So, why Paris? The answer is provided by the American Captain Spencer in his description of his round trip of Germany and France in the mid-1860s: Paris is the "capital of Europe, the center to which rich, happy people from all corners of the world are flocking and where they are guaranteed to find all their desires already catered for." The World Exhibition drew a million visitors to the place where windows on new worlds were always opening. Like the writer Emma Niendorf, commenting in 1854, they were fascinated by the pace of the big city and by the diversity of the population. "Contrast upon contrast. Among the faddish, lavish forms of dress, and exhausted or excited faces, are figures in religious garb quietly gliding along: serenely peaceful pink faces in the midst of this frenzy. Beside them, a Greek man in richly embroidered dress, an Oriental with a trailing gown, a bearded rabbi, or a Moor."

The different forms of transport are an experience in themselves—cabriolets, coaches, omnibuses, carts. "Heavens above! The shaft of one cabriolet is already tickling the brim of my hat!" groans Müller, out of breath. And as the 17-seater buses swing the passengers past "noisy tradesmen, small eateries, offices for military replacements, shops selling birds, and beer bars," they come across a cross-section of Parisian society inside the coach. As the writer Eduard Kossak described in 1855 in his "Stereoscopes of Paris:" "They trundle along, through the Latin Quarter to the poor side of Paris and through the bustling, somber city center to the upper banks of the Seine, carrying passengers who are the most wonderful examples of its colorful population. These seats contain such contrasts."

Newcomers can rely on the help of personal guides to the city to find their way around—they accompany them, joining them in conversation and visits to museums, the opera, theatres, restaurants, and coffee houses. They observe the scaffolding and magnificent buildings springing up everywhere as part of Haussmann's urban regeneration during the Second Empire, and become quite carried away by their enthusiasm. "All of Paris, the heart of Paris, lies before me like a dream," enthuses Emma Niendorf in her book "Contemporary Paris." "The Seine, the bridges, the quais, the magical way they are lit up"—they create a timeless impression of beauty that every tourist shares with the writer even today. Like her, travelers in the mid-19th century cast their eye across the Place de la Concorde in amazement and

Wilhelm Scholz, The Paris Guide, woodcarving from "Schultze und Müller in Paris" by D. Kalisch, Berlin 1855, Staatsbibliothek, Berlin

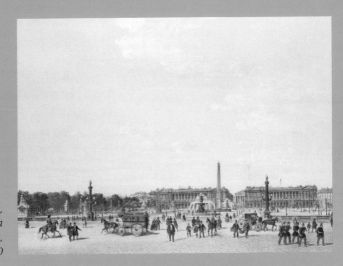

Place de la Concorde, engraving from a drawing by C. Reiss, 1850

disbelief: "On the right are the identical buildings on Concorde Street; on the left is the Concorde bridge with the portico of the Assemblée Nationale, which is now officially no longer the legislative assembly, but will soon be the Palais Bourbon again. Behind it is the church dome of Les Invalides. In the center is the Obelisk of Luxor with its hieroglyphics, between fountains that are like silver-dusted, cascading veils. Far back on the horizon like a vision of glory is the Arc de Triomphe. A cloudscape glowing in the sunset passes over it."

Foreigners stroll through the streets, past alleys and shops that are even open on Sundays, displaying things never seen before: "These wall-hangings, whose flowers arch to the rafters. These walls of mirrors, clocks, girandoles, all the gold and crystal chandeliers and lamps hanging from the brown Renaissance ceilings

and dazzling in the gaslight, a miniature magic forest." These details move Emma Niendorf and the travelers as much as the larger backdrop of the city itself. Thus, even in the rain, their heads bowed and protected by an umbrella, they sneak a look at yet another attraction that makes them forget the bad weather and gaze spellbound—the shoe of a Parisian woman. "Such an indescribably light and elegant shoe is actually Paris itself, the complete Parisian woman. It is often the smallest things that illustrate the greatest ones."

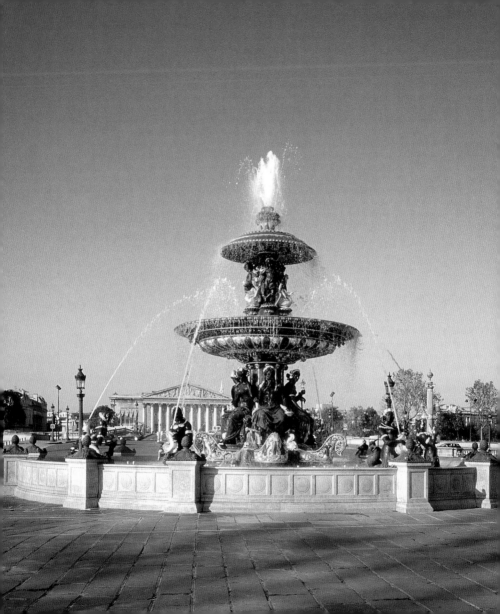

Place de la Concorde

Following the second Treaty of Aix-la-Chapelle in 1748, which had sealed the temporary compromise between the warring powers of England and France, the city of Paris decided to build an equestrian statue to Louis XV. The king donated the area to the west of the Tuileries and commissioned Jacques-Ange Gabriel (1698–1782) to design the square. Gabriel created two identical buildings on the north side—the Hôtel de la Marine and the Hôtel Crillon—whose facade design ties in with the Louvre colonnade, albeit in a more elegant variation. In 1836, the royal monument that was melted down during the French Revolution was replaced by an obelisk from Luxor dating to the reign of Ramses II (13th c. BC, see p. 456 for illustration). It took seven years to transport the 220-tonne, stone column from Egypt and put it in place. The other prominent feature of this impressive square, where more than 1,300 people were guillotined during the Reign of Terror, is the large, decorative bronze fountain by Jacob Ignaz Hittorff (1792–1867). The bourgeois king, Louis-Philippe, who himself ruled in turbulent times (1830–1848) wanted to eradicate the memory of the square's blood-soaked history, and asked for a design scheme that was strictly non-political. This was implemented by Hittorff with his decorative figures inspired by the Italian Baroque.

La Madeleine

The curious combination of Christian church architecture and a temple of Antiquity that characterizes La Madeleine is also a reflection of its complex construction history. Originally planned as a church by Louis XV, the building that was still unfinished in the post-revolutionary period was supposed to be used as a stock exchange, national bank or commercial court. Napoleon on the other hand wanted to turn it into a temple to the glory of the victorious army, and Louis XVIII finally wanted it to be a church of atonement in memory of the royal family who had been executed on the nearby Place de la Concorde. In the meantime, using it as a

railway station was even an option. It was not until 1842 that the classical edifice was finally consecrated as the parish church of Mary Magdalene, as originally planned. The facade with 52 Corinthian columns on a high pedestal matches that of the Palais Bourbon, the seat of the Assemblée Nationale on the opposite bank of the Seine. The pediment depicting the Last Judgement was completed by Philippe Henri Lemaire in 1833.

The interior

Divided into three domed bays and terminating in a semicircular apse, the interior actually resembles a massive hall of glory: it is more like Roman baths than a Christian church. It is somewhat gloomy, as the planned lunette windows have been walled up; instead, there are now murals with scenes from the life of Mary Magdalene.

Champs-Élysées

The Champs-Élysées—which must be one of the most famous boulevards in the world—has now lost much of its 19th-century glamour. During the Second Empire (1852–1870) "tout Paris" would meet here. People walked in the park areas, frequented the numerous restaurants and cafes, or visited the great panoramas on display in the rotundas, the Théâtre du Rond-Point and Théâtre Marigny, which are still preserved today. In 1855, the adjacent area on the Seine side on the Cours la Reine was used for the World Exhibition: the Grand Palais and the Petit Palais were also built for this event. On the other side of the street, Avenue de Marigny leads to the Élysée Palace, the official residence of the French president. The Champs-Élysées then continues steadily up to the Arc de Triomphe, with the park-lined boulevard on the other side of the Rond Point turning into a built-up avenue that still plays a significant part in the life of the city. The grand military parade on the July 14 national holiday takes place here every year, as did both the bicentennial festivities commemorating the French Revolution in 1989 and the World Cup victory in 1998.

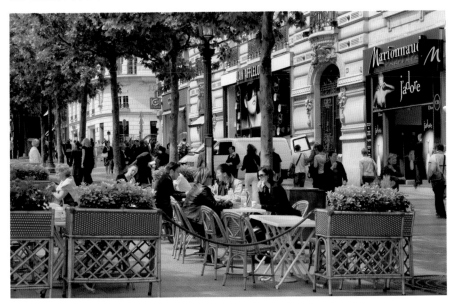

Fashion—naturally

by Charlotte Seeling

Off to Paris for the fashions—as valid today as it was in the 19th century. For it was back in 1858 that the successful dressmaker Charles Frederick Worth had the bright idea of giving a name, his own name that is, to fashion. By sewing labels with the signature "C. Worth" into his gowns, he liberated them from the anonymity of the standard masses of custom-made clothing and elevated them to the aristocratic heights of haute couture, as it was henceforth known. Meaning literally "high sewing," these garments were not only worn at royal courts—each pattern was as unique as a work of art. It was not just a case of using the finest fabrics and precision cutting, or premium workmanship and elaborate embroidery—it was primarily about creativity. And in this regard Charles Frederick Worth was clearly way ahead of his contemporaries. The experienced eye of the elegant Empress Eugénie, the wife of Napoleon III, was understandably quite taken with his creations. No sooner had she begun to be dressed by Worth than other royal spouses followed suit, especially Empress Elisabeth of Austria, the tragic "Sisi" with the narrow waist. It was the ladies from the upper aristocracy that spread the reputation of haute couture across the globe. Since then "anyone who is anyone" has made the pilgrimage to Paris on account of fashion, whether to be transformed from a plain Jane into a preening style icon, as was the case with Wallis Simpson, the Duchess of Windsor, or whether, like Worth, it was to rise from being a plucky little tailor to revered couturier. He could never have established his haute couture in his hometown of London, although there was, and still is, a ruling dynasty there too. So it was that France, rather than England, became the cradle of global fashion.

View of the workshop of couturier Charles F. Worth, 1907, photograph

So off to Paris! There, and only there, do you find the successful combination of down-to-earth craftsmanship and boundless imagination. Try as they may, other cities cannot displace Paris from its top position, even if the "swinging London" of the pulsating 60s and flashy Milan of the affluent 1980s did come close. New York, too, experienced the trend of being "cool" around the Millennium, but the heart of fashion beats in Paris—it was born there and it returns there, after every minor infidelity. Not that the French are actually the better fashion designers. Often designers from abroad set the definitive trends, beginning with Worth, continuing with the Spanish maestro Cristobal Balenciaga, who rose to prominence before World War II, then on to the ingenious little Tunisian Azzedine Alaïa, who gave the 80s his stamp of "sexy," and finally the wild young things at Dior and Givenchy, John Galliano and Alexander McQueen

Erwin Blumenfeld (1897–1969). The model Lisa Fonssagrives on the Eiffel Tower in a silk dress by Lucien Lelong, fashion photograph for Vogue magazine, May 1939 edition

from England. Belgium has also been particularly good at producing designers. For years, graduates of the Royal Academy of Antwerp have made up the avant-garde in a way that Paris has not been able to manage. But the seed

that has increasingly been planted elsewhere flourishes in the city on the Seine.

Why Paris? Certainly no other country is quite as concerned about fashion as France, where haute couture is regarded as an integral part of

the culture, and is supported, but also regimented, accordingly. But the proverbial Parisian chic will not take orders: it emerges on the street, in the cafes, and in the salons. It is the "je ne sais quoi"—that certain elusive something—that allows fashion to thrive in Paris, though not necessarily in the rest of France. The bourgeoisie and bohemian society together constitute the rich, fertile soil. One group would never be seen dead in anything but the proper outfit for the occasion, while the other would rather die than be dressed "properly." Catherine Deneuve can be cited as an example of the first category, and Jane Birkin for the second: one is the epitome of feminine elegance, and the other has perfected the "anything goes" look. But no matter where they were born, the very same article of clothing defines them as Parisian woman—the little black dress. But anyone who thinks that this "uniform" equalizes everyone before the god of fashion is seriously mistaken. The insider spots immediately whether a woman in black comes from the bourgeois right bank of the Seine, the Rive Droite, or from the opposite side, the rebellious Rive Gauche. Such fine distinctions may not be evident to a foreigner at first glance. But even he recognizes that a Parisian woman can look incredibly chic, in spite of the run in her stocking and the "just fell out of bed" hairstyle. And the next one can have the appeal of an erotic bombshell despite the intimidating aristocratic bearing. That is what fashion can do, if you know how to apply it—you learn how to do it in Paris. Quite naturally.

The lesson takes place on the hoof, if you choose the right streets. The foundation course leads past the Right Bank, the traditional head office of the big names in the business. On the corner of Rue François 1er and Avenue Montaigne, the couture houses of Dior and Ricci confront one another in all their traditional glamour, though the people who gave them their names have long since met their makers. At No. 50, where Madeleine Vionnet once created her as yet unsurpassed bias cut, hangs the sign "Jil Sander," which is already unconnected with the person and no more than a brand name like most of today's fashion houses. Valentino and Ungaro are some of the very few among the older generation who still design their own collections.

Rapidly crossing the Champs-Élysées, past the galleries on Avenue Matignon and hurrying into Faubourg Saint-Honoré. Opposite Hôtel Bristol, a favorite haunt of the fashion scene, Christian Lacroix established one of the most recent couture houses in 1987. But even Lacroix, like most of the others, launched a second, more affordable, line some time ago. The first to take the plunge into "prêt-à-porter" was Yves Saint Laurent, with his "Rive Gauche" collection: a revered genius, his couture house is located next to Givenchy and Lanvin on Rue du Faubourg Saint-Honoré. Names like Rabanne, Versace, Feraud, Hermès, and Gucci complete the famous mile of fashion.

It is worth going further upriver into Rue Saint-Honoré, turning into Rue Cambon to Chanel, the only legend that is more alive than most of the newer brands, thanks to Karl Lagerfeld. At the other end of Rue Cambon, the Maria Luisa boutique has remained the top trendsetter for decades, even in spite of hot competition from Colette, the ultra-trendy concept store at no. 213 Rue Saint-Honoré. Photographers, models, and

stylists who live a few blocks down the street in the Hôtel Costes buy their international magazines, trainers, cosmetics, and favorite mineral water from Colette's selection of about 80 types. The fashion course finishes up on Place du Carrousel at the Louvre where the prêt-à-porter shows take place twice a year, in March and October, before carefully selected invited guests. Although prêt-à-porter is only the cheaper offshoot of haute couture, it is still prohibitively expensive for most people. If you need convincing, just go across the Seine and walk down to the quarter around Saint Sulpice church in Saint-Germain-des-Prés: there, dotted around the revolutionary forerunner Saint Laurent with his 1966 "Rive Gauche" line, the emergent brands have established themselves, from Prada to Martine Sitbon, as well as Sonia Rykiel and Armani.

So how do you put into practice what you have just learned, if you are not fortunate enough to be a millionaire? Just like any Parisian woman— go into one of the big department stores like Printemps, Lafayette, or Bon Marché and make a beeline for one of the inexpensive creations of unknown designers that have that certain something. It will probably be a little black number, customized a million different ways and fresh every time.

Coco Chanel (1883–1971), fashion illustration, 1923

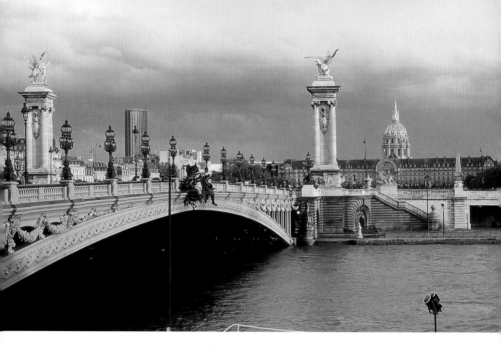

Pont Alexandre III

What is without doubt the most elegant bridge in Paris was completed for the World Exhibition in 1900. Its name and iconographic scheme are reminders of the Franco-Russian alliance between Tsar Alexander III and the president of France in 1892. The low, metal, span structure connecting the Champs-Élysées with the dome church of Les Invalides is decorated with garlands and candelabra surrounded by putti in the style of the Belle Époque.

Two massive columns were built for stability at each entrance to the bridge, on top of which are gilded goddesses of fame and winged horses. At their feet on both sides sit personifications of France in historical costume: on the right bank is France in Charlemagne's time and France of the modern age, while on the opposite side is France of the Renaissance and in the era of Louis XIV. The two emblems of state are symbols of the alliance and are positioned beside each other on the bridge, along with figures representing the Seine and Neva rivers.

Grand Palais

The Grand Palais was erected between the Seine and the Champs-Élysées for the World Exhibition in 1900, its impressive roof construction of iron, steel, and glass demonstrating just how innovative engineering could be at that time. In keeping with contemporary taste for all things historical, the architect responsible, Charles Girault, created a classical stone facade for the monumental building. The rich ornamentation harks back to the era of Louis XIV, a reference to the "Grand Siècle" of Baroque. Thus a stunning edifice was created, with colonnaded side wings 787 ft. (240 m) in length flanking a massive portico with double Corinthian columns. The decorative figures representing Art and Peace on top of the portico projections and the bronze quadrigas (four horse chariots) at each corner correspond to the historical style of the Belle Époque. The Grand Palais has undergone extensive restoration work and is now used for temporary exhibitions and the important art trade fair in Paris, FIAC.

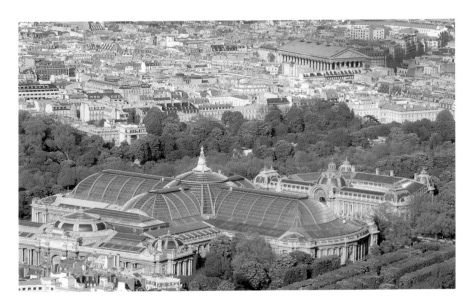

Petit Palais

Directly opposite the Grand Palais is its "little brother," the Petit Palais, which was retained for use by the city of Paris at the end of the World Exhibition. Charles Girault, who won the bid for both building projects, designed and executed a textbook example of the eclectic approaches to architecture at the turn of the century. He developed an extremely elegant structure with an impressive main facade by cleverly combining transpositions of Parisian architecture such as the Louvre colonnades, the church of Les Invalides, and the Hall of Mirrors at Versailles. A large, exterior stairway leads up to a portal framed with multiple columns and arches and rich sculptural decoration: thirteen sculptors, mainly from the École des Beaux-Arts, collaborated on the arrangement. In counterpoint to this is the light elegance of the cast-iron latticework that was produced by Girault himself.

The semicircular garden is equally as lavish in its layout and decor, lined with colonnades and frescoes by Paul Baudoüin, a pupil of Puvis de Chavannes. The interior architecture is captivating with its ceiling frescoes in the entrance area and main gallery, its exuberant stuccowork, and the handrails on the staircases with elaborate floral decoration. The Petit Palais is no less than a modern chateau, albeit dedicated to industrial

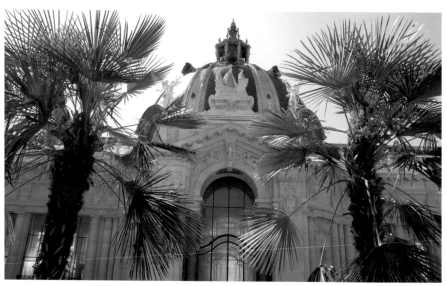

progress and later to the arts, rather than to a regent.

As intended at the end of the World Exhibition, the incredibly mixed art collection of the city of Paris moved into the Petit Palais. The collection developed its profile initially through private donations and legacies made to the city on the basis of the attractive new home for them. In this way, eight paintings by Gustave Courbet were added by his sister Juliet, as well as the Zoubaloff endowment in 1916 containing sculptures by Maillol and Rodin. Paintings by Cézanne and Renoir also came from the estate of the art dealer Ambroise Vollard, which now count among the masterpieces of the collection.

In addition to the body of paintings and sculptures, an extensive collection of drawings and print graphics was assembled. There is also an applied arts section, which includes jewelry by Georges Fouquet, vases by Émile Gallé, and the complete interior of a dining room from designs by Hector Guimard, one of the most important French Art Nouveau artists. This has produced an overall artistic impression of the age, and of the 19th century in particular, which engages with the architecture in a close and meaningful relationship.

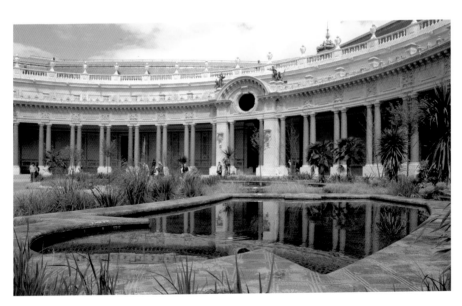

Arc de Triomphe de l'Étoile

Surrounded by the roar of heavy traffic, the massive archway stands at the top of the Champs-Élysées in the middle of Place Charles de Gaulle, with twelve streets branching off it in a star formation. Like the smaller Arc de Triomphe at the Louvre, it is a memorial to the Battle of Austerlitz. Napoleon I commissioned the monument as early as 1806, but it was not fully completed for another 30 years. Jean-François Chalgrin (1739–1811), who drew up the plans, conceived the decisive idea of repeating the arch motif on the sides in order to neutralize the axial dimension of the portal and match it perfectly to the curve of its context. Four monumental groups were commissioned from various artists in the 1830s as part of the decorative arrangement, of which "La Marseillaise" by François Rude (1784–1855), on the right of the side facing the city, is by far the most famous and successful. Rude dramatized the theme of insurrection for liberty and one's country, dressing the scene in the historical garb of the Gaul uprising under Vercingetorix. In spite of the re-evaluation of the Napoleonic era by subsequent generations, the Arc de Triomphe remained a national monument that was used and even misused repeatedly as a means of asserting identity. In 1885, the body of Victor Hugo lay in state for two nights under the arch. In 1940, German troops marched ostentatiously through the portico into the city. At the same spot, four years later, the Liberation by allied troops was celebrated. After World War I the Tomb of the Unknown Soldier was built beneath the arch as a monument against war, an idea that has been adopted many times since across the world.

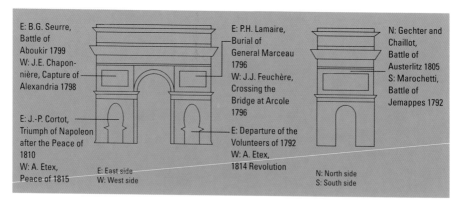

E: B.G. Seurre, Battle of Aboukir 1799
W: J.E. Chaponnière, Capture of Alexandria 1798

E: J.-P. Cortot, Triumph of Napoleon after the Peace of 1810
W: A. Etex, Peace of 1815

E: East side
W: West side

E: P.H. Lamaire, Burial of General Marceau 1796
W: J.J. Feuchère, Crossing the Bridge at Arcole 1796

E: Departure of the Volunteers of 1792
W: A. Etex, 1814 Revolution

N: Gechter and Chaillot, Battle of Austerlitz 1805
S: Marochetti, Battle of Jemappes 1792

N: North side
S: South side

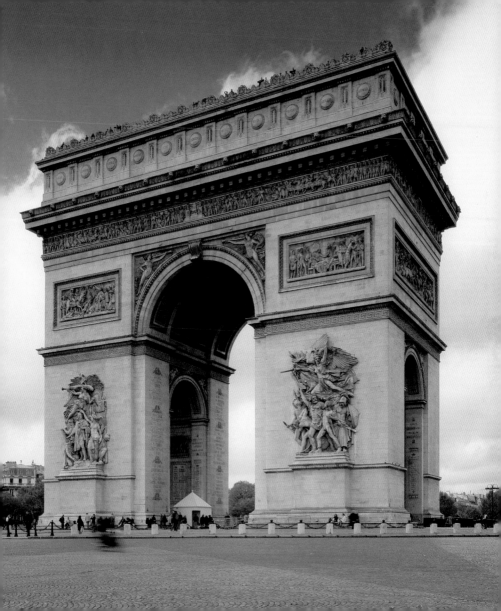

The Historical Axis II—from the Louvre to La Défense

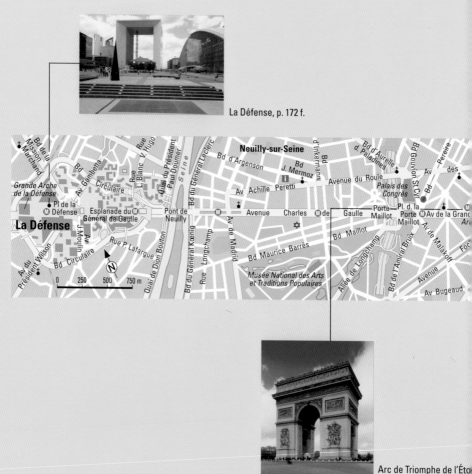

La Défense, p. 172 f.

Arc de Triomphe de l'Éto
Place Charles de Gaulle,

Champs-Élysées, p. 159

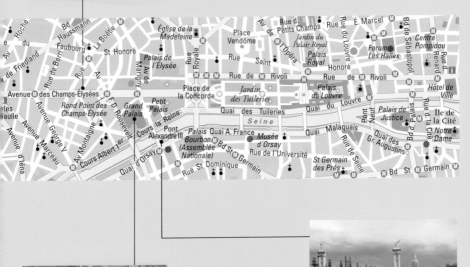

Grand Palais, 31,
Av du Général Eisenhower
and Petit Palais, 1, Av Winston
Churchill, p. 165 ff.

Pont Alexandre III, p. 164

The Historical Axis–from the Louvre to La Défense **171**

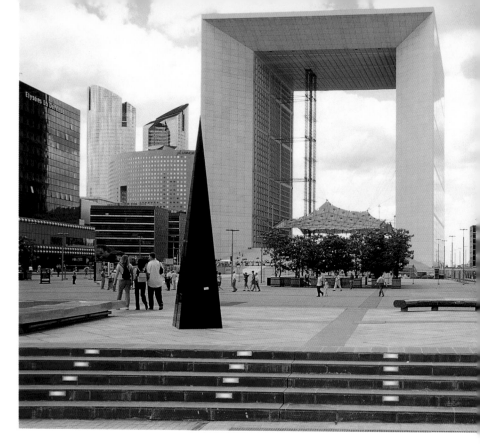

La Défense

The satellite town of La Défense, which actually lies outside the Périphérique, is still the continuation, from the point of view of topography and architectural history, of the east–west axis of Paris. This runs from the Louvre Pyramid through the Arc de Triomphe to the Grande Arche, commissioned by François Mitterrand, which was built here between 1985 and 1989 by the Danish architect Johan Otto von Spreckelsen. The first building phase on what had hitherto been an area neglected by urban development was launched between 1957 and 1959, with

overburdened capital and decentralize the huge volume of traffic. For this reason, the decision was taken to locate the highway system underground for the second development phase, which began in 1964 and entailed the construction of a platform to support the architecture. The vast open spaces on top of the concrete base were, however, rapidly found to be uninviting, drafty, and out of proportion, so an attempt was made to alleviate this impression by installing sculptures by Alexander Calder and Joan Miró, among others. La Défense increasingly developed into no more than an office and business town: only around 20,000 people now live there, while 100,000 commute in each day to get to their jobs in one of the big skyscrapers. The original intention of limiting the height of buildings to a maximum of 328 ft. (100 m) was abandoned in the 1970s. This resulted in the construction of ever-taller buildings, whose different styles provide a good insight into architectural development in the late 20th century. When the towers became increasingly visible from the city center, there were loud protests about the changes taking place in the municipal area. Top architect Jean Nouvel had even started to design the visionary "Tour Sans Fin" (tower without end)—a 1,378-ft (420-m)-high granite block whose glass dome is meant to look as if it is disappearing into the ether. So the 360 ft. (110 m) Grande Arche is still the main attraction, and the orientation point for the great perspective that stretches from the heart of the city to what is (so far) its outer end.

the construction of a huge exhibition hall. The CNIT Building, as it is called, with its concrete vaulted roof supported on three pedestals and its glass facade, represented a groundbreaking achievement in engineering. In the 1960s, a whole series of high-rise buildings was added, the aim of which was to provide new office and living space for the

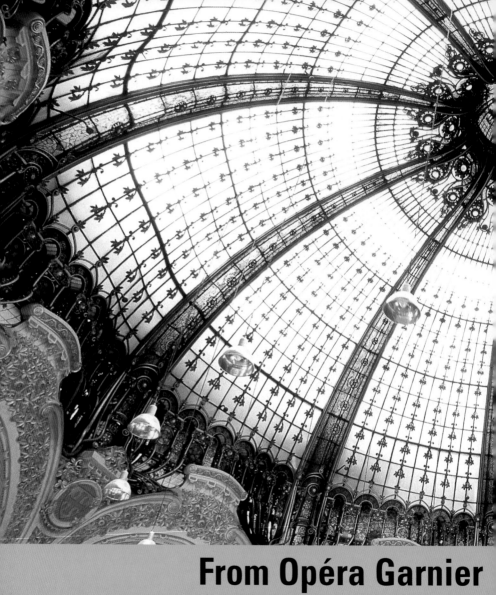

From Opéra Garnier

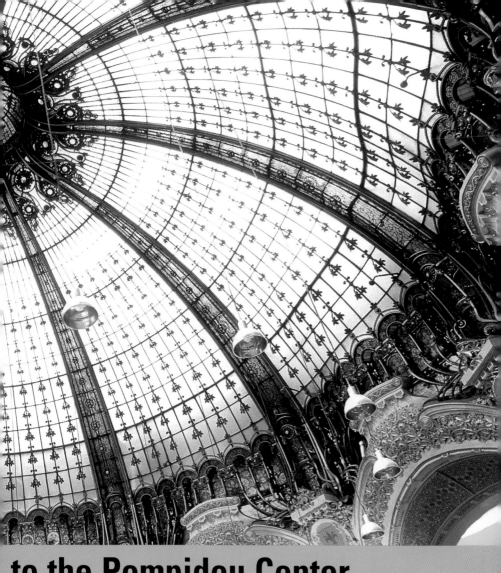

to the Pompidou Center

From Opéra Garnier to the Pompidou Center

"The beauty of Paris is such that I sometimes find it disturbing, because I sense how fragile and vulnerable it is," observed the French writer Julien Green (1900–1998) with some concern in his book entitled "Paris" (1983). He was referring to some of the architectural disasters of the 20th century, among which he numbered the new Pompidou Center. In fact, the Second Empire (1852–1870) had left far more pronounced marks on the city center. Under Napoleon III, the "New Paris" emerged in the area around the opera house, a new quarter of grand boulevards that became populated with cafes, restau-

The newly completed Opéra Garnier building, with horse-drawn coaches in the foreground, 1890

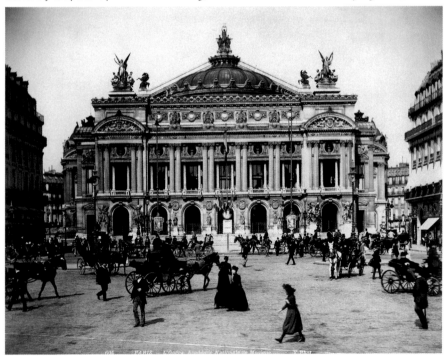

rants and the first department stores. The urban society of the Belle Époque rapidly became established there, its members from the financial aristocracy and upper classes sharing the same insatiable need for self-promotion. Neo-Baroque pomposity reached its peak in the Opera House building: the style that borrowed from palace architecture was interpreted and adopted as a way of ennobling the present day. "Paris must not become a factory. Paris must remain a museum." This remark, made in 1885 by the Opera's architect, Charles Garnier, is indicative of the way historicism saw itself.

Yet even under Napoleon III, functional buildings were already appearing that were made from the pioneering materials of the age—iron and glass. The market halls by Victor Baltard were exemplars of a modern industrial architecture in which a new functional aesthetic prevailed. The "belly of Paris," the nickname given to Les Halles, was used as the title for a novel by Émile Zola ("Le Ventre de Paris") and, until it was torn down in 1971, this huge market hall dominated and invigorated the district. In the 1970s, culture replaced trade as the driving force of the Beaubourg quarter. The controversial Pompidou Center building, which ripped a massive hole in the medieval quarter, boosted the restoration of the French capital as the cultural capital of Europe. Surprisingly, Garnier has now been proved right in this regard—

Preceding spread: View inside the glass dome of Les Galeries Lafayette

"The Dance," replica of "La Danse" (1869) by Jean-Baptiste Carpeaux, Opéra Garnier facade

although it looks like the inside of a factory or laboratory (the term "cultural refinery" is also frequently used) the Pompidou Center has been instrumental in triggering a conservation process in Paris that has visibly progressed since the 1980s in the form of countless museum constructions and conversions.

From Opéra Garnier to the Pompidou Center

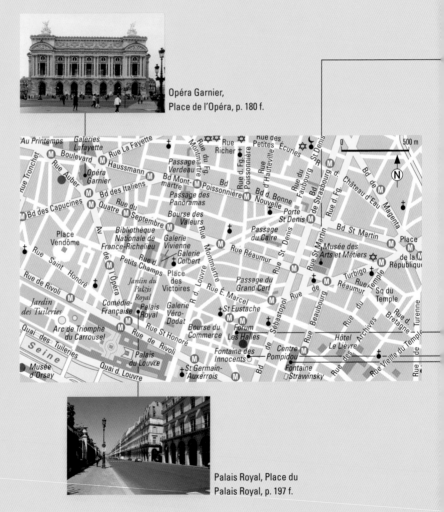

Opéra Garnier,
Place de l'Opéra, p. 180 f.

Palais Royal, Place du
Palais Royal, p. 197 f.

St-Martin-des-Champs/Musée des Arts
et Métiers, 270, Rue Saint-Martin, p. 219 ff.

Forum des Halles, p. 208

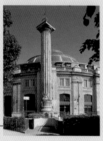

Fontaine des Innocents,
Place des Innocents,
p. 199

Pompidou Center/Musée
National d'Art Moderne,
ace Georges Pompidou, p. 210 ff.

Also worth seeing

1 Paris arcades and covered passages, p. 188 f.

2 Bibliothèque Nationale de France—Richelieu-Louvis site, 58, Rue de Richelieu, p. 192

3 Comédie Française, Place Colette, p. 193 ff.

4 Place des Victoires, p. 198

5 Bourse de Commerce, 2, Rue de Viarmes, p. 199

6 St-Eustache, 2, Rue du Jour, p. 206

7 Fontaine Stravinsky, Place Igor Stravinski, p. 218

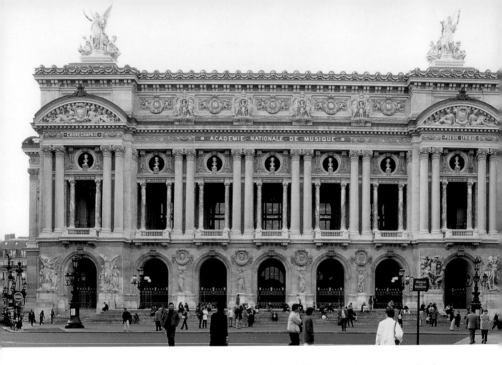

Opéra Garnier

Virtually no other building speaks such volumes about the need of an epoch to define itself as the Paris Opéra, realized by Charles Garnier (1825–1898) between 1860 and 1875. Commissioned by Napoleon III after he had just escaped an assassination attempt in front of the opera's provisional home in Rue Le Peletier, the massive building was erected in the center of the new business district, Quartier Vendôme. An unknown architect, Garnier, beat more than 100 competitors—one of whom was the famous architect, Viollet-le-Duc—with his design. He created an ostentatious building, combining references to the Baroque palace with extremely elaborate ornamentation. Even at a distance, its architecture is designed for maximum impact: a palace facade in the Neo-Baroque style greets the visitor, with the dome—then a triangular stone pedestal—rising up behind. The latter indicates the location of the stage area and is crowned by a statue of Apollo with a lyre.

Stairway

The famous stairway, together with the vestibule and two foyers, takes up a far greater amount of space than the stage and auditorium and illustrates the extent to which a visit to the opera during the Belle Époque was a real social occasion. People came here to be seen in their finery, exchange news and gossip, do business, and strike up romantic liaisons. The excessive ornamentation in different shades of marble and gold, the enormous onyx balustrade, the grand chandeliers, and the monumental figures on the landings—all became the backcloth for staging the self-assurance of the bourgeoisie.

Auditorium

The auditorium below the richly decorated copper dome, with over 2,000 seats, has kept its festive red-and-gold interior. The vertical space is divided into four balcony levels, offering an unrestricted view of the stage and, more importantly, of the opera-goer. The ceiling fresco painted by Marc Chagall in 1964 combines representations of Paris buildings with references to famous musical works, including the Ballets Russes premiere of Igor Stravinsky's "The Firebird" in 1910, the year Chagall arrived in Paris.

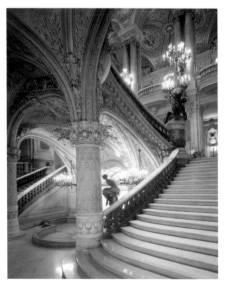

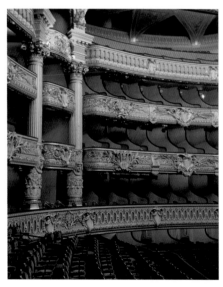

An epoch rebuilds—the "transformation of Paris" during the Second Empire

by Martina Padberg

"Le vieux Paris n'est plus..." was the gentle, melancholic lament of the writer and lyric poet Charles Baudelaire. "Old Paris is no more / the shape of a city / changes faster, alas, than a human heart" he wrote in his poem "Le Cygne" (The Swan), which was published in his (in)famous collection "Les Fleurs du Mal" (The Flowers of Evil) in 1857. People were reluctant to attribute this somewhat conservative aphorism to Baudelaire, the great proponent of modernism, but it reflected the feelings of his generation. He and his contemporaries had experienced the rapid and inexorable decline of the old Paris in the few years since the coup d'état and the coronation of Napoleon III as Emperor (1851/52).

Between 1853 and 1870, the forward-thinking Emperor and the city prefect appointed by him, Georges-Eugène Haussmann (1809–1891) molded the new face of the French capital that is still largely responsible for the impact of Paris today. Under their direction, axial swaths were cut into the rambling structures of the quarters, which entailed the demolition of around 25,000 buildings and the construction of about 40,000 houses, radically transforming the cityscape. A modern metropolis was created, which took account of the new functional as well as aesthetic demands of the age. Formerly employed as a military engineer, Haussmann designed and implemented the extensive building projects with corresponding precision. He put in place

far-reaching expropriation legislation that gave him the power he needed totally to flout private ownership agreements.

In no time at all, a massive reconstruction project had been set in motion with a team of

Adolphe Yvon, Napoleon III hands over the Decree for Annexation, c. 1865.
Oil on canvas, Musée Carnavalet, Paris

chosen experts and in collaboration with Napoleon III, who had returned to France from his exile in England with plenty of ideas on urban development. All Paris was turned into a gigantic building site. This engendered heavy criticism at the time, mostly from intellectuals, which has in part left its mark on later assessments of Haussmann, even to this day. People felt homeless in this newly evolving world, coupled with a loss of all things familiar. As noted by one of the Goncourt brothers in his diary entry of November 18, 1860:

Formal opening of Boulevard Haussmann, 1927

"All that is here now, and that is yet to come, is alien to me, in the way the new boulevards are alien, these streets without angles, without the excitement of different views, relentless in their linearity, which no longer remind us of Balzac's world, but instead of an American Babylon of the future."

To understand these critical cultural observations, they have to be seen in context. Only a decade earlier, in fact, Paris had still been a medieval city to all intents and purposes. Hemmed within the city walls erected by Louis XVI around 1785, where 60 customhouses raised taxes on imported goods, the city could not keep up with its expanding population.

With their densely built-up areas of narrow, dark alleys, many of the city's districts had become completely overcrowded, with every attic and cellar occupied. By the mid 19th century, the population had exceeded one million and, mainly due to migration from the provinces, continued to increase at such a rapid rate that the two million mark had been reached as early as 1881. Living conditions became drastically worse as a result, with illness, misery, and crime everywhere. In his novel "La Cousine Bette" (Cousin Bette), published in 1846, Honoré de Balzac portrays one such miserable quarter right in the city center, near the Louvre: "Darkness, silence, icy air, and the cellar-like depths of the floors make these houses like vaults—graves with living human beings entombed in them. Anyone passing this gruesome quarter in a carriage can easily become spooked, and no one can be blamed for not venturing there unless absolutely necessary, especially at night when the scum of Paris gets together here and every vice feels at home."

Dirty, smelly, and dangerous—was this the world of Balzac as articulated by Goncourt? At any rate, it was the reality of Paris. Nearly all the inhabitants still drew their drinking and washing water directly from the Seine or fountains that were contaminated by the large, inner-city cemeteries. It is hardly surprising, therefore, that cholera epidemics broke out in 1832 and 1849; they cost many lives, particularly in the old quarters of the city. Creating an urban network with a functioning sewerage system, installing street lighting to provide greater security especially at night, and the expansion of broader streets for the massive increase in traffic were some of the initial aims in terms of urban development when the new prefect took office in 1853.

"Paris above and below ground." Cross-section of a Paris street and ground beneath, undated. Etching, Musée Carnavalet, Paris

"New Paris"

Haussmann radically opened out the structure of the city. Demolition and excavation took place everywhere and for years the whole city was shrouded in dust and rubble. Great swaths of streets were cut through the traditional quarters, which were complex in both architectural and social terms. And the city prefect did not exactly flinch in this task—the densely packed medieval buildings on the Île de la Cité in particular were almost completely demolished. A few important monuments such as Notre Dame, the Conciergerie, the Palais de Justice, and Sainte-Chapelle were the only ones spared. On the right bank of the Seine a network of broad boulevards and avenues was created, framed by the closed architecture of the five-story apartment buildings that now seem so typical of Paris. They formed a functional traffic grid and interconnected the outlying railway stations.

The terminals, boulevards, stations, stores, and racecourses that sprang up during this period gave people an intense awareness, as yet unprecedented, of the mobile, anonymous, and collective nature of big city life. It was a new, frightening, and at the same time inspirational

experience for people to be able to transform themselves into anonymous passers-by in the metropolis: circulating within an incredibly fast-moving cosmos, far from any form of social control, but also outside a manageable social network. Charles Baudelaire, having recently lamented the decline of the old Paris, was the lyric poet who went on to discover this modern age of the big city and its "flâneurs" (strollers). The artist Édouard Manet and the Impressionists around Claude Monet became its portraitists. The most important literary chronicler of this transitional period was without a doubt Émile Zola (1840–1902), who painted a tableau of Parisian society during the Second Empire in his novels with great precision and sharp observation. The avaricious speculator, the rejected coquette, the corrupt financier, and the poor servant girl all inhabit Zola's novels and illustrate the Janus-faced era of Haussmann. Yet all the while this emergent city was offering its inhabitants unimagined possibilities for advancement, the impoverishment of the masses was continuing unabated, as they were forced to move away from the expensive, cleaned up residential areas within the city boundaries to districts like Montmartre that lay outside the city walls.

On the other hand, the "grand boulevards" around the opera house soon established themselves as the public stage for the "new Paris," where a constant stream of people strolled for mile upon mile. Cafes, restaurants, theatres, and vaudeville opened up for Parisian society to make its appearance. Around this well-heeled scene thronged the demi-monde, the twilight world of deadbeats, parvenus, prostitutes, and—last, but not least—the literati and artists

Front elevation of a Parisian apartment block of the Second Empire, copper engraving from 1858

who were also desperately awaiting their big break. Zola portrayed the considerable allure of this new epoch, but also the constant threat posed by the emerging new department stores to anything individual, in his novel "Au Bonheur des Dames" (The Ladies' Paradise), published in 1883. It was probably based on the department store "Le Bon Marché" founded in 1852 by Aristide Boucicaut, for which Gustave Eiffel designed a new iron and glass shell in 1876 and which is regarded as the prototype of the modern department store. For the first time, goods were spread out in such a way that customers could move freely between displays, browsing and looking at the new price tags themselves.

Personal conversations with sales personnel were replaced by an enticing presentation of goods in richly decorated surroundings, while the impressive glass domes, ornamental staircases, surrounding galleries, and atriums were reminiscent of church or theatre architecture. Female customers, in particular, were meant to lose themselves in the anonymous crowds of consumers in this artificially arranged, luxurious world of goods in the "grands magasins," succumbing completely to their secret passions as if in an act of seduction. It was all about creating a "Ladies' Paradise" as depicted by Zola in his eponymous novel, because it was the woman "who was given ample opportunity for cheap purchases once they had caught her eye with their new displays." The sheer variety of items on offer now created the desire for ownership, a complete inversion of the traditional relationship between the customer and the trader. The concept of democratization of consumption emerged and sales turnover boomed. Shoppers, both male and female, flocked from the lower social classes into the new consumer goods temples that were springing up thick and fast. The biggest and best known of these are still in existence today—Le Printemps (1865), La Samaritaine (1869), and Les Galeries Lafayette (1896). With these impressive syntheses of the arts driven solely by the market economy, the society of the Belle Époque had created a metaphorical place for its self expression.

The obvious change in values at that time was indeed reminiscent of the "American Babylon of the future" already cited. Today we look at 19th-century Paris in its aged patina through rose-tinted spectacles—it remains a magnificent

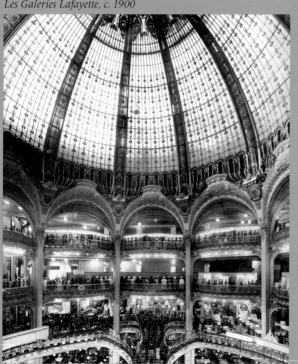

Les Galeries Lafayette, c. 1900

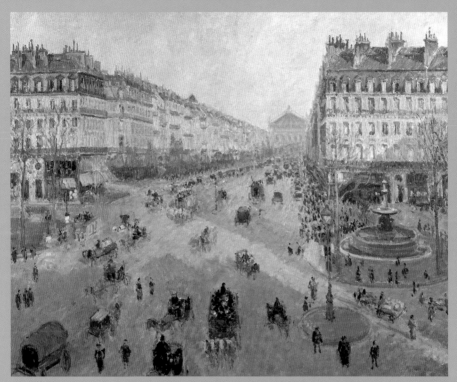

Camille Pissarro (1830–1903), Avenue de l'Opéra and the Théatre Français, 1898.
Oil on canvas, Musée Saint-Denis, Reims

ensemble, bearing witness to an epoch that sig-
nified the inexorable triumph of modernity.

Galerie Colbert and Galerie Vivienne

The "passages," or covered shopping arcades, are a Parisian invention. Created between 1820 and 1840, their new steel frame structure made city walks and browsing around shops possible irrespective of the weather and daylight, thanks to the artificial illumination of gaslight. Galerie Colbert and Galerie Vivienne are certainly among the most beautiful of these 120 or more glass-roofed galleries that developed on the right bank of the Seine. Sheltered from traffic and the dirt of the streets, they became a meeting place for the affluent bourgeoisie. With this style of architecture, the emergent modern consumer society created its own space within cosmopolitan life, which in retrospect rapidly assumed a mythical status thanks to its unique ambiance. Conscious of their gradual decline, the surrealist writer Louis Aragon paid literary homage to the arcades in his 1926 novel "Le Paysan de Paris" (The Paris Peasant). Walter Benjamin, who moved to Paris in 1927, continued the myth in his famous unfinished work "The Arcades Project." In it, he describes them as the "flâneur's lounge," in which there is a collective worship of the fetishism of consumer goods. By the time Benjamin's book appeared, all of this was already history. For the passages and galleries were superseded in the mid-19th century by the big department stores and many were subsequently demolished or fell into disrepair. It was only as the 19th century and its architecture was re-evaluated that the remaining passages were renovated, engendering the sense of past elegance they impart today.

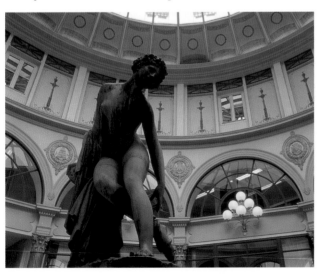

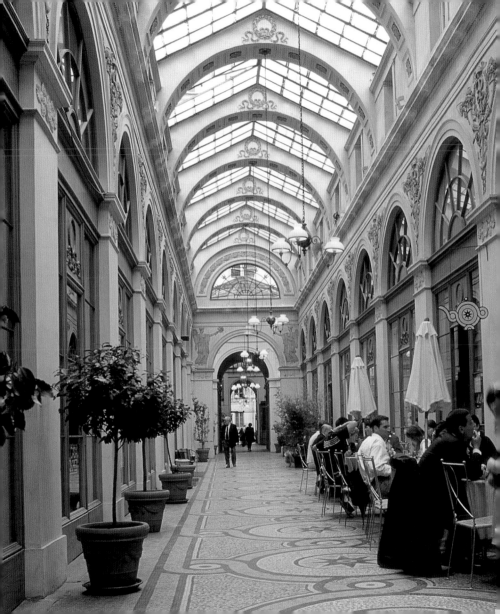

Paris arcades and covered passages

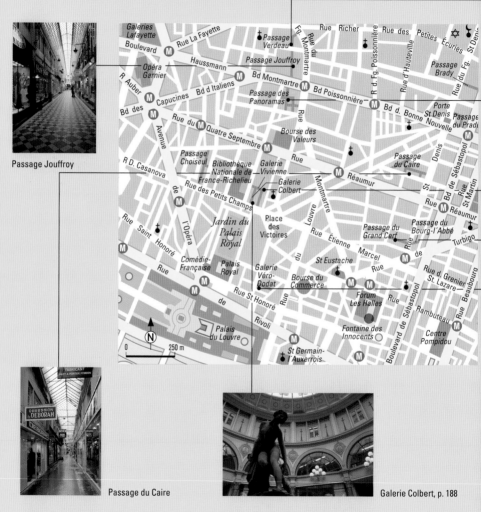

Passage Jouffroy

Passage du Caire

Galerie Colbert, p. 188

Passage Verdeau

Passage des Panoramas

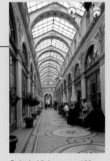

Galerie Vivienne, p. 188

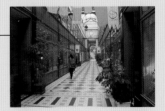

Passage du Grand-Cerf

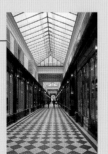

Galerie Véro-Dodat

Bibliothèque Nationale de France—Richelieu-Louvis site

Even though the books of the National Library were moved in 1996 to their new building directly on the Seine, it is still possible to view the collections of valuable manuscripts and codices, engravings, maps, and plans, as well as medals and coins, in the Rue de Richelieu site. The famous reading room (1868), one of the most elegant examples of the iron vaults of Henri Labrouste (1801–1875), is an impressive structure in terms of the height, width, and lightness of touch that characterize the 16 slender, fluted columns bearing the terra-cotta-clad domes. The semicircular windows match the painted lunettes that give the illusion of a view into a wooded landscape. Among those who worked under these trees, representing a counterbalancing image of nature in a world of the intellect, were Gustave Flaubert, James Joyce, and Walter Benjamin.

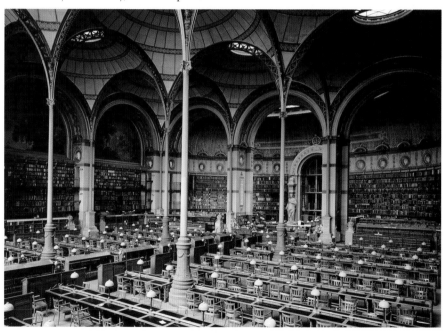

The Comédie Française—from court theater to national theater

by Nicole Colin

The Comédie Française, the oldest permanent ensemble in the western world, has been the heart of French theater for over 300 years. Early on, the stage was recognized in France as an excellent means of political influence and representation. In 1641 Louis XIII began to support the actors of the Hôtel de Bourgogne and, in the process, discovered the possibilities of subsidized theatre, which allowed the state both to offer artistic freedom and to set boundaries.

The true father of the Comédie Française is Molière, born into a bourgeois family as Jean-Bapiste Poquelin (1622–1673). After touring the provinces for 13 years, the actor, stage director, dramatist, and theater manager returned to Paris in 1658 in order to agitate the theater scene there with his satirical comedies. His first guest performance was a great success and his company was hired by Louis XIV. His plays have an almost avant-garde momentum, which is based first and

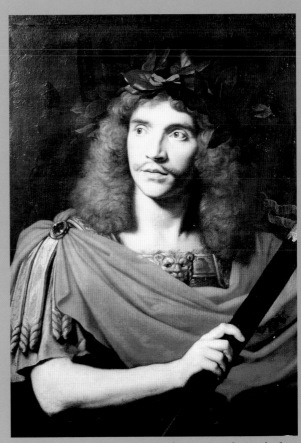

Pierre Mignard, Molière in the role of Caesar in "The Death of Pompeii," oil on canvas, collection of the Comédie Française, Paris

Edmond Geffroy, The Associates of the Comédie Française, 1840, oil on canvas, collection of the Comédie Française, Paris

foremost on his precise observation of real life. Convinced that passion could not be governed by reason, Molière departed from the aspect of Christian ideology that regards the darker side of human nature as a tragedy. Instead he provoked laughter through revealing human beings as they really are, with no illusions.

It may seem paradoxical that these socially critical comedies of manners enjoyed state support during the age of absolutism. On closer examination, however, it becomes clear that it is really a clever piece of chicanery: laughter seems like liberty to an audience that has no legal right to it. And, in spite of all the mockery, the work of Molière still constitutes the expression of a the-

atre of education and rules. Even if the exclusive audience often reacted angrily to the way he unmasked the excesses of the aristocracy in his plays, the king was only too happy to have fun at the expense of his court and join in the cheers of those in the standing area.

After the death of Molière, his company of actors joined those of the Théâtre du Marais and moved into the Théâtre Guénégaud. It was a time of healthy competition and a lively exchange of ideas, especially with the troupe of the Hôtel de Bourgogne. On August 18, 1680 the birth of the Comédie Française was announced by Louis XIV, who decreed that the two rival companies should merge to form the "Troupe unique du roi" (the

king's sole company). It was given its new name in 1689—Le Théâtre de la Comédie Française. Just like 300 years ago, the uniqueness of the Comédie Française is still based on its special modus operandi as an actors' cooperative: the real power lies in the hands of the 30 permanent members, the "sociétaires." They are employed on a permanent, profit-sharing basis in an appointment that carries exceptional distinction and status—almost like the conferment of a title. With over 800 performances and 240,000 spectators each season, the Comédie Française outperforms every other theatre in France. Though it describes its repertoire as consisting of "the whole of literature in existence," it is clear from internal statistics that its duty is first and foremost the cultivation of French drama. Other than Racine, Corneille and Marivaux, Molière is the outright winner—no season's program can be without his name. Between 1680 and 1980 there have been almost 30,000 performances of his comedies. "Tartuffe" has been staged in countless different ways over 3,000 times to date. Far less importance is attached to foreign plays, however, and it was not until the 1970s that authors like Brecht, Beckett, and Strindberg were added to the repertoire. In spite of artistically brilliant directors and first-rate actors, the Comédie Française has long since ceased to be the place to find innovative theatrical events. The production style remains overwhelmingly conservative, out of deference to the close affinity with their established audiences—the "citizen-spectators." As a symbol of bourgeois culture and a landmark between the avant-garde and popular theatre, the Comédie Française sees itself not just as one of the five national theaters, but as the Theater of the Nation par excellence.

Théâtre des Variétés, 19th century, Bibliothèque Nationale, Paris

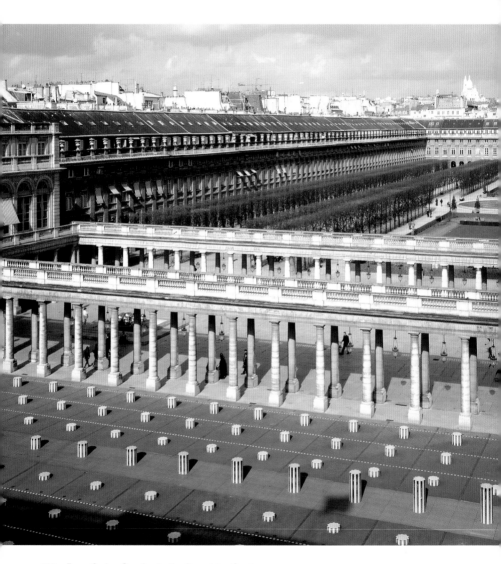

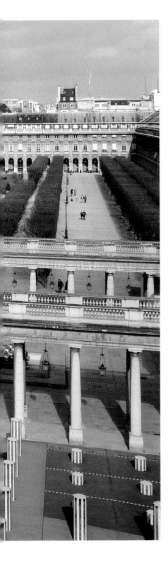

Palais Royal

Cardinal Richelieu (1585–1642), the powerful statesman, commissioned Jacques Lemercier (1585–1645) to build him a palace right next to the Louvre, which was completed between 1634 and 1639 and bequeathed by Richelieu to the Crown after his death. It was given the name Palais Royal after Anne of Austria moved in during her regency with the 15-year-old Dauphin, later Louis XIV, even though no other king subsequently resided there. The Sun King signed it over to his brother, the duc d'Orléans, as appanage (provision of maintenance for a king's younger child). Since then, the Palais Royal—which was completely rebuilt in the 18th century—has been inherited by the cadet branch of the Bourbon dynasty. The characteristic wings with arcades, built between 1780 and 1784 by Victor Louis, were supposed to be rented out to clear the enormous debts of the then owner, Louis-Philippe, duc d'Orléans. As the Palais Royal remained thereafter nominally under the private ownership of the dukes of Orléans, the police were not permitted to enter the complex, which developed into one of the most glitzy venues in Paris. Genteel and not quite so genteel folk met up in the cafes, theatres, restaurants, and brothels. In pre-revolutionary times, political clubs became established here to pursue their conspiracies and debates. It therefore comes as no surprise that, on the evening of July 13, 1789, the call came from Camille Desmoulins in the palace garden to storm the Bastille, and with this call, the beginning of the French Revolution. In what was once the cour d'honneur there is now a sculpture by Daniel Buren (1986) consisting of 260 column stumps, an ironic interpretation of the rhythm of the colonnades by Pierre Fontaine (1829). The garden is used as an exhibition space for contemporary sculpture, including works by George Segal and Magdalena Abakanowicz.

Place des Victoires

One of the most spectacular statues in Paris was sited in Place des Victoires, one of the royal squares, but like so many others it was melted down during the Revolution. This bronze of Louis XIV, which was lit up by flambeaus every night after 1686, stood over 13 ft. (4 m) high atop a 23-ft. (7-m) pedestal. An elaborate scheme of figures, reliefs, and inscriptions celebrated the king as the courageous victor over the Grand Alliance of Germany, Spain, and the Netherlands. The project for the square was financed, not by the king, but by a loyal courtier, the Marshal de la Feuillade,

resulting in financial ruin for him and the loss of his own home. The square was unceremoniously demolished by its architect Jules Hardouin-Mansart (1646–1708) to make way for a unified new development. The original closed horseshoe layout was completely changed by the encroachments of the 19th century and the architecture of its facade—rusticated arcades on ground level, two stories with a massive Ionic pilaster order, and Mansard roofs—can now only be discerned on a few houses. The equestrian statue is a new sculpture from 1822.

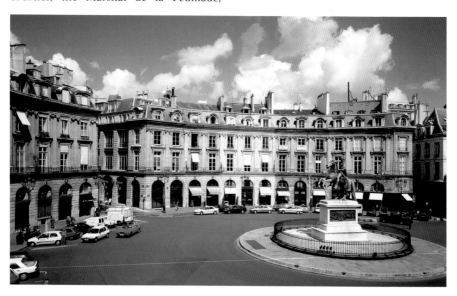

Bourse de Commerce

On the edge of the old marketplace is the round building of the Commodities Exchange, which was erected in 1887 by Paul Blondel on the site of the former Hôtel de Soissons, one of the town palaces of Catherine de Medici. An older building (the Halle au Blé, or Wheat Exchange, 1767) dating from the time of Louis XVI, was partially incorporated into it. The cast-iron and glass cupola also harks back to its predecessor, as in 1811 the central court-yard of the Wheat Exchange was covered by a spectacular iron dome with a 131-ft. (40-m) span. The column on the facade, a remnant of the Medici palace, was presumably used for astronomical observations.

Fontaine des Innocents

The little fountain temple on the square of the same name used to belong to the monastery of the "innocent children" and the adjoining cemetery. Originally the loggia had only three arcades, which served as a respite for the gentry during parades. It was built in 1549 by Pierre Lescot, one of the architects involved in the construction of the Louvre, and decorated by Jean Goujon with reliefs depicting water nymphs (the Naiads).

Following page:
Barthélemy d'Eyck, St-Chapelle and the Palais de la Cité as seen from the Seine, c. 1450. June illustration for "The Very Rich Hours of the Duc de Berry," illustrated manuscript on parchment, 29 x 21 cm, Musée Condé, Chantilly

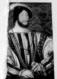

François I
(1515–1547)

Thousands of
Huguenots murdered in
St Bartholomew's Day
massacre (8/24/1572)

Henri IV
(1589–1610)

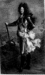

Louis XIII
(1610–1643)

Louis XIV
(1643–1715)

Storming of the Bastille
(7/14/1789) starts the French
Revolution

1500 1600 1700

Louvre, Pierre Lescot
wing (1548–1553)

Pont-Neuf
(1578–1604)

Place des Vosges
(inaugurated 1612)

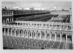

Palais Royal
(1634–1639)

Château de Versailles
(from 1662)

Panthéon
(1764–1790)

Leonardo da Vinci,
Mona Lisa
(1510–1515), Louvre

El Greco,
Christ on the
Cross
Adored by
Donors
(ca. 1585–
1590),
Louvre

Michelangelo Merisi
da Caravaggio, The
Fortune Teller (ca.
1594/1595), Louvre

Nicolas Poussin,
Shepherds in Arcadia
(ca. 1638–1640), Louvre

Jean-Antoine Watteau,
Pierrot, known as Gilles
(ca. 1718/1719), Louvre

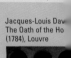

Jacques-Louis David,
The Oath of the Ho...
(1784), Louvre

Michelangelo,
Dying Slave,
for the tomb
of Julius II
(1513/1514),
Louvre

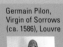

Germain Pilon,
Virgin of Sorrows
(ca. 1586), Louvre

Facade decoration on
the corps de logis of
Hôtel de Sully (1626)

Gianlorenzo Bernini,
Cardinal Richelieu
(1640), Louvre

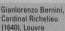

Baroque sculptures in
the Cour Marly of the
Louvre

Napoleon colum...
Place Vendôme (...

School of Fontainebleau
influenced by Italian
Mannerists: Diana the
Huntress (ca. 1550–1560),
Louvre

Cardinal Richelieu founds
the Académie Française
(1635)

Edict of Nantes brings Wars
of Religion in France to an
end (1598)

Voltaire (1694–1778),
Enlightenment
philosopher and poet

First volume of Diderot's
Encyclopédie (1751) publis...

History

Inhabitants of Lutetia surrender their settlement as Roman troops advance in 52 BC. Lutetia is a Roman colony for 300 years

 Louis IX, Saint Louis, (1226–1270) builds Sainte-Chapelle as a palace and reliquary chapel

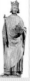 Charles V (1364–1380)

Hundred Year[s] between Fran[ce] England (133[7]

Merovingian king Clovis defeats the army of the last Roman governor in France and moves his royal seat to Paris in 508

Philippe Auguste II (1180–1223) builds the medieval Louvre as part of the town fortifications

0 1000 1300

Architecture

 Notre Dame (foundation stone laid 1163)

Donjon (fortified towe[r] Château de Vincennes

Gallo-Roman baths of Lutetia in Musée de Cluny (1st–3rd c.)

Sainte-Chapelle (1245–1248)

 Tour St-Jacques (1508–1522)

Painting

Rose window from Notre Dame, north facade (ca. 1250)

 The Lady and the Unicorn tapestry (ca. 1485–1500), Musée de Cluny

Window detail from Sainte-Chapelle (ca. 1200), Musée de Cluny

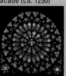

Jan van Eyck, The Madonna of Chancellor Rolin (ca. 1434), Louvre

Sculpture

Nautes Pillar (14–37 AD), Musée de Cluny

 Charles V, by unknown sculptor (ca. 1375), Louvre

Adam from Notre Dame (ca. 1260), Musée de Cluny

 Tomb of Philippe Pot (last quarter of 15th c.) Louvre

Culture

Lutetia Parisiorum settlement mentioned in Caesar's "De bello gallico" (Renaissance manuscript)

Theology schools merge into a university in 13th c.

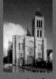 François Villon (1431–after 1463), vagrant and poet who incorporates vernacular and slang in his poetry

St-Denis (reconstruction after 1137), burial place of French kings from 639 through 1824

 Joan of Arc (1412–1431), painting by J. A. D. Ingres (1854), Louvre

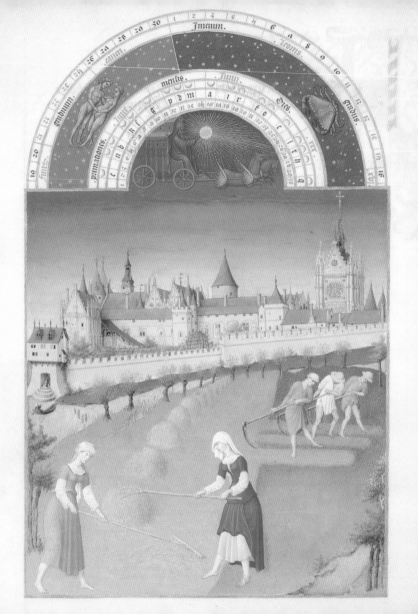

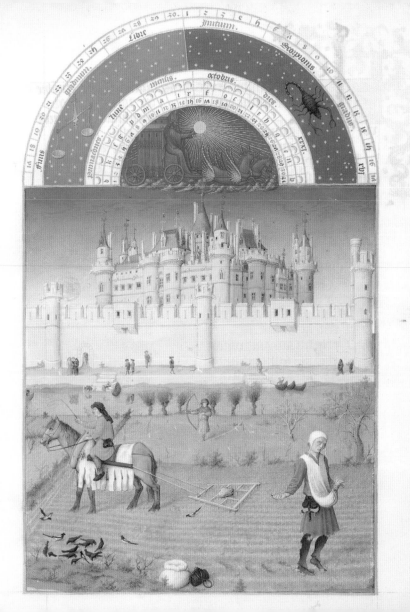

Treaty of Versailles (6/28/1919) seals end of World War I

Liberation of Paris, August 1944

François Mitterrand, President of France, 1981–1995

History

1900　　　　　　　**1950**　　　　　　　**2000**

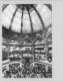

Interior of Galeries Lafayette (1904–1906)

Sacré-Coeur (consecrated 1919)

Palais de Chaillot (1937)

Maison UNESCO (1958)

Pompidou Center (1977)

Bibliothèque Nationale de France (new building), F. Mitterrand site (1995)

Architecture

Pablo Picasso, Self Portrait with Cloak (1901), Musée Picasso

Claude Monet, Water Lilies (1916–1919), Musée Marmottan

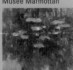

Painting

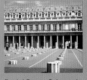

Niki de Saint-Phalle and Jean Tinguely, Fontaine Stravinsky (1982/83)

Daniel Buren, Columns in the cour d'honneur of the Palais Royal (1986)

Sculpture

Art Nouveau: Alfons Mucha, Fouquet's jewelry shop (1900), Hôtel Carnavalet

French existential philosophers make Existentialism an international cultural movement

André Malraux, writer and French minister of culture (1959–1969)

Christo and Jeanne-Claude, The Pont-Neuf Wrapped (1985)

Edith Piaf (1915–1963)

Culture

Napoleon I takes power in coup d'état in 1799 and is crowned Emperor of France in 1804

Napoleon III (1852–1870)

1871 Paris Commune defeated, painting by Maximilien Luce, Musée d'Orsay

Dreyfus Affair—wrongful conviction of French Jewish officer results in serious crisis in domestic politics of Third Republic (1894)

1800

Rue de Rivoli (1801–1855)

Arc de Triomphe de l'Étoile (1806–1836)

Gare du Nord (1861–1865)

Reading room of Bibliothèque Nationale de France—Richelieu-Louvois site (1868)

Opéra Garnier (1860–1875)

Eiffel Tower (1889)

Théodore Chassériau, Esther Preparing Herself to Meet King Assuerus (1841), Louvre

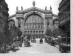

Gustave Courbet, Burial at Ornans (1849/1859), Musée d'Orsay

Edouard Manet, Le Déjeuner sur l'herbe (1863), Musée d'Orsay

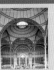

Auguste Renoir, Dance at Le Moulin de la Galette (1876), Musée d'Orsay

Vincent van Gogh, Bedroom in Arles (1889), Musée d'Orsay

Chinese Thousand Flowers vase (18th c.) Musée Guimet

Sculpture gallery in the great hall of the Musée d'Orsay (works ca. 1850)

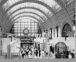

Jean-Baptiste Carpeaux, Ugolino and his Sons (1862), Musée d'Orsay

Auguste Rodin, The Age of Bronze (1875/76), Musée Rodin

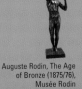

Edgar Degas, Little Dancer Aged Fourteen (1880/81), Musée d'Orsay

Jardin des Plantes (known as Jardin Royal before the Revolution) becomes leading research center in 18th c.

Transformation of Paris (1853–1870): under Napoleon III, Baron Haussmann modernized the city without regard for existing structures

Numerous arcades still define the Paris cityscape today

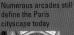

Death of Victor Hugo (1885)

First Métro line runs for the World Exhibition (1900)

St-Eustache

Built over a century, from 1532 through 1640, the parish church in the district of Les Halles was designed by an unknown architect on the cusp between the Gothic and Renaissance periods. The five-nave layout is clearly modeled on Notre Dame, while the dimensions of St-Eustache bear comparison with those in the cathedral. The three-part division of the south elevation into radiating chapels, side aisles, and central nave are similar to the famous Gothic model, as are the flying buttresses and the facade with a rose window. The west facade was put in place in the 18th century.

Interior

The new Renaissance style was most clearly articulated in the decorative work of the interior. Thus the piers of the central nave have Ionic pillars, fluted Ionic pillars, and rounded Corinthian columns layered one upon another. The elaborate composite capitals of the crossing piers and the decorative reticulated vaulting are also salient features. The expensive interior decorative work, which was badly damaged during the Revolution, was facilitated by donations from prosperous merchants and guilds, as well as the aristocracy. One example is the tomb of Jean-Baptiste Colbert (1619–1683) by Antoine Coysevox. One of the north chapels has a triptych by Keith Haring (1958–1990) in one of his characteristic designs. The colored sculptural group by Raymond Mason depicts the merchants' departure from the district before the old market hall, Les Halles, was demolished (1971).

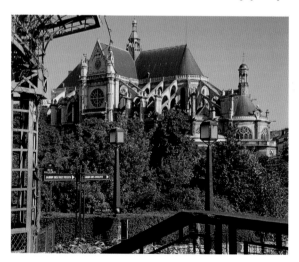

Previous page:
Barthélemy d'Eyck, The Louvre as seen from the Seine, c. 1450. October illustration for "The Very Rich Hours of the Duc de Berry," illustrated manuscript on parchment, 29 x 21 cm, Musée Condé, Chantilly

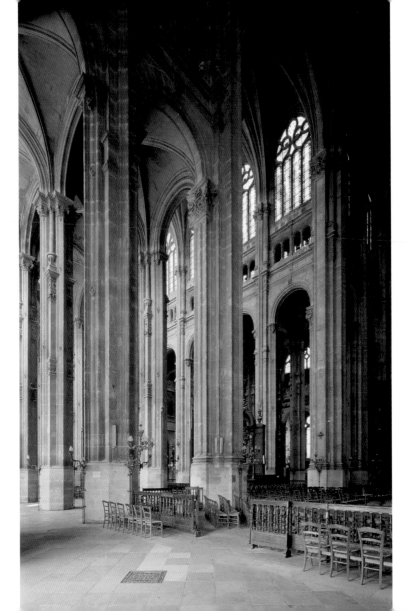

Forum des Halles

The Forum des Halles is situated at the end of a large, landscaped square with a rather empty feel to it—a constant reminder of the scar left behind when the old market halls of Victor Baltard (1805–1874) were torn down in the 1970s. After lengthy discussions about the redevelopment of one of the prime city center sites, Jacques Chirac, in his capacity as the newly elected mayor, championed a design by the architects George Pencréach and Claude Vasconi that was subsequently completed in 1979. With its arched, steel ribs, some of which open out organically, the Forum is meant to recall the iron "umbrellas" of the old market hall, but its architecture is not really convincing in that regard. A multi-level shopping mall has been built underground.

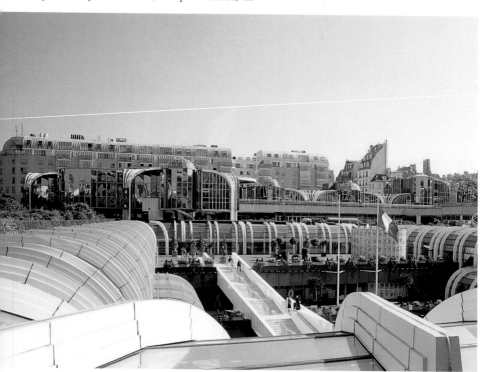

Les Halles—the Belly of Paris

by Martina Padberg

When Louis-Philippe took a close personal interest in the redevelopment of the central market in Paris in the mid-19th century, he gave the commission to the architect Victor Baltard, who designed a massive stone building in the Classical style in keeping with contemporary tastes. Napoleon III, who laid the foundation stone for this building on September 15, 1852, soon became disenchanted with its conventional style and called a halt to the building works. The forward-looking emperor summoned the newly appointed prefect, Haussmann, and explained to him that he had in mind a glass and iron construction: "All we need is opened umbrellas." Baltard then developed glass pavilions with iron pillars and roof structures, which were some of the most progressive feats of engineering of his day. Louver-style lattices optimized the ventilation, while elevated central aisles provided better lighting. The two cruciform groups of buildings were connected by covered walkways so that the pavilions could be reached comfortably in bad weather. The emperor was simultaneously delighted and astonished that this trendsetting design came from the same architect who had perpetrated the horrendous "Fort de la Halle." Haussmann's self-assured riposte was: "Maybe the same architect, but not the same prefect." The halls soon became operational and until 1969 supplied the city with staple foodstuffs and every imaginable delicacy. In his novel "The Belly of Paris" (1874) Émile Zola created a monument to this rich trading place with its unique social community. The demolishing of Les Halles in 1969 must rank among the most unfortunate urban planning decisions of the 20th century.

Felix Benoist, Les Halles, coloured lithograph, ca. 1870–1880

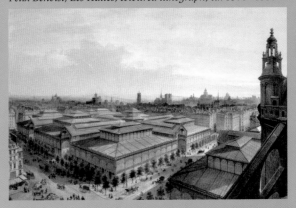

The Pompidou Center

A cultural center that invites dialogue with art and other people, where art is not kept in a museum, but is represented in all its disciplines as a living part of society embodying openness and flexibility—this might describe the aims associated with the center founded by Georges Pompidou (1911–1974) and opened in 1977. This concept of a fundamentally democratic culture for all, indicative of the early 70s, was given physical form in the design by the architects Renzo Piano and Richard Rogers. Disclosing the service functions in the brightly colored pipes turned to the outside, with glass versions transporting visitors on exterior escalators to the upper floors, was just as much a part of the overall concept as the flexible-looking, modular system from which the building seems to be comprised.

The Pompidou Center, which seems rejuvenated and as up-to-date as ever after its restoration (1997–2000), has from the outset tried to make connections with the city it overlooks from its terrace—a stunning view. In fact, visitor numbers have already exceeded all expectations for some years now, while the piazza leading down to the main entrance has developed into one of the liveliest squares in the city center. Ambitious temporary exhibitions of 20th-century art, which complement and enhance the coverage of the in-house collections, also make a significant contribution to the success of the Center. An additional point of interest is its comprehensive library, which is also open to visitors.

The reconstructed workshop of Constantin Brancusi (1876–1957) is attached to the museum and has been open to visitors since 1997. A Rumanian by birth, he lived in Paris from 1904 and belonged briefly to the workshop of Auguste Rodin. All through his life, Brancusi grappled with the principle of simplifying sculptural forms. He found inspiration in working with Rumanian folk art and African sculpture. His work process led to the development of a completely abstract formal style that concentrated on the absolute essentials. As well as sculpturing tools, casts for all his important sculptures can be found in his workshop, which he set up in 1916 in a small cul-de-sac in the 15th arrondissement and extended several times over the following decades. A glimpse into this milieu that has been authentically reconstructed with the help of photographs gives the opportunity to become acquainted with the richness of forms and the use of different materials in the work of Brancusi. Another immediate neighbor of the Pompidou Center is the Institute for Research and Coordination of Acoustics and Music, or IRCAM, which has made a significant contribution to the development of contemporary music. Founded in 1969, it too was an initiative of Georges Pompidou, with its first director, the famous composer and conductor Pierre Boulez, prioritizing productive dialogue between science and art. The aim was to expand the range of instrumentation and forms of expression used in contempo-

rary music. Before long, IRCAM was presenting pioneering ways of experimenting with computers and digital music production. In recent years the Institute has organized a range of festivals, thus opening it out to a wider audience.

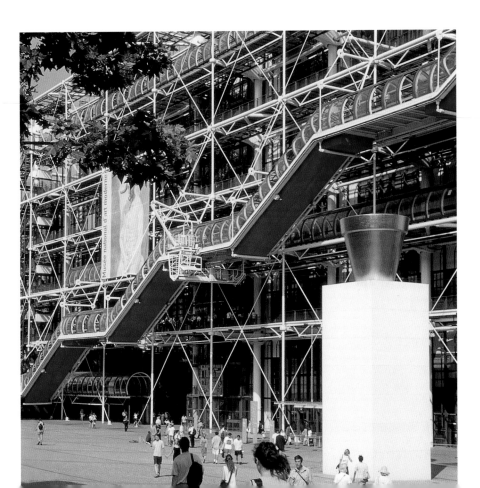

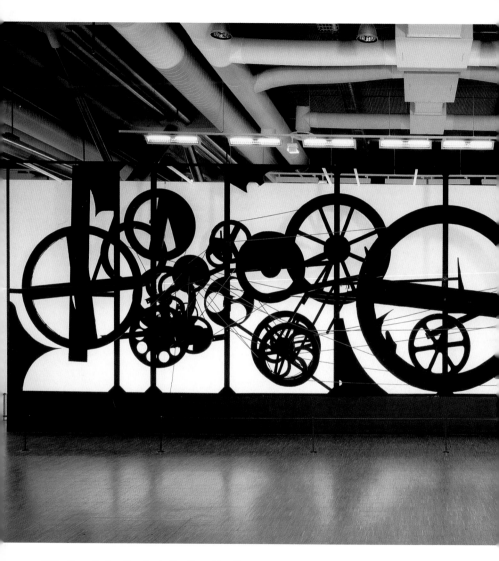

Musée National d'Art Moderne in the Pompidou Center

Jean Tinguely (1925–1991),
Requiem pour une feuille morte
(Requiem for a Dead Leaf), 1967
Iron and Motorized Parts,
1150 x 305 cm

The museum, substantially expanded following the renovation, is located on the fourth and fifth floors and has one of the most significant collections in the world in terms of modern and contemporary art. The center was given direct endowments from the families of, among others, Matisse, Chagall, and Picasso. The huge kinetic sculpture by Tinguely greets the visitor: the Swiss artist, who lived mostly in France from the 1950s on and had a considerable influence on the artistic scene of "Nouveau Réalisme" (New Realism), put it together out of "objets trouvés" (lost-and-found). The perpetual motion of this machine without function has a gently melancholic effect, which is underlined with restrained irony by the title of the work.

Henri Matisse (1869–1954), Luxury I, 1907
Oil on canvas, 210 x 138 cm

Henri Matisse, who dominated the art scene in Paris with Picasso before World War I, is represented in the Pompidou Center by a selection of outstanding works from every period of his artistic life. "Luxury I" was created after the artist had rejected Fauvism, an artistic movement launched three years earlier by Matisse along with André Derain, Maurice Vlaminck and others, and which was primarily defined by a new intensity in its use of color. As Derain later recalled, "colors became our dynamite." In the few years of its existence Fauvism did, in fact, develop an explosive power that produced a long-term ripple effect on European art. To begin with, Fauve painting came under harsh attack by art critics, but soon it began to arouse considerable interest among the leading gallery owners in Paris. Unlike the Impressionists, the Fauve painters were able to pursue their artistic careers as specific commissions guaranteed them a living. At the height of this early success, however, Matisse sought new directions for his painting. In this respect, "Luxury I" is a key work. The painting portrays a modern Venus, who appears to have just stepped out of the water with two companions worshipping her. The lake and its strip of shore, the mountains in the background and the sky—all are merely hinted at with thin, smeared brushstrokes in delicate, pastel shades. The sketchy style and concentration on a few dominant colors in individual areas of the picture are characteristic of this new phase of his work, which found Matisse occupying himself with the possibilities of simplified, monumental compositions. This process was stimulated by his engagement with the work of Puvis de Chavannes (1824–1898); the structural composition of solid, clearly defined areas of color was particularly reminiscent of the great 19th-century muralist. In terms of subject matter, Matisse tapped into earlier paintings in which he had also created idyllic, open-air bathing scenes. His more recent, heavily built figures and almost primitive use of color were seen by his contemporaries, however, as artistic provocation—one critic referred to his Venus as a "yellow giantess." A few years later his large-format painting "Dance" (1909–1910, The Hermitage, St. Petersburg) created the prototype for modernist painting. The monumentalism of "Luxury I" was now combined with a sweeping, dynamic composition in which the color palette is restricted to just three contrasting colors. Matisse had taken a new and groundbreaking step forward. Even in the works he produced as an old man, Matisse managed to sustain the strength constantly to reinvent his own work.

Wassily Kandinsky (1866–1944), Painting with the Red Spot, 1914,
Oil on canvas, 130 x 130 cm

radically altered by social upheavals, scientific discoveries—such as quantum and relativity theories—and psychoanalysis.

Wassily Kandinsky is regarded as the founder of abstract art. His "Painting with the Red Spot" comes at the end of what was a sporadic development from figurative to abstract painting for him; the Russian artist underwent this transition in Munich between 1910 and 1914, as part of the "Blue Rider" group of artists. Using landscape motifs as starting points, form and color build a momentum of their own, matching or contrasting, mixing or separating. This opened up the possibility of new dimensions for perception and expression in art. In an analogy with music, it was felt that painting could only develop intuitively and be experienced as a clash of colors. Yet Kandinsky saw the reality of the present day essentially reflected in his paintings. Any naturalistic form of representation was called into question by the image of the world and it inhabitants in the 20th century; a world that had been

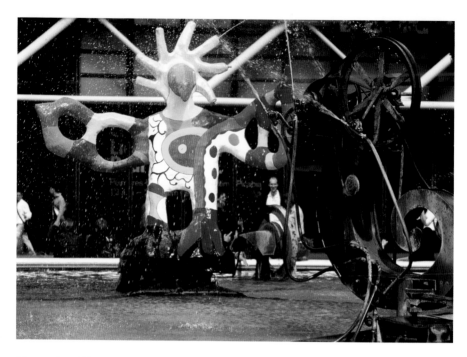

Fontaine Stravinsky

The large fountain designed by the artistic couple Jean Tinguely and Niki de Saint-Phalle (1930–2002) was installed in front of the Late Gothic St. Merri church and in the immediate vicinity of the Pompidou Center. The brightly colored figures and the black kinetic machines move continuously, turning round on themselves and spraying water into the air. The composition of dancing sculptures is dedicated to the Russian composer Igor Stravinsky (1882–1971), who lived on and off in Paris after 1910 and wrote several important ballets for the Paris Opéra, including "Petrushka" (1911) and "The Rite of Spring" (1913).

Following a musical rhythm, the movements of the individual sculptures blend into a harmonious synthesis of choreographed images.

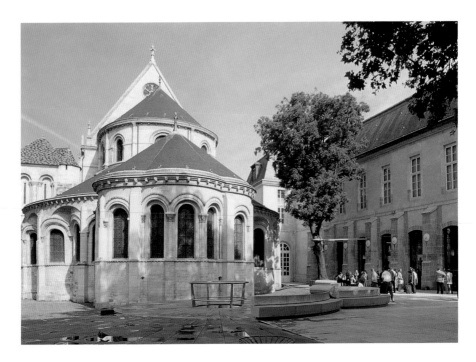

St-Martin-des-Champs

Back in 1060, Henri I built a basilica in fields on the outskirts of the city, which he dedicated to St. Martin; ownership was later transferred to Cluny Abbey. All that remains today of the imposing priory is a section of the wall with a fortified tower, a heavily restored round tower, the new part of the church dating from the 12th and 13th centuries, and the refectory. The new church building, which was begun under Prior Hugo I (1130–1142), is a product of the transition between Romanesque and Gothic. The refectory, which is now used as a reading room, was completed around 1235 and is a rare example of medieval monastic architecture in Paris. Both buildings were given over to secular use in 1794 as part of the newly founded Conservatoire des Arts et Métiers. Linked to the technical college, it developed into the Musée des Arts et Métiers, which was re-opened in the spring of 2000 following renovation works.

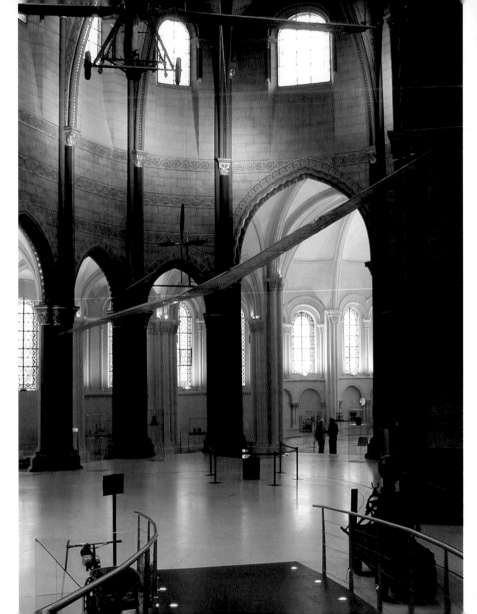

Musée des Arts et Métiers in St-Martin-des-Champs

The museum provides a vivid and explanatory exhibition of the most important technical developments in the period 1750 to 1950. The tour also leads through the beautiful church interior where, among other things, old cars and flying machines are on display. Looking at the medieval architecture is just as exciting, as it is easy to see the transitional period of the 12th century through the juxtaposition of Romanesque and Gothic architectural elements: a Romanesque groin vault meets an early Gothic rib vault in the choir loft; pointed arch arcades sit next to round arched windows; and column heights and the form of capitals and shafts reveal many inconsistencies. Yet the overall impression of the interior is magnificent, perhaps precisely because of the many fractures in the architectural style. Finally, the museum exhibits are supplemented by another important object that looks completely out of place, and revolutionizes how the space is articulated and interpreted.

Various instruments manufactured for the experiments of Blaise Pascal, 17th century

Blaise Pascal (1623–1662) was one of the last great inventors and scientists to be equally preoccupied with theological and philosophical questions. Even as a child, he showed enormous analytical ability and outstanding mathematical skills, which he applied again and again in solving practical problems. At the age of 19 he developed the first mechanical calculator in the world to ease the workload of his father, who was employed as a royal commissioner and tax collector in Normandy. One of the last remaining nine copies of this innovation is in the Musée des Arts et Métiers (Museum of Arts and Trades) along with the instruments used by Pascal in his famous experiments (1647) to prove the existence of the vacuum and calculate height-dependent atmospheric pressure. This is why the physical unit of pressure still bears his name today.

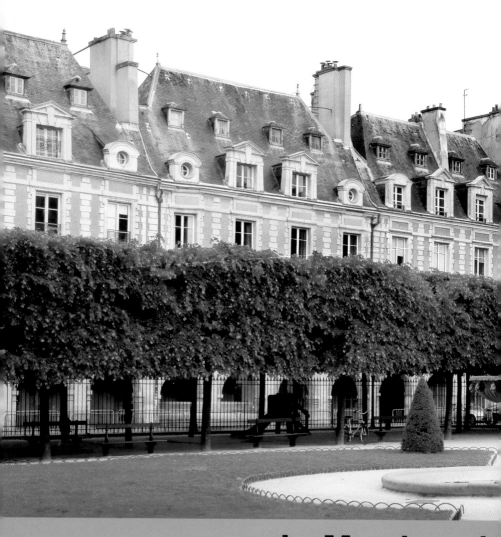

Le Marais and

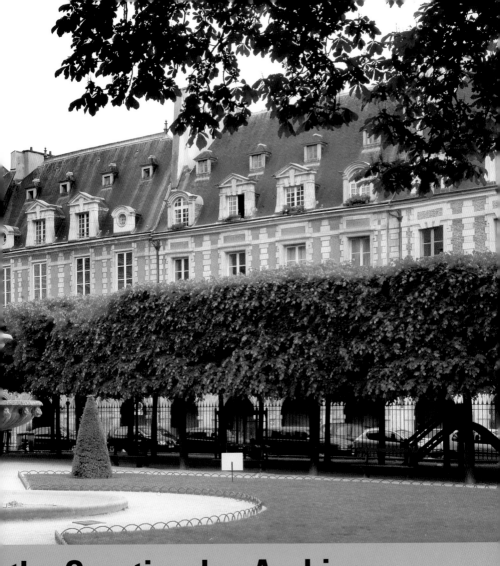

the Quartier des Archives

Le Marais and the Quartier des Archives

Old palaces of the aristocracy, galleries of contemporary art, museums with either top-class or whimsical collections, a lively Jewish community, the strident gay scene, long-established craft shops, and extremely expensive luxury apartments—Le Marais is packed with all sorts of contradictions, making it one of the most interesting quarters of Paris. The former "marais" (swamp) was drained in the 12th century and settled by monks. The secretive and wealthy order, the Knights Templar, which had been founded to protect pilgrims to Jerusalem and was under direct authority of the Pope, built its own fortification here—the inhabitants, numbering as many as 4,000, were subject only to the laws of their order and lived free from tax liability and guild rules. Philippe IV disbanded the powerful secret order in 1305 on grounds of heresy

John-Claude Nattes (ca. 1765–1822), View of the Tour du Temple and the Rotonde du Temple, 1805, aquatint, 30 x 40 cm, Châteaux of Versailles and the Trianon, Versailles

Park in the Square du Temple

and arrested the Grand Master, Jacques de Molay. Many of the Templars were burnt at the stake. The Templar district continued into the 19th century, however, and after the revolution the king's family was held prisoner here for a few months.

The golden age for Le Marais began in the 17th century, with the construction of numerous elegant townhouses for the aristocracy. The most important of these, some of which are open to visitors, bring to life the cultural, social, and intellectual world of the privileged classes during the Grand Siècle. The starting point for a tour could be the Place des Vosges, whose construction marks the beginning of this epoch and merits attention for being a complete synthesis of the arts. In the 18th century, genteel society moved to Île St-Louis, Faubourg-St-Honoré, or St-Germain. Small-scale manufacturers then set up in business in Le Marais. The Jews who lived there, many of whom had migrated from the east, built several synagogues in the area around Rue des Rosiers and Rue Pavée, forming a community that is still active and important today. The old buildings, on the other hand, fell increasingly into disrepair. Under André Malraux, who was Minister for Cultural Affairs from 1959 until 1969, a campaign began to save the dilapidated quarter, with much of it being renovated and preserved. The facades, which originally were black (and partly responsible for the gloomy

Street view in Le Marais

impression created by the area), have long since been a pleasure to look at. Yet critics of the current development work fear that the loss of affordable housing and commercial space will lead to an exodus, turning Le Marais into a museum piece. So far, however, a vibrant art scene is preventing any long-term dust from gathering.

Preceding spread:
Place des Vosges in Le Marais

Le Marais and the Quartier des Archives

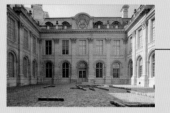

Hôtel de St-Aignan/Musée d'Art et d'Histoire du Judaïsme, Rue du Temple, p. 244 f.

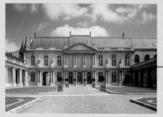

Hôtel de Soubise, 60, Rue des Francs-Bourgeois, p. 228 f.

Place des Vosges, p. 250 f.

Also worth seeing

1 Hôtels in Le Marais, p. 230 ff.

2 Hôtel de Sully, 62, Rue St-Antoine, p. 252 f.

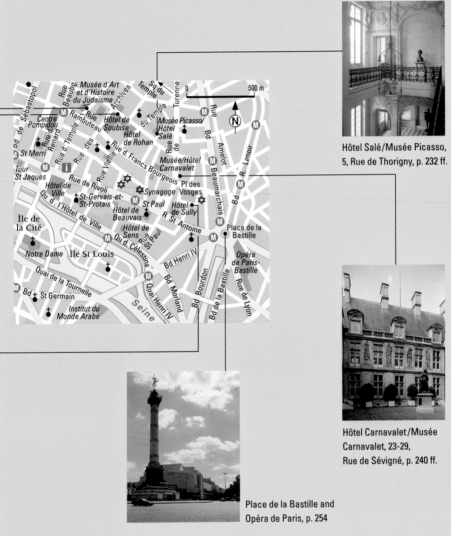

Hôtel Salé/Musée Picasso,
5, Rue de Thorigny, p. 232 ff.

Hôtel Carnavalet/Musée
Carnavalet, 23-29,
Rue de Sévigné, p. 240 ff.

Place de la Bastille and
Opéra de Paris, p. 254

Hôtel de Soubise

This private residence, which was built between 1705 and 1709 by the architect Pierre-Alexis Delamair, marks the chronological and stylistic peak of "hôtel" building in Paris. The patron of this grand town palace was François de Rohan, the Prince de Soubise, who acquired the land with royal funds. Louis XIV granted him a generous endowment for a rather particular reason, for Rohan's wife had actually been one of the king's many mistresses for a brief period. Delamair took his design in a new direction. The previous building on the site, the Gothic Hôtel de Clisson dating back to the 14th century, was demolished apart from a turreted portal and replaced by a completely different style of building whose nine-bay facade features an ornamental central projection with columns on two levels and a pediment. The spacious inner courtyard that provided coach access is lined on each side by an imposing colonnade and closed off to the street by a recessed portal in the external wall. The exterior of the building does not flaunt an appearance of wealth and splendor, unlike the interior, which ensures maximum privacy in an intimate atmosphere.

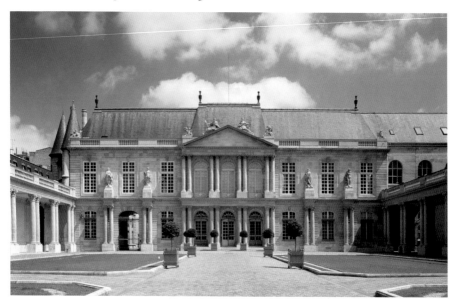

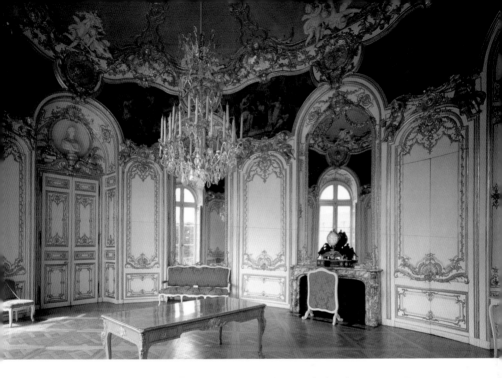

The bedchamber of the Princess de Soubise

The Hôtel de Soubise now houses the National Archives, but it is also possible to view some of the preserved suites with their magnificent rocaille decoration. In 1735, the then owner commissioned Germain Boffrand (1667–1754) to refurbish the interior. Hercule Mariadec de Soubise, who at the age of 60 had just entered into a second marriage with a beautiful, 19-year-old girl, attached special importance to fitting out the rooms on the second floor in a grandiose style for the young princess. Her bedchamber became a complete work of art, with its white paneled walls that seem overgrown with delicate golden ornamentation. The corner medallions on each side of the bed were decorated with heroic scenes from mythology by François Boucher (1703–1770), one of the most successful Rococo artists. He was also responsible for the painting "The Three Graces bringing up Cupid" above one of the doors.

Hôtels in Le Marais

The numerous town houses and palaces in Le Marais are the expression of the lifestyle of the French aristocracy at the turn of the 17th and 18th centuries. The gigantomania of Versailles, where the royal court of around 20,000 people settled on a permanent basis in 1682, resulted in the aristocracy retreating to private town palaces; they had had enough of the formal pomp and ceremony of the court, the endless political intrigues, and last but not least the huge expense involved in keeping up with the appropriate lifestyle at the court of the Sun King. The type of dwelling known as the "hôtel" was developed—a "house between a courtyard and a garden" that combined both showy formality and comfort. A cour d'honneur, which was usually closed off to the street, led up to a rather modest, Classical facade. Usually based on a U-shaped ground plan, suites for a range of purposes could be accommodated separately in the galleries of the hôtel. In place of the decorative forms borrowed from antiquity, more natural leaves and twine were used for the often richly ornamental, Rococo-style stuccowork in the intimate living rooms.

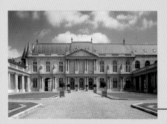

Hôtel de Soubise, p. 228 f.

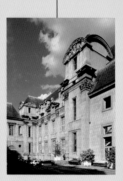

Hôtel Lamoignon

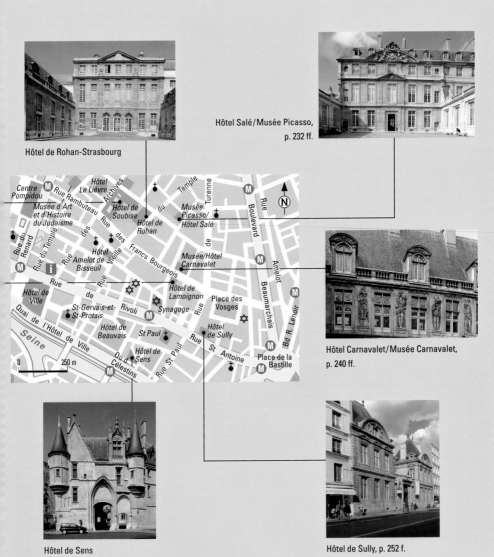

Hôtel de Rohan-Strasbourg

Hôtel Salé/Musée Picasso, p. 232 ff.

Hôtel Carnavalet/Musée Carnavalet, p. 240 ff.

Hôtel de Sens

Hôtel de Sully, p. 252 f.

Map labels:
Centre Pompidou
Rue Rambuteau
Hôtel Le Lièvre
Rue des Archives
Temple
Turenne
Musée d'Art et d'Histoire du Judaïsme
Hôtel de Soubise
Rue du
Musée Picasso/Hôtel Salé
Rue Boulevard
N
Rue du Renard
Rue du Temple
Rue des
Rue Vieille
Rue des Francs Bourgeois
Hôtel de Rohan
de
Musée/Hôtel Carnavalet
Amelot
Hôtel Amelot de Bisseuil
Rue
de
Hôtel de Lamoignon
Synagogue
Place des Vosges
Beaumarchais
Bd R. Lenoir
Hôtel de Ville
St-Gervais-et-St-Protais
Rivoli
Quai de l'Hôtel de Ville
Seine
Hôtel de Beauvais
St Paul
Rue St Paul
Hôtel de Sens
Qu. des Célestins
Rue St Paul
Hôtel de Sully
Rue St Antoine
Place de la Bastille
0 250 m

Musée Picasso in the Hôtel Salé

The Hôtel Salé is one of the most beautifully preserved town palaces in Le Marais. It was built between 1656 and 1661 for Pierre-Aubert de Fontenay, the collector of the salt tax, thus giving it its nickname, which means "salt palace." The architect Jean Bouiller de Bourges designed a lavish ensemble for the patron and his wife, Marie Chastelain, which comprised a cour d'honneur, a main building with monumental facade, and adjoining service buildings. The staircase is especially impressive, with ornate sculptural work by Martin Desjardins. Medallions with busts of famous ruling couples from antiquity can be seen above the Corinthian pilasters, an indication that the patron did not have a particularly modest opinion of himself. The tondi are framed by Atlas figures, whose gestures suggest the style of Michelangelo has been adopted. The ceiling has elaborate stucco-work in the shape of garlands, volutes, putti, and masks. The place is covered with the intertwined monograms of the first owner and his wife. The Venetian ambassador took up residence in these massive premises in 1671; they changed hands many times thereafter. The palace was expropriated during the Revolution and then, in 1815, it became an educational establishment for young boys. Honoré de Balzac (1799–1850) spent his final school year here, committing his memories to paper in the novel "Les Petits Bourgeois." In 1962 the city bought the palace, which had become very run down in the meantime, and turned it into the Musée Picasso after extensive renovation work (1976–1979).

The collection

Picasso's last wife, Jacqueline, died in 1986, 13 years after her husband. Her heirs signed over around 250 paintings, 160 sculptures, countless documents and sketch books, and individual reliefs and ceramics to the French state as a way of covering their inheritance tax. An endowment was also made of Picasso's private collection, including works by Braque, Cézanne, Matisse, and others, as the artist had made provision for their public display. This collection can be seen in sep-

arate rooms on the second and third floors of the museum. Supplementary purchases mean that the Musée Picasso now offers a comprehensive overview of how the oeuvre of one of the greatest artists of the 20th century developed. Following a chronologically structured tour, the visitor discovers a body of work that is marked by great creative energy and constant evolution, even in the late period of Picasso. The Baroque Hôtel Salé is entirely compatible with modernist art, not least thanks to the interior architecture of Roland Simounet, whose ramps, ter-

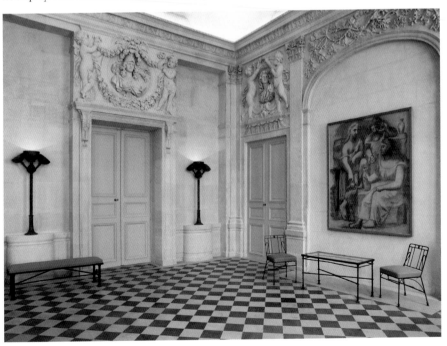

races, and fragmented rooms seem like an architectural application of Cubism. The purist furnishings by Diego Giacometti, especially the fragile chandeliers, are playful but restrained references to Picasso's own sculptural language.

Pablo Picasso (1881–1973), Self-portrait, 1901
Oil on canvas, 81 x 60 cm

The early self-portrait, showing the artist at just 20 years of age, was produced during his second stay in Paris and is a masterpiece of the "Blue Period" (1901–1904). The mono-

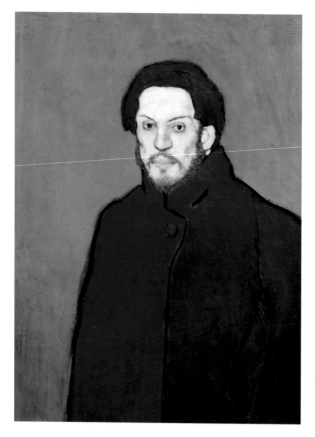

chrome background and the monolithic block of the high-buttoned cloak combine to give Picasso's face a particularly intense impact. He depicts himself as serious, cadaverous, and totally focused on himself. In fact during his early years in Paris, Picasso lived on the poverty line, in common with most of his fellow artists. Yet his resolute stare already conveys the self-confidence he had in his ability to carve out a suitable place for himself in the artistic capital of Europe. As Picasso became acquainted with collectors like Gertrude Stein and gallery owners like Ambroise Vollard and Daniel-Henry Kahnweiler in particular, his slow but inexorable rise began in 1905 until he became the leading painter of the avant-garde.

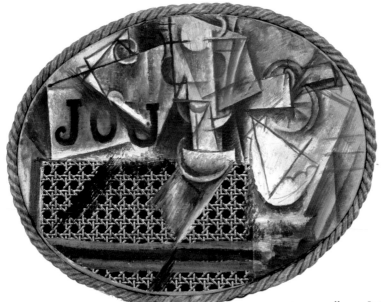

**Pablo Picasso, Still Life with
Chair-Caning, 1912**
Oil and oilcloth on canvas, rope,
29 x 37 cm

Inspired by the work of Paul Cézanne and through contact with African and Oceanic art, examples of which could be seen in the Ethnographic Museum in Trocadero, Picasso began to experiment in 1907 with creating the geometric forms that resulted in Cubism. The object of the image became increasingly fragmented during this process, until it was often only indicated in the title of the work. This small-format work is evidence of Picasso's next great discovery, which was to have an enormous impact on the future development of art in the 20th century—collage. Instead of an imitative painting process, the artist put the object itself into the picture as a fragment of reality. In this case, an oilcloth with the imprint of a chair's basketwork was stuck onto the canvas, replacing the representation of the chair by the artist—ironically Picasso uses an imitation for this, rather than the actual material. The reflection on image and copy, on reality and reproduction of reality, reaches a new dimension with the principle of collage, exploding the boundaries of panel painting and finally dissolving them.

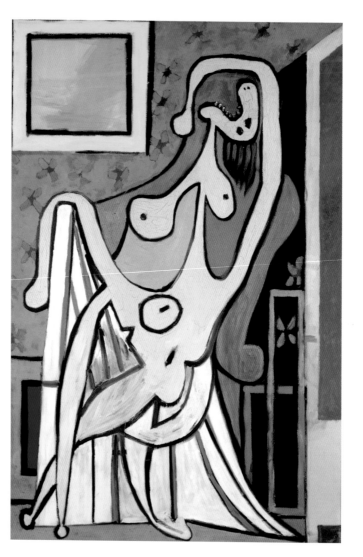

Pablo Picasso, Nude in an Armchair, 1929
Oil on canvas, 195 x 129 cm

Picasso's "Classical Period" (1918–1924) with its monumental, voluminous figures was followed around 1925 by pictures showing the human body as deformed and distorted. In contrast to the Cubist works of the early years, it is no longer a question of formal experimentation, but instead about the visualization of a threatening transformation process: frenzy and despair seem to be mutating the female body into a monster. The extremities are overlong and ridiculously twisted, with the natural starting points on the torso displaced. The head consists almost exclusively of a gaping mouth, armed with dangerous teeth. The representation of the sagging breasts and straddled crotch is merciless. The fury of the woman is further reflected in the room's gaudy color scheme, which is accentuated by the complementary contrast of red and green. Although Picasso did not personally belong to the group of young Surrealists around André Breton in the early 1920s in Paris, his contacts with them may have been the source of some inspiration. His portrayal of the nude seems more likely to have developed from an existential necessity and doubtless reflects the personal problems he was having with his wife at that time, Olga Koklowa, who suffered from jealousy and fear of abandonment.

Pablo Picasso, Portrait of Marie-Thérèse, 1937
Oil on canvas, 100 x 81 cm

Despite the erotic relationship with Dora Maar, Picasso still produced many portraits of Marie-Thérèse Walter around 1936/37: she had become his lover in 1927 and given birth to his daughter Maya in September 1935. She is said to have been cheerful, gentle, and maternal and this is how Picasso depicts her in this portrait, which stands in stark contrast to that of Dora Maar (see p. 238). The same pose and the white, box-shaped room make the portraits companion pieces, mirroring his inner conflict in deciding between the two women.

Pablo Picasso, Portrait of Dora Maar, 1937
Oil on canvas, 92 x 65 cm

Picasso met the young photographer Dora Maar a year before he painted this portrait. He was fascinated by this vivacious and elegant intellectual woman and soon became her lover. Their relationship lasted until 1943. Picasso portrayed her in a self-assured pose and with an alert gaze. The strong contrasts between the red and black of her clothes add a sophisticated touch to her appearance. Pointed, angular shapes, especially in the way the hands and the patterning of her clothes are painted, convey a sense of clear determination. The narrow, box-like room that seems to enclose the subject of the portrait has a strangely unsettling effect.

Pablo Picasso, Bathers, 1956
Bronze,
ht. between 136 and 228 cm

In the summer of 1955, Picasso and his new companion, Jacqueline Roque, who was later to become his wife, moved into the Villa La Californie in Cannes on the Côte d'Azur. On the beach there the following year, he completed a sculptural group made out of everyday objects and pieces of wood he had found. A bronze of the sculpture is displayed in the museum according

to the layout he specified in the drawings he left. Legs are made out of the feet of a bed; broom handles and an old picture frame serve as arms; a large disc is used as a head; the facial features are achieved by the assembled pieces of gathered wood and sparse carvings. This playful work by Picasso, which takes up a central theme of art and re-interprets it, transposes the collage principle to the medium of sculpture, while simultaneously reducing the sculptural work to a flat surface: the group of figures was meant to be viewed from one particular direction.

Musée Carnavalet
in the Hôtel Carnavalet

Of all people, it was Baron Haussmann, under whose aegis the old Paris practically disappeared, who encouraged the estab-

lishment of a municipal museum and proposed the purchase in 1866 of the Hôtel Carnavalet for this purpose. This led to the restoration of one of the few remaining complete Renaissance buildings in Paris. Built between 1547 and 1560 for the president of the parliament at that time, Jacques des Ligneris, scholars attribute the design of the corps-de-logis to the architect Nicolas Dupuis, who evidently based it on Italian models. This is demonstrated in the clear symmetry of the mullioned windows that is broken up on the second floor by decorative bas-reliefs of the Four Seasons, which came from the renowned workshop of Jean Goujon. The hôtel was then bought in 1578 by Madame de Kernevenoy and acquired the name it has today— "Carnavalet"—from the corruption of her Breton name. Numerous subsequent owners extended and rebuilt the palace. Significant changes were made in the 17th century by François Mansart: he added a wing extension on the right side, rebuilt the existing left one extensively, and created a new facade on the side of Rue de Sévigné, very clev-

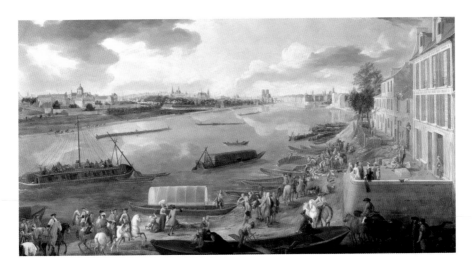

erly incorporating the original Renaissance portal. The street name is also a reminder of the most famous inhabitant of the palace, Marie de Rabutin-Chantal, Marquise de Sévigné (1626–1696). Her salon attracted the most notable intellectuals in the city. A beautiful and spiritual writer herself, she wrote around 1,500 letters to her daughter who lived in the provinces, giving a deeply personal insight into the lives of the Paris aristocracy in the 17th century. A bronze statue of Louis XIV stands in the cour d'honneur: it was originally located in the courtyard of the town hall in Paris and is one of the few royal monuments to have survived the iconoclasm of the French Revolution.

Pierre-Denis Martin (1663–1742), View of Paris from the Quai de Bercy, 1716
Oil on canvas, 170 x 315 cm

In the palace of the same name and the adjoining Hôtel Le Peletier, the Musée Carnavalet today houses a comprehensive collection on the history of Paris from its beginnings up to the 20th century. Numerous vedutas convey a visual impression of the city's development and the life of its inhabitants. This large-format painting by Martin shows a popular view down the Seine to Île Saint-Louis and Île de la Cité. On the left can be seen the large complex of the Hôpital de la Salpêtrière, founded during the reign of Louis XIV. The picture is brought to life by a genre scene in the foreground, populated with figures.

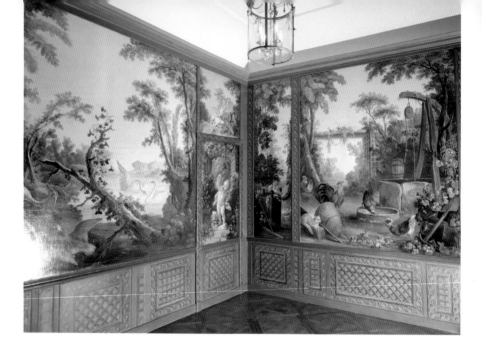

François Boucher (1703–1770), Jean-Honoré Fragonard (1732–1806), Mural from the Salon Demarteau, ca. 1765

As well as paintings, complete interiors tell the story of the everyday life and domestic culture of the—mostly privileged—inhabitants. There are partial as well as complete units of interior decor on display, which were saved from the town palaces that had mostly been destroyed. An outstanding example is the mural by the copper engraver, Gilles Demarteau, who decorated his store on the Île de la Cité. The workshop of François Boucher, who was by then the official court painter to Louis XV, created an illusionist view from a summer house, whose three-dimensional effect is simulated by the panel framing; it seems as if hens are clucking, dogs are barking, and swans are swimming on a pond, all in the middle of Paris. It is likely that the maestro himself painted the grisailles of the two putti at the water basin, while delegating the depiction of triumphant Cupid to his most famous pupil, Fragonard. In displaying the imaginative power of art, the complete work is bound to have boosted the sales of this graphic artist.

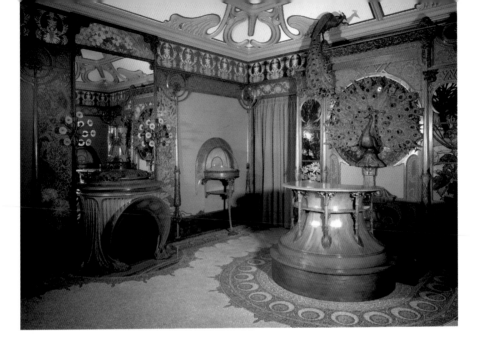

**Alfons Mucha (1860–1939),
Fouquet jewelry store, 1900**

Several interiors from the 19th and early 20th centuries can be seen in the Hôtel Le Peletier, which is connected to Hôtel Carnavalet by a gallery. Also worth seeing, in addition to the rather plain bedroom of Marcel Proust, are the salon of the famous Café de Paris (1899) by Henri Sauvage and the ballroom of Hôtel de Wendel, decorated by the Catalonian artist José-María Sert y Badia in 1924. Another highlight is the reconstructed Art Nouveau interior, which was designed by Alfons Mucha for a jewelry

store in the heyday of this style. The Czech artist, who worked mainly as a poster artist for Sarah Bernhardt among others, developed a rich style of ornamentation based on plant forms. This was used for the walls, ceilings, and furniture alike, merging the room into a unified, lively, and animated whole.

The question of which items of jewelry could hold their own against such a powerful style of room had a simple answer—Fouquet sold almost exclusively jewelry designed by Mucha himself.

Musée d'Art et d'Histoire du Judaïsme in the Hôtel de St-Aignan

The Hôtel de Saint-Aignan, an imposing Baroque building, is situated in the heart of Le Marais. The royal architect, Pierre Le Muet, was commissioned to build it between 1644 and 1647 by the Count of Avaux, who signed the Peace of West-phalia in his capacity as the diplomatic representative of France. A heavy wooden gate leads into the impressive former courtyard of honor, with its massive pilaster order. The duc de Saint-Aignan acquired the town palace in 1688 and commissioned Le Nôtre, who landscaped the park at Versailles, to design the garden. It was closed in 1988 to hand it over to the Jewish community for the purpose of representing their history. The museum, which opened in 1998, is jointly supported

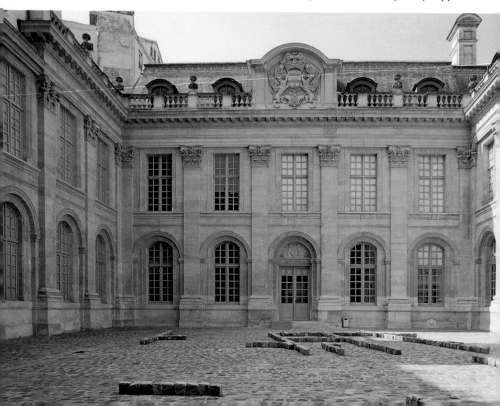

by the city and the state; according to the museum's director, Laurence Segal (in an interview with the author of this article) "the republican tradition prevented Jews from taking the idea forward themselves." Since then the community has become so multicultural, however, that it would be hard to show all its different roots. Jews from Eastern Europe fled here from pogroms towards the end of the 19th century: to the "Pletzl," as Le Marais was known in Yiddish. Some of them lived in the Hôtel de Saint-Aignan in 1939, the artist Christian Boltanski recording their names on a firewall in the atrium.

A linear exhibition trail leads through three main sections, which are crammed with private donations. The first of these covers the Middle Ages, the end of which was marked

Christian Boltanski, the inhabitants of Hôtel de St-Aignan in 1939, installation, 1998

by the expulsion of the Jews in 1394, and is mainly illustrated by a collection of tombstones from Paris cemeteries and by the writings of Talmudists. The second main section deals with the period of the emancipation of the Jews during the French Revolution up to the Dreyfus Affair in the 1890s. The tour continues into the 20th century, which is represented by the works of famous Jewish artists such as Modigliani and Chagall, and ends in the present day—the Pletzl is still here, after all.

A walk through the Jewish side of Paris

by Rita Degenhard

Entering Rue des Rosiers from the direction of the Saint-Paul metro—the main street of the old Jewish quarter and still a center of Jewish culture in Paris—it is easy to walk past the first synagogue without noticing it. This building beckons surrep-

A synagogue in Le Marais

titiously from the time before the ostentatious temples of the 19th century, when Jews were mainly concerned with practicing their religion as unobtrusively as possible. It is difficult to know exactly when this mindset changed. As one of the many smaller siblings of the three great synagogues in Paris, and like every Jewish prayer hall, it refers to the destroyed temple in Jerusalem and reflects the Ten Commandments, which led to the building of the very first shrine in the wilderness. Le Marais, the Jewish quarter between the 3rd and 4th arrondissements, owes its name to the former swamp on which it is built.

It is still possible to catch a scent of the old glamour at the turn of the 17th century: it suits the small workshops of up-and-coming fashion designers, the falafel stalls, cafes and kosher restaurants, and the bookshops with the latest works of Alain Finkielkraut, one of the most important intellectuals in France. Posters still hang on many house walls, joyfully announcing the arrival of the Messiah, who was believed to have been discovered some years ago in Rabbi Menachem Mendel Schneerson from Brooklyn. His followers in Paris, members of a strict religious movement, met up in assembly rooms on the Boulevard Poissonnière in 1993: there, they were instructed to the accompaniment of cheerful cassette music ("Oioioi Mosciach, Mosciach our king!") in how best to meet the savior if and when the time came—turn the lights out? Wear a tie? Put on a wig? Devout Jews in Paris come predominantly

from the Maghreb, from Algeria, Tunisia, and Morocco. They either emigrated from their home countries or were driven from them, after the former French colonies became independent and during the Israeli-Arab conflicts. Whereas this generation of North African, or Sephardic, Jews was primarily concerned with assimilating into France even before arrival—following the motto of the Jews during the German Enlightenment "A citizen on the street, a Jew at home"—there was a discernible return to traditionalism in the 1970s. The romantic anti-capitalism of the '68 generation, which galvanized the descendants of East European Jews like Alain Finkielkraut to become freedom fighters in the Third World, made the children of the newly assimilated Jews seek out orthodoxy. It is true that their parents were, on the whole, practicing believers, but they did not know why they had to eat kosher or honor the Sabbath. Younger Jews on the other hand—or at least some of

*Jewish stores on
Rue des Rosiers*

Jewelry shop in the Jewish district of Le Marais

them—learn Yiddish, attend a religious college (yeshiva), and in some cases master very little French. At the main Jewish festivals, for example the Passover Seder, it is often possible to hear four different languages at the table: Arabic from the grandmother, Yiddish from the Rabbi, French from the parents, and Hebrew from Israeli relatives, who moved to the Jewish state after the Six Day War in 1967 in order to preserve their identity. The food on sale in Rue des Rosiers is as Arabic as the hits on "Radio Shalom"—the only Jewish radio station in France, whose frequency is right next to that of the Arabic station. It is hardly surprising, for Islamic dietary law is after all very similar to the Jewish kashrut, which precisely stipulates how food should be prepared and used. The fast-food chain McDonald's finally had to give up its plan to open a branch in the middle of Le Marais: protests against non-kosher food had become so militant the company was unwilling to risk further negative press in France.

In Rue des Rosiers there is row upon row of kosher cafes, a Jewish news dealer, and a hairdresser. In the past few years, boutiques have also opened, which are slowly but surely "yuppifying" the old Marais. Most importantly, however, it is possible to eat really well here. For example, a Tunisian platter can be had as an appetizer: couscous with two small onions, parsley, tomatoes, lemon juice, and fresh mint. The dish is made the night before and then served on salad leaves. This can be followed with kosher pizza, such as Pizza Napolitaine. And, how is it possible to resist the delicious merguez, those spicy little sausages

served with yeast dough or onions and coriander? And it is usually impossible to pass the kosher snack stands with their unforgettable and addictive falafels. Nothing else for it but to mutter something about these small, firm little balls made of chickpeas—not meat—with finely chopped cabbage and pepper, and an inexplicable, wafting aroma of lemon, and then stagger with a blissful smile toward the dessert, which might well turn out to be absinthe.

Jewish food galore

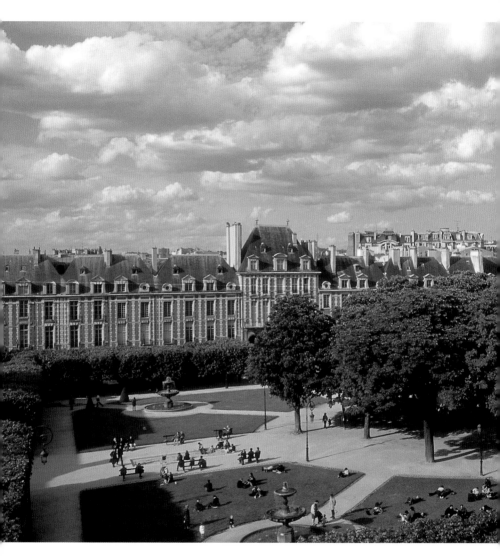

Place des Vosges

The purpose of the large, enclosed square, designed during the reign of Henri IV at the beginning of the 17th century, was to act as a public stage for courtly life. The pavilions of the king and queen, which were designated as the royal couple's residence, stand out on the south and north sides by virtue of their higher level and more elaborate facade design. Surrounded by 36 noblemen's palaces with identical facades, the royal image of "primus inter pares" (first among equals) seems to have assumed architectural form. In spite of its size, the square has an almost homely feel to it, thanks to the use of red brick and the well-proportioned buildings with their arcades, main story with French windows, another level above it, and a hip roof with dormers. The square was not inaugurated until after the assassination of the king in 1612, on the occasion of the double wedding of Louis XIII to Anne of Austria and his sister Elisabeth to the future Philip IV of Spain. Although a royal couple never actually lived on Place Royale, as it was known until the French Revolution, it became one of the most important meeting places for aristocratic society during the 17th and 18th centuries. After the Revolution, when the equestrian statue of Louis XIII erected here by Richelieu in 1639 was torn down, the square was renamed after the first département to pay taxes to the new republic.

Hôtel de Sully

The entrance to one of the most magnificent town palaces in Paris is tucked away in the south-west corner of the Place des Vosges. The site stretches right up to Rue St-Antoine and comprises gardens, corps de logis, and a courtyard of honor with two side wings and an entrance portal. Building began as early as 1625—the design is assumed to have been by the royal architect Jean Androuet du Cerceau—but it had changed owner even before its completion. The works were finished in 1638 under Maximilien de Béthune, duc de Sully, at that time the elderly former finance minister of Henri IV who had fallen out of favor with Louis XIII.

The Hôtel de Sully, one of the first town palaces in Le Marais, was beautifully restored in the early 1960s and is one of the most representative buildings from the first half of the 17th century. Its ornamentation is restrained on the side facing the street, but its full splendor unfolds in the cour d'honneur, which feels very enclosed by the wings of the building. Today, the magnificently restored Hôtel de Sully and the Jeu de Paume house the Centre National de la photographie et le Patrimoine photographique (National Center of Photography and Photographic Heritage). Both museums carry an ambitious joint program of exhibitions and seminars on contemporary photography. Additionally, the Hôtel houses an excellent bookshop specializing in the city of Paris and architectural history.

Facade ornamentation on the corps de logis

The facade design of the main block, which was completed by 1626, has elaborate ornamentation combining elements of the Renaissance with early Baroque. The passageway from the garden through to the courtyard of honor is adorned on each side of the main story with sculptures representing the Four Seasons. These are supplemented by allegorical figures of the Four Elements on the side sections of the cour d'honneur. The facade is divided vertically by the window bays and horizontally by smooth, stone bands running across it. Their internal articulation is rich in detail, especially the window lintels and gables that are lavishly decorated with acanthus, rosettes, vines, and masks. The drapes, bands, and volutes on the dormers, which are overlaid by protruding gables, underline the impression of an elaborate, yet fresh, style of architecture.

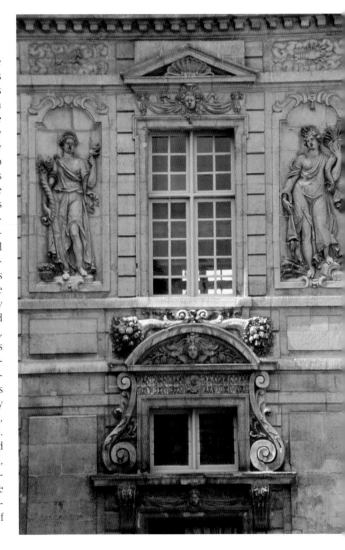

Place de la Bastille and Opéra de Paris

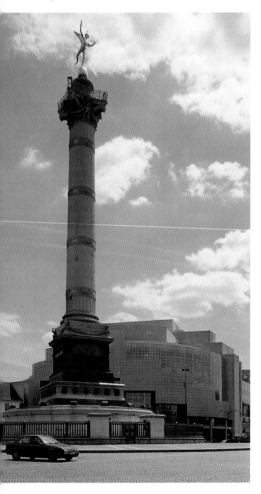

There is no denying the discrepancy between the national significance of this square and its appearance. As nothing was left of the Bastille after its storming on July 14, 1789, the square is now dominated by the massive July Column, which was built in 1840 as a memorial to the July revolution and has a golden "spirit of freedom" figure poised on top of it. The 700 victims of the revolutions of 1830 and 1848 lie beneath the marble base, which dates back to a project of Napoleon—the Emperor wanted to erect a 79-ft. (24-m)-high bronze elephant on it. François Mitterrand commissioned a popular opera house to be built on this historically significant site, as a counterpoint to the upper class pomp and splendor of the Opéra Garnier. The design by the Canadian architect Carlos Ott conveys the idea of transparency and openness through the choice of a partially glazed facade. The white-clad exterior of the building, which was completed in 1989, rises in steps toward a central point, taking up the direction of the internal staircase. The main entrance is announced by the anthracite portal, which has echoes of the Grande Arche of La Défense. In spite of all the criticism, the new building does actually inject some life into the quarter. In 1995, the viaduct of a disused railway line running parallel to Avenue Daumesnil was turned into the Promenade Plantée; the arcades have since been glazed and now accommodate studios for young designers and artisans.

Enlightenment and revolution—Paris ablaze

by Stephan Padberg

Described by Kant as "man's emergence from his self-imposed immaturity" (1783), the Enlightenment was an appeal to all humanity. As beings endowed with reason and independent thought, people would emancipate themselves from the chains of tradition and create a society that was freer, happier, and morally superior. Paris—described by Goethe as the "center of the civilized world" as he looked back in 1820 in his

"Let's hope the game ends soon."
Unknown artist, 1789, colored engraving,
19.3 x 13.9 cm, Bibliothèque Nationale de France, Paris

essay "Judgments of French Critics"—was regarded as the hub of this movement, together with London and Berlin. The particular starting point here produced a radicalism that finally led to the eruption of the French Revolution between 1789 and 1799.

It all began just 100 years earlier, with the crisis caused by the rule of Louis XIV. During the heyday of absolutism, the court of "Le Roi Soleil" (The Sun King) firmly established its prime social and political position within the estates hierarchy. The power and revenue of the state increased and the administration was centralized. Yet there was an inherent contradiction between, on the one hand, the successes in colonial policy and progress in trade, transport, and manufacturing, and an unjust and backward social structure on the other. The first two estates, the aristocracy and the clergy, were exempt from taxation, and they persisted in their reactionary defense of their privileges and preferential income. The bourgeois third estate was divided—those who were profiting from the economic upturn strove for promotion to the ranks of the aristocracy by buying office so that they could enjoy its advantages. Yet the petit-bourgeoisie, along with the so-called fourth estate, the large mass of the population in

the towns and countryside, was groaning under the burden of high taxes and duties.

When the harvest was poor, there were food shortages everywhere, resulting in starvation, epidemics, and eventually spontaneous unrest. The accumulating assets of the state were invested in building chateaux such as Versailles, in luxury goods, and in the war chest. At the end of the Sun King's reign, by which time France had been bled dry, high-ranking civil servants began to make restrained attacks on the government, while in intellectual circles a free-thinking spirit became fashionable. The standard criticism related to the tyranny and despotism of rulers, the idleness and vices of the privileged few, and also the strong alliance between the monarchy and the Catholic Church. After the Protestant Huguenots were driven out in 1685, the absolute demand of the Enlightenment became religious tolerance accompanied by condemnation of dogmatism and "swindling priests."

Anicet-Charles-Gabriel Lemonnier, Reading of Voltaire's Tragedy "L'Orphelin De La Chine" in the Salon of Madame Geoffrin in 1755, 1812, oil on canvas, 6.25 x 9.6 cm, Musée des Beaux-Arts, Rouen

The Intellect, Good Taste, and Utopia

The Salons became important meeting places in these circles. In the early 18th century, society ladies began to invite artists and philosophers on certain weekdays. All were welcome, provided they were adequately charming and intellectual. Some, like Rousseau, were critical of the playful type of debates in the Salons, which lacked any commitment. As in the arcades, gardens, and cafes of the Palais Royal, where news was announced and shared, rumors were started, and intrigues woven—and where gambling, prostitution, and other pleasures were indulged—it was in the Salons that the power of public opinion was forged, rhetorical geniuses honed their style, and ambitious and educated young men from the provinces tested their literary and political craft. Even the fathers of the Enlightenment frequented the Salons—Voltaire, Diderot, Montesquieu, and d'Alembert.

Various strands of thought supplied the Enlightenment with intellectual weaponry and contributed to its internal dynamics. Opposing thought stood face to face: reform theology and

atheism; philosophical systems thinking and the individual observation of the natural sciences; belief in progress and skepticism about the future. Yet all these tensions once again produced the need for harmony and the reconciliation of opposites, such as was offered by the vision of universal reason inherent in the laws of nature. Slowly, a Utopian prospect began to emerge—the hope of a new age of rational human forms of existence.

Repression, Resistance, and Success

The activities of the Enlightenment philosophers were not without danger. There was no freedom of the press, and anyone breaching state or clerical censorship risked being thrown into prison, exiled, or sentenced to serve as a galley slave. Even Voltaire got to know the Bastille at first hand. For this reason, many of the early Enlightenment texts were printed in Amsterdam or Geneva, then smuggled across the border and re-issued illegally in France or produced there under pseudonyms. The police in Paris listed over 100 portable printing presses in 1789 that were used for illegal book production. Moreover, the most radical texts circulated within the extensive correspondence network of the Enlightenment thinkers as secret manuscripts that were copied out repeatedly. Their thoughts were passed on verbally in the numerous cafes, writers' circles, academies, salons, opera boxes, and reading groups.

The peak and symbol of the heightened cultural influence of the Enlightenment was the success story of the "Encyclopaedia" published by Diderot and d'Alembert and released in 35 volumes between 1751 and 1780. Their distribution in many public and private libraries throughout Europe produced a quantum leap in information: the fundamental idea was to convey all knowledge currently

Title page of the "Encyclopédie, ou Dictionnaire Raisonné des Sciences, des Arts et des Métiers, par une Societé de Gens de Lettres," Vol. 1, Paris 1751

available. Their openness to content that was critical of the government provoked a hostile reaction from those opposed to the Enlightenment. In 1757, the clergy held the "party of philosophers" responsible for the assassination attempt on Louis XV and obtained a temporary ban. The 4,000 subscribers both at home and abroad, however, whose advance payments should have been reimbursed, insisted on the delivery of the outstanding volumes. When these were finally allowed to appear, the whole world knew that the "spirit of the time" had taken its leave of the "powers of darkness" once and for all.

Title page of the book by Emmanuel-Joseph Sieyès: "Qu'est-ce que le Tiers État?" (What is the Third Estate?), 3rd edition, 1789, 20 x 13 cm, Bibliothèque Sainte-Geneviève, Paris

The Revolutionary Situation

Things came to an explosive head when the monarchy was forced for the first time in over 170 years to convene the Estates-General on the eve of the French Revolution, in an attempt to create unity in a political crisis. The country was in economic ruin, and the disparities between rich and poor had reached unbearable proportions. The state was near to bankruptcy and all attempts at reform in fiscal and taxation policy had failed, thanks to the opposition of the aristocracy and parliaments. The provinces and the capital were rocked by starvation and spontaneous uprisings. The nobility tried to make capital out of the weakness of the government and proposed a constitutional change that would make small concessions even to the bourgeoisie.

Yet once it was set in motion, the emergent political opinion developed a dynamic of its own—at last the moment seemed to have arrived to steer the ideas of the Enlightenment, its drafts to the constitution, its principles, and its criticism along one united path with one single throw of a switch. "It is the wish of His Majesty," it stated in the electoral regulations for the Estates-Gen-

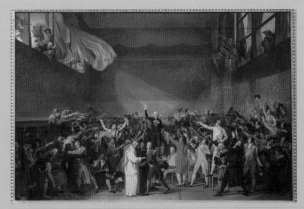

Jacques-Louis David (1748–1825), Tennis Court Oath, 1790/91.
Oil on canvas, 65 x 88.7 cm, Musée Carnavalet, Paris

their assembly hall, they retreated to a nearby sports hall and swore an oath there on the tennis court, to stay together until a new constitution was confirmed.

At the same time, the people of Paris stepped onto the stage, for rumors were immediately circulating that the National Assembly was about to be dissolved by force. Armories were raided; a citizen's guard was set up; and the crowd destroyed the hated custom houses and stormed the Bastille. Across the country, chateaux began to burn simultaneously. The first decision made by the National Assembly was to do away with aristocratic rule and all privileges. With the Declaration of the Rights of Man and of the Citizen on August 26, 1789, it seemed for many like the dawn of a new day. Yet if not for the Parisian masses, which were led by a colorful mixture of women from all classes who transported the reluctant king in a triumphant procession from Versailles right into the heart of the city, the revolution would not have become the textbook example of democracy that it did.

eral, "to ensure that the wishes and complaints of every man in the furthest parts of the kingdom shall reach him." This prompted the men of the Third Estate to lift the censorship. Walls everywhere were covered in placards; tracts, fliers, and pamphlets sprouted up all over the place; and the concerns of the populace were detailed carefully in complaints books. A revolutionary mood became all-pervasive. Abbé Sieyès wrote self-confidently in a successful election pamphlet: "What is the Third Estate? Everything. What has it been until now? Nothing! What does it demand? To become something." At the meeting of the Estates-General in Versailles in June 1789, the deputies of the Third Estate established the National Assembly, thus transforming themselves from representatives of Estates to representatives of "a single and indivisible nation," with the majority of the clergy and 80 aristocrats joining them. When they were refused entry to

The Birth of Something Completely New

On July 11, 1791 the mortal remains of Voltaire, the icon of the "enlightened century," were brought ceremoniously to the Panthéon.

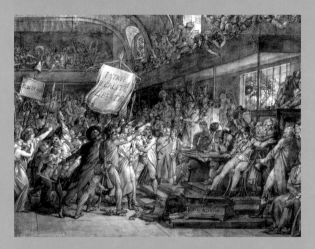

On August 10, 1792 the masses storm the Tuileries from the Paris sections, contest the power of the legislature, and demand the abolition of the monarchy. Baron François Gérard (1770–1873), August 10, 1792, 1794, pen and brown wash, white highlights, 66.8 x 91.7 cm, Musée du Louvre, Paris

Members of the popular movement carrying picks accompanied the funeral procession. This was just one of many such scenes which were to symbolize the context of the two struggles for freedom: that of the Enlightenment and that of the people.

The Revolution was in need of such rituals to bridge the gulf between the past and the future and to legitimize the dissolution of the God-given authority of the monarchy by a constitutional state based solely on the rights of the individual and the general will of the people.

From the very start, the new representatives of the nation had come under pressure. The king, Louis XVI, was not to be trusted, as he was secretly forming alliances with the armies of the Austro-Prussian coalition, which threatened to attack French soil in 1791 in the name of the divine monarchy and raze Paris to the ground. The danger inside the country was just

as great. There was revolt from all sides: by the peasants whose economic plight could not be alleviated by the revolution; by the church whose estates had been expropriated and whose priests all had to swear an oath to the constitution; and by the provinces, which wanted more independence from the capital. At the same time, the representatives of the people felt exposed to the demands of the suspicious Paris proletariat, for whom the price of bread and wages were the real indices of progress. When a rebellious crowd stormed the Tuileries on August 10, 1792 and took the king prisoner, the talk about the sovereignty of the people became a reality. The foundation of the republic and the trial and death sentence of Louis XVI put the seal on the break with the past.

Those who now claimed to guide the destiny of France had to give meaning to the chaos

through words and deeds. Political clubs like the Jacobins took on this interpretative work with extensive networks, not just in Paris, but countrywide. With great inventiveness and speed they sought to transpose the philosophical tenets of the Enlightenment into a political form, improvising with black-and-white paintings and legends to educate the sovereign ruler—i.e., the people. The Revolution created its own calendar, renamed streets and squares, introduced a different style of speaking, and adopted new public holidays, martyrs, and saints.

Jacques-Louis David, The Death of Marat, 1793. Oil on canvas, 165 x 128 cm, Musée Royaux des Beaux-Arts, Brussels

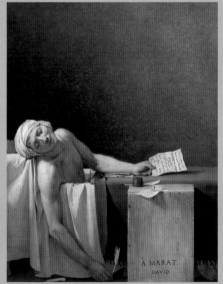

The Revolution Strikes its Limits

The revolutionaries became increasingly radical in the battle with their opponents, resulting in the Jacobin Reign of Terror that ultimately succeeded during the crisis of 1793/4 in uniting the forces of the Paris popular movement with the bourgeois revolution. When the first news of victory reached Paris from the fronts, the "Thermidor Reaction," a revolt of moderate bourgeois forces, ended the state of emergency on July 17, 1794. Robespierre and his supporters were sentenced to death, with the nouveau riche bourgeoisie and their elegant offspring celebrating the end of the "incorruptibles" with debauched excesses. To invoke the link between their politics and morality, the Thermidorians ostentatiously placed the memorial of the "sensitive" Enlightenment thinker Rousseau in the Panthéon, opposite that of the murdered journalist Marat who for years had preached hate and mistrust against the Establishment in his revolutionary paper "Friend of the People" and had demanded "100,000 heads." The balance of power remained unstable for another five years. It was not until December 15, 1799 that the self-appointed consul Bonaparte declared: "Citizens, the revolution is adhering to the principles on which it originally stood. It is at an end."

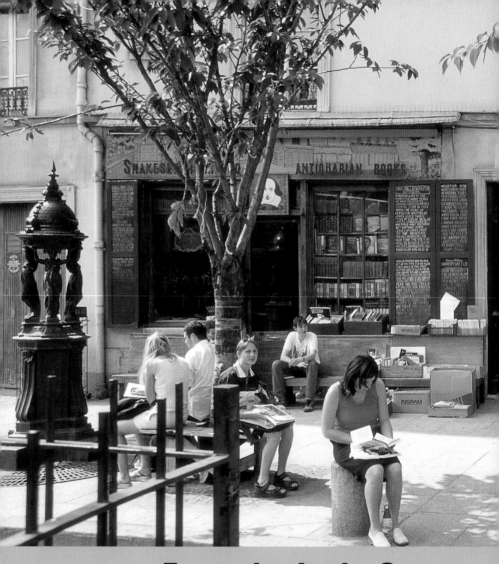

From the Latin Quarter

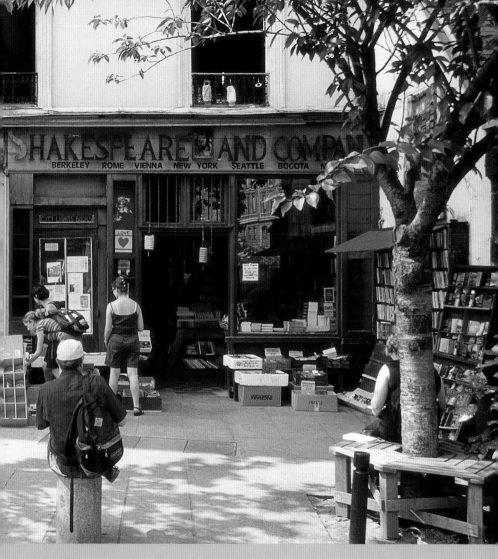

to Montparnasse

From the Latin Quarter to Montparnasse

"The left bank of the Seine was calling me, and it continues to do so today, calling and holding me. I can't imagine ever leaving it, in much the same way as an organ can never leave its allotted place in the body." Only the Rive Gauche—the intellectual heart of the city—was ever considered by Adrienne Monnier as the site for her small bookshop "La Maison des Amis des Livres," which she opened in 1915 at no.7, Rue de l'Odéon between Boulevard Saint-Germain and the Jardin du Luxembourg. It rapidly became the meeting place for the literary avant-garde. André Breton, Sidonie-Gabrielle Colette, Guillaume Apollinaire, Jean Cocteau, and many

Preceding spread: One of the many famous bookshops in the quarter—"Shakespeare and Company" in Rue de l'Odéon, Saint-Michel

Inside the bookshop

others felt at home here, and were inspired by the contents of the shelves and exchanges with colleagues.

The knowledge and literature business has always been the prime driving force for developments on the Left Bank. The famous University of Paris, founded in the 13th century, soon became the leading higher education institution in Europe, attracting an international student community whose communal language was Latin—thus, the Latin Quarter was born. To the west lies the quarter of Saint Germain-des-Prés, which grew up during the Middle Ages around the monastery of the same name in the middle of meadows and fields ("prés" in French). In the 18th century, when the district became the preferred residential area for the Parisian aristocracy, palaces were built on a grand scale that now mainly house government ministries and embassies. The quarter was discovered by the intellectual scene in the early 20th century and the area between Rue de Seine and Saint-Sulpice is still characterized by numerous bookshops, publishers, galleries, and antique dealers today. Montparnasse became an artists' quarter in the early 20th century. Right down at the south end in Rue de Dantzig, a colony had already sprung up by 1905 in which penniless painters and sculptors, particularly from eastern Europe, found a place to live and work. Marc Chagall, Ossip Zadkine, Jacques Lipchitz, and Constantin Brancusi were just some of the artists who set up home and shop for a time in La Ruche. The

Fontaine Saint-Michel, 1858–1860, from a design by Gabriel Davioud (1823–1881)

"beehive" became the breeding ground for the Paris School. Urban developments in the 1970s have changed the area considerably. The Maine-Montparnasse Tower, the only skyscraper in central Paris, has come to symbolize the insensitive response to the old buildings in the city.

From the Latin Quarter to Montparnasse

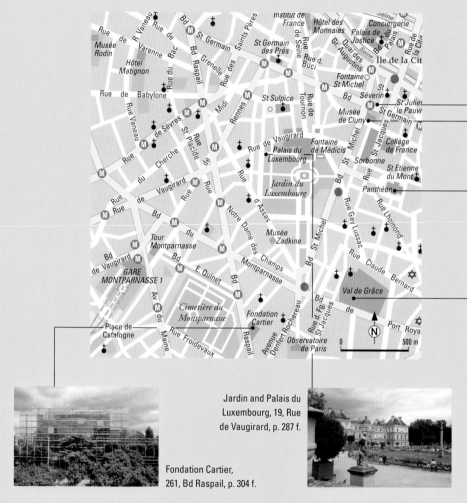

Jardin and Palais du
Luxembourg, 19, Rue
de Vaugirard, p. 287 f.

Fondation Cartier,
261, Bd Raspail, p. 304 f.

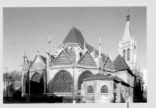

...éverin, Rue des Prêtres
Saint-Séverin, p. 269

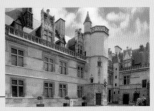

Hôtel de Cluny/Musée National du
Moyen Age,
6, Place Paul Painlevé, p. 270 ff.

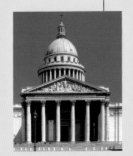

Panthéon, Place du Panthéon,
p. 279 ff.

Val-de-Grâce, 277,
Rue St-Jacques, p. 302 f.

Also worth seeing

Boulevard St-Michel

"Place St-Michel embraces you. It stretches out its arms to you and enfolds you like a lover. It is the gateway opening onto the Latin Quarter, the harbor at which I wanted to disembark. This is home." Thus observed Wolfgang Koeppen (1906–1996), during one of his trips to Paris. Wide and bustling, Boulevard St-Michel cuts through the Latin Quarter, forming part of the north–south axis that runs from the Gare de l'Est to Montparnasse via Île de la Cité. Haussmann extended the boulevard considerably, creating a new viewpoint on Place St-Michel with the reconstruction of the fountain (1858–1860), thereby masterfully conceal-ing the problematic sharp bend in the junction with Boulevard du Palais. Since the Middle Ages, students from the nearby Sorbonne have lived on both sides of the boulevard, setting the heartbeat of the quarter. In May 1968 Boulevard St-Michel became the stage of the student revolt that ended up in a general strike and was a factor in the resignation of Charles de Gaulle (1969). Since 1970, only subjects in the Humanities have been based in the university area of the Latin Quarter, and students can scarcely afford the high rents of the city center any more. Yet young intellectuals still feel at home in the local scene around the "Boul' Mich."

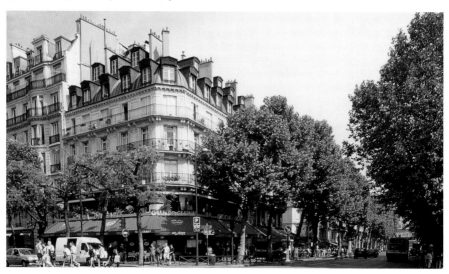

St-Séverin

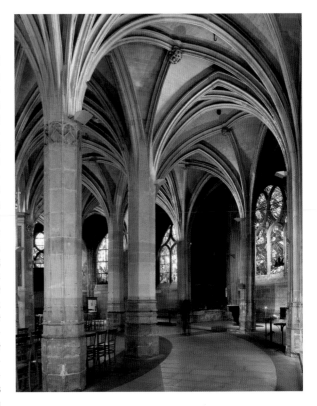

The late medieval church of St-Séverin, which was enlarged between the 13th and 16th centuries and gave its name to the old quarter to the east of Boulevard St-Michel, is one of the most beautiful parish churches in Paris. In spite of the protracted building period, it is a harmonious ensemble, as the unknown architect in charge of the 15th-century reconstruction made an excellent job of integrating the existing structure when he created the five-aisle sacred building with transept, applying elaborate tracery and Flamboyant-style ornamentation. The pillars of the double ambulatory are particularly stunning, its vault supports fanning out to form an organic web. One pillar even has a spiral shaft. Joris-Karl Huysmans (1848–1907) described the virtuoso vault construction as a "palm forest"—an image that accurately reflects the feeling of the space. As was customary in the Middle Ages, St-Séverin parish had charnel houses ("charniers" in French). These can be visited from the side of Rue de la Parcheminerie. The dead were first buried in the ground; their skulls and bones were later stored in the roof trusses. In 1474, the first gallstone operation was performed in public in this cemetery, on a man who had been sentenced to death. The patient survived the procedure, was pardoned, and received an additional monetary reward from the king's coffers.

Musée National du Moyen Age in the Hôtel de Cluny

The architecture that houses the Museum for Medieval Art also marks the temporal boundaries of the works on display. These are the ruins of the Gallo-Roman baths of Lutetia (ca. 200 AD) and the former residence of the Cluny abbots from the end of the 15th century. The magnificent town palace was built between 1485 and 1510 by Jacques d'Amboise, the dean of the famous monastery in Burgundy, as an inn for abbots visiting Paris. Along with the Hôtel de Sens, it is one of the few remaining secular Gothic buildings in Paris. Of particular note is the courtyard with its fountain and staircase, and the monastic, intimate atmosphere: it has been extended on the Boulevard St-Germain side by new abbey gardens based on medieval models. The museum collections belonged for the most part to the famous collector, Alexandre du Sommerard (1779–1842), who lived in the Hôtel de Cluny from 1833 and allowed private access to his treasures. After his death, the City of Paris purchased the palace along with its valuable collection and, within two years, the museum had opened that is now owned by the state. Following reorganization in 1977, the displays focus exclusively on exhibits from the Middle Ages, which are complemented by occasional pieces from antiquity.

The Pillar of Nautes (with figure of a Paris boatswain), between 14 and 37 AD,
Limestone, 110 x 80 x 80 cm, originally in Notre Dame, Paris

On display in the frigidarium, the cold room of the baths, is the votive pillar from antiquity, which was discovered in the 18th century during excavations under the choir of Notre Dame. The inscriptions on the square blocks reveal that it was a public monument erected by the guild of Seine mariners in honor of the Roman god Jupiter. The reliefs on the pillar depict Roman deities, as well as Gallic gods such as Esus, the god of woodcutters. The religious tolerance on the part of the Romans may seem surprising, but it may have been used as a compensatory measure for stabilizing the provinces.

The Lady and the Unicorn, ca. 1485/1500

Wool and silk, 300 x 330 cm

The sequence of six large tapestries that makes up "The Lady and the Unicorn" (on display in its own rotunda) was probably produced in the late 15th century in Brussels for the wealthy Jean Le Viste as a precious gift for his bride. The unicorn, symbol of purity and chastity, appears on all the tapestries along with the elegantly dressed lady, as does the bridegroom's family coat of arms: the lion. The five senses—smell, hearing, sight, touch, and taste—are represented allegorically against a rich floral background of "mille-fleurs" (a thousand flowers) and countless plants and animals. In this way, sensuous pleasures are associated with the (female) virtues of the courtly universe. The sixth tapestry shows the bride standing beneath a blue tent and looking at the contents of her jewelry casket. The motto accompanying it—"A mon seul désir" (To my only desire)—indicates a love whose bonds transcend wealth or precious things. The representational style shows the influence of emblematic texts that were in circulation around 1500, especially those from Italy and the Netherlands. We see

here a combination of finely nuanced realistic detail and late medieval abstraction. Such tapestries, very few of which have been preserved in a series, were among the most sought-after luxury items of their time, fulfilling both the desire for extravagant decoration and the need for warmth and protection from drafts in the cold, stone palaces. The English writer Tracy Chevalier, who achieved international recognition with her first work about the artist Jan Vermeer—"Girl with a Pearl Earring"—published another novel in 2005. Entitled "The Lady and the Unicorn" it is based on a famous work of art and tells the fictional story of how the six tapestries in the Hôtel de Cluny came into being. She weaves together the tense relationships between the man who commissioned the tapestries (a nouveau riche Parisian courtier), the painter who designed them, and the Brussels tapestry weavers who made them, plus all their wives, daughters, and maids. Naturally, it is all about clandestine love, unsuitable desire among different classes, power, and intrigue. Yet it also depicts the harsh reality in the workshops of the Flemish tapestry makers and the magical power of the mythical creature that dominates these works.

The University of Paris in the Middle Ages—
Rise and fall of an intellectual center

by Oliver Burgard

The life and times of a typical medieval scholar: he was born the son of a poor prince and grew up in a provincial town. As he translates and speaks Latin fluently, he is regarded as one of the brightest of the cathedral students in his town. His teachers see in him a future bishop, or even a cardinal. At the tender age of just 17, they send him away from home, telling him "Go to Paris. Study theology at the university. You'll find the best teachers there." Thus the scholar sets off, along with other students from all corners of the globe. He is alone, without baggage, and with few worldly goods, but bursting with talent and ambitious enough to undertake a long journey. Weeks later he finally reaches his destination—Paris.

In the early 13th century, the city on the Seine was a medieval metropolis, where modern buildings were already beginning to appear. The Louvre was extended by the king, Philippe II, streets were paved, and covered market halls were built. The population of around 80,000 was steadily rising and trade was booming. Yet Paris was more than just a flourishing economic location—it was the intellectual center of Europe. Its university was the oldest on the continent next to that of Bologna, made famous by all the great minds of the western world who taught there: Albertus Magnus (1206–1280) and Thomas Aquinus (1225–1274) in the theology faculty, and the scientist Roger Bacon (1214–1294), famous for his research in the field of refraction and math.

The theology faculty was seen as the elite training ground for ecclesiastical staff, benefiting from papal policy in respect of universities that favored Paris over others in order to create a consistent curriculum. In this way, the initial, somewhat loose community of teachers and pupils had within a few years become transformed into an institution whose fame reached far beyond its geographical borders. In 1208, Pope Innocent III sent a letter to the "doctores" in Paris, addressing them as the "universitas vestra" (the whole of you). A Papal Bull in 1231 ratified the "universitas magistrorum et scoliarum parisiensium." From this time on, Paris was established as the leading center of theological training in Europe.

The king was also supportive of the new university, for the capital of his kingdom needed specialists—not only theologians, but also lawyers and doctors. Other than Oxford and Cambridge, Paris was the only European higher education institution in the 13th century to comprise all four faculties of a medieval university—theology, law, medicine, and the liberal arts. The theology degree was the longest and most demanding, taking between 10 and 15 years of study, while the liberal arts only took 4 years. The latter was divided into a "trivium" with Latin, rhetoric, and logic, as well as a "quadrivium" (four paths) of geometry, astronomy, music theory, and arithmetic. Finally, law and medicine were seen even in the Middle Ages as subjects with practical

Albertus Magnus (1206–1280), later known as Saint Albert the Great, taught from 1240 through 1248 at the theology faculty of the University of Paris. Tommaso da Modena (ca. 1325–1379), Albertus Magnus, 14th c. Fresco, Seminario Vescovile, Treviso

relevance. Their graduates could expect a secure professional career with very good earning potential.

Our scholar, then, spent many years in "lectiones" and "disputations," the lectures and seminars of the theology course. At the end of his studies, he had another, major hurdle to overcome: the oral examination, in which his knowledge was thoroughly tested. He passed! Now, he was fully equipped for a career in the church—but also plagued with debt, for university studies were expensive; the more famous the teacher, the higher the fees.

In the feudal society of the Middle Ages, the university formed a social subsystem that functioned according to its own, self-defined rules. It brought together students from all social classes and countries—in Paris, the scholar from the provinces met the well-bred sons of aristocratic French families, but also the penniless foreign immigrants, who like him scraped a living without income or fixed abode. Some got into debt in order to pay the course fees, while others had to beg and

steal; no-one was judgmental about it. "Who could fail to take pity on those who are homeless for the love of knowledge?" Emperor Friedrich Barbarossa is reputed to have said about medieval students. The lucky ones found lodgings in the colleges, which were built as student residences and later became the actual centers for teaching. This was how Robert de Sorbon, the Confessor of Louis IX, founded a college for students of theology and ecclesiastical law in 1258 on the left bank of the Seine, which later became the Collège de Sorbonne.

At the height of its glory toward the end of the 13th century, the University of Paris had over 3,000 members. It went into decline a few years later, however, when political tensions developed between the French king and the Vatican. In 1378, the crown installed an antipope in Avignon as a demonstration of power. This triggered fatal consequences for university life, as hundreds of professors and students loyal to Rome left the city. With their departure, the university in Paris lost its reputation to higher education establishments in Italy and Germany, where the educated emigrants were welcomed with open arms.

Carlo Crivelli (ca. 1430/35–1494), the so-called Demidoff altarpiece with the figure of St. Thomas Aquinas on the upper right panel, originally painted for San Domenico in Ascoli Piceno, National Gallery, London

Chapel of the Sorbonne

The chapel is the only remaining part of the old university building commissioned by Cardinal Richelieu in the 17th century in his role as principal of the Sorbonne. It was realized by Jacques Lemercier (1585–1654) in the Italian Baroque style. It was consecrated in 1648—that is, after the time of Richelieu, who died in 1642. The main facade on the courtyard side is built in varied stucco work that is festively ornamental. The

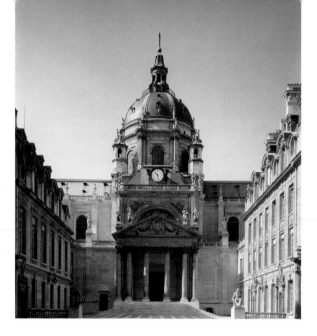

Classical portico with pediment and the high vaulted dome with drum give the facade a majestic appearance in a style element that is further enhanced by the allegorical figures on the upper level and which has been incorporated into church architecture in Paris in various forms: for example, Val-de-Grâce, the dome of Les Invalides, and the Collège des Quatre-Nations. Inside the chapel, most of which is closed off, lies the tomb of Richelieu, unfinished until 1694, more than 50 years after his death: sculpted by François Girardon (1628–1715), it depicts the cardinal dying in the arms of Piety. The personification of Knowledge has already collapsed in grief,

while weeping geniuses hold the coat of arms of the deceased cardinal. All the interior fittings of the chapel fell victim to the Revolution and, in 1794, it was rededicated as a "temple of reason." Alexandre Lenoir (1761–1839), who saved many sacred and secular monuments from the iconoclasm of the "sans culottes," moving them to the Musée des Monuments Français, was also able to preserve the Richelieu memorial. It was subsequently reinstalled in the south transept. The skull of Richelieu lies beside it; it was believed to have been lost after the ransacking of graves by the revolutionaries, but was rediscovered in the 19th century.

Bibliothèque Ste-Genevière

Only the name of the library and a few valuable manuscripts are left as reminders of the important medieval monastery that originally stood nearby. In the church attached to it, the remains of the city's patron, Saint Geneviève, were put on display in a richly decorated reliquary, which was carried through the city streets in a ceremonial procession during difficult times—natural disasters, wars, or epidemics. The reliquary was destroyed during the Revolution, and the remains are now in the choir chapel of St-Étienne-du-Mont. Above all, however, the site of the Bibliothèque Ste-Genevière has a place in the history of knowledge: this is where one of the most powerful and renowned colleges in Paris was situated—the Collège de Montaigu, whose students included intellectual giants such as the humanist Erasmus, the reformer Calvin, and St. Ignatius Loyola, founder of the Jesuit

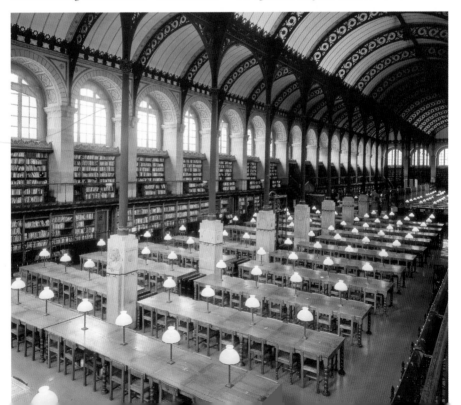

order. The new library was built by Henri Labrouste between 1844 and 1850, after which he was commissioned to design the reading room of the Bibliothèque Nationale. From the outside, the elongated facade seems rather plain, but the reading room on the upper floor is stunning, marking a high point of cast-iron architecture. Labrouste designed a high, two-span hall that has space for 650 readers and is dominated by the effect of the open metal construction. Here, in an atmosphere steeped in history, it is possible to study manuscripts by Baudelaire, Verlaine, and Rimbaud.

Panthéon

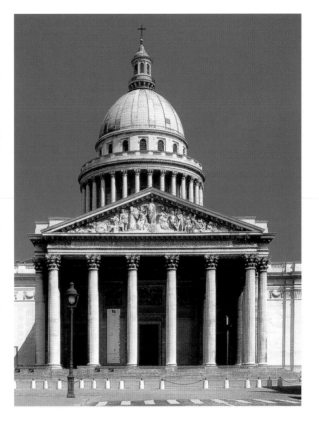

Sitting atop the Montagne Ste-Geneviève and made even higher by an additional plinth, the Panthéon can be seen from far and wide. As far back as ancient times, there was a Roman shrine on the old Mons Luticius. Then, in the 6th century, an early Christian church was built and the patron saint of Paris, Geneviève (ca. 422–512), was entombed there. When Louis XV became dangerously ill in 1744 he vowed to build a new church to the saint and, on his recovery, gave the commission to the architect Jacques-Germain Soufflot (1713–1780), one of the leading exponents of Classicism.

Soufflot conceived a massive, Baroque church to compete with the internationally outstanding architecture of the basilica of

St. Peter in Rome, the cathedral of St. Paul in London, and the church of Les Invalides of Louis XIV. The formal facade is dominated by monumental columns that give shape and support to the Classical portico and the high drum. Structural problems with the dome arose during the long building period, which delayed further work. Soufflot eventually died without having the satisfaction of seeing his ambitious project completed. The church was finally finished ten years later in the midst of revolutionary turmoil and, by the following year, had been rededicated as the pantheon for the "great men from the epoch of French liberty." In adapting the building to its new role as burial place and national hall of fame, 42 windows were bricked up. The pediment relief sculpted by David d'Angers between 1831 and 1837 bears the motto "Aux grands Hommes, la Patrie reconnaissante" (To great men, the grateful homeland). In the years that followed, the vicissitudes of the political balance of power determined whose remains were entombed in the crypt—or even removed. The tombs of Voltaire and Rousseau have been preserved from the revolutionary era. During the 19th century, the Panthéon became a pawn in the mighty struggle between Church, Monarchy, and Republic: the building was twice turned back into a church (in 1823 and 1852) before the death of Victor Hugo in 1885 provided a fitting reason to return the Panthéon to its republican designation. Today it is the final resting place of, among others, Soufflot, Alexandre Dumas, Émile Zola, Pierre and Marie Curie, and, last but not least, the writer and cultural minister, André Malraux (1901–1976).

Interior

The vast interior soars up from a ground plan based on a Greek cross and is further distinguished by the theme of columns. The building is structurally defined by the 52 fluted Corinthian detached columns and the 76 engaged columns that rest on a surrounding podium. Contemporaries described the original impression of the space, with its expansive, light, and subtle qualities, as being inspired by the spirit of the Enlightenment and as one of the greatest accomplishments of French architecture. It is, however, difficult to appreciate the achievement of Soufflot today because of the bricked-up windows and the loss of sacral function: the shrine of Sainte Geneviève should sit high up within the crossing. The Panthéon is now an impressive, if cold and dark, mausoleum. Frescoes from the 19th century depict scenes from the life of Sainte Geneviève: those by Puvis de Chavannes (1824–1898) are remarkable, and made a lasting impression on the young Picasso during his "Blue Period".

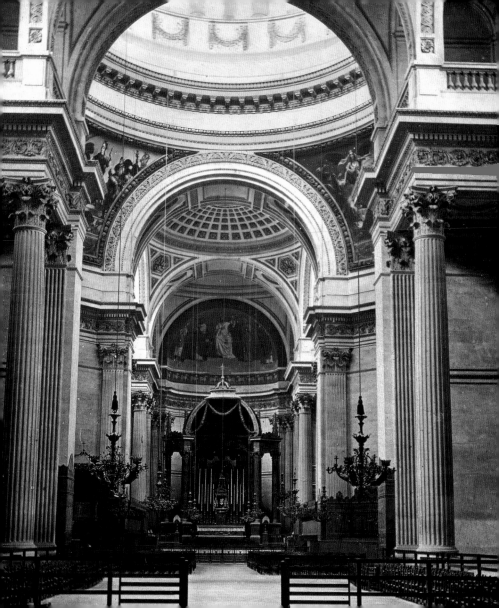

Between physics and metaphysics—
Foucault's pendulum

by Jörg Völlnagel

A thin metal wire, about 220 ft. (67 m) long, a 61 lb. (28 kg) bob, and a bag of the finest sand—the prerequisites for the astonishing pendulum experiment in 1851 were really rather simple. The French physicist Jean-Bernard-Léon Foucault had chosen the location for his scientific demonstration carefully, so that it would ensure plenty of attention for his experiment. Born in Paris on September 18, 1819, the scientist died there as well, 49 years later. He demonstrated the rotation of the earth in a pendulum that was suspended from the dome of the Panthéon. This pendulum experiment in 1851 was not in fact new, nor was the evidence it provided surprising. A similar experiment with a pendulum had been carried out as early as 1661 in the Accademia del Cimento in Florence, one of the institutions for research into the natural sciences founded by Leopold de' Medici. The time was apparently not ripe then, however, for such a discovery, and the appropriate response was not forthcoming. Once it is launched and kept in perpetual motion by a magnet on the ground, the pendulum swings majestically through space from one side to another. At the same time, the plane of oscillation undergoes a barely discernible change, like the hands of a watch slowly describing their path. For Foucault's historical experiment, a pin on the underside of the pendulum marked out the changes in the sand. The time taken to complete a rotation depends on the latitude of the location: at the North and South Pole it takes exactly one day, while in Paris, which lies approximately midway between 48/49° latitude, it is a little over 32 hours. It is only on the equator that no change in direction occurs, and the pendulum always swings on the same line.

The circular movement observed in the pendulum is caused by an inert force that imposes what seems like displacement to the side—in the northern hemisphere it is to the right, while south of the equator it is to the left—if it is observed from the earth: that is, from a base that is itself rotating. In fact, in appearing to describe this path, either clockwise or anticlockwise, the pendulum is actually

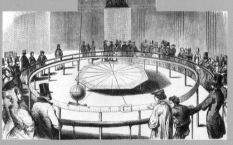

The 1851 pendulum experiment by Foucault in the Panthéon in Paris, historical etching by an anonymous engraver, Bibliothèque Nationale de France, Paris

maintaining its sidereal oscillation plane. Thus a fundamental theoretical abstraction was achieved, over and above the interpretation of the experiment: no matter where the pendulum is set up, it defies the effect of the earth's rotation, just as if the freely mounted, swinging object is a fixed point in the universe—to all intents and purposes the navel of the world.

This idea is the starting point for the bestselling novel by Umberto Eco, "Foucault's Pendulum." The tale is based on a world domination plan by the Knights Templar and the conspiracy that ensues—Eco hangs his plot on the pendulum, a symbol for the only fixed point in an endless sea of religions, philosophies, and world views, not to mention history, myths, and speculation. In his novel Umberto Eco provides evidence of his extraordinary gift for narration while, for Léon Foucault, the eponymous pendulum experiment he conducted in the Panthéon has brought him immortality, securing his place in the hallowed halls of a scientific pantheon of the mind.

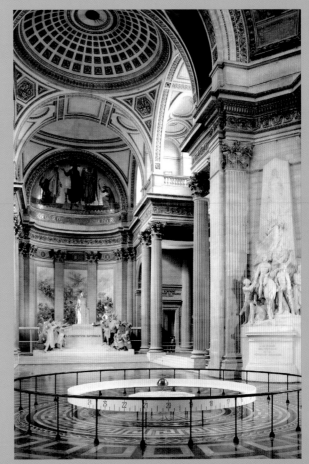

Foucault's pendulum under the dome of the Panthéon

foundation stone of the facade, with conse-cration taking place in 1626. The lengthy building period led to a fusion of different styles, from Flamboyant Gothic to early Baroque elements. A Mannerist symbiosis of different ornamental elements can be seen in the stucco work and pediments of the facade, added as a final touch to the main Gothic structure by Claude Guérins. Over the portal in the Classical style with a triangular pediment there is a segmental pediment with Gothic rose window, which is in turn surmounted by a steeply pitched gable with an oculus. The main facade is adorned with rich sculptural ornamentation in the form of vases and volutes, which had to be replaced in the 19th century; the axial symmetry is broken by the tower, which is offset to the side.

Interior with rood screen

Clearly influenced by the floor plan of Notre Dame, the interior still has Gothic pointed arches in the choir, but Renaissance elements in the nave and transept. The only remaining rood screen in Paris, which was probably built between 1530 and 1535 by Philibert Delorme, spans the interior in a broad, three-centered arch with a finely chased balustrade above the central nave. Two ornately carved spiral staircases lead up to the rood loft, where the readings were given, and also pro-vide access to the choir gallery. Of particular note are the high quality bas-reliefs in the pendentives of the rood screen arch.

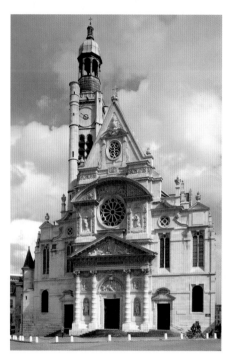

St-Étienne-du-Mont

When the quarter around St-Étienne became densely populated in the 15th cen-tury, primarily with the large number of university students, it proved necessary to rebuild the parish church, which dated back to 1222 and at the time belonged to the Ste-Geneviève monastery directly adjacent. The works dragged on for over 120 years; in 1610 Marguerite de Valois personally laid the

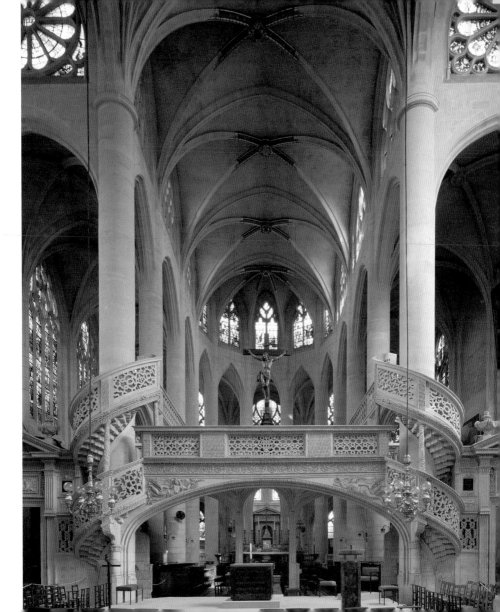

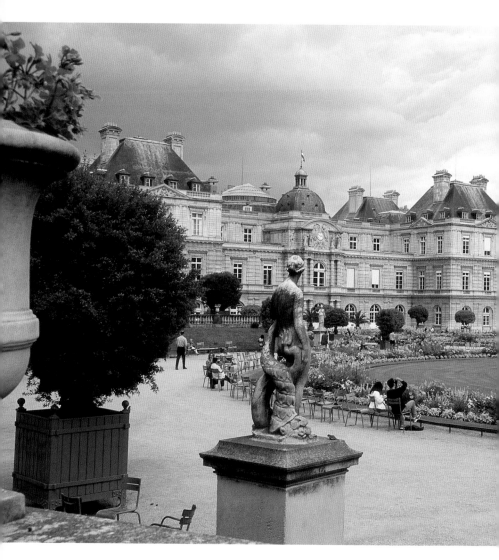

Jardin and Palais du Luxembourg

Following the murder of her husband Henri IV in 1610, Maria de' Medici bought a sizeable piece of land from François de Luxembourg to build a prestigious palace for herself far away from the Louvre. She commissioned its design to Salomon de Brosse (ca. 1571–1626), who followed her wishes and based it on Palazzo Pitti where she spent her childhood. The plans of the Florentine castle were dispatched to Paris and de Brosse's sketches were examined in Italy. Yet the layout, with the corps de logis and two side wings flanking a cour d'honneur, were typical of a French palace. Italianate influence can be detected particularly in the design of the facades, with their coarse rustic style and heavy pilaster order. Maria de' Medici moved into the unfinished palace in 1625, but it was this refuge of all places that became the stage for serious disputes with her son, Louis XIII, and

Cardinal Richelieu, whom she had installed in the adjacent Petit-Luxembourg in the belief that he was her ally. In 1631, just a year after the palace was completed, the widow was forced to flee into exile. She died in 1642 without ever seeing again either the palace or the fabulous Medici Cycle painted by Peter Paul Rubens for the gallery in the right wing between 1622 and 1625. These paintings are now on display in the Louvre. The gardens, which form one of the best loved parks in the city center today, are a classic example of French landscape design—the main axis is formed by the large octagonal pond, from which a uniform layout of paths radiates out through the green space with its flowerbeds and borders. It was extended to the south as far as the observatory after the demolition of an old Carthusian monastery during the Revolution, and now terminates at Boulevard Montparnasse.

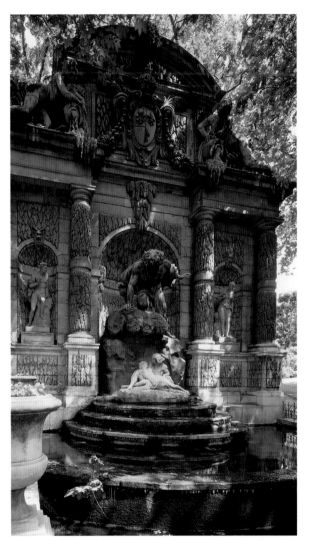

Fontaine de Médicis

All that now remains of the park that was originally modeled on the layout of the Boboli Gardens in Florence is the man-made grotto. The gardens were completely altered during the early 19th-century building works that turned the palace into the seat of the Senate. Jean François Chalgrin, who directed the construction work, built a fountain inside the grotto. Even the central sculptural group with the giant Polyphemus (he is in love with Galatea but finds her with Acis) is a 19th-century addition. The faun and huntress located in niches to the right and left were completed around 1860. The only copies from the original are the tympanum, with the Medici coat of arms, and the two river gods, of the Rhône and the Seine. Yet the park creates the impression of the Italianate gardens with their natural design and absence of geometric rigor.

"America is my home, but Paris is where I feel at home"—the American scene on the Left Bank

by Martina Padberg

There were many reasons to make the pilgrimage to Paris in the first half of the 20th century—fleeing from family or social pressures, longing for a freer and self-determined life, or hoping for

Man Ray (Emmanuel Radnitzky, 1890–1976). Portrait of Gertrude Stein, ca. 1930

fresh inspiration for one's own artistic work. An international band of art students gathered in the "cultural capital of Europe"—successful and less fortunate painters, talented and talentless writers, dancers, and musicians, all trying their luck in the "city of light." The Americans formed a particularly large and close-knit group. The puritanical mentality and narrow-mindedness of the American meritocracy, and possibly Prohibition as well, ensured that the young, intellectual elite preferred to move to the Paris scene. Depending on financial circumstances, they lived in one of the luxury "hôtels particuliers" or in a small, shabby room. But it was always on the Rive Gauche (Left Bank), the spiritual center of the city near the Sorbonne, where the stylish university life was still the order of the day and very cheap at that.

Bags hardly unpacked, many an émigré then launched enthusiastically into a life of which he, or she, had long dreamed—for many, Paris became a turning point, and sometimes a point of no return as well. This was the case for Gertrude Stein (1874–1946), one of the most glamorous figures within the artistic and literary scene, who never went back to the USA. Shortly after she moved to Paris with her brothers Leo and Michael in 1903, she swapped her "boring" medical studies for the unconventional life of a writer. She set up house in Rue de Fleurus, which became one of the most important and

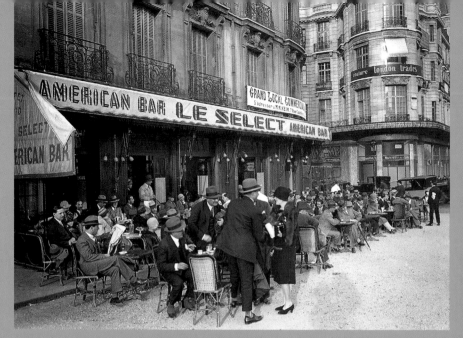

Meeting place of the American avant-garde in Paris—"Le Sélect" cafe in Montparnasse, ca. 1926–1927

exclusive meeting places in the city. With plenty of intuition and progressive taste, she began around 1905 to buy paintings by avant-garde artists who were still quite unknown at that time, and thus ranked among the first collectors of Henri Matisse, Pablo Picasso, and Georges Braque. At her regular weekly soirees, she introduced artists to influential critics, buyers with purchasing power, and young art students. Even for many American writers like Ernest Hemingway and Ezra Pound, Gertrude Stein was a contact point in both professional and personal matters.

Unconventional lifestyle choices were accepted in the milieu of the Paris art scene, so it is hardly surprising that many women who felt bound in domesticity at home came here to lead an independent life. The young Sylvia Beach (1887–1962), who would also spend the rest of her life in the French capital, took her parents by surprise back home in Princeton in 1919 with the telegram notifying them that she had opened a bookshop in Paris. "Shakespeare and Company" in Rue de l'Odéon rapidly became an institution—not only were books bought here, but literary history was written as well. Ernest Hem-

ingway, F. Scott Fitzgerald, John Dos Passos, e.e.cummings, and Henry Miller—all found their second home in the bookshop of Sylvia Beach. They could borrow the most recent English books for free, and even rely on credit when times were tough. If money problems were really bad, then it was possible to apply to the exceptionally rich, generous, and eccentric Natalie Clifford Barney (1876–1972), who lived in a luxurious house in Rue Jacob from 1902 onward and broke the hearts of countless women with her "scandalous" behavior.

Pushing back boundaries, breaking taboos, and taking risks in one's artistic and private life all characterized the time in Paris for many Americans. Heavy drinking, love, and suffering were in evidence, but there was hard work too. First really important works frequently appeared here; even, sometimes, the big break to fame and fortune. Hemingway started work on his novel "Fiesta," John Dos Passos developed a new narrative structure similar to collage with his "Manhattan Transfer," Henry Miller shattered all formal and moral benchmarks with his "Tropic of Cancer," Man Ray carved out an impressive career as a photographer, Alexander Calder built his first mobiles, Isadora Duncan charmed the whole of Paris with her modern dance, Cole Porter worked on jazz compositions, and George Gershwin sketched out his initial ideas for the musical "An American in Paris," which later won an Oscar. When World War II broke out, the lights were extinguished, and after 1945 the cultural life never returned to its previous intensity.

On looking back especially, as a bewildering array of autobiographies did, the years in Paris

American publisher and bookshop owner Sylvia Beach, founder of "Shakespeare and Company," 1920

seemed like a "moveable feast"—the title of a novel by Hemingway.

St-Sulpice

Over a period of more than 200 years, five principal architects were involved in building the new parish church of St-Germain, which was started in 1646 with the laying of the foundation stone by Anne of Austria. Lack of funds, the unrest of the Fronde wars, and then the Revolution brought the work repeatedly to a standstill. The nave and transept were completed under Curé Languet de Gergy, who was the parish

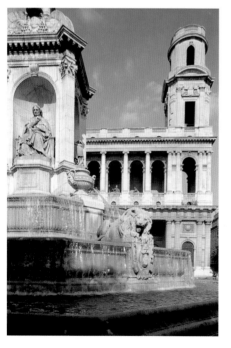

priest from 1714 through 1748 and whose rather whimsical tomb is located in one of the St-Sulpice chapels, albeit in a now incomplete state. A competition was launched for the facade design in 1732, which was won by the Florentine Jean-Nicolas Servandoni with an early Classical submission. Servandoni, who actually specialized in theatre design, created a main facade that harks back to the architecture of the Roman Empire with its two tiers of Doric and Ionic columns, exuding simple rigor as well as monumental grandeur. But even the facade was never actually finished—only one of the two towers was built, and the pediment between them was destroyed by lightning. The fountain by Louis Visconti has stood in front of the church since 1844 and is dedicated to four bishops; it emphasizes the austere effect of the church's architecture.

The Lady Chapel

Very little of the old interior was left, for the rich parishes were plundered during the revolutionary turmoil of 1793 when the church was re-designated as the "temple of reason." For the inauguration, a sparsely dressed young woman with bared breasts, representing Reason, was carried through the nave and surrounding streets. In 1790, the famous revolutionary Camille Desmoulins married his wife Lucile in St-Sulpice. Their best man, Robespierre, sent the couple to the guillotine four years later,

along with Danton. When the storms of the Revolution had abated, St-Sulpice was once again consecrated as a church, in 1800. The previous year, Napoleon had held a celebration here on his return from his controversial Egyptian campaign. Today, the most impressive feature is the Lady Chapel, which boasts colored marble, paintings (1746–1751) by Carle van Loo, and an ornate golden entablature, and has survived as a rare example of late Baroque religious art in Paris. Visible from the entrance there is a statue of the Virgin on top of the globe, a major work of the sculptor Jean-Baptiste Pigalle (1714–1785), situated in a niche ornately decorated with Corinthian pilasters. Frescoes by Eugène Delacroix are in the first chapel on the south side of the transept, which he painted two years before his death in 1863, depicting Jacob wrestling with the angel and Heliodorus plundering the temple.

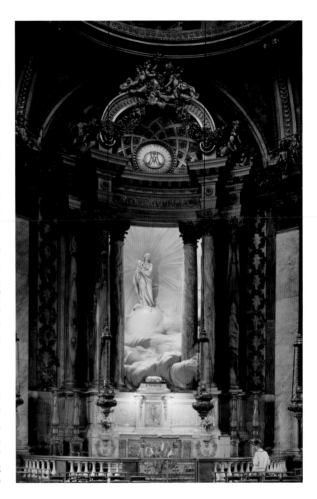

Boulevard St-Germain

Boulevard St-Germain is the main artery of the Rive Gauche, running across it from east to west from the 5th to the 7th arrondissement. A pulsing center with lots of cinemas and bistros, it stretches between the junction of Boulevard St-Michel and the monastery church of Saint-Germain-des-Prés. Opposite the church are the two historical cafes, Aux Deux Magots and Café de Flore, where the "who's who" of artists and literati has been meeting since the 1920s. Guests included the Surrealists around André Breton and Max Ernst as well as Pablo Picasso, Alberto Giacometti, Albert Camus, and Antoine de Saint-Exupéry. In the post-war period, the cafes became the public place of work for the Existentialist circle around Jean-Paul Sartre and Simone de Beauvoir.

Market stall on the busy Rue de Buci

Cafe "Aux Deux Magots"

Inside the cafe "Aux Deux Magots" on Boulevard Saint-Germain

Writing, discussions, and arguments were conducted in the well-heated rooms. On the other side of the street in Brasserie Lipp, a hungry Ernest Hemingway stopped off during his early years in Paris (1921–1926), if he had enough money. Today the brasserie, founded in the 19th century by a cafe owner from Alsace, is a meeting place for famous people in Paris. Little streets branch off on both sides of the boulevard, and a large number of publishers, archives, galleries, and antique dealers have become established there. The famous bookshop of Sylvia Beach, "Shakespeare and Company," which became a second home to many English and American authors in Paris, has been in Rue de l'Odéon since 1921. Hemingway was in and out of it just as much as James Joyce, whose *roman-à-clef* "Ulysses" was published in 1922 at enormous financial risk by Sylvia Beach, as no established publishing house would take it on.

St-Germain-des-Prés

View of the former abbey of St-Germain-des-Prés, ca. 1640
Copper engraving, Bibliothèque Nationale, Paris

Apart from the church and the 16th-century abbot's palace in Rue de l'Abbaye, little is left of the former large Benedictine monastery, which was fortified after experiencing numerous attacks and looting by the Normans in the early Middle Ages. The fortress-like west tower dating back to the early 11th century, which is the oldest church tower in all of Paris today, does however convey something of the need for protection felt by the abbey lying outside the city walls. During the Revolution, the monastery was secularized, and in September 1792 it became the stage for a bloody massacre that left over 300 dead. The tombs of Merovingian kings that had lain here since the 6th and 7th centuries were destroyed along with the sculptural ornamentation of the west portal, which was suspected of depicting the iconography of the ruling class. A text

A. *Porte de l'Abbaye.*
B. *L'Eglise.*
C. *Chapelle de la Vierge.*
D. *Refectoire.*
E. *Dortoir.*
F. *Cloitre.*
G. *Bibliotheque.*

H. *Le Pressoir.*
I. *Infirmerie.*
K. *Jardin.*
L. *Porte Papale.*
M. *Fosses.*
N. *Maison Abbatiale.*
O. *Chapelle de S. Symphorien.*

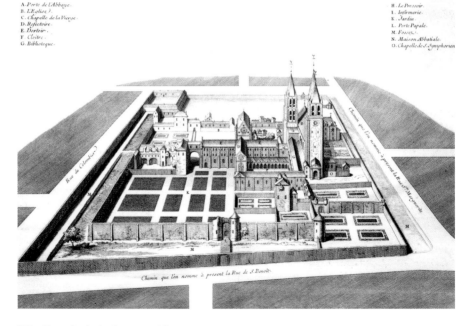

from the 9th century documents what were once the magnificent features of the Merovingian church, said to have included marble columns, richly gilded walls and roof truss, and an elaborate mosaic floor. Over many centuries the monastery developed into an autonomous local community under the direct authority of the Pope, which flourished both economically and culturally. Renowned scholars of the arts who were members of the convent made St-Germain-des-Prés into an intellectual center in France. Its excellent library had been opened up for research purposes by the 17th century.

The five-bay nave has been preserved from the Romanesque 11th century building, although originally it was flat roofed and had an open roof truss, and was not vaulted until the 17th century. The south wall was also rebuilt during this construction work, for structural reasons. The originals of the Romanesque capitals can now be found in the Musée de Cluny, but even the reproductions convey an idea of the original sculptural ornamentation. The early Gothic choir with ambulatory and radiating chapels was consecrated in 1163 by Pope Alexander III, the same year the foundation stone was laid in Notre Dame. It has a three-level elevation with arcades, triforium, and clerestory. The clerestory windows were enlarged at a later stage to allow more light into the main body of the church. The pointed arches of the triforium were sacrificed in this process. The massive, round piers in

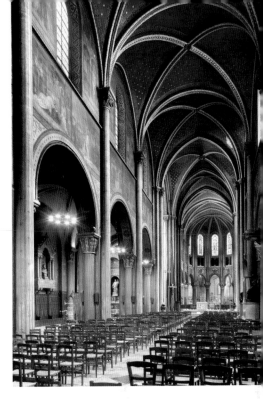

the choir, the alternating capitals of which have either acanthus carvings or figures, stand out conspicuously. Also worth noting is the beautiful marble statue "Notre Dame de Consolation", the Virgin comforting the baby Jesus, dated around 1340: it is situated on the right side next to the entrance in the south aisle.

The Prince of Saint-Germain-des-Prés— the life and times of Boris Vian

by Nicole Colin

The short life of Boris Vian (1920–1959), who suffered from a heart condition, seems like a race against time. The feverish profusion and variety of his work reflects the attitude to life of a whole generation of artists and intellectuals who are recorded in history under the collective name "existentialists."

It was the love of jazz that drew Boris Vian into the artistic scene and out of his sheltered upbringing. As a real all-rounder, this trained engineer worked first as a jazz trumpeter and then as a critic, writer, and translator. He wrote nine novels, countless poems, and over 500 songs of different kinds, from anti-war protests to nonsense hits. He wrote plays and opera, screenplays and sketches, and also worked as an actor and chansonnier. Math and physics interested this restless universal genius as much as poetry and philosophy. As a member of the elite "Collège de Pataphysique" he fought to disseminate Alfred Jarry's logic of the absurd alongside Marcel Duchamp, Max Ernst, Joan Miró, Michel Leiris, Man Ray, and Eugène Ionesco.

The cafes of Saint-Germain-des-Prés were the center of literary, artistic, and intellectual life at that time, especially the "Deux Magots," the "Rhumerie," and the "Flore." The uncrowned king and spiritual heart of this kingdom was Jean-Paul Sartre, who put his finger on the pulse of the time and became a cult figure. Existentialism became a fashionable lifestyle choice and spread triumphantly from Paris to the rest of Europe. There was less interest in the complex deliberations of Sartre than in rebelling against the conventions of society, as being existentialist was perceived. In his "Manual of Saint-Germain-des-Prés," Boris Vian caricatured bourgeois notions of the bohemian, existentialist lifestyle—after relaxing in the morning sun at the "Flore," they strolled down to the "Deux Magots" for afternoon coffee, and then ended up around midnight in a cellar bar, where they partied the night away until dawn.

And, in fact, the life of Vian was rather like that. Unlike Sartre, Prince Boris—as he was known—was a committed skeptic who avoided political debates, concentrating instead on his work as a musician and entertainer. In 1942, he started an amateur jazz band with Claude Abadie, playing the small bars and cafes in Saint-Germain-des-Prés; he was the undisputed leader of the jazz clubs in the quarter. In 1947, Frédéric Chauvelot hired him as a trumpeter and gig organizer for the "Tabou" club, "the most famous cellar after the liberation" (Boris Vian), where the intellectual elite rubbed shoulders and danced with celebrities such as Maurice Chevalier, Yves Montand, and Martine Carol.

Among those he put on stage here was the young Juliette Gréco, who became the muse of the Existentialists—even Sartre, Albert

The "Café de Flore"—meeting place of Parisian intellectuals in the 1950s

Camus, and François Mauriac wrote songs for her.

The disreputable charm of the cafes and artists' cellars could only be sustained for a short time, however. The haunts soon became well known and sought out increasingly by freeloaders who wanted to dip into a world outside the bourgeois moral order for just one night. The real protagonists felt compelled to escape. In 1948, Chauvelot left the "Tabou" and set up the exclusive "Saint-Gérmain-des-Prés" club, where Boris Vian showcased stars of the international jazz scene including Duke Ellington, Charlie Parker, and Miles Davis.

His success as a musician made Vian into a well known personality, whereas his literary works were scarcely noticed. Disappointed by the lack of interest in his novels, Vian made a bet and in the space of just two weeks wrote the scandalous detective novel "I will spit on your graves," which he published in 1946 under the pseudonym Vernon Sullivan. As a result of the scandal created by this book, which was crammed with sex, blood, and whiskey, it did in fact become his greatest success, though it ended up bringing him more trouble than it was worth. The novel was finally banned in 1949 at the end of a drawn-out legal process. Vian was outraged when Michel Gast turned it into a dull, schmaltzy movie dealing with social issues in 1959. He went to the preview in the Marboeuf cinema to have his name removed from the credits, but collapsed and died in the theatre.

Boris Vian, 1956

Boulevard Montparnasse

Auguste Rodin, Honoré de Balzac, 1891–1897
Bronze, ht. 297 cm

The great Boulevard Montparnasse with its constant bustle marks the northern boundary of the eponymous quarter that was opened up by the urban developments of Haussmann in the 19th century and took over from Montmartre in the early 20th century as the quarter favored by artists. During the inter-war period, in particular, Montparnasse saw its most exciting times and became the melting pot for a cosmopolitan scene, characterized by Americans such as Alexander Calder and Man Ray; the Spanish Surrealists around Salvador Dalí, Joan Miró, and Luis Buñuel among others; the Italian Amedeo Modigliani; Germans like Max Ernst and Max Beckmann; and many Russian-born artists, including Sergei Eisenstein and Ossip Zadkine. The places where the international avant-garde used to meet at the Carrefour Vavin are still there—the cafes and brasseries—La Coupole, Le Sélect, La Rotonde, and Le Dôme, where noisy celebrations and parties took place. At the junction with Boulevard Raspail, take a second look at the monument to writer Honoré de Balzac (1799–1850). Auguste Rodin was commissioned to produce this by the French writers' association, its long gestation period lasting from 1891 through 1897. When the finished sketch for the mono-

lithic figure was exhibited in public in the Salon of the Société Nationale, a cry of indignation broke out. The disparity between the conception of what a monument to a writer should be and the passionately depicted figure before them—wrapped up in a cloak with a fleshy face ravaged by life—was too great. The first bronze cast was not made until 1930, and nine years later the sculpture was allocated its current public place in the city.

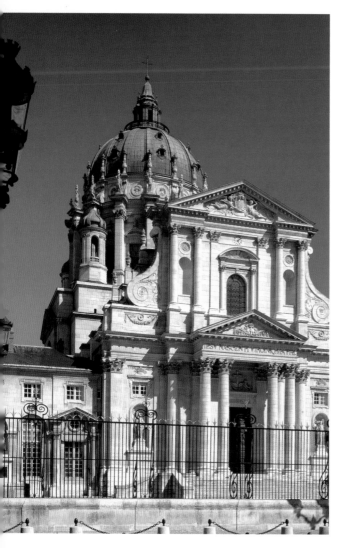

Val-de-Grâce

The church was an endowment by Anne of Austria to the congregation of the Benedictine monastery, after she gave birth in 1638 to the heir to the throne and future king, Louis XIV, after 20 years of marriage. In front of the church is a cour d'honneur, which is flanked by two corner pavilions and closed off on the street side by cast iron railings. An ornately decorated drum with dome and lantern rises up from a double facade with a Corinthian portico. Combining both French and Romanesque influences, the building was designed by François Mansart in 1645, with some of the detail being reworked by Jacques Lemercier. Today the church, which has an impressive interior, can only be visited in guided tours, as the former monastery complex now houses the French military hospital with an associated museum.

View of the Val-de-Grâce abbey
Copper engraving, 1668, Bibliothèque Nationale, Paris

Anne of Austria (1601–1666), the Spanish infanta and daughter of Philip III of Spain, was still a child when she was betrothed to Louis XIII in 1615 as part of the alliance between Spain and France. Her position at the French court was, and remained, extremely difficult, as the king and his closest advisor, Richelieu, regarded her as an enemy in her own house because of her Spanish origin. For a long time the marriage seemed doomed to be childless.

For this reason, Anne made a refuge for herself in a newly settled Benedictine monastery in Faubourg St-Jacques. In 1655, work began on a new building in the monastery complex, which reminded her of the Escorial in her homeland with its long facade and corner pavilions facing the garden. The regent was already spending most of her time in the complex, which was at that time far from the city, and she designed a palace for the location which was never actually built. Today, the former monastery is completely surrounded by housing and accessible from Rue Saint-Jacques.

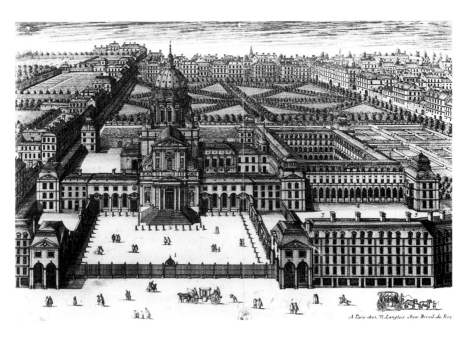

A Paris chez N. Langlois Avec Privil. du Roy

Fondation Cartier

The building by Jean Nouvel (1994) on Boulevard Raspail houses the administration of the Cartier group and its associated foundation, which is dedicated to supporting the arts.

Nouvel, who had already designed the Institut du Monde Arabe in Paris in 1987 and is, without doubt, the most important contemporary architect in France, developed a structure that appears to work without walls and is joined together by tiered sheets of glass. The transparent material is constructed as layered sheets jutting from the body of the building both lengthways and breadthways, in the form of free-standing glass membranes; at these points, the structure becomes completely translucent. With this commission, Nouvel seems to have carried through his own programmatic statement about the dematerialization of architecture in the age of virtual reality. This minimalist building does have its pit-

falls, however—the massive influx of light and absence of solid wall surfaces are extremely restrictive in terms of its use as an exhibition venue.

A second glass screen forms a shield between the building and the street, opening up to make way for an old Lebanese cedar that was planted here almost 200 years ago by the Romantic writer and statesman, Chateaubriand (1768–1848). Visitors to the exhibition are directed into the building under the branches of this imposing tree—with its complex structure, it seems as if the building seeks to remain as mysterious as the garden it encloses. Here the artist, Lothar Baumgarten, created a "botanical theater," an installation that continually changes with the seasons, using 35 varieties of trees and over 200 different plant species native to France.

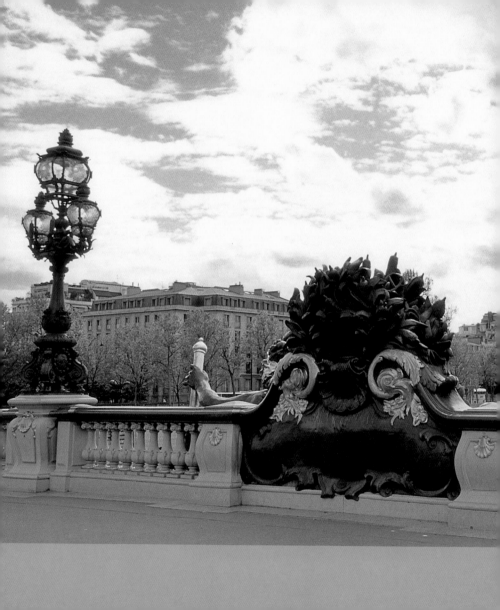

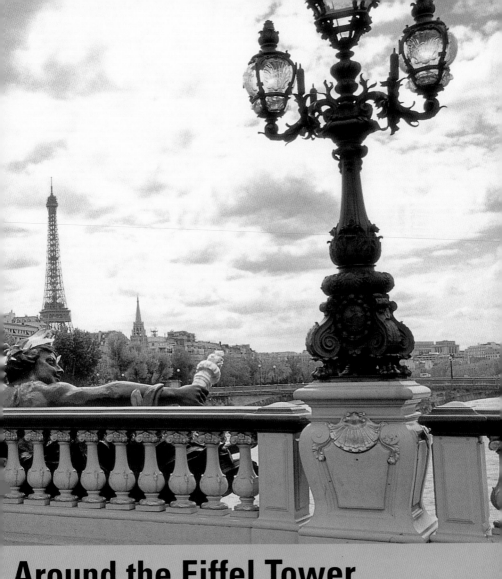

Around the Eiffel Tower

Around the Eiffel Tower

A trade fair, a cabinet of curiosities, a zoo, a botanical garden, a museum, and an amusement park—the six international exhibitions that took place between 1855 and 1937 on the Champ-de-Mars in Paris catered in a variety of ways for the thirst for knowledge and desire for sensation on the part of visitors. They were able to marvel at technical

Champ-de-Mars, view from the Eiffel Tower

innovations, expensive luxury goods, and all sorts of weird and wonderful items from the colonies. At the same time, however, the euphoria about progress around 1900 manifested itself in an ambivalent way. This was indicative of the inner turmoil of the fin-de-siècle, a reaction to the constant stream of new inventions and the huge uncertainty caused by the upheavals of the Industrial Revolution.

Elaborate pavilions and stunning buildings were created to display this "walk-in panorama," such as the Gallery of the Machines (1889) whose steel frame construction gave the glass hall a spectacular width span of 380 ft. (115 m), or the Palais du Trocadéro (1878), a round building in the Neo-Byzantine style that was straight out of a fairy tale, with its towers and wings curving out on each side. Only the Eiffel Tower (1889) and the Palais de Chaillot (1937) still survive today, marking out the important urban transverse axis from the elevated north bank of the Seine across the Champ-de-Mars to the École Militaire.

Musée du Quai Branly, which opened in 2006 close to the Eiffel Tower, sets a new tone in architectural terms. The commission for this project, personally promoted by Jacques Chirac, went once again to the architect Jean Nouvel. In keeping with his philosophy of creating architecture that has an interactive relationship with its environ-

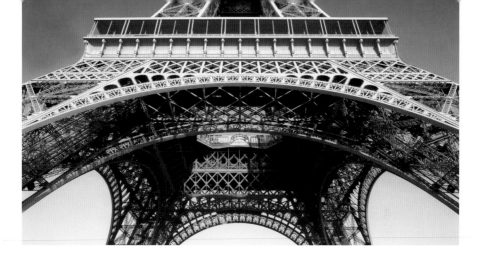

ment, he "grew" a glass wall (40 ft./12 m high and over 650 ft./200 m long) that separates the museum grounds from the heavy traffic of the road on the bank of the Seine, while still affording passers-by a view of the whole museum complex of five separate buildings. This is the worthy new home to the art of Africa, Asia, America, and Oceania, which was previously housed on the outskirts of the city at Porte Dorée and in the anthropological museum at Trocadero. The place where the worlds of the 19th century came together thus continues to be a venue for the unknown, where perhaps for the first time the 21st century can achieve a perspective that is free from Eurocentric prejudices and projected assumptions.

Preceding spread: The Eiffel Tower from Pont Alexandre III

Adjoining it to the west on either side of the Seine is the elegant 16th arrondissement, which was formed under Haussmann from the three rural communities of Chaillot, Passy, and Auteuil. Julien Green, who spent his childhood in Passy, recounts vivid memories in his little autobiographical work "Paris" (1983) of the narrow, cobbled village streets and the peace and quiet of the area away from the city. That has all gone, now that the land has been developed with wide street axes like Avenue Foch to the north and the boulevards. Large apartment blocks in historicist and Art Nouveau styles are reminders of the origins of the area, however, so walking around is still a pleasure.

Around the Eiffel Tower

Musée Guimet, 6, Place d'Iéna, p. 342 ff.

Palais de Tokyo/Musée d'Art
Moderne de la Ville de Paris,
13, Av du Président-Wilson, p. 332 ff.

Musée du Quai Branly
p. 336 f.

Also worth seeing

1 UNESCO, 7, Place de Fontenoy, p. 312 f.

2 Champ-de-Mars, p. 324

3 École Militaire, Av de la Motte-Piquet, p. 325

4 Musée des Monuments Français, p. 330 f.

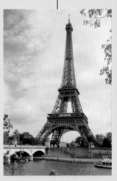

Eiffel Tower, Quai Branly, p. 326 f.

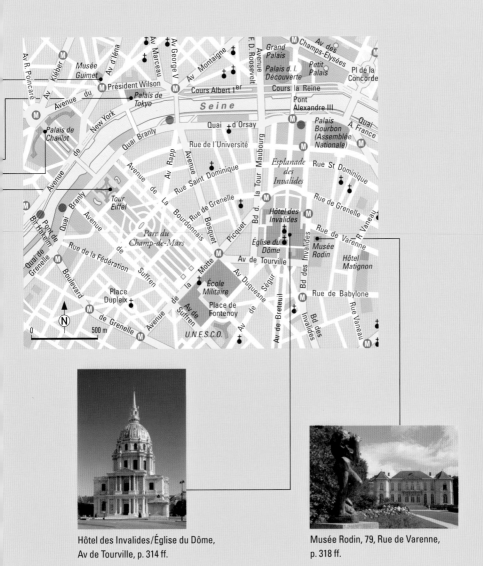

Hôtel des Invalides/Église du Dôme,
Av de Tourville, p. 314 ff.

Musée Rodin, 79, Rue de Varenne,
p. 318 ff.

UNESCO

The largest international organization in Paris, UNESCO (United Nations Educational, Scientific and Cultural Organization) has been located on Place de Fontenoy since 1958. Founded in the immediate aftermath of World War II in London in 1946, the aim of UNESCO is to raise the level of education on a worldwide basis. This was instigated by the realization that people are less susceptible to manipulation by totalitarian systems if their knowledge and qualifications enable them to make decisions for themselves. The striking complex, comprising a main administration building, conference center, and delegates' building, was built between 1955 and 1958 as a collaborative international project. Those involved were the Hungarian-born Marcel Brauer (1902–

1981), who worked in the Bauhaus in Dessau in the 1920s and lived in the USA from 1937, the Italian architect Pier Luigi Nervi (1891–1979), and Bernard-Louis Zehrfuss (1911–1996) from France. They designed a three-wing administrative building realized in the shape of a Y, which rested on massive concrete piers. Seven floors rise above the open first floor, which are articulated externally by vertical concrete pilaster strips and horizontal bars in the form of a grid. The closed-off end walls and flat roof give the building, which has over 1,000 windows, a rigorous, cubic form that is derived from the Bauhaus tradition. More than anyone, however, Le Corbusier, who worked in Paris in the 1920s and 1930s, paved the way for the UNESCO building. In his famous Five Point Plan of 1927, he identified the most significant criteria for modern house building as free-standing

concrete supports (pilotis), the self-supporting steel frame construction, the open floor plan, the curtain facade of broad horizontal windows, and the flat roof—all architectural concepts that have been realized in this building. Unfortunately, the building is beginning to show its age all too clearly.

Many internationally renowned artists took part in the external decoration and interior design of the building and its gardens, but their work can only partially be seen from the outside by visitors. For instance, Pablo Picasso's mural "The Fall of Icarus" and Miró's famous ceramic wall depicting the sun and moon are both located inside the complex. Likewise, the relief by Hans Arp and the tapestry by Jean Lurcat and Le Corbusier cannot be viewed when walking around the building. On the other hand, the beautiful Japanese garden designed by Isamu Noguchi can be seen from Avenue de Saxe. From Avenue de Suffren, a monumental sculpture by Henry Moore and an equally large mobile by Alexander Calder are visible. In the newer, cube-shaped annex are works by Alberto Giacometti, Eduardo Chillida, Jesús Raphael Soto, and Ellsworth Kelly. There are also internationally significant artistic posts represented in the UNESCO assembly that ensure the daily work of the organization takes a more fulfilling direction and also provide guidance, not just in aesthetic matters.

Hôtel des Invalides and the Eglise du Dôme

Under Louis XIV and the Marquis de Louvois, Secretary of State for War, a comprehensive reorganization and modernization of the French army was undertaken, which also included the establishment of a hospital for invalids to care for wounded soldiers and provide accommodation for disabled veterans. The massive complex is like a monastery, whose inner courtyards are interconnected by walkways over 10 miles (17 km) in length. It was built between 1671 and 1674 in front of the gates of Paris on Grenelle Plain, based on designs by Libéral Bruant. The establishment was soon occupied by up to 6,000 pensioners who, though protected from hardship by state welfare, had to follow a strict daily regime—every time they went out or received a visitor, they needed permission from the governor, while everyone who was still physically capable had to take part in church services, practice drills, and guard duty. The army museum, which is still housed in part of the complex today and is dedicated to the complete military history of France, documents the living conditions at that time in the Hôtel des Invalides. Models and plans for the French fortress can be viewed in the relief maps gallery.

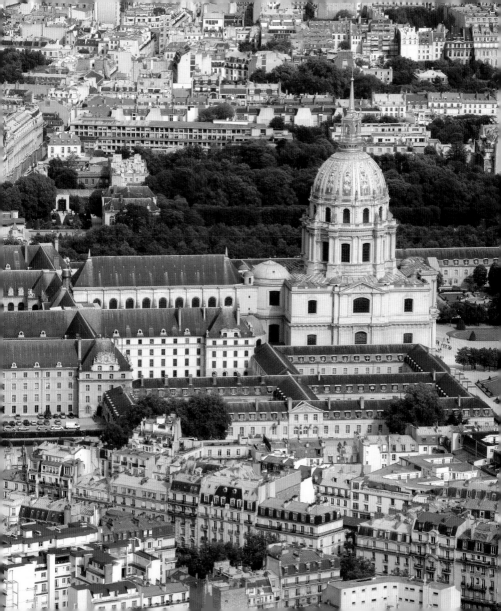

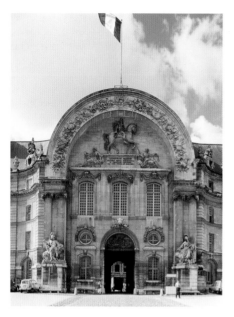

rich ornamentation on the great ceremonial portal glorifies the military victories of Louis XIV, whose equestrian statue appears in the tympanum, flanked by the allegorical figures of Justice and Wisdom. This is, however, a replica as the original work by Guillaume Coustou was destroyed during the Revolution. The inscription on the pedestal relief identifies the king as the charitable patron of the building.

Plan of the Église du Dôme

In 1676, Louvois commissioned the young architect Jules Hardouin-Mansart to design the crowning glory of the extensive building project—a chapel for the court's festival services that would adjoin the simple soldiers' church and also form the main facade of the whole institution. Hardouin-Mansart found a wonderful solution to this complex task by adding a central building in the shape of a Greek cross onto the long structure of the soldiers' church, along the lines of Baroque pilgrimage churches. This building is structured according to strict geometric principles: all of the other spatial components are measured in relation to the radius of the rotunda. Thus a separate church building was created with a facade configured in the grand style with a paired Ionic and Corinthian column order.

Esplanade and North Facade

The Hôtel des Invalides complex is closed off on the city and Seine sides by an extensive esplanade that leads to Pont Alexandre III. In the past, the residents had easy access to a ferry point from which they could be taken over to the other bank, while the home could be supplied with all necessary provisions. Robert de Cotte designed the overall layout of the landscaped areas and the north facade from 1704 through 1720. From this side, the site is accessed through an ornately decorated gate of honor, past defensive tombs armed with cannon. The

Interior view

The church, probably designed as the burial place for Louis XIV, was completed in 1706 and became the mausoleum for Napoleon Bonaparte in 1840—his remains were brought back to Paris from exile in St Helena, where the deposed emperor had died in 1821. Louis Visconti installed an open crypt directly underneath the dome, where the oversize porphyry sarcophagus was finally installed in 1861. The whole design scheme for the crypt was geared towards the glorification of the emperor: twelve marble statues bearing victory symbols surround the tomb, while ten bas-reliefs in the round gallery celebrate the successes of his state policy. The entrance to the crypt, guarded by two bronze statues, is reached by stairs behind the altar. The inscription above it is taken from Napoleon's testament, and reads: "I would like my remains to rest on the banks of the Seine, among the people I have loved so much." Visconti's reconstruction work made lasting changes to the main body of the church; whereas Hardouin-Mansart's original concept drew the visitor's gaze up to the triple shell dome with paintings by Charles de La Fosse, the crypt and tomb now dominate the overall impression.

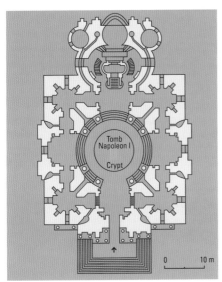

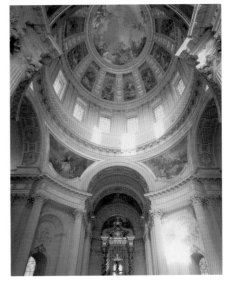

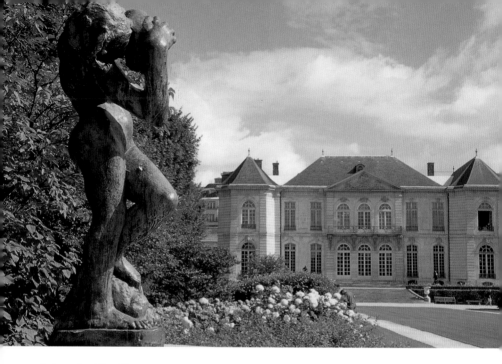

Musée Rodin

It was Rainer Maria Rilke who encouraged
Auguste Rodin, the sculptor for whom he
worked as secretary, to move into Hôtel
Biron. "My dearest friend," he wrote on
August 31, 1907, "you should see this beau-
tiful building and the room I have just
moved into today. Its three wings have a
wonderful view onto an overgrown garden
where occasionally you can see rabbits
jumping gaily through the fences just like
on old tapestries." Built between 1728 and

1731 by Jean Aubert for the wealthy wig-
maker and speculator Abraham Peyrenc de
Moras, the Hôtel Biron resembles a chateau
and is a typical example of the formal palace
architecture of 18th-century Paris. With a
nine-bay elevation on the garden side and
eleven-bay facade on Rue de Varenne, the
three-wing structure is clearly articulated
with subtle, elegant ornamentation in the
Rococo style. The stately building, framed
by projecting corner pavilions, was home to
the Duc de Biron from the middle of the
eighteenth century. He remodeled the
extensive grounds into one of the most

attractive parks in the city. Many other owners occupied it, including the Papal legate and the Russian embassy; it also served as a home for young girls run by the Société du Sacré-Coeur de Jésus. In 1905 the French state acquired the premises, which by then were in a very dilapidated condition, and made rooms available as artists' studios. As well as Jean Cocteau, Henri Matisse, and the famous dancer Isadora Duncan, the sculptor Clara Westhoff also worked here, who handed over the studio in 1907 to her husband, Rainer Maria Rilke. Auguste Rodin (1840–1917) moved into the building at the age of 68, purchased it within a year, and was soon planning to turn it into a museum. With this in mind, he bequeathed his assets to the French state in the form of a generous endowment. This collection, which was opened to the public in 1919, provides a comprehensive overview of Rodin's sculptural and graphic works.

Auguste Rodin (1840–1917),
The Age of Bronze, 1876/77
Bronze, 178 x 59 x 61 cm

This early work by Rodin was his very first large-scale sculpture. Even by this time his modeling of the figure was masterful; the piece is infused with a vibrant, life-like quality enhanced by the play of light on the bronze. Rodin completely avoids any descriptive details or subject matter—neither the figure nor his gesture of desperation lend themselves to interpretation in the absence of any significant associated data, such as an explanatory title for the work. Instead, the powerful vitality becomes the central theme. In 1880 the nude figure was bought by the French state and Rodin also received what was to be his most important commission. He was to design a monumental door for the proposed Musée des Arts Décoratifs. Although the museum was never built, the "Gates of Hell" developed into his life's work for Rodin.

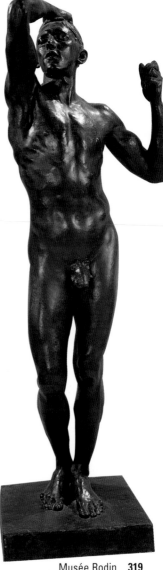

Musée Rodin

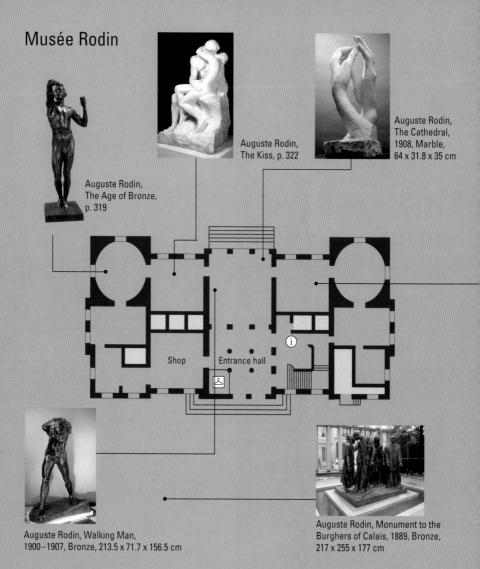

Auguste Rodin,
The Kiss, p. 322

Auguste Rodin,
The Cathedral,
1908, Marble,
64 x 31.8 x 35 cm

Auguste Rodin,
The Age of Bronze,
p. 319

Shop

Entrance hall

Auguste Rodin, Walking Man,
1900–1907, Bronze, 213.5 x 71.7 x 156.5 cm

Auguste Rodin, Monument to the
Burghers of Calais, 1889, Bronze,
217 x 255 x 177 cm

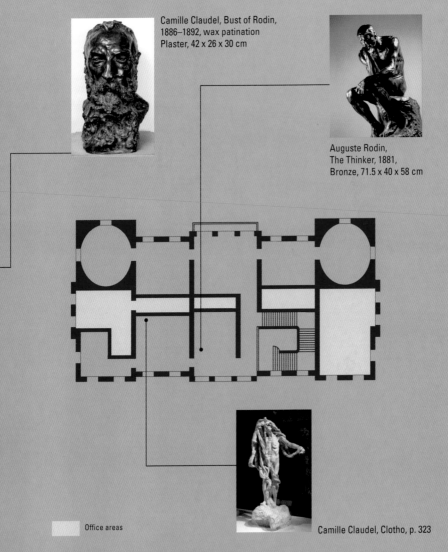

Camille Claudel, Bust of Rodin,
1886–1892, wax patination
Plaster, 42 x 26 x 30 cm

Auguste Rodin,
The Thinker, 1881,
Bronze, 71.5 x 40 x 58 cm

Office areas

Camille Claudel, Clotho, p. 323

Auguste Rodin, The Kiss, 1888/89
Marble, 181.5 x 112.3 x 117 cm

Initially created as part of the "Gates of Hell" project, this famous group of lovers was subsequently developed as independent sculptures. In their original context, they were Paolo Malatesta and Francesca da Rimini from the "Divine Comedy" of Dante. When they kiss for the first time, they die, for at that moment Francesca's husband (Paolo's older brother) surprises and kills them. This narrative context was obliterated by Rodin—instead, the historical couple is replaced by two anonymous lovers united in a moment of absolute passion.

There are replicas in Copenhagen and London of this large marble sculpture, which is regarded as one of the best known and most successful works by Rodin. The artist himself was rather more critical of this work: in a conversation in 1907 he expressed his profound skepticism about the subject and what he perceived as his traditional academic treatment of it. In its final formulation it goes against Rodin's lifelong quest for open, incomplete, and living sculpture.

**Camille Claudel (1864–1943),
Clotho, 1893**
Plaster, ht. 90 cm

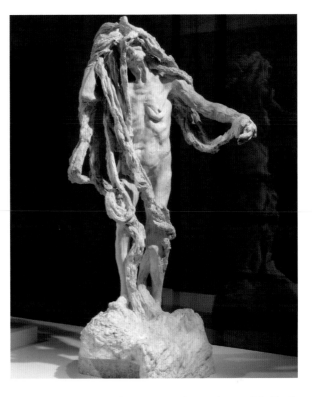

Camille Claudel began to work in Rodin's studio when she was 19 years old. She soon went from being a talented pupil to his favorite model and then his lover. For almost ten years they were bound up in an intense artistic and romantic relationship, which ended in personal tragedy for Claudel. Rodin, who was by then already 43 years old, was not prepared to leave his long-term companion, Rose Beuret, with whom he had a son. Moreover, in spite of taking part in exhibitions and receiving positive criticism, Camille Claudel, who was far younger than Rodin, never managed to step artistically from his shadow. In 1893 she broke up with Rodin for good and retreated to her own studio on Boulevard d'Italie. Many of the sculptural works from this period reflect the pain and helplessness she felt. She depicts the mythological figure of "Clotho" (one of the three Fates, who spins the threads of life and thus determines Man's destiny) as an old woman and mercilessly portrays her withered body. In 1913, suffering from severe depression and hallucinations, Camille Claudel was committed to an institution for the mentally ill by her mother and brother, the famous writer Paul Claudel. She was forced to remain there for over 30 years, until death claimed her.

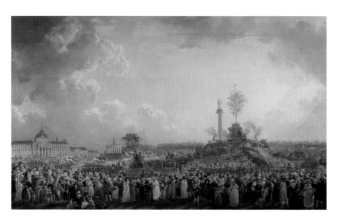

Champ-de-Mars

Pierre-Antoine Demachy (1723–1807), The Festival of the Supreme Being on June 8, 1714 at the Champ de Mars, 1794
Oil on canvas, 53 x 88 cm,
Musée Carnavalet, Paris

The large area of green parkland between the École Militaire and the Eiffel Tower that is a favorite haunt of joggers these days was used as a training and parade ground in 1765, which explains why it was named after the Roman god of war. From 1780, the Champ-de-Mars was also made available occasionally for large public events like horseracing or as the launch pad for hot air balloons. The Fête de la Fédération was held here on July 14, 1790, the first anniversary of the Revolution—it was a spectacular festival aimed at uniting a post-revolutionary nation in tatters, which was skillfully portrayed by the artist Jacques-Louis David. In front of 300,000 people, delegations from every département in France, the National Guard, and the king himself swore an official oath of allegiance at the "altar of the homeland" to the new constitution. Barely four years later, when the Reign of Terror was at its peak, Robespierre organized a "Festival of the Supreme Being" at the same spot. Once again, it was David who articulated the artistic response to the setting up of a new state religion in the society that had been radically secularized since 1789. He built a "Temple of Immortality" in the style of antiquity and erected a "Tree of Freedom" on top of an artificial hill, alongside a statue of Hercules symbolizing the strength of the revolution. Only six weeks later, on 9 Thermidor (July 27, 1794) Robespierre was executed despite his efforts to inject fresh spirit into the flagging revolution. The massive Champ-de-Mars was subsequently used in the 19th and 20th centuries for international exhibitions. Between 1907 and 1927, the exhibition area was reduced, and residential streets and a park were added.

École Militaire

The military academy, which provided free officer training mainly for young aristocrats without means, was a project sponsored by Louis XV. The king accordingly commissioned the architect Jacques-Ange Gabriel to design a lavish building that would match the scale of the neighboring Invalides of Louis XIV. The first cadets were accepted in 1777, but the building works dragged on into the pre-revolutionary period. The most famous graduate of the École Militaire was Napoleon Bonaparte, who after only 12 months' training at the age of 16 obtained a commission as lieutenant of artillery. His assessment included the following prophetic statement: "Under the right circumstances he has a great future ahead of him." The large complex, whose main facade is accentuated by eight monumental Corinthian columns and crowned by a dome, is still home to a military academy today.

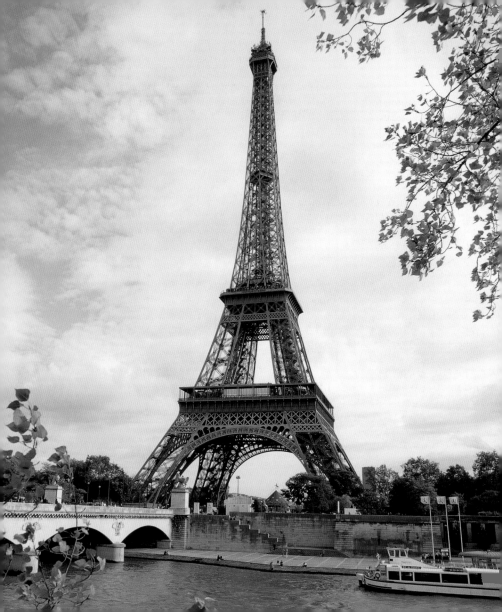

The Eiffel Tower

"We—writers, painters, sculptors, and architects, passionate lovers of the as yet unblemished beauty of Paris—protest... against the building of the unnecessary and monstrous Eiffel tower in the heart of our city... In order to comprehend what we are anticipating, one must for a moment imagine a ridiculous, astronomical tower soaring above Paris like a huge, gloomy factory chimney, and imagine all our monuments humiliated, all our buildings diminished, until they disappear in this nightmare." This pamphlet was published on February 14, 1889 in the newspaper "Le Temps" and signed, among others, by Charles Garnier, Joris-Karl Huysmans, and Émile Zola. It clearly reflects the reactions of contemporaries to the intention of engineer Gustave Eiffel (1832–1923) to build a 985-ft. (300-m) tower that was meant to represent the achievements of the French steel industry in the context of the World Exhibition that same year. For the first time an edifice was to be erected that did not hide its steel frame structure behind a historical facade, as had until then been the aesthetic convention. A new way of thinking in architecture was thus set out which made the functionality of a building the sole criterion of the design and was to have a decisive influence on modern architectural development. Eiffel, who had until then made a name for himself primarily as a builder of bridges, was able to achieve maximum height with minimum material by using wind resistant truss girders made of iron. He also used prefabricated components that could be quickly assembled on site by a relatively small number of workers. When the Eiffel Tower was completed it was seen as a monument to progress that was just as significant for the dying nineteenth century as the profound rejection of the associated paradigm shift in art. Capable of holding up to 10,000 visitors at any one time, the Eiffel Tower not only fits into the cityscape without any problem, but has become the real landmark of the capital and embodies the incredible mood of change in fin-de-siècle Paris. In contrast to the initially critical attitude of many intellectuals, in the early twentieth century the Eiffel Tower was viewed with increasing enthusiasm by artists—Guillaume Apollinaire and Jean Cocteau dedicated poems to it, and it was painted many times over by Utrillo, Rousseau, and Robert Delaunay in particular. The art historian Siegfried Giedion found in the Eiffel Tower a complete metaphor for the structural perception of modern architecture: "In the air-whipped staircases of the Eiffel Tower... you encounter the core aesthetic experience of contemporary architecture—objects, ships, sea, houses, masts, landscape, and ports all stream through the fine web of iron, which is held tight in the airspace. They lose their defined shape, circling into each other as you descend, blending together simultaneously."

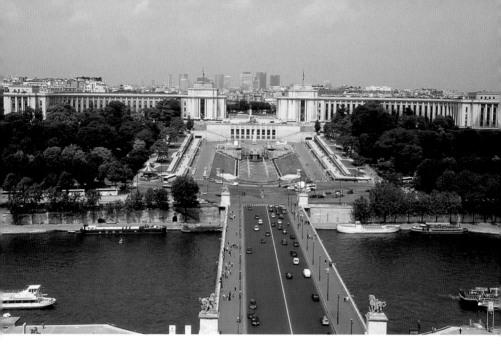

Palais de Chaillot

The Palais de Chaillot was built on the foundations of the Trocadéro in 1937 for the World Exhibition. Structured on a symmetrical axis, it served as the main entrance to the massive exhibition area. Two pavilions rise up to the left and right and are flanked on each side by curved wings. The architectural language is clearly defined by the spirit of the 1930s, combining the functionalism of the "streamline moderne" style with a type of monumentalism that is instantly reminiscent of similar contemporary architecture in the totalitarian states of Germany, Italy, and the Soviet Union. Following a devastating fire inside the building in 1997, the Musée des Monuments Français still remains closed. Its re-opening under the new name, Cité de L'Architecture et du Patrimoine, is scheduled for the fall 2007. The Musée de la Marine illustrates the history of seafaring and the Musée de l'Homme houses an anthropological collection.

Facade detail

The overblown architectural design of the Palais is most pronounced in its pronounced vertical lines and in relation to the ramps. These lead up to the complex from the Seine and offer a wonderful view across to the Left Bank. Many artists and sculptors were commissioned for the decorative work of this austere looking building. The ones that stand out most strikingly today are the eight gilded Art Deco statues on the terrace. In front of the left pavilion stands the monumental sculpture group with Apollo by Henri Bouchard (1875–1960), whose former studio can be visited in the nearby Rue de l'Yvette. The inscriptions, early indications of the building's use as a museum, were written by Paul Valéry. The grounds, which stretch as far as Pont d'Iéna, are decorated with fountains and sculptures.

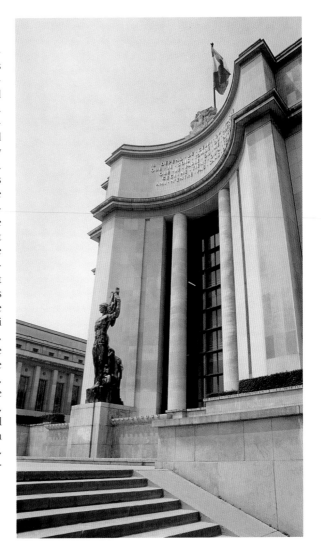

Past and identity—Eugène Viollet-le-Duc and the Musée des Monuments Français

by Martina Padberg

Usually a trip to a museum holds the promise of encountering unique objects that are the product of the individual creativity of male and female artists. It is all quite different in the Musée des Monuments Français, however. There are certainly collections displaying magnificent French architecture and sculpture, especially of the Middle Ages, but not one is an original. Instead, there are casts of portals, capitals, vault sections, and individual sculptures, along with replicas of frescoes and stained glass. A tour of the exhibits enables the very first thing that every novice art historian learns—to compare like with like. Highlights include the Roman tympana from Vézelay and Autun, the Well of Moses by Claus Sluter from Dijon, and the barrel vault from the abbey of St-Savin-sur-Gartempe, painted with a fresco. By showing at a glance what would otherwise be separated by hundreds of miles, the relationships, influences, and interdependencies between epochs and styles becomes more apparent and the development lines of schools and individual artists can be traced. Such awareness exercises occupied the found-

Eugène Viollet-le-Duc, Sainte-Chapelle during the restoration, unfinished drawing

Musée de la Sculpture Comparée, (Sculpture Room), ca. 1889. Photograph by Alfred Mieusement

ing fathers of the museum as well, one of them being the eminent medievalist and restorer Eugène Viollet-Le-Duc (1814–1879). Modeled on the Victoria & Albert Museum, which had opened in 1852 in London, a collection of casts of outstanding art works, particularly by the younger generation of artists, was to provide stimulation and guidance. The eclectic assemblage of historical art forms was not the aim, however—conversely, through a discussion about the exhibits, Viollet-le-Duc hoped for a creative stimulus that would launch and promote a progressive development in art. He believed that medieval architecture had achieved a level of constructive perfection and functionalism that could prove useful when dealing with modern materials such as iron and glass. Retrospection would also help to advance contemporary development or, to be more precise, the latest cast-iron structures were not in his view at variance with Gothic architecture, but its successors. In 1869 Viollet-le-Duc published a 10-volume work "Dictionnaire raisonné de l'Architecture française" in which he assembled all the knowledge he had acquired in his extensive experience as a restorer. In Paris he directed the urgently needed restoration of Notre Dame, Sainte-Chapelle, the Château de Vincennes, and Saint-Denis, developing mandatory standards of conservation that for the most part remain relevant today. His dealings with ancient things were characterized by a rational and analytical interest in knowledge, based on science and research as well as a well-founded appreciation of their worth. Rediscovering and preserving Gothic architecture as a historic monument was his great achievement. The re-establishment and opening of the Musée des Monuments Français (1882) was directly linked to this work. The comparative and cognitive way of seeing that was made possible by the extensive collection of casts also enabled a better understanding of personal (art) history and from that a little more of national identity. And preservation only seems worthwhile if the object is understood.

Eugène Viollet-le-Duc, founder of historic preservation in France

Palais de Tokyo, Site de Création Contemporaine

With the opening of the Site de Création Contemporaine in the west wing of the Palais de Tokyo, Paris finally has a venue for new contemporary art. The classical notion of a museum was consciously avoided. Flexibility and experimentation are seen as more important in terms of providing a display location with vibrancy equal to the lively art scene.

Hence the interior has been deliberately made to look more like a building site than a dignified temple to the muses. Rough walls and ceilings, exposed wiring, and a caravan for the ticket desk are all indications that the artists are intended to be in control of the building. The interior space is continually redesigned by their frequently

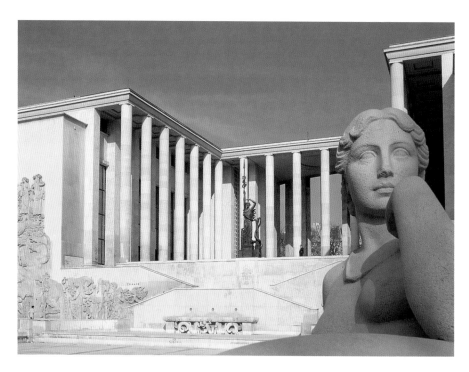

changing installations. New routes are also taken in the dialogue with visitors—instead of weighty catalogues, there are video interviews with the exhibiting artists. One-to-one discussion is also encouraged, so twelve so-called "mediators" are on hand, replacing traditional museum attendants and all too willing to provide information about the current exhibits. The aim of all this is an exchange with the visitor, rather than a lecture. Even the opening times are not typical of a museum, but are specifically geared toward the recreational needs of the modern city dweller. As culture can mostly be consumed in the evenings, the building opens from midday through midnight. In this way, art is in direct competition with cinema and theatre, and a restaurant meal can be neatly combined with an exhibition visit in the chic foyer.

Palais de Tokyo, Musée d'Art Moderne de la Ville de Paris

The east wing of the Palais de Tokyo houses the city's collection of modern art from Fauvism to the present day. Initial plans for a museum documenting the developments of post-19th-century art go back to the 1920s, and were realized in the context of the World Exhibition in 1937. The Palais de Tokyo was built specifically for this purpose, but the museum did not actually open until 1961. The monumental colonnade in particular is typical of a Neo-Classical structure, which opens out to the Seine across an open staircase and forecourt with water basins. The art is perfectly framed by the light, airy architecture of the interior.

Amedeo Modigliani (1884–1920), Woman with Fan (Lunia Czechowska), 1919
Oil on canvas, 100 x 65 cm

Born in Livorno, Modigliani lived in Paris from 1906 until his premature death in 1920. There he came into contact with the international avant-garde and worked in the milieu of the artists' residence known as "La Ruche" in Montparnasse. Modigliani developed an unmistakable personal style, which is most clearly marked in his nudes and portraits. "Woman with Fan," a portrait of his close friend Lunia, is a typically elongated and stylized figure. The whole body seems to be inscribed in ellipses and contained within a closed outline. All the details are subsidiary to the overall composition. The calm demeanor and mask-like face convey an undertone of melancholy, which cannot be dispelled by the vibrant colors of the dress and the wall of the room. In fact the strong contrasts make the light flesh tone even more translucent and the figure more ethereal.

Fernand Léger (1881–1955), The Discs, 1918
Oil on canvas, 240 x 180 cm

After World War I, Léger explored the world
of machines as the central theme of his
paintings. "The Discs" is an outstanding
example from this period of his work, which
was replaced in the 1920s by large, nude
portraits. Léger depicts a multilayered inter-
locking and overlapping of discs, wheels,
drums, and replacement parts from the road
and rail industries. The animated dynamism
of the gadgets presented as a collage—
assembled without any regard for their func-
tionality in terms of formal principles—is
emphasized by the traffic-light color
scheme. The picture is an expression of
Léger's fascination with the modern world
of technology.

Musée du Quai Branly

The idea behind this large museum in Paris, the most recent one to be built in the city, is based on the principle that people take pleasure in discovering and engaging with cultures outside Europe. The complex developed by Jean Nouvel is an ensemble of five structures located in the heart of the city on the banks of the Seine and houses a comprehensive collection of art and artifacts from Africa, Asia, America, and Oceania. Special question-and-answer sessions are held during temporary exhibitions based closely on the main themes, while the art forms on display are made more immediate through a rich program of theatre, music, and dance including different ethnic rites and rituals. Documentaries and feature films are shown in the in-house cinema and there is an incredibly varied program of lectures, seminars, and discussions. The notion of the voyage of discovery to far-off continents is reflected in the architectural layout of the garden, a gently undulating landscape that stretches out covered in ferns,

trees, and bamboo groves. Even the massive concrete piers, supporting a long bar-shaped building, appear to grow up out of this landscape.

Inside the lobby, a glass silo housing the musical instruments dominates the interior space, a showcase announcing the richness of the collection in all its diversity. As visitors ascend the long ramp leading to the

main exhibition area, specially produced video and audio displays support the totally new concept of presentation that gives true meaning to the exhibits. The complete permanent exhibition then unfolds over a long main gallery dubbed by Nouvel as "La Rivière" (the river), which leads to the four continents. Running down the middle of this is the "Snake," a half wall covered in brown leather with benches and embedded, interactive monitors offering a short, informative break. Individual exhibits imbued with special significance have been placed by Nouvel in the protruding, brightly colored boxes that can be seen clearly from outside. The aim of these modern cult spaces is to preserve the sacral nature originally associated with objects on display here. Here, the strange and secretive atmosphere encountered by the visitor is conveyed by the predominant darkness throughout the exhibition. What is required is an exploratory approach, literally as well as metaphorically. In complete contrast to this interesting background scheme, the exhibits are then presented in classical museum style in rather airless display cases.

Dark times—occupation and resistance 1940–1944

by Stephan Padberg

After France and Britain declared war on the German Reich in response to its invasion of Poland two days earlier on September 3, 1939, there followed a tortuous waiting period of eight months. Since the 1920s, France had pursued a defensive military strategy, its mighty fortifications in the West, the Maginot Line, appearing to guarantee protection and security. Yet while the mobilized army held out there, the Germans had all the time they needed to prepare for their *blitzkrieg* offensive in the Ardennes. As a result of some favorable coincidences, their fast-moving aircraft and panzer formations managed to break through the French front in two places on May 10, 1940 and encircle it from behind. The Battle of Dunkirk began simultaneously, ending in the retreat of British and several thousand French troops across the Channel. The casualties on the French side after the first few months were 92,000 dead and 200,000 injured, with 2,500,000 prisoners of war. A mass exodus from the north-east toward central and southern France began, with 8,000,000 refugees flooding the roads and hampering their own troop movements—they were shot at by bombers, or rounded up by German units who tried to give the impression of being good-natured and helpful victors. On June 10, the French government declared Paris an "Open City" and relocated first to Bordeaux and then to Vichy. Within a few months Paris had lost half of its population as people fled in panic. On June 14 the swastika was flying from the Eiffel Tower and, a week later, the armistice was signed.

The Germans divided France into different zones: in the east they tried to separate off, or annex, parts of the country; the north and west, including Paris, were put under direct military rule; and in the center and south, they handed over an unoccupied zone to the Vichy government until November 1942. This regime

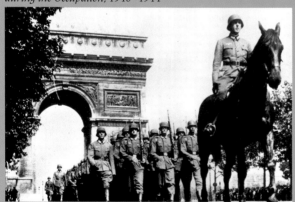

Germans marching up the Champs-Élysées during the Occupation, 1940–1944

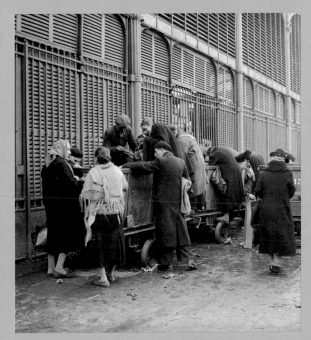

Parisians gathering leftovers from the streets in front of Les Halles, Paris, 1940–1944

laborated with the occupiers in plundering the country. As early as July 1940 they enacted laws against "undesirables" and Jews of their own accord. Calmly and efficiently, but by force where necessary, the Germans turned their neighboring country into an inexhaustible source of goods and services for their war effort. France was forced to pay daily reparations of 20 million Reich marks, at an exchange rate that was arbitrarily set at 1:20. Everything from food, all kinds of raw materials, textiles, machines, and even a human labor force was transported to the Reich. The French had to make do with meager rations and their own skills of improvization. There was not enough milk and butter for the children. Bakers had to use a strange substitute bran mix instead of white flour for bread. Parisians used every spare corner of earth in the city and the outskirts to grow vegetables and potatoes in the warm months for their own use: turnips, once used as animal feed, became the main foodstuff. Throughout the cold winters, many suffered from the frost in their unheated homes. As there was no petrol and nearly all the automobiles and trucks had been seized, wood and gas generators were built as substitute engines, while bicycles with trailers were used as taxis. Businesses

tried to create the illusion of national independence and even regeneration with the slogan "work, family, homeland," even though the apparatus of State and the Press had been brought under Nazi control. After the shock of defeat, the French longed for security and self-confidence once more, both of which Marshal Pétain, the elderly war hero of Verdun and Vichy figurehead, seemed to symbolize. Hoping to take their place some day as Germany's equal partner in the new Europe, his regime willingly col-

found inventive ways of producing synthetic material or previously unknown methods of energy generation. The black market flourished and strange, shady options for social advancement presented themselves.

On the surface, the mood was actually not too bad. The occupiers were not of course welcomed with open arms—the smiling soldiers on the propaganda posters and the well-behaved Wehrmacht troops on leave strolling around with valuable currency to spend could not fool the people of Paris. Yet the pressures of occupation brought out an odd instinct for survival as well. Not only did the suicide rate drop, the birth rate rose from 1940 through 1944, and there was an increasing need for distraction and all kinds of cultural stimuli. It suited the Germans to keep the spirits of the population up with mass entertainment such as horse racing, fashion shows, cinema, and dancing. They were only partially successful, however, at controlling the intellectual life. While the respected literary journal "Nouvelle Revue Française" was taken over by the fascist writer Drieu La Rochelle, the underground produced illegal resistance pamphlets such as "Le Combat" with Albert Camus as editor-in-chief. French cinema survived by producing escapist historical or fantasy films, a golden age, while Jean-Paul Sartre's existential plays reflected the mood of uncertainty and "introspection" between collaboration and resistance. Behind the appearance of normal, everyday existence, the two fronts gradually moved apart. From his exile in London, General de Gaulle had already called upon his compatriots in June 1940 to continue the fight. Yet to begin with not many heeded his appeal. The first to do so were the Communists, who were accustomed to operating illegally—they built up a functioning organization, producing fliers and engaging in sabotage. The Germans reacted with threats, demands for the culprits to be denounced, torture, and firing squads. From the summer of 1941 onward, members of the Wehrmacht were no longer allowed to walk alone in the streets of Paris for reasons of safety. The more the population began to suffer from deprivation, the more the occupiers avenged the "jabs" of the Resistance with oppression and reprisals; the more men fit for work were sent to Germany as forced labor after 1943 and the more Vichy France participated in the deportation of Jews for the "Final Solution," the more the French turned away from their government. Only about one percent of the population actively participated in the Resistance, but members of the underground were increasingly able to move around "like fish in water." In May 1943 the different groups united as the "National Resistance Council;" a

Parisians queuing in front of Le Bon Marché department store to exchange old material for textile goods, October 1943

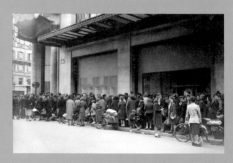

year later their violent operations had grown to almost civil war proportions. The Wehrmacht and SS responded with blanket terror, destroying entire villages and perpetrating massacres on the civilian population. The real liberation only began on June 6, 1944 with the Allied landings in Normandy. General de Gaulle insisted that a French armored division under General Leclerc would be the first to enter Paris on August 25. The Resistance had already begun to drive out the occupiers a week beforehand. They advanced on town halls and police headquarters, captured trucks, ammunition and weapons, erected over 400 barricades, and engaged in exchange of fire with the Germans and the French militia. Paris presented a very uneven picture during these days: housewives queued in front of shops that hardly had any food left for sale, curious folk hung around cafes and street corners waiting for something to happen, funeral processions honored those who had died, paramedics drove around in vans, random shots could be fired without warning, armed men could storm a building, and civilians not involved could be hit by a bullet.

The war had not even ended when the French and Allied troops marched in and wiped out the last German positions. For most Parisians, however, it meant the dawn of euphoric and triumphant weeks. The nightmare of foreign rule was over, while the feeling of freedom made it easier to overcome the contradictions of collaboration and resistance and begin rebuilding the nation.

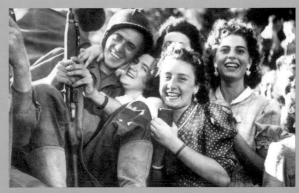

La Libération de Paris, (the Liberation of Paris)
August 25, 1944

Musée Guimet / Musée National des Arts Asiatiques

The foundation of the museum, which now has the most extensive collection of Far Eastern art outside Asia, was the initiative of the Lyon industrialist Émile Guimet (1836–1918). He took part in numerous expeditions and began to collect Egyptian, Greco-Roman, Buddhist, and Hindu artifacts as a result of his interest in the history of religion. His collection formed the basis of the current museum, which also amalgamated the holdings of the former Indochina museum in Trocadero, the Asiatic collections from the Louvre, and a few private endowments. The museum was built in the Classical style in 1889—the entrance is located in a rotunda adjoined by a *tholos* (Greek round building surrounded by a colonnade) which towers over it. The sole focus of the collection in the 1920s was on Asian art, but this was later extended to include porcelain, ceramics, lacquered furniture, folding screens, masks, textiles, and paintings. The institution now provides an excellent overview of the artistic output of Asia. Following an extensive restoration of the interiors (1997–2001) by the architectural team of Henri and Bruno Gaudin, the museum displays its objects by cultural region in elegant rooms with natural illumination.

Buddha protected by the nâga Mucilinda, Khmer art, Cambodia, 13th c.
Stone

Khmer art from Cambodia is represented in the Musée Guimet by a collection unsurpassed in the West. This sculpture from the golden age of the Khmer depicts an episode from the life of Buddha. The Enlightened One was meditating on a river bank, unaware of the danger of the rising water, and was saved at the last moment from behind by the lake-dwelling naga Mucilinda, a mythical creature with many heads.

Shiva Nataraja, South India, 11th c.
Bronze, 96 x 80 cm

This beautifully crafted bronze shows the god Shiva as the "Lord of Dance" (Nataraja). Encircled by a ring of fire, he embodies and controls the cosmic cycle of birth and death. The dynamic power of his dance is emphasized in the formation of his many arms. The mobility of his body is countered by the calm, knowing smile with which he confronts the observer—the dual nature of this Hindu god enables him to present as either creator or destroyer.

Utamaro Kitagawa (1753–1806), Musashi, Ise monogatari, Japan, ca. 1798 (Edo period)
Woodblock print, 37.2 x 24.2 cm

One of the most renowned masters of Japanese printmaking, Utamaro here depicts an episode from the famous Ise tale in this woodblock print: two illicit lovers flee from their pursuers and hide among the reeds of the Musashi plain. Typical of Utamaro's style and the "ukiyo-e" prints of which he was the master are the elegant lines, the organic forms, and the two-dimensional style of representation. "Ukiyo-e," whose themes were usually everyday scenes, landscapes, and illustrations of popular tales, were collected extensively in 17th and 18th century Japan. Utamaro also specialized in erotic subjects, portraying courtesans and lovers in the "Edo" (Tokyo) pleasure quarter. The accentuated feminine beauty and sensual presence account for the particular attraction of his prints, which also found many collectors in Paris in the 19th century. In the context of the strong interest in Japanese art and culture prevalent in Paris in the 1860s— noticeable in the foundation of significant East Asian activities, the amassing of large collections, and numerous exhibitions and publications—French avant-garde artists also found Japanese woodblock printing a source of inspiration. The Impressionists around Monet, as well as Seurat, Cézanne, and van Gogh, were enthusiastic about these prints. Paul Gauguin decorated his studio with Utamaro

prints and Toulouse-Lautrec saw profound confirmation of his own style in the works of Utamaro in terms of his bold artistic concept and choice of subject matter.

Mille-Fleur vase in three colors, Ming dynasty, China
Porcelain, ht. 48 cm

The extensive collection of Chinese ceramics and porcelain, amounting to around 15,000 items, is one of the highlights of the museum, documenting the unbelievably high quality of this sector in China, the home of porcelain manufacture. The vase adorned by Mille-Fleur (a thousand flowers) is an outstanding example of the craftsmanship and aesthetic aspiration that was continuously refined with the wide ranging support of successive Chinese emperors. During the 17th and 18th centuries, Chinese porcelain was one of the most important exports from the Far East, destined mainly for the noble houses of Europe.

Around the Bois de Boulogne

Musée Marmottan, 2, Rue Louis-Boilly, p. 352 f.

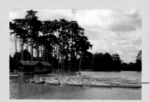

Bois de Boulogne, p. 354 f.

Castel Béranger, 14, Rue La Fontaine, p. 349

Villa La Roche/Fondation Le Corbusier, 8-10 Square du Docteur-Blanche, p. 350 f.

Parc André-Citroën, p. 348

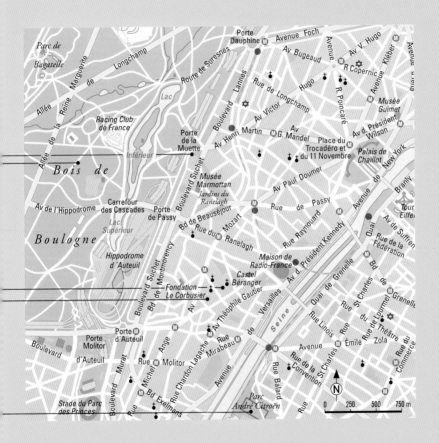

Parc André-Citroën

A large park, now one of the most beautiful and best loved in Paris, was built on the site of the former Citroën automobile plant between 1988 and 1995. It combines modern architecture with landscape art inspired by French, English, and Japanese gardens. The central themes in laying out the structure of the park, which is divided into several sections, were a diversity of symbolic features and a fusion of plants, water, and stones. The "White Garden" with its white-flowering shrubs is counter posed to the "Black Garden," which is full of dense plants with dark foliage, flowers, and conifers. A labyrinthine walkway opens out onto a small square with fountains. At the heart of the park is a great lawn, the "parterre," which extends to the banks of the Seine. Two viewing towers made of granite form a contrast to the two massive transparent greenhouses built by the architect Patrick Berger. Between these, water fountains spout up from over 100 positions on a sloping surface. Finally there are the "theme gardens" in separate zones, each corresponding to a different sense; thus there are gardens for sight (silver), taste (red), touch (orange), and hearing (green).

Castel Béranger

The six-story apartment block built by Hector Guimard (1867–1942) in Rue La Fontaine in 1897/8 is nothing less than a textbook example of pure Art Nouveau architecture. Guimard designed a lively facade, each level of which is divided differently by projections and recesses with balconies and bays. A wide variety of materials, from red brick and rough-hewn stone through enamel tiles to ornate iron-work with floral motifs on the railings and eaves, characterizes this award-winning building. Of particular interest is the cavernous entrance with its elaborate wrought-iron gate and pillars. The artist Paul Signac, one of the first inhabitants of these luxuri-ously appointed apart-ments with bath and telephone, was captivated by Guimard's eccentric cre-ation. Close by, in 17–21 Rue La Fontaine, is another residential house built by Guimard in 1911, which has a far more reg-ularly structured facade with clearer lines.

Fondation Le Corbusier

The Swiss architect Charles-Édouard Jeanneret (1887–1965), known as Le Corbusier, finally moved to Paris in 1917 after completing his studies with Auguste Perret and Peter Behrens. He is one of the great theoreticians of modern architecture. As early as 1914 he had developed a construction principle based on the industrial manufacture and application of reinforced concrete structures that were mainly meant to be used for social housing. The first building he completed in Paris, however, was the private studio for his new friend, the artist and art theorist Amédée Ozenfant, with whom Le Corbusier published the avant-garde journal "L'Esprit Nouveau;" both were concerned with promoting a purist style in art and architecture. At the same time, Le Corbusier was formulating his own ideas about architectural theory and urban planning, and set out his initial program in 1923 ("Towards an Architecture") followed in 1927 by his famous "Five Points of Architecture." His functionalist structures have been built the world over and had a considerable influence on the development of building design. In Villa La Roche, the home of the present Le Corbusier Foundation, his architectural oeuvre can be explored as well as his less well known artistic and sculptural works. Paintings, furniture, and draft plans for important architectural projects are all on display here.

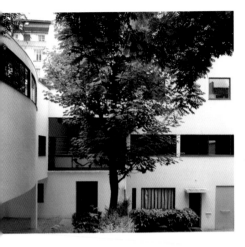

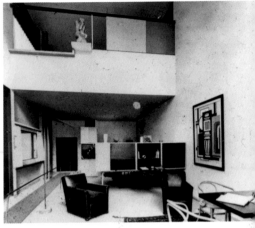

Villa La Roche, Paris 1923

Pavillon de l'Esprit Nouveau, Paris 1925

Le Corbusier completed the architectural ensemble consisting of two villas (1923–25) for his brother, the musician Albert Jeanneret, and for his friend, Raoul La Roche, a banker. The houses take the form of cubic structures, which are divided by large windows and terminated by a flat roof, the whole being brought to life by a curved wing. Parts of the residential block rest on pilotis (concrete piers), which were a characteristic feature of Le Corbusier architecture. The white outer shell is devoid of ornamentation, while the interior sequence of rooms is structured on clear, rational lines. A tour round the Villa La Roche gives a good idea of how it would feel to live in one of his houses.

Le Corbusier responded to the needs and wishes of his client, who had to house an extensive collection of paintings and wanted public as well as private rooms, through the sequence of rooms, which develops a rich vocabulary of sculptural forms—an "architectural promenade" that leads the visitor across steps and ramps as well as terraces and platforms. En route, interesting visual perspectives continually open out into other parts of the house. Even the plain windows are deployed in different ways: for example, in the form of narrow ribbon windows or as a substitute wall. The furnishings and displayed works of art exploit the functional and purist environment of Le Corbusier in all its facets.

Musée Marmottan

Pierre-Auguste Renoir (1841–1919),
Claude Monet, reading, 1872
Oil on canvas, 61 x 50 cm

Built and furnished in the historical style favored in the early 19th century, the palace was both the residence and private museum of the collector and historian Paul Marmottan (1856–1932). On his death he bequeathed the premises along with the collection—consisting mainly of Renaissance tapestries and sculptures, and paintings, furniture, and porcelain from the Napoleonic era—to the Académie des Beaux-Arts. The museum is now primarily famous, however, for its fabulous collection of Impressionist paintings. The first of these came to the Musée Marmottan in 1957 from the circle of friends around Claude Monet; they were a bequest from the doctor, Georges de Bellio, who was friendly with many artists and had often looked after them in a medical capacity. In 1971 the son of the artist, Michel Monet, gifted 65 paintings to the museum, thus helping it to build one of the most important Monet collections and a worldwide reputation.

Sitting comfortably reading a paper and smoking his pipe, and dressed in a bourgeois coat with a hat and walking stick—as seen in this portrait by his friend Renoir—Monet hardly fits his contemporary image of revolutionary artist. The painting co-

incides with the turning point that marks the beginning of Impressionist art: the same year, Monet painted his famous programmatic picture, "L'Impression, soleil levant" (Impression, sunrise). It, too, is in the Musée Marmottan and for those who visited the first Impressionist exhibition in 1874 it revealed unmistakably the nature of outdoor painting. The sketchy painting technique, which causes contours and even the object itself to dissolve, created a scandal. For Monet it meant rejection and financial ruin, forcing him to live and work for years in dire conditions. For this portrait of him, however, Renoir—whose every work puts the emphasis on the optimistic, upbeat side of life—chose a moment of self-absorption and contentment.

Claude Monet (1840–1926),
Water lilies, 1916–1919
Oil on canvas, 130 x 152 cm

In the late 1880s Monet began work on his signature theme, depicting a subject at different times of the day and in changing light and weather conditions. After his first successful sales enabled him to buy a house in Giverny in 1890, he created a Japanese inspired garden there with a water lily pond, which became central to this great series in his oeuvre. As he grew older, he concentrated exclusively on this theme, working hard to achieve greater artistic freedom through a radical process of abstraction—picking out a close-up detail in a picture wipes out any spatial context. Color and style become the main content of the image and form the basis of the sensual beauty of his later work. These can be experienced directly in the separate room devoted to them in the Musée Marmottan.

Bois de Boulogne

The Bois de Boulogne was a royal hunting ground dating from Merovingian times. The wood was also used for centuries by French kings as an intimate retreat. Henri IV, for example, installed his former lover Catherine de Verdun as the mother superior of the 13th-century Longchamp convent there, which had been founded by the sister of Saint Louis. The Château de Madrid, built for himself by François I in the 16th century, was turned into the semi-official residence of his mistresses by his son and heir, Henri II. Finally, under the aegis of his wife, Louis XIV built a pleasure palace for the same purpose and also issued building permits for country houses for the upper aristocracy. Several lavish stately homes were built, but they all fell victim to the Revolution. Under Napoleon III, the Bois de Boulogne was then opened to the public following the example of Hyde Park in London. It thus became the "green lung of Paris" demanded by the socialist Louis Blanc for the population of the capital, who were suffering the effects of progressive industrialization. Baron Haussmann commissioned Adolphe Alphand (1817–1891) to design a huge, landscaped garden. He demolished the wall that had previously surrounded the wood and created two lakes, an artificial waterfall, and a dense network of paths. Around 1860 Gabriel Davioud added a series of

pavilions, kiosks, and restaurants in the style of the Belle Époque. Race courses at Longchamp and Auteuil were also built in the 19th century, in the English style, thus completing the portfolio of pleasure opportunities that were, of course, primarily the preserve of the rich and privileged. In his novel "Nana" (1880), Émile Zola gives a vivid description of all Paris storming the green oasis every Sunday.

Bagatelle, Orangery

This small palace with Trianon and Orangery is the successor to the previously mentioned pleasure palace of Louis XV and the product of a gambling bet. In 1775, the Comte d'Artois (the brother of Louis XVI and later King Charles X) who was just 18 and well known for his pleasure-seeking and dissolute lifestyle, accepted a bet of 100,000 livres from the young queen, Marie-Antoinette, to create a wealth of layouts and water gardens in only 64 days. He entrusted the task to the experienced architect François-Joseph Bélanger (1745–1818). The undertaking was successful, thanks to the ruthless confiscation of numerous building materials

delivered to Paris. By then, however, the project had already cost 1,200,000 livres, so that the amount wagered had become irrelevant. Until the Revolution, the Bagatelle was the venue of choice for the glittering celebrations of the doomed courtly society of the Ancien Regime. Today the beautiful gardens around the Orangery are one of the main highlights of the park.

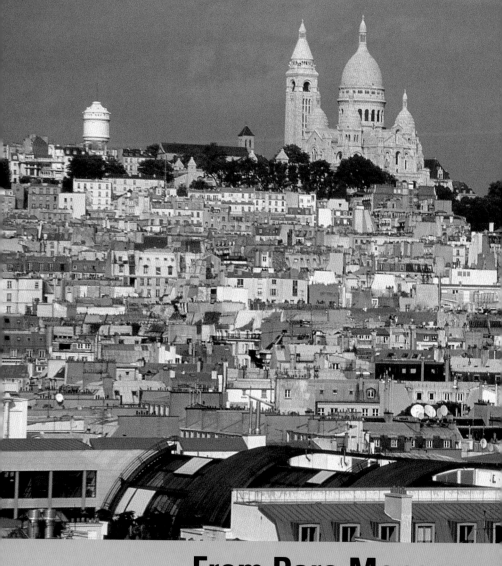

From Parc Monceau

to Montmartre

From Parc Monceau to Montmartre

In the decade before the French Revolution, the Duke of Chartres, Louis Philippe d'Orléans (1747–1793) created a landscape garden just outside the gates of Paris, south of the little hamlet of Monceau. Its eccentric features, which included temples of antiquity, Chinese pagodas, artificial grottoes, and ruins, matched his colorful personality. An erudite aristocrat and officer whose numerous affairs ensured plenty of gossip in Paris, he made no secret of his rejection of the royal court and empathized with the ideas of the Enlightenment. During the Revolution he joined the Jacobin Club, assumed the name Philippe Égalité after the king was deposed, and became a deputy in the National Convention. In January 1793 he even voted for the execution of the king, but that same year followed him to the guillotine himself: he was accused of plotting a putsch to install himself as monarch. His famous garden, known as "La Folie de Chartres," was a luxurious setting in which to cultivate such strongly felt sentiments in the 18th century. It survived the vicissitudes of the revolutionary period, but was halved in size during the 19th century, with Adolphe Alphand rebuilding it as a park for public use. A few features were preserved, such as the "naumachia"—an oval water basin with a colonnade—or the beautiful rocaille entrance gate on Boulevard de Courcelles. Even today they add a special touch to Parc Monceau, which is now surrounded by elegant townhouses. At the north entrance there is also one of the last custom houses from the 18th century: a rotunda built by the

Colonnade and "naumachia" in Parc Monceau

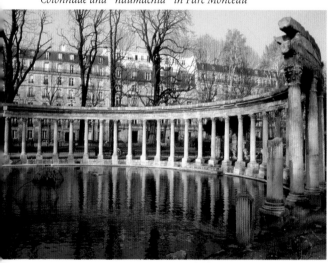

Preceding spread:
View of Montmartre
and Sacré-Coeur

revolutionary architect Claude-Nicolas Ledoux. Close to the park are two smallish private museums: Musée Cernuschi with a collection of Chinese art and Musée Nissim de Camondo with its sumptuous Rococo interiors.

Like the original Monceau, Montmartre was for a long time a tranquil village "extra muros." Because of its hilly location, which also guaranteed a fresher climate in high summer, prosperous Parisians built a number of lavish country houses here among the cottage gardens and windmills in the 18th century. Not many of them survived, however. The dance halls and taverns on the other hand, which opened up for the entertainment of aristocratic and upper bourgeois audiences, made "la butte" (the mound) famous as Parisians so succinctly, but appropriately, call Montmartre. The libertarian subculture that emerged here in the 19th century was chronicled by draftsman and illustrator Henri de Toulouse-Lautrec (1864–1901). He developed an innovative representational form inspired by Japanese woodcuts that was pioneering especially in terms of poster design. He created a monument to the Belle Époque in his portraits of the capricious dancers, shady impresarios, and weird characters of the quarter, keep-

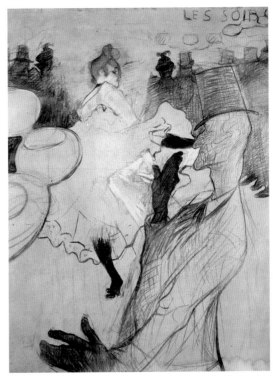

Henri de Toulouse-Lautrec (1864–1901), La Goulue at the Moulin Rouge, ca. 1890, charcoal, Musée Henri-de-Toulouse-Lautrec, Albi

ing the myth of Montmartre alive even today.

From Parc Monceau to Montmartre

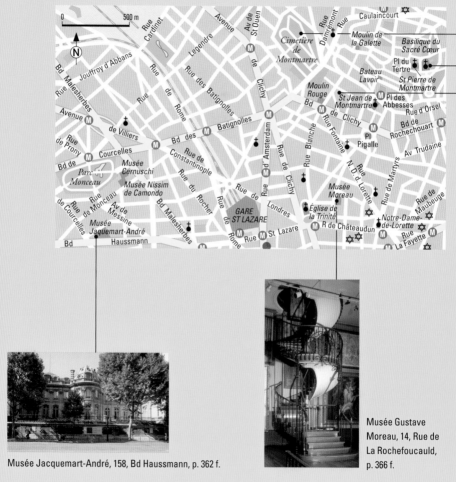

Musée Jacquemart-André, 158, Bd Haussmann, p. 362 f.

Musée Gustave Moreau, 14, Rue de La Rochefoucauld, p. 366 f.

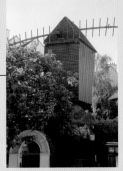

Cimetière de Montmartre, 20,
Av Rachel, p. 378 f.

Sacré-Cœur, 35, Rue du
Chevalier de la Barre, p. 372 f.

Butte Montmartre, p. 368 f.

Also worth seeing

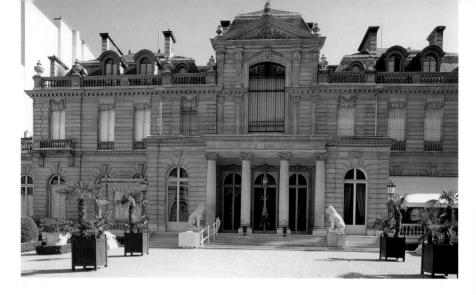

Musée Jacquemart-André

Édouard André (1833–1894) hosted a housewarming celebration in 1875 for his luxurious town palace, which the architect Henri Parent had built in the style favored by contemporary tastes, rehearsing the Classical models of the 18th century. The impressive presentation of the magnificent facade and generous proportions of the driveway leading from Boulevard Haussmann are mirrored in the lavish interiors of this elegant house, which the visitor can appreciate virtually unchanged today. André, who came from an exceptionally wealthy family of bankers, shared a love of art with his wife, Nélie Jacquemart, a young painter. He built up an outstanding collec-

tion of artifacts, each displayed in its appropriate setting. Public reception rooms and private retreats were designed in the same, opulent style. To begin with, the couple concentrated on Rococo painting, decorating the rooms in the manner of the 18th century, with paintings by François Boucher, Jean-Baptiste Chardin, and Élisabeth Vigée-Lebrun. Later, André and his wife collected mainly early Renaissance Italian art, amassing impressive treasures that can be seen in a museum-style display in the three gallery rooms. The former library houses more highlights of the collection, including paintings by Rembrandt, Frans Hals, and Anthonis van Dyck.

Winter garden and staircase

The winter garden was an extremely popular design feature of the 19th century, as a bright, cool place that added an exotic touch to the interior of a house with its plants and palms from southern climes. One such example was created in the Jacquemart-André house, with elaborate decoration in marble and stucco. The adjoining stairway in the form of an ellipse and set with pillars has a double staircase curving up to the upper floor and a front wall dominated by a fresco by Giambattista Tiepolo (1696–1770). The trompe l'oeil effects of the fresco, which was brought over from Villa Contarini in Veneto in 1893, never fail to astonish. The historical scene shows the Doge of Venice receiving Henri III of France.

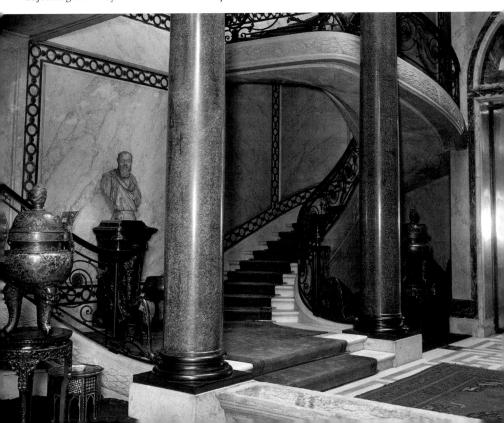

Steam and iron—the station as hub of the modern metropolis

by Martina Padberg

When the Impressionists opened their third group exhibition in Rue Le Peletier in 1877, not far from Boulevard des Italiens, six paintings with views of Gare Saint-Lazare were on display by Claude Monet alone. They were part of a 12-picture series the artist had finished that March, showing the architecture of the station from different perspectives. So that he could complete

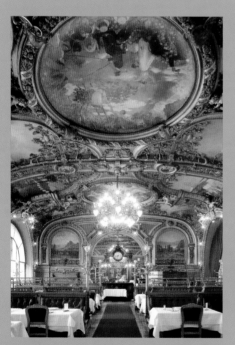

his work on site, Monet had rented a room next to the station. The subject matter was in vogue. With the rapid expansion of the railway network from around 1850, it seemed as if new stations were springing up all over Paris; as public entrances to the city, they assumed the role and appearance of modern town gates. The architects of the Gare du Nord (1861–1865), Gare de Lyon (rebuilt 1899), and Gare d'Orsay (1900) tried to outdo each other with monumental facades, stunning iron and glass structures, sumptuous interiors, and excessive decoration. No wonder even their contemporaries were reminded of "modern cathedrals." The new stations were also comparable to medieval places of worship in terms of their attraction. Vast hordes of travelers made the pilgrimage to the hissing machines, which seemed to be living creations of the industrial age and expanded considerably the personal horizons of their users. The atmosphere of the 19th century can still be sensed today on arriving at Gare du Nord or visiting Gare d'Orsay, now converted into a museum. The splendid decor of the emergent age of the railways is most impressively preserved in the wonderful restaurant "Le Train Bleu" in Gare de Lyon, which was originally only open to first class travelers.

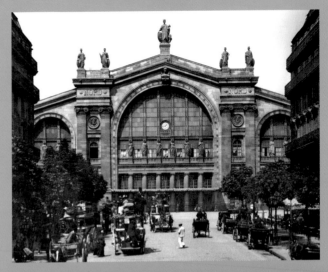

Gare du Nord, built 1861–1865 by Jakob Ignaz Hittorf, contemporary photo

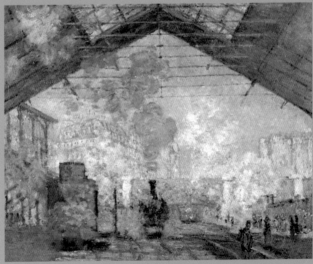

Claude Monet (1840–1926), Saint-Lazare station, 1877, oil on canvas, 75.5 x 104 cm, Musée d'Orsay, Paris

Left:
Marius Toudoire, ceiling decoration "Le Train Bleu" restaurant, Gare de Lyon, 1900–1901

Musée Gustave Moreau

His house was a place of retreat and research, a studio, and a cabinet of curiosities: Gustave Moreau (1826–1898), one of the most important fin-de-siècle painters, personally designed and supervised its conversion to his own museum. A few years before his death, he had two extra stories added to the narrow house in Rue de La Rochefoucauld so that he could preserve and display his massive body of work. Nearly 1,000 paintings and around 5,000 drawings and watercolors are on show, hung closely together and in special display cases, yielding numerous insights into the idiosyncratic world of this Symbolist painter. A notorious loner and avid collector of curiosities, who was always retreating from the Parisian art scene to the privacy of his home, he was a successful and celebrated artist. He took part regularly in the annual art salons and in the International Exhibition of 1867. In 1883 he was distinguished with the cross of the Legion of Honor; the following year he was admitted to the Académie des Beaux-Arts; and in 1892 he was appointed professor at the École des Beaux-Arts. Moreau then devoted himself seriously to teaching and was regarded within the conservative academic milieu as a very liberal individual who took great pains over the personal development of his students. The most famous of these, Henri Matisse, had previously found academic education stifling

and frustrating with William Bouguereau. Looking back in 1925 on his time with Moreau, Matisse remarked: "What a charming teacher he was! At least he was capable of becoming enthusiastic and even passionately excited."

Gustave Moreau (1826–1898), Unicorns, ca. 1885
Oil on canvas, 115 x 90 cm

The visual world of Moreau derives its energy from mythical and biblical sources, manifesting itself as an imaginative expression of dreams and fairytale fantasies that the artist has committed to canvas in dense, dazzling artwork. In parallel with the realism of Courbet and the approach of the Impressionists, who were only interested in immediate visual effects, Moreau developed a unique form of painting that reflects much of the sentiments of the fin-de-siècle generation—a return to the emotional in the face of pressures caused by social and industrial modernization; a sense of individuality in the midst of the urban experiences of collectivism and anonymity; and finally the need for visual self-immersion in a mythical universe beyond rationally organized society. The deeper layers of consciousness, which are expressed through human imagination and in dreams, provided archetypes of the imaginary world from which Moreau created his images. This ostensibly backward-looking type of painting exerted a profound influence well into the 20th century. In particular, the Surrealists around Salvador Dali and Max Ernst discovered an inspirational model in Moreau in the 1920s and celebrated his pictures as being the first manifestations of an irrational, surreal form of painting.

Butte Montmartre

"La Butte," a pastoral idyll even in the mid-19th century, was a village lying outside the city gates. "You can enjoy the purest air there, the settings are so varied, and there are wonderful views to be had ... There are even slopes bordered by green hedges..., mills, taverns, summer houses, rural climes, and quiet alleys strewn with thatched cottages, barns, and wooded gardens." This was the description given in 1852 by Gérard de Nerval ("Walks and Memories") of the northern edge of the city, which was not incorporated until 1860 and was spared the massive rebuilding work of Haussmann. The old urban structure has been retained to this day, so climbing up lots of steps and walking down narrow, winding streets is necessary to become acquainted with this district, the population of which really exploded in the 19th century. It was mainly the poorer people who flocked here, fleeing the rocketing rental prices in the redeveloped "Nouveau Paris" of the grand boulevards. It was still possible to find cheap lodgings here, and in the surrounding quarries and huge building site of the Sacré-Coeur there was always work to be had. The simple, but cheap, liv-

ing conditions and liberal atmosphere on the mound, where contact with potential models could be made in the demimonde of the taverns and cafes, attracted many artists and gallery owners before the turn of the century—Degas, Renoir, Seurat, Toulouse-Lautrec, van Gogh, Picasso, Braque, and Matisse all lived and worked for a time in Montmartre, lending an aura of change and non-conformity to the place. It has kept its social mix in spite of some renovation work in the 1980s, primarily in the eastern section away from the tourist trails, and is nowadays characterized by a multicultural diversity that holds up an alternative to the ghettoes appearing in the suburbs of Paris.

Place des Abbesses

Two lovely examples of fin-de-siècle architecture can be found on this square—the first is one of the few remaining Metro entrances by Hector Guimard (1867–1942), whose iron railings with abstract floral motifs presented a completely new type of design steeped in Art Nouveau, while the second is the St-Jean-l'Evangeliste church, which was constructed between 1894 and 1904. This sacred building made of reinforced concrete is the first example of an overall concept in which the architectural possibilities of the material have been consistently articulated. The architect Anatole de Baudot (1834–1915), a pupil of Henri Labrouste and Viollet-Le-Duc, used a structure composed of 26 supports bridged by

extremely thin-walled slabs. Even the 82-ft. (25-m)-high external wall is only 10 in. (25 cm) thick because faced concrete was used. The facade design has arched, interlocking, green ceramic bands, which form effective breaks in the red-brick facing, and demonstrates the astonishing malleability of the new material.

Le Métro—the artery of the city

by Oliver Burgard

For Franz Kafka, the Paris subway was a place filled with secrets. He expressed amazement in his diaries of 1911 at "the unnatural casualness of passengers as they willingly embark on a journey in the Paris Métro." The philosopher André Glucksmann had quite a different view of it. For him, the metro was the true cultural center of France, where all sorts of people, cultures, and expressive forms mingled. In the morning and late afternoon especially, the metro is bursting at the seams. In other big cities, those who can afford it prefer to hire a cab to avoid the stifling conditions of the subway. In Paris, however, traffic jams above ground have been a permanent feature for years. This is why everyone heads for the escalator—from the manageress of the Dior store to elderly war veterans, for whom separate seats are reserved in some carriages.

The Paris Métro is a place for superlatives; it is the fastest form of transport in the city, and therefore the most used. It carries five million people every day, most of them in a hurry. At interchange stations like Châtelet/Les Halles or Montparnasse, people seem to fly along the miles of underground walkways. On the platform, things move quickly. Missed a train? No problem—the next one will be along in two minutes. If people are crammed together like sardines behind the carriage windows, however, even folk in a hurry sometimes let a train pass, in the vain hope that the next one might be better.

The first line of the Paris Métro was opened in July 1900 for the International Exhibition, connecting Port Maillot in the west to Porte de Vincennes on the opposite side of the city. The architect Hector Guimard designed the first stations; floral glass and steel constructions in the style of Art Nouveau were created, which

Hector Guimard (1867–1942), Métro entrance on Place des Abbesses, 1895/1900

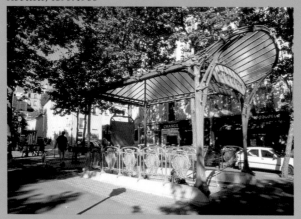

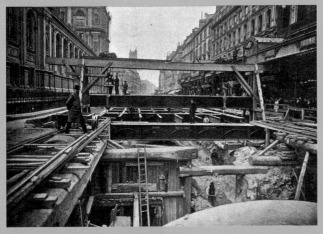

Métro construction along Rue Rivoli, 1898

the new Bibliothèque François Mitterrand. A dense network of stations covers the 14 lines, which operate between 5.30 a.m. and 0.30 a.m. Each line has its own clientele and distinctive smell. The lines are named after their terminus and have different colors, making it easier to negotiate the RATP subway network. The journey time between stations is one minute, just enough time for a few pages of a book or a quick flick through "Le Monde."

many Parisians at that time found shockingly ugly, but their beauty can be admired all the more today in the Abbesses entrances preserved in their original style in Montmartre or Passy in the 16th arrondissement. Louvre-Rivoli station has the finest platforms, where a miniature exhibition of important works of art gives a foretaste of the largest museum in the world. On the other hand, the stations that are still clad with the white tiles of the early days seem plain and functional. The architects chose them for two reasons—because they were easily cleaned and reflected the light, rendering the subway hygienic and bright.

The ultramodern stations of Line 14 exude an aura of clinical cleanliness today. Since fall 1998 a futuristic ghost train, which is completely computer programmed and swishes through the tunnels without a driver, has linked Madeleine with

It becomes clear that Paris cannot function without the metro when it is out of action. And as "la grève," the right to strike, is one of the enshrined political traditions, there is yet another outbreak of chaos every year in Paris when the RATP workers down tools. Long suffering locals have learned to work around the problem; trusting in the virtue of fraternity, they stand at the roadside with their thumbs stuck out.

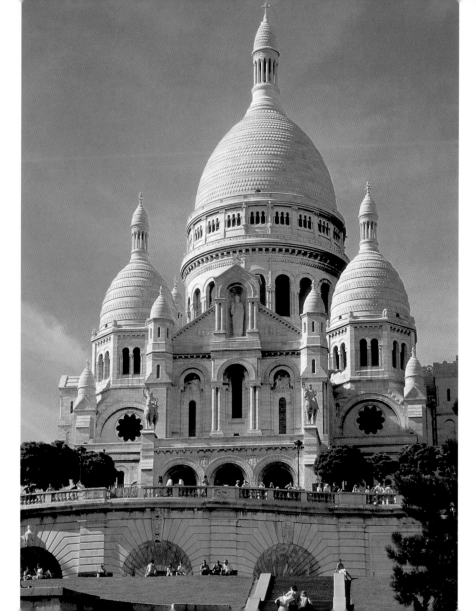

Sacré-Cœur

After the war against Prussia was lost in 1871, patriotic Catholics commissioned the architect Paul Abadie (1812–1884) to build a church of atonement—a symbol that would be clearly visible across the city from its position on the mound of Montmartre. Byzantine, Moorish, and Romanesque models were reworked in an eclectic style in line with the historicist approach to architecture. The huge, main dome of the gleaming, white, central structure towers up into the sky and, along with its four smaller subsidiary domes and a campanile, forms an interesting silhouette that can be seen for miles around. A huge statue of Christ with a burning heart surrounded by a crown of thorns stands in the central bay of the facade in reference to the right of patronage of the church. Consecrated in 1919—the same year as the Bauhaus was founded in Germany—the building has had an appalling press from the beginning. "Confectionery style" is one of the milder descriptions of this blatantly regressive architecture, with its total lack of any contemporary relevance. Today the church is seen mainly as a landmark and topographical reference point. It is often visited purely to enjoy the view across the city. The dramatic fusion of completely different period styles into one new entity does, however, reveal a great deal about the final dying throes of historicism, which had in fact already expired by 1900.

Interior

The huge mosaic inside the building is its most eye-catching feature, in yet another link to earlier Byzantine church architecture. The central theme is the worship of the Sacred Heart of Christ, a particular form of mystical Christianity that goes back to the Middle Ages. Christ appears as a protective and consecrating spiritual leader, at whose feet Mary, several popes, and representatives of the five continents have gathered. To the right, St. Michael and Joan of Arc appear as advocates of the kneeling personification of France.

Place du Tertre

This small square with its many cafes and restaurants is the focal point of the quarter. Here, countless portraitists and silhouette artists seek out their clientele, who want to take home reminders of the old artists' quarter in the form of these rapidly turned out pictures. The young painter Émile Bernard (1868–1941) lived just around the corner in Rue Cortot after 1885; he studied with Toulouse-Lautrec in the studio of Fernand Cormon on Boulevard de Clichy and later would work for a time with Paul Gauguin. Suzanne Valadon (1865–1938) lived close by, a self-taught artist who modeled for Renoir and Toulouse-Lautrec. Under their influence she developed into an expressive painter in her own right. In 1893 she painted the portrait of the famous composer Érik Satie, who lived in a cramped room next door. Her son, Maurice Utrillo, also produced landscapes of Montmartre that were tranquil and full of atmosphere, including one he painted in 1909 of Place du Tertre looking onto the house of Hector Berlioz. Not far from Rue Cortot is the tavern "Au Lapin Agile," which was run briefly in 1902 by the writer Aristide Bruant and was a popular meeting place for artists before World War I. Pablo Picasso and Maurice de Vlaminck were among those who stopped off on the hill during their productive years. Across and opposite is something of an oddity—the last vineyard of Paris "in miniature." "Goutte d'Or," a fairly mediocre wine, was still being produced here in the 18th century on quite a large scale, with the eastern part of the 18th arrondissement being named for it. Today, only about 5,000 bottles are produced, while grape-picking on the first Sunday in October is marked by a small folk festival.

The "Bateau-Lavoir"—Montmartre's Art Factory

by Martina Padberg

The stage for what became an artistic revolution in 1907 was scarcely more than a shabby shack. Nicknamed "Le Bateau-Lavoir" after the laundry boats on the Seine by the writer Max Jacob (1876–1944), this was where Pablo Picasso (1881–1973) worked in spring of 1907 on the painting that was to become an icon of modernity—"Demoiselles d'Avignon." The working environment was important for the development of this picture, for it was in the quarters of a former piano maker in Rue Ravignan, on the corner of Place Émile-Goudeau in the heart of Montmartre, that a colorful group of young artists took lodgings in the early 20th century. In the years following the move of the young Spaniard to the narrow, rambling building, others joined him at various points, including his compatriot Juan Gris, the Frenchman Georges Braque, Kees van Dongen from the Netherlands, Amedeo Modigliani from Italy, and Otto Freundlich from Germany. It was not long before Picasso, Gris, and Braque developed a close working and personal relationship. The nucleus of Cubism had been formed.

The paintings of the three artists at this time were characterized by the extensive reduction of the object to a simple cubist form, by the absence of illusionist perspective and by a subtle color palette of grays and browns; they came close to creating a group style. As Braque later remarked in an interview, the artists felt like "climbers roped together on a mountain"—i.e.,

Portrait of Pablo Picasso, photograph ca. 1907

on a dangerous and lonely path that they could only conquer together.

The difficult living and working conditions in Le Bateau-Lavoir contributed to the close alliance forged by the group, at least for a time—the only wash basin in the house was located in a dark corner right next to a steep wooden staircase and was used by all the residents of the "ship."

Montmartre, Le Bateau-Lavoir, ca. 1915

On entering the house, the stench of damp mildew, mold, and the numerous cats was almost overwhelming. The small windows admitted hardly any air and light into the rooms, while the confined area meant that every resident became witness to the various relationship breakdowns that occurred in the house. In other respects also the comfort factor fell short of present standards—there was no gas or electricity, so Picasso, who preferred to work at night, could only work at his easel by the light of an oil lamp. People only lived there until they could afford to rent somewhere more salubrious, or alternatively until they could not even raise the few francs for an atelier in this house. Yet the period spent in Le Bateau-Lavoir became a turning point artistically for Picasso and many of his fellow residents. The down-to-earth and unconventional atmosphere in Montmartre provided plenty of inspiration and stimulation in their search for innovative ideas. There were lots of cafes and little restaurants, like the "Lapin Agile" which is still there today, where they could meet fellow artists and also writers,

actors, and musicians. Conversations with, for instance, the writer and art critic Guillaume Apollinaire (1880–1918) or the aforementioned Max Jacob, sharpened their vocabulary on art theory and broadened their intellectual horizons. In Apollinaire, Picasso and his friends found a committed comrade-in-arms whose essays and critiques brought Cubist painting to public attention. The concentration on compositional principles and the rejection of illusionism were decisive steps in the development of 20th-century art and opened the door to abstract painting. The unassuming building that housed the first "art factory" in the history of painting was destroyed in a fire in 1970.

Guillaume Apollinaire in the atelier of Picasso, Bateau-Lavoir

Moulin de la Galette

"The paintbrush touches the canvas like the sun on the crowd beneath the trees... Happiness is almost sufficient for an understanding of these pictures." This was the assessment of art critic Julius Meier-Graefe in 1929 in his monograph on Pierre-Auguste Renoir, whose painting "Moulin de la Galette" (1876, Musée d'Orsay, *see* p. 80) made famous the mill and dance hall setting on Rue Lepic. It was mainly working people from the area who came to dance here at the end of the 19th century. It was also, however, a regular haunt of artists and writers who wanted to get away from upper-class society. In the evenings especially, the dance hall, which was steeped in tradition, would transform itself into a rather seedy meeting place for the Paris demimonde. A particularly gruesome tale is associated with the mill, which was built between 1621 and 1628. Nicolas-Charles Debray, the owner of the mill from 1809, had the idea of opening a wine bar in another building, as no alcohol taxes were levied outside the city limits. He defended his flourishing business in 1814 at the end of the Napoleonic Wars, embittered by the onslaught of a brigade of Cossacks. When he put up fierce resistance to the threatened pillaging, the soldiers crucified him on a sail of his windmill. Moulin de la Galette, as well as the neighboring Moulin Radet, is no longer open to the public, as private flats have been built here.

Cimetière de Montmartre

Together with Montparnasse and Père-Lachaise, this cemetery is one of the 18th-century establishments that led finally to the implementation of the ban on burials within the city, demanded for a long time on grounds of hygiene. The area on the hillside was chosen as the existing limestone quarries there had been exhausted. During the 19th century in particular, the burial ground was extended into the "city of the dead" that typifies Paris and where many famous people have also found their final

resting place. Among these are the artists Jean-Baptiste Greuze and Jean-Honoré Fragonard, the writer Henri Beyle—whose nom de plume was Stendhal—and the renowned Madame Récamier, whose por-

trait was painted many times. Heinrich Heine, who lived in Paris from 1831 and engaged intensively in a dialogue about German and French culture, is buried here along with the composer Hector Berlioz, Jules and Edmond Goncourt, the brothers who made their names as writers and critics, and the great novelist Alexander Dumas. Likewise buried in Montmartre cemetery is the Cologne-born composer Jacques Offenbach (1819–1880). He did not live to witness the premiere of his one grand opera "Les Contes d'Hoffmann" (Tales of Hoffmann), but died penniless and alone after suffering financial ruin with his opera company "Bouffes Parisiens."

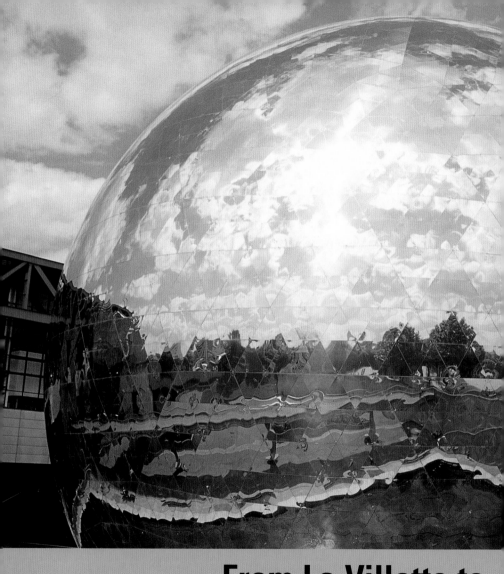

From La Villette to

Bois de Vincennes

From La Villette to Bois de Vincennes

"Quartier Perdu" (Lost Quarter) is the title of a novel by Patrick Modiano (born 1945), many of whose books deal with departures and returns, and restless migrations in and out of Paris. These comings and goings are probably most pronounced in the north-west sector of the city, in the 19th and 20th arrondissements. Belleville, which was once an autonomous town council, now sits on the border of these two districts. It has always been the destination and stopover point for immigrants who arrive with not much more than the desire to realize their dream of happiness in Paris. They used to come from the provinces, but now it is North Africa and Asia. Here, on the old border of the city where no-one else wanted to live—near the huge slaughterhouse of La Villette and in a busy industrial area—simple apartment blocks were built that provided refuge for those who needed to get out of the city center.

The waterways of Canal St-Martin and Canal de l'Ourcq, which were constructed by Napoleon I to improve the supply of drinking water to Paris, attracted businesses

Rotonde de La Villette, the former custom house at the park entrance to La Villette, was built in 1789 by Claude-Nicolas Ledoux

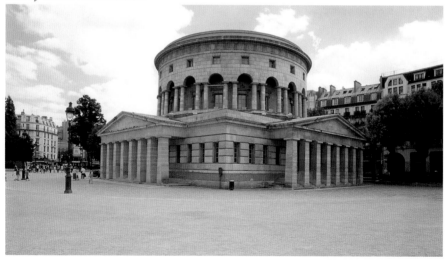

that require a large amount of water, such as tanneries, paper mills, and faience porcelain manufacturers. In this environment working class areas emerged that were considered volatile slums in the 19th century. Belleville took part en masse in the revolt of the Commune in 1871, its barricades being the last to withstand the National Guard. It is hardly surprising therefore that Napoleon III tried to upgrade the infrastructure of the district. One of his flagship projects was the creation of the atmospheric Parc des Buttes-Chaumont. The decision to turn La Villette into a cultural and educational center after the closure of the abattoir was also driven by the desire to create a new direction for the hitherto neglected quarter. This brought in visitors who had not been seen there before—tourists, day trippers, people looking for some relaxation—so once again it was a question of people passing through, not staying, but who would take away impressions of a different kind of Paris that was simple, working class, and multicultural.

Preceding spread:
The Géode, the geodesic dome cinema
in the futuristic Parc de la Villette

Canal Saint-Martin flows into the Seine at the
marina behind the Place de la Bastille; for over
half of its course, it runs underground.

From La Villette to Bois de Vincennes

Parc de La Villette, p. 386 f.

Bois de Vincennes, p. 396

Château de
Vincennes,
Av de Paris, p. 397

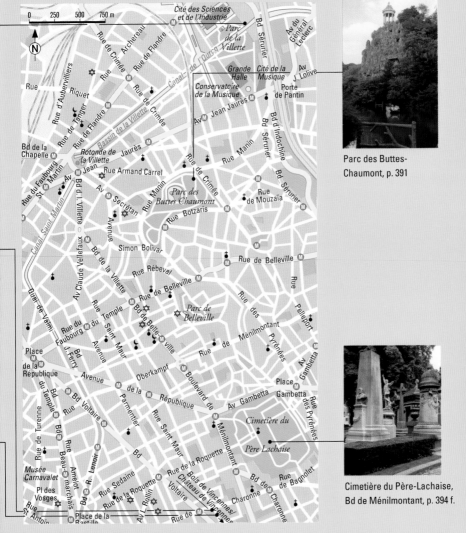

Parc des Buttes-
Chaumont, p. 391

Cimetière du Père-Lachaise,
Bd de Ménilmontant, p. 394 f.

Parc de La Villette

On the site of the old abattoir, a project sponsored by Mitterand was set up between 1982 and 1993—a science park for the 21st century. From the start, the idea was not to create an artificial pastoral idyll, but instead a living cultural center for the benefit of the underprivileged working class 19th arrondissement. The Swiss architect Bernard Tschumi designed an extensive and multipurpose open area, with large grassy spaces that could be used for playing, picnicking, sports, and sunbathing. The small, red, sculptural buildings dotted around the site—the so-called follies—are meant to encourage the visitor to engage in different types of activities: it is possible to hire play equipment and mats, find out about events, and get a snack in them. A few serve as observation towers and bridgeheads. Some enclosed areas form the ten theme gardens, including the Bamboo, Dragon, Dunes,

Mirror, and Island gardens. They can be accessed via a blue-paved path that weaves playfully through the park. Complementing the organically growing "Promenade des Jardins," a linear ramped bridge—the "Galerie de la Villette"—forms the north–south axis and interconnects the two gateways to Paris, the metro stations. The numerous buildings in the park were conceived by different architects. The Grande Halle of the old slaughterhouse was preserved, a 19th century steel frame construction, and was converted into a building to house events. Some of the new developments include the stunning, gleaming Géode cinema, a museum of science and technology, a music center, and a concert hall.

Canal St-Denis

Jardin des Bambous
(Bamboo Garden)

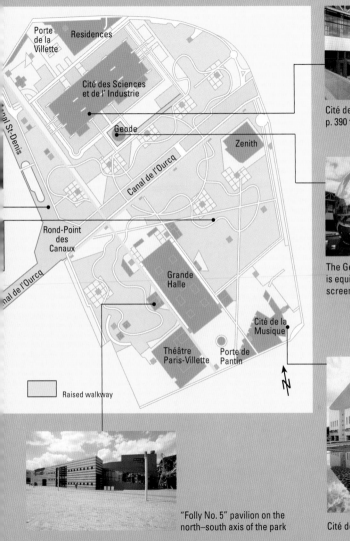

Porte
de la
Villette

Residences

Cité des Sciences
et de l' Industrie

Geode

Zenith

Canal St-Denis

Canal de l'Ourcq

Rond-Point
des
Canaux

Canal de l'Ourcq

Grande
Halle

Cité de la
Musique

Théâtre
Paris-Villette

Porte de
Pantin

N

Raised walkway

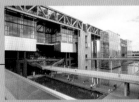

Cité des Sciences et de l'Industrie,
p. 390 f.

The Géode—the cinema auditorium
is equipped with a hemispherical
screen.

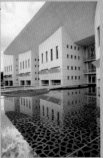

Cité de la Musique, p. 388

"Folly No. 5" pavilion on the
north–south axis of the park

Parc de La Villette **387**

Cité de la Musique

Adjacent to the Porte de Pantin entrance, the visitor is greeted by the Cité de la Musique, which was realized between 1990 and 1994 by Christian de Portzamparc. It contains a conservatory with practice rooms, a library, student residences, a museum of instruments, the institute for music teaching, and a large concert hall. A postmodern building with eclectic structural forms, it was designed and built in close collaboration with the French maestro of contemporary music, Pierre Boulez, and is characterized by an open, dynamic quality. The effectiveness of the asymmetrical complex lies in the diverse articulation of individual forms, which are merged together under one large curved roof, just like a musical composition. Portzamparc was awarded the prestigious Pritzer Prize for Architecture for this ambitious project.

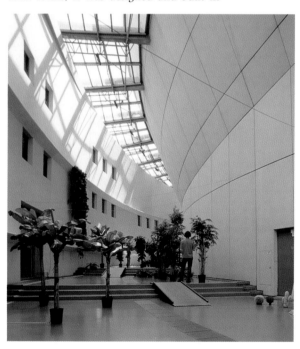

Musée de la Musique

With around 4,500 exhibits, the museum provides an outstanding overview of the historical development of music from the Renaissance to the 19th century. Brief excursions into musical history outside Europe complete the tour, which becomes a genuine listening experience with the obligatory audio guide. The interior design of exposed concrete and wood frames the collection in a functional yet elegant way. As well as the permanent collection, temporary exhibitions display different epochs of musical history or specific cultural contexts.

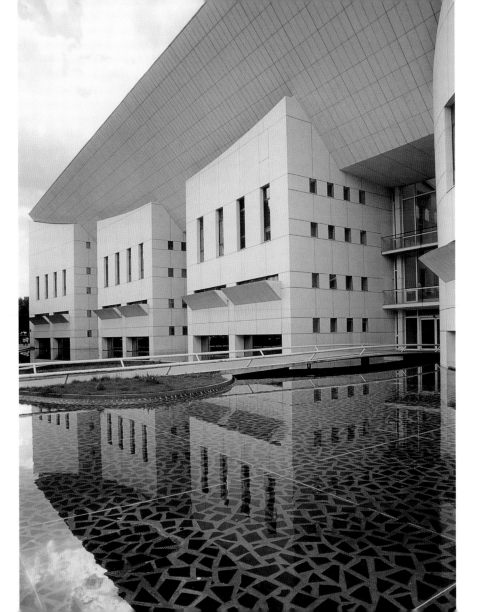

Cité des Sciences et de l'Industrie

From 1980 through 1987, Adrien Fainsilber built the massive Cité des Sciences et de l'Industrie beside the park exit, on the site of the former huge slaughterhouse. The cubist building, surrounded by a moat, could accommodate the Pompidou Center four times over within its space and houses a museum of science and technology that focuses on providing interactive, fun-filled access to the world of the natural sciences. The Explora permanent exhibition comprises 20 themed areas relating to the universe, water, land, man and his genes, industry, and communication. For children between the ages of 3 and 12, special educational zones have been set up. There

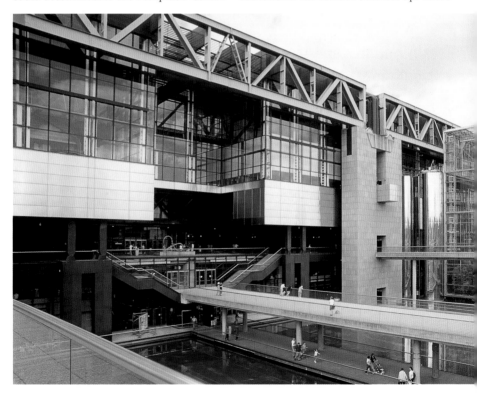

is always something to see, hear, touch, and try out here, a hands-on approach that helps to understand the exhibits. A planetarium, the Cinaxe movement simulator, and a 3-D cinema complete the portfolio, which would be impossible to cover in a single visit.

Parc des Buttes-Chaumont

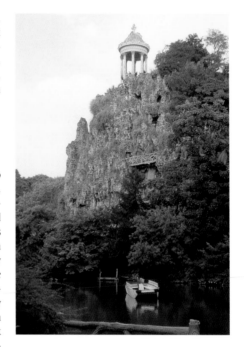

Paris has Napoleon III to thank for several parks, which were created or renovated during the Second Empire as a result of his admiration for English urban gardens, especially Hyde Park in London. The expansive Parc des Buttes-Chaumont was created by Adolphe Alphand between 1864 and 1867 on the bleak terrain of exhausted limestone quarries. It became the place of relaxation for the working-class inhabitants of Belleville and one of the most romantic parks in all Paris. Man-made grottoes, waterfalls, and a large lake with a rocky island and Corinthian round temple on top—all the different features of English landscape gardens were used here. Together they make up an artificial paradise of nature that can be explored on foot via winding paths, wobbly pendant bridges, and lots of steps. Gabriel Davioud, who had also worked with Adolphe Alphand on the Bois de Boulogne, designed the installation of kiosks, a cafe, and a brasserie in the park, as well as the "tempietto," a replica of the Vesta temple near Tivoli.

She had no regrets—Edith Piaf, queen of the chanson

by Oliver Burgard

It is the stuff of which myths are made. Born during the first winter of the war on December 19, 1915, under a gas lamp in Rue de Belleville. A cop as midwife. The father too drunk to get his pregnant wife to hospital on time. Edith Gassion, later Piaf, was all too willing to help weave her own myth, even if her birth certificate shows that she saw light of day in l'Hôpital Tenon.

What is true is that this most famous of French singers came from a very deprived background. She wrote in her autobiography that at the age of 18 she knew "only the dregs of society" and had seen "nothing but ugliness and misery." What had to be discovered about life, she learned on the street. Her father was a street acrobat who let his little daughter warble away to catch the attention of passers-by. It was not just singing she learned on the streets. "I thought that a girl could never say 'no' to a boy. I thought that was part of our role as women." All her life, Piaf said 'yes.' "I was always looking for the one, great, true love, so that is perhaps why I had so many men in my life. I never wanted to settle for the deceit and mediocrity of most men I had fun with." She was afraid of being lonely, "of that terrible loneliness that constricts your heart as the dawn breaks, or in the twilight hours when you ask yourself if life is worth living and why."

She was discovered at the age of 19 by a dapper nightclub owner, Louis Leplée, who picked her up off the street to sing in his cabaret, Gerny's. She looked like a shy, well-behaved girl, standing on the stage in a black skirt and hand-knitted jumper at the start of her career in 1935. Her style went down well. This child of the streets—a grown woman, yet no taller than a girl—was popular with music hall and variety audiences, and the radio stations and record industry took to her as well. The speed of her success transformed the lady into a diva. She surrounded herself with an entourage of real and

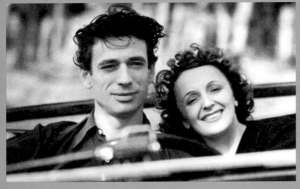

Edith Piaf and Yves Montand, 1945

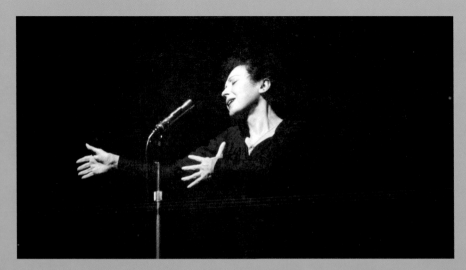

not so real friends, who had to put up with her moods and rages. In Paris she was known as the "monstre sacré" (holy monster). Her repertoire was made up of 200 songs, all variations of the recurrent theme of painful, unfulfilled love that ends in tragedy—love that destroys people, as it did her. On October 28, 1949 the man she loved most in her life, the boxing champion Marcel Cerdan, was killed in an air crash on his way to see her. He had wanted to travel by boat, but she persuaded him to "take the plane" as she could not wait to see him.

Six months later, she was dependent on two injections daily of both cortisone and morphine, and plenty of alcohol as well. She went into rehab; this was neither the first time nor the last. At her artistic peak in the 1950s, she was a cel-ebrated singer as well as film star. Yet her emaciated body was as delicate as that of an old woman. She suffered from gastric ulcers and liver cancer. Piaf orchestrated her own decline like a song, staggering onto the stage and forgetting her words; breaking down, but singing on.

On a bright fall day on October 14, 1963, 40,000 people came to Père-Lachaise cemetery to say their last farewells. "It's true that I led a terrible life, but it was wonderful too, because I loved, and loved life above all."

Edith Piaf (1915–1963) on stage, 1961, Paris

Cimetière du Père-Lachaise

What is undoubtedly the most famous cemetery in France—named for the Jesuit and father confessor of Louis XIV, François de La Chaise—lies on the east side of Paris, on the site where La Chaise owned a fairly large piece of land in the 17th century. Since the burial ground opened in 1804, over a million people have been interred here. In a literal sense, a huge city of the dead developed, and for several months during the suppression of the Commune in 1871 it was turned into a battlefield,

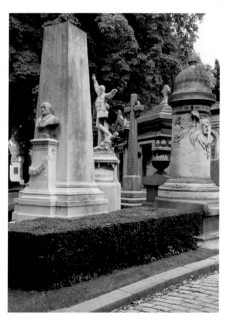

where the last Communards entrenched themselves between the graves. When the uprising was finally suppressed on May 28, 1871, the 147 survivors were executed against the Mur des Fédérés (Communards' Wall) in the north-east corner. This unique graveyard is a picturesque, if melancholy, place of pilgrimage due to the numerous graves of famous people (often with very elaborate headstones), the mature tree population, the cobbled paths, and the hilly location providing lovely views across the city. More importantly, a walk through Père-Lachaise is like browsing through a "who's who" in the cultural history of France and Europe. Among those who have found their final resting place here are the famous lovers, Abélard and Héloïse, as well as Edith Piaf, Oscar Wilde, Sidonie-Gabrielle Colette, Baron Haussmann, Guillaume Apollinaire, Honoré de Balzac, and last, but not least, Jim Morrison.

A map is required to negotiate the vast area it covers, which is far more extensive than any park in the city. Escalating grave tourism, vandalism, and the exuberance of nature have all led in recent years to progressive dilapidation, making it necessary to carry out renovation and preservation work. The city of Paris has a scheme for sponsoring graves as a way of raising finance. Plenty of burials are still taking place today, but only certain famous personalities retain the right to interment for an unlimited time.

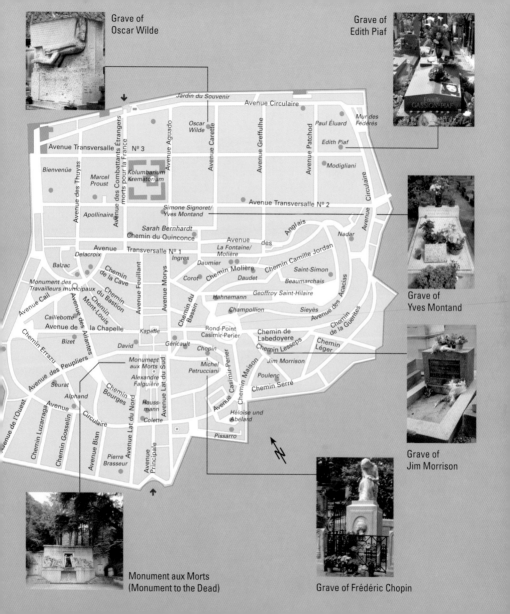

Grave of
Oscar Wilde

Grave of
Edith Piaf

Jardin du Souvenir

Avenue Circulaire

Avenue Transversalle

Nº 3

Oscar Wilde

Paul Éluard

Mur des
Fédérés

Avenue des Thuyas

Avenue Aguado

Avenue Carette

Avenue Greffulhe

Avenue Patchod

Edith Piaf

Bienvenüe

Kolumbarium
Krematorium

Modigliani

Marcel Proust

Avenue des Combattants Étrangers
morts pour la France

Apollinaire

Avenue Transversalle Nº 2

Simone Signoret/
Yves Montand

Avenue

Grave of
Yves Montand

Sarah Bernhardt

Nadar

Anglais

Chemin du Quinconce

Avenue
Transversalle Nº 1

Avenue des
La Fontaine/
Molière

Delacroix

Ingres

Daumier

Chemin Camille Jordan

Saint-Simon

Balzac

Chemin
de la Cave

Corot

Chemin Molière

Daudet

Beaumarchais

Monument des
Travailleurs municipaux

Chemin
du Bastion

Chemin
Mont-Louis

Caillebotte

Avenue Feuillant

Avenue Morys

Chemin du Bassin

Hahnemann

Geoffroy Saint-Hilaire

Champollion

Sieyès

Avenue des Acacias

Grave of
Yves Montand

Avenue Call

Bizet

Avenue des
Atlantes

Avenue de la Chapelle

Kapelle

Rond-Point
Casimir-Perier

Chemin de
Labedoyere

Chemin
de la Guerres

Chemin Errazu

David

Géricault

Chopin

Chemin Lesseps

Chemin
Léger

Avenue des Peupliers

Monument
aux Morts

Michel
Petrucciani

Jim Morrison

Grave of
Jim Morrison

Seurat

Alexandre
Falguière

Avenue Lat du Sud

Avenue Casimir-Perier

Chemin Maison

Poulenc

Alphand

Chemin
Bourges

Haussmann

Chemin Serré

Avenue de l'Ouest

Avenue

Circulaire

Avenue Lat du Nord

Colette

Héloise und
Abélard

Chemin Luzarraga

Chemin Gosselin

Avenue Bian

Pierre
Brasseur

Avenue Principale

Pissarro

N

Grave of
Frédéric Chopin

Monument aux Morts
(Monument to the Dead)

Bois de Vincennes

From royal hunting ground to defensive fortification, from king's residence to prison, from porcelain manufacture to an arsenal of weapons—the checkered history of the Bois de Vincennes reaches back to the 5th century, when Frankish kings were already hunting there. In 1183, Philippe August walled in the area and built a royal residence. For the next 500 years or so, the forest was reserved for the king to use as a hunting ground.

The vast forest has a zoological garden, a floral garden with seasonally changing plants, a racetrack, and various sports facilities, all ready and waiting for those in need of relaxation. Like the Bois de Boulogne, it was remodeled by Napoleon III as an English-style park in the 19th century. The emperor also collaborated on this project with landscape designer Adolphe Alphand, who created two artificial lakes, waterfalls, and boardwalks for walkers and riders. In keeping with contemporary tastes, Gabriel Davioud added the architectural features, such as the small, round temple of antiquity on Lac Daumesnil. The exit to the forest on the northern side leads to the town of Vincennes, and the chateau that bears its name.

Château de Vincennes

The chateau that survives today, which is open to the public, is a heterogeneous mix. It consists of the Donjon built in the 14th century, the separate chapel (modeled on Sainte-Chapelle and completed in the 16th century), and the Classical structures built by Louis Le Vau in the 17th century. Among those who lived in the Pavillon de la Reine was the powerful Cardinal Mazarin, who was appointed governor of Vincennes in 1652 and died here in 1661 following the Treaty of Oliva, at the height of his political power. Before the chateau at Versailles was ready for habitation, the young Louis XIV lived in the Pavillon du Roi with his bride, the Spanish Infanta Maria Theresia. Later the Donjon served as quite an exclusive prison; Mirabeau, Denis Diderot, and the Marquis de Sade were some of those incarcerated in it. A cadet school was finally established under Napoleon Bonaparte and the complex was reinforced as a stronghold once again. The indomitable General Daumesnil, who had lost a leg in a battle against the Austrians, became its most famous governor. In 1814 he held the fortress against the superior coalition forces led by Blücher, shouting to the negotiators who were calling on him to capitulate that they would have to take his other leg if they wanted Vincennes. Paris fell on March 30, 1814, but still Daumesnil refused to yield.

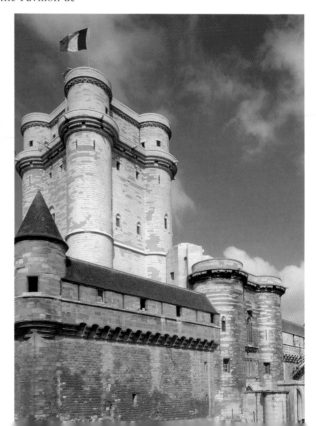

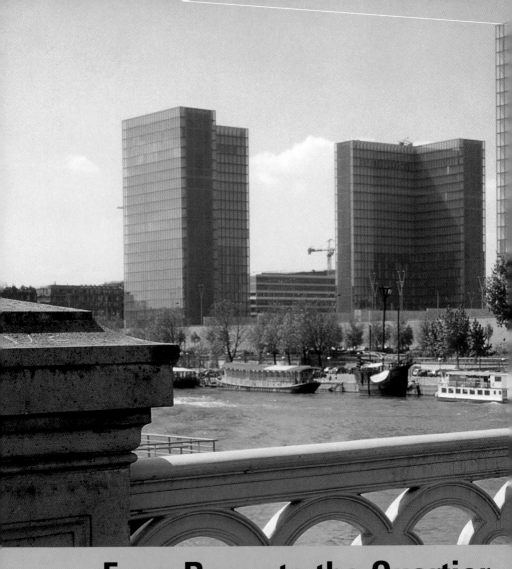

From Bercy to the Quartier

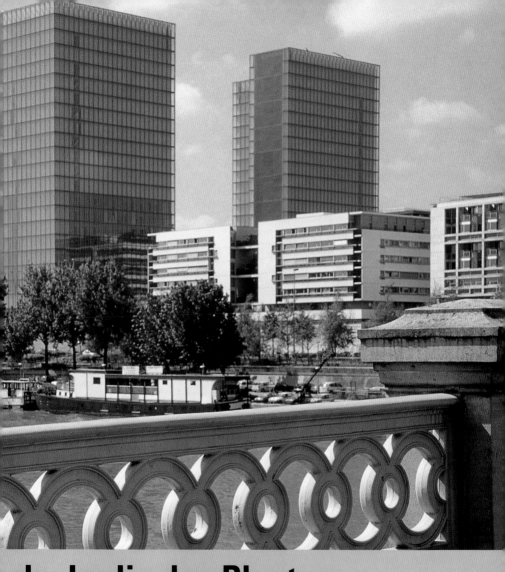

du Jardin des Plantes

From Bercy to the Quartier du Jardin des Plantes

On studying a current map of Paris, a large, white area around the new National Library becomes apparent. "Under construction" is indicated several times in the elongated strip of land between Gare d'Austerlitz and Quai d'Ivry. Huge building works are underway in the Tolbiac quarter, which have more or less been completed on the other side of the Seine in Bercy. In the last few years ambitious projects have been realized there—the huge Palais Omnisport, the Cinémathèque Française, and the Ministry of Finance—which are embedded in a new, modern, residential area around Rue de Bercy. Parc de Bercy, sizeable gardens with expansive lawns and an axial network of paths, was built right on the banks of the

Seine. An elevated terrace provides a lovely walk above the river. The facade articulation of the adjoining apartment blocks, which open out onto the park in a U-shape, is based on a rational division along vertical and horizontal lines. Formerly an important trading center for French wine, which was brought for storage here from the wine-producing regions and then sold on, the Bercy district has gradually become a showcase for a modern concept of urban development. Cultural facilities, the huge sports stadium (used for football games, boxing matches, horse shows, and even concerts), a business district, and the recreational area of the park have combined to form a new, functional living environment, though one that is devoid of history. There are only a few reminders of the tradition of wine trading dating back to the 17th century in the municipality, which used to lie outside the customs boundary of Paris. The memorial gardens were created within the park, with restored warehouses, a railway track, and a few

Cour Saint-Émilion in Parc de Bercy

*Preceding spread:
the Bibliothèque Nationale de France—Site F. Mitterrand, seen from the banks of the Seine*

Construction site in the Tolbiac district

and a pedestrian bridge that crosses directly to Parc de Bercy. These works, which are due for completion in 2025, are regenerating what had been a derelict industrial landscape into a space for living, working, and relaxing.

The vast area of La Salpêtrière hospital complex is adjoined to the north by the botanical gardens district, le Quartier du Jardin des Plantes, which stretches as far as the Seine and the boundaries of the Latin Quarter. Around Rue Mouffetard, in particular, a network of small, narrow streets with an almost provincial feel have been preserved. Nearby are the ruins of the Arènes de Lutèce, the old Roman amphitheatre with a capacity of 15,000 seats, where circus performances and gladiator combats were staged, as was customary throughout the Roman Empire.

old plane trees. A similar idea is now being developed on the Left Bank as well—the plan is to preserve the old flour mill of the Grands Moulins and a large cold-storage warehouse from the 1920s. Meanwhile, new residential and office buildings are springing up around the National Library, along with an elegant riverside walkway

From Bercy to the Quartier du Jardin des Plantes

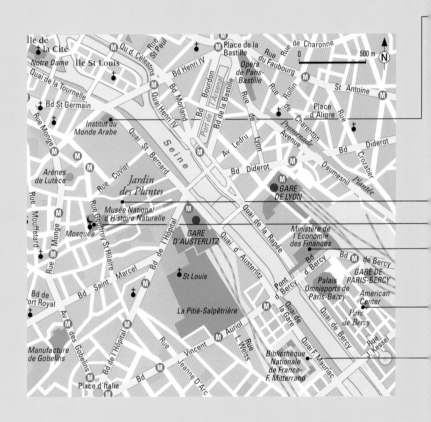

Institut du Monde Arabe, 1, Rue des Fossés St-Bernard, p. 418 f.

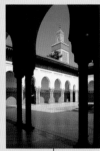

Mosque, 39, Rue Geoffroy-St-Hilaire, p. 416 f.

Muséum National d'Histoire Naturelle, 57, Rue Cuvier, p. 409 ff.

Ministère de l'Économie et des Finances, 139, Rue de Bercy, p. 405

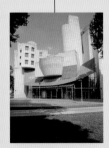

Bibliothèque Nationale de France – Site F. Mitterrand, 11, Quai François Mauriac, p. 406 f.

Cinémathèque Française, 51, Rue de Bercy, p. 404

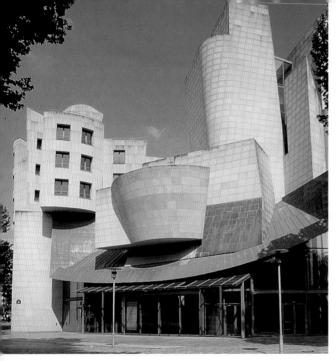

Cinémathèque Française

The American Cultural Institute, which had been in Montparnasse since 1934, was rehoused in a new building in the Bercy area in 1994 and caused a sensation. One of the most prominent exponents of deconstructivism, the American architect Frank O. Gehry, designed a spectacular standalone building as the highlight of the new neighborhood. The interwoven main structure makes optimum use of the relatively small site and is composed of tilting, sliding, and soaring sections that explode the closed structure of the building. The golden sandstone and zinc-clad roofing draw parallels with historical Parisian construction types, the former town palaces of the aristocracy in the Marais and 19th-century residential houses.

Today, the American Center is home to the Cinémathèque Française, which now has a collection of 40,000 films. Its multiple cinemas have regular film screenings, and there is also a wide-ranging educational program on film history and basic issues relating to film as a medium. Two studios and an audio visual center are used for workshops. Exhibitions in the spacious gallery wing and a library complete the facilities, which are open to the public. The highlights of Gehry's building are without doubt the imaginative staircase and the reception hall with its wonderful view over the park and the Seine; the building is also well integrated, from a functional point of view, with the expanding neighborhood in Bercy and Tolbiac on the other side of the river.

Ministry of Economics and Finance

When the expansion of the Louvre forced the Ministry of Finance to move from the Richelieu wing, the city administration chose a site between Pont de Bercy and Gare de Lyon for the new building required. The intention was to stimulate new development in the eastern part of the city with this important project. Paul Chemetoff and Borja Huidobro won the national design competition with the unconventional idea of setting the building at right angles to the river instead of in parallel to it, counter to the standard way of developing a tract of river land. One wing of the large administrative complex, where around 6,500 people are employed, actually projects into the Seine, supported by huge pillars. This allows the Ministry, which is responsible for setting and collecting taxes, to introduce itself into the traffic on the water and on Quai de Bercy like a customs station. The old customs boundary was in fact located here, so the comparisons with a medieval city gate, where taxes were traditionally levied, are perhaps not unfounded—even though François Mitterrand rather irreverently remarked that it reminded him of a turnpike on the freeway. The relocation from the Louvre took place in 1989; the Minister of Finance now travels to the National Assembly by waterway.

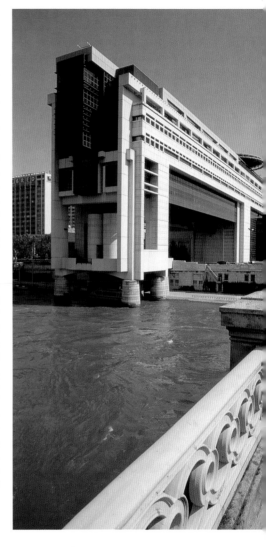

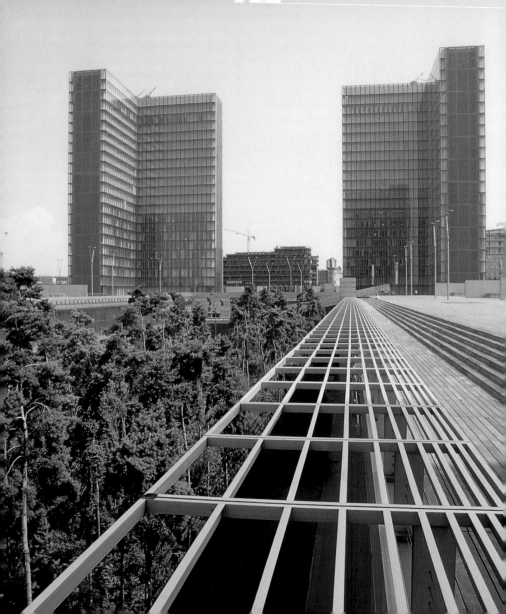

Bibliothèque Nationale de France – Site F. Mitterrand

Collecting books and manuscripts was an integral part of royal cultural policy from the Middle Ages onward, and was written into the statute books by Francois I in 1537. Even today, a copy of every printed book in France must be submitted to the Crown (or as it is now, State) Library. Colbert, the influential minister of Louis XIV, set up a national library in 1666 for the king's accumulated collection of 200,000 volumes; it developed into one of the most valuable collections in the world and now has over 12 million books. Since 1995, most of this national treasure has been stored in the new library building in the Tolbiac district. The architect Dominique Perrault, then 36 years of age, won the bid for this ambitious project in 1989. His design was controversial from the outset—a plinth construction with huge, soaring glass towers at each of its four corners, the "L"-shape of which is reminiscent of opened books. The architecture is in fact seriously inadequate in terms of its functionality. The anticipated storage of the light- and temperature-sensitive books in the glass towers was unworkable for reasons of preservation. Timber louvers had to be added later, which ruined the transparency Perrault had envisaged. On the other hand, darkness plagues the underground reading rooms, which are supposed to accommodate 10,000 users per day. There has also been criticism of the noticeably elitist atmosphere, due in no small part to the sumptuous interior decor of expensive wood, stainless steel, and glass. The narrow, tunnel-like entrance to the library complex on Rue Émile Durkheim and the sloping ramps leading down to the information and service areas have also been viewed as the architectural expression of reserve. Students and academics have made the loudest complaints, however, because of the bureaucratic hurdles that have to be overcome in obtaining a user's card through to borrowing from the stacks.

The design of the square inner courtyard in the center is one of the best ideas realized by Perrault in the new library building. Tall, slender-growing trees from a number of European countries have been planted here, creating a kind of sunken forest. The thick foliage emerges from the depths of the basement level, providing a soothing view from the reading rooms. This is a reference by Perrault to a fresco in the reading room of the old Bibliothèque Nationale in Rue de Richelieu, which depicts a wooded landscape. Since time immemorial the wood has been a mythological place on the border between the known from the unknown, a metaphor of discovery for bibliophile researchers.

La Pitié-Salpêtrière

Paris during the Ancien Régime was a city characterized by the daily misery of those who were without work and lodgings, and who depended on the charity of others. Around 55,000 beggars lived on the streets of the French capital in the 17th century, added to which there was an army of prostitutes and vast numbers of children who had been abandoned by their destitute parents. As the social situation worsened on the eve of the Revolution, each day thousands were losing their last goods and chattels. The aim of state relief for the poor and sick was, however, not to support the weak or reintegrate those who were foundering, but simply to control and subjugate the impoverished masses. In the 17th century a series of internment establishments were set up for this purpose. One of these was the large Salpêtrière complex, built by Louis Le Vau in 1656 for Louis XIV from a former arsenal for gunpowder production. Built in 1670, the St Louis Chapel—with its dome crowned by an octagonal lantern that dominates the facade of the present day hospital—was the creation of Libéral Bruant, who was working at the same time on the Hôtel des Invalides. The octagonal central structure can accommodate up to 4,000 people. Jammed together in inhumane conditions in the Salpêtrière were mainly sick, disabled, and mentally disturbed women, but also orphans and girls with so-called behavioral problems—i.e. prostitutes. Up to 20,000 people, some of whom were in chains, were kept in vast halls. Often the stay in this institution with its formidable architecture was the last stop in a short and desperate life.

Musée National d'Histoire Naturelle

Originating from the medicinal herb garden of Louis XIII, which was established in 1635, the Natural History Museum is one of the most important institutions of its kind internationally, with its vast botanical gardens, the zoo with animal houses and vivarium, and its outstanding collection of minerals and fossils. As was then the style, the iron frame construction of the Grande Galerie by Louis Jules André (1886) was initially concealed behind a stone facade. The large exhibition building suffered neglect during the 20th century and, after sustaining damage during the war, had to be closed in 1965 for reasons of safety. The essential renovation and refurbishment work did not take place until 1990–1994; it was undertaken by the architects of the new Ministry of Finance, Paul Chemetoff und Borja Huidobro, along with the stage designer and film director, René Allio.

Jardin des Plantes

During the 17th and 18th centuries, botanists were constantly being dispatched to faraway lands in order to enrich the collection of "le jardin royal des herbes médicales" with rare specimens of exotic plants. Among these botanists were the three Jussieu brothers, who gave their name to the district around the botanical gardens. Between 1739 and 1788 the royal gardens were run by the eminent naturalist Georges-Louis Leclerc, Comte de Buffon. He extended them considerably as far as the banks of the Seine, created a renowned research center, and opened up the educational garden to the public. Part of the garden was developed in the French formal style with straight paths, tree-lined avenues, and square parterres; there was also a park inspired by English landscape design, as well as a labyrinth on a man-made hill. After the Revolution the garden was renamed "Musée d'Histoire Naturelle" and a zoo was

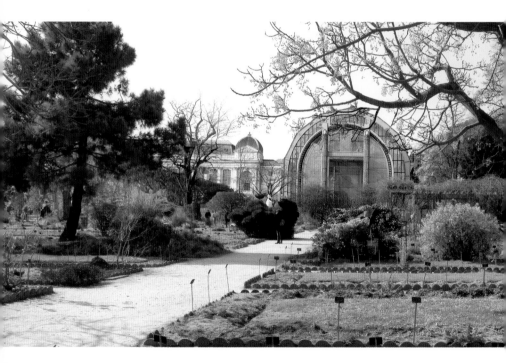

added, with animals being brought together from the royal menagerie in Versailles and banned wandering animal shows. For the first time Parisians could marvel at live exotic species like elephants, bears, and giraffes. The huge greenhouses contained several thousand tropical plants; built in 1830 by Hector Horeau, they are early, progressive examples of iron and glass construction.

La Grande Galerie de l'Évolution

The high hall of the Muséum National d'Histoire Naturelle with its surrounding galleries over four floors provides information about the diversity of life on our planet, the development of the different species, and the role of mankind in evolutionary history. The displays make widespread use of computer-based interactive media. As well as conveying the theory of evolution, there is a general introduction to the working practices and techniques of the natural sciences. The arrangement of stuffed savannah animals is particularly impressive; among these is a rhinoceros dating back to 1770, the oldest preserved animal in the collection. An effective sound installation simulates the different climatic weather conditions, such as rain, thunderstorms, or gales, transporting the visitor back to daily life in the earliest days of natural history. Making science a living experience in this way captures the imagination of visitors of all ages.

Precious images in wool, silk and gold—manufacture of Paris Gobelin tapestries

by Birgit Sander

Gobelin was the name of a Parisian family of dyers who founded a tapestry factory on their land in the early 17th century. The workshops in Faubourg Saint-Marcel, which are still there today, hark back to a glittering past. The tapestries manufactured here represented the luxurious pinnacle of the craft. Gobelin products adorned residences across Europe, the name being applied not only to those made at the family workshops but to tapestries in general. Pictorial wall hangings were already familiar in the Middle Ages, serving both as festive decorations for interiors and protection from the cold. They were produced with colored threads using tapestry techniques—a textile-making process in which vertical and horizontal threads, or warp and weft, are woven together on frames following a pattern. The growing sophistication of home decor during the Renaissance led to an increased demand for tapestries. Flemish workshops were at the forefront of tapestry production. The magnificent interior decoration cultivated during the Baroque and Rococo periods was to lead to a boom in luxury crafts.

To fan the flames of competition, the French king, Henri IV, promoted the national manufacture of tapestries in the 17th century. In 1607, he brought weavers from Flanders to Paris, giving them special privileges and generous financial support. The Flemish masters, Marc de Comans and Frans van den Plancken, committed themselves in return to set up 60 frames in Paris, train apprentices, and sell the tapestries at the customary trade prices. Under Louis XIV in 1662, the workshops and all their craft divisions for interior decor were amalgamated into one large factory under the control of the Crown. Taste in Europe was defined by the sumptuous style of architecture and interior design of the Versailles Sun King. Until the French Revolution, the Paris Gobelin factory was the unopposed trendsetter in Europe, both artistically and in terms of craftsmanship.

Celebrated painters like Charles Le Brun (1619–1690), Jean-Baptiste Oudry (1686–1755), and François Boucher (1703–1770) were directors of the company and supplied the designs for the tapestries. The brilliant translation of subtly nuanced painting into a woven form required the highest level of technical perfection. More than 250 weavers, both Flemish and French, were employed in the workshops. The associated dye works supplied wool and silk in natural colors, while gold- and silver-coated threads were also used. The color scale of around 120 tones in the 17th century was expanded fourfold in the next century, though the consequence was often a reduced resistance to light.

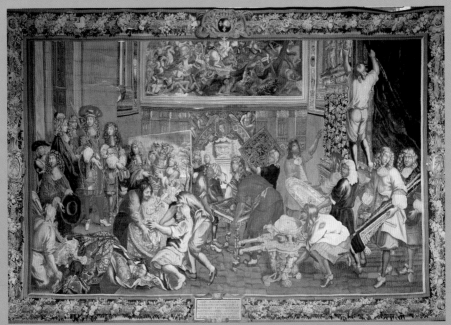

Tapestry depicting Louis XIV visiting the royal Gobelin factory on October 15, 1667, Atelier Leblond, after a design by Charles Le Brun, 1729–1734, 375 x 580 cm, Châteaux de Versailles and the Trianon, Versailles

The technique of tapestry making

The massive tapestries with their warp and weft structure were created on huge frames. The warp threads run lengthwise and, the denser they are, the finer the weave. The colored threads, the weft, are woven crosswise and alternately through the warp, within the outlines specified in the design, and then threaded back in the other direction. This differs from the classical weaving technique in which the weft runs across the entire span of the weave. To achieve the effects of a painting, the color is changed in short cycles. The weft threads covering the warp are interlocked to close the gaps in the weave.

Two methods of weaving were used in the Paris factory—for the haute lisse (high warp) technique on an upright frame, the original design, known as the cartoon, hangs behind the vertical warp, which is then worked by hand. This allows the weaver direct control of the sections of the

image and gives a distinct advantage when copying paintings, leading to a greater appreciation of this technique.

The basse lisse (low warp) technique using a flat frame, which makes it possible to work faster, was brought to Paris by the Flemish weavers. In this case the warp runs horizontally on rollers operated by pedals. The weaver can then use both hands for the bobbins of colored weft threads. The cartoon is attached back to front under the warp, so the weaver is looking at the reverse side of the illustration. The illustration that is being worked in reverse is therefore only seen when it is removed from the frame.

Products of the Paris factory

The court, aristocracy, and clergy were very fond of sumptuous finishes for their luxurious tapestries, favoring lavish border decorations interwoven with silk, gold, and silver. The factory also produced copies of famous compositions that were less expensive in terms of materials and less time consuming to make. Even so, these remained luxury, prestige items exclusive to wealthy clientele.

Depictions of gods and heroes of antiquity and historical and biblical scenes in rich colors adorned the rooms of magnificent baroque buildings. The themes were simultaneously entertaining and uplifting. Grand representational sequences like the 14-part series "The Story of Louis XIV" glorified the Sun King. Tapestries increasingly became an integral element in interior design and, as part of the ensemble, were no longer movable fittings but fixed to the walls.

Baroque pathos gave way to the playfulness of rococo. Pastoral idylls, affairs of the gods, or scenes of exotic journeys now decorated the medallion illustrations of the delicately-colored tapestries. Misty borders with flower garlands and birds became fashionable, known as "alentours tapestries." They found favor among the English aristocracy in par-

Tapestry depicting Moses being saved from the waters, Atelier Plancken-Corman, from a design by Simon Vouet, ca. 1630, Musée du Louvre, Paris

High warp workshop in the royal factory in Paris: Diderot, Encyclopédie, 1762–1777, Vol. XXVI, Plate 1771

ticular, as well as in France. As before, however, the French court was dominant: Louis XV, Madame de Pompadour, Louis XVI and Marie-Antoinette all commissioned work, ordering expensive tapestries as diplomatic gifts for the royal courts of Europe.

The French Revolution put an end to production, but only for a short time. While Napoleon returned to producing series of heroic figures, Art Nouveau around 1900 liberated tapestry making from its ties to painting, conceiving it instead as surface art. Artists like Picasso and Matisse gave fresh impetus to tapestry in the 20th century. Synthetic dyes were only used for a very short time. The state-run enterprise in Avenue des Gobelins still works with traditional techniques, using naturally dyed wools and silk. At a time of mass produced goods, it is preserving an illustrious, centuries-old tradition of French craftsmanship.

The Mosque

With its soaring minaret and Spanish-Moorish style architecture, the great Islamic mosque beside le Jardin des Plantes is an impressive sight on the streetscape. It was built between 1922 and 1926 by the architectural group Heubès, Fournez and Mantout. The complex is made up of three structures, which house the prayer hall, a Koran school, and the Institute for Islamic Religious Studies. There is also a Turkish bath, or hammam, in one of the surrounding houses.

Inner courtyard

The interior has a courtyard surrounded by double columns and decorated with brightly colored ceramic tiles. There is also a Moorish garden, which is traditionally interpreted as a symbolic representation of Paradise in Islamic architecture. A small souk (outdoor market) is directly accessible to the visitor, offering Oriental arts and crafts and a tea house. It was mainly Moroccan craftsmen who contributed to the decoration of the mosque with mosaics, carvings, chasing, and encrustation, inspired by the old royal city of Fès.

Institut du Monde Arabe

A foundation set up by France and 19 Arab countries in the 1980s set itself the task of rejuvenating what had become a thorny relationship between France and the Arab world—characterized by alienation and the additional burden of colonial politics—by means of a jointly supported cultural institute. The plan was to build a complex that would be conducive to cultural dialogue and consist of a museum, library, and function rooms. The stunning design for the building, which was selected by François Mitterrand as the first of his "Grands Projets," was by Jean Nouvel and established his international career. The architect conceived two interrelated structures: the museum of Islamic art was housed in a curved, wedge-shaped building that tapers to a point and has a glass facade; the library, on the other hand, is located in a rectilinear block, which is a continuation of the adjoining science faculty built in the 1960s. The two structures are separated by a deep cleft that ends in a square inner courtyard paved with mirrors and lies on the same axis as the apse of Notre Dame opposite—an understated gesture that, if nothing else, brings Islam and Christianity into visual contact with each other.

South facade

The combination of Arabic tradition with Western modernism became a general theme in Nouvel's architectural vision and reached a striking conclusion in the cladding of the facade. The ornamentation of carved, wooden latticework screens—which are traditionally used in Arab countries in front of balconies and windows to temper the piercing sunlight and safeguard the private domain of women—were reinterpreted here with over 20,000 light sensitive, metal sun shields. The diaphragms open and close in response to light penetration, creating an animated shadow play through the interior of the library. The resolution of the wall—a paradigm in Nouvel's architectural work—was staged as a cultural "crossover." While the museum's collection provides an overview of the historical development of Arabic art from its beginnings to the present day, the library holds around 60,000 books on Arabic history and culture as well as 1,200 current periodicals. The manuscripts are kept in a tower that winds upward in a spiral like a minaret. There is a wonderful view from the tower across the Seine and the Île de la Cité, which can be particularly enjoyed by visitors to the restaurant on the top floor, which is used in the afternoons as a tearoom.

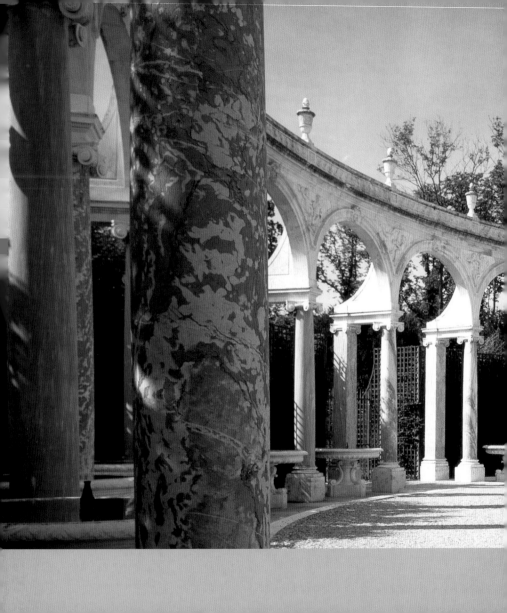

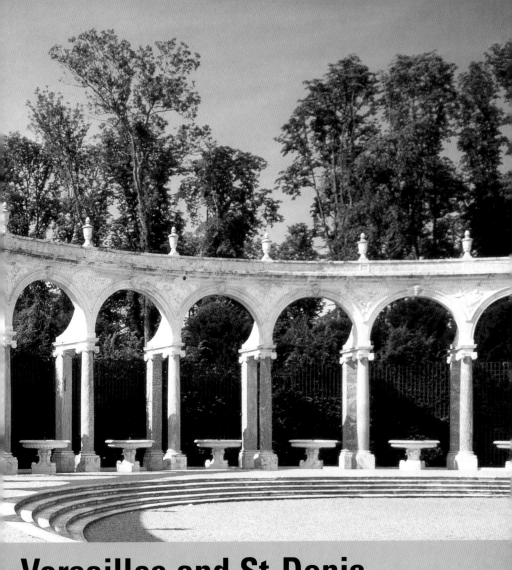

Versailles and St-Denis

Versailles
Château de Versailles

Versailles represents the indisputable high point of European palace architecture. The vast scale of the palace and gardens, its grandiose overall plan, and the huge financial commitment required to build and maintain it made the seat of power of Louis XIV (1643–1715) a unique expression of his aspirations to political hegemony. Shortly after taking over the reins of government in 1662, the king commissioned the leading artists of the day to rebuild and extend the existing small hunting palace built by Louis XIII; they were the architect Louis Le Vau, the landscape designer André Le Nôtre, and the artist and interior designer Charles Le Brun. The national budget was for decades so overburdened by the expenditure that the influential finance minister, Colbert, constantly urged restraint on the king. For Louis XIV, however, Versailles was not merely a building, but an integral component of his power politics, which justified the level of investment.

Preceding spread: Château de Versailles, colonnade by François Girardon in the palace gardens

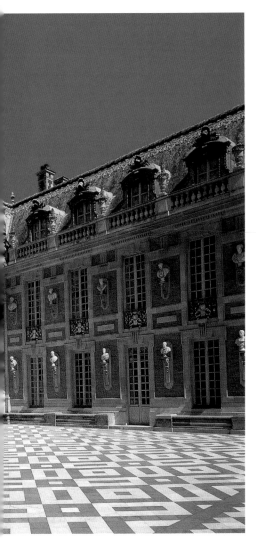

Marble Courtyard

The magnificent splendor of the chateau and park served to convey the self-assurance of the monarch. Louis XIV concentrated decision-making powers in all matters relating to state policy in his own hands and set himself up as the sovereign ruler, answerable only to God. His residence was therefore intended to reflect and reinforce this exclusive position. This was translated very skillfully even in the design of the three courtyards leading up to the main part of the palace, which control the visitor access routes. The first of these, the extensive Cour des Ministres, was originally flanked by two wings and could be used by general traffic as well as government and court officials. The narrower Cour Royale, on the other hand, had previously been closed off by imposing railings, with only princes and special envoys in state coaches being allowed to use it. The square of the Cour de Marbre, which owes its name to its precious marble paving and lies right in front of the king's suite, was reserved for the select few. The level was originally a few steps higher, which meant that even the most illustrious guests had to approach the king on foot. The elaborate facade ornamentation, especially the busts of the Roman emperors and the gilded balcony supported by double columns on the central projections, all emphasize the importance of the royal palace.

Château de Versailles

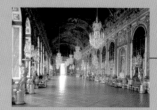

Hall of Mirrors, p. 426

Second floor

South wing North wing

Royal opera

The ground plan shows a three wing layout with a courtyard of honor and other wings on the lateral and longitudinal axes, which were built in 1678 by Jules Hardouin-Mansart. The front buildings and wings formerly housed the administration, guards, service staff, government officials, and courtiers. Members of the upper aristocracy and royal family also lived in many of these apartments, their proximity to the king's suite being dependent on the occupant's ranking in the court hierarchy. In the center of the main palace building, the apartments of the heir to the throne were accommodated on the first floor, while the Bel Étage was reserved for the queen and king. An enfilade of richly decorated salons led to the "Grands Appartements du Roi." This impressive sequence of rooms was meant to act as immediate preparation for the meeting with the king. The Chapel Royal was not completed until 1710 by Robert de Cotte.

La Méridienne

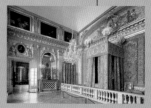

King's bedchamber, p. 426

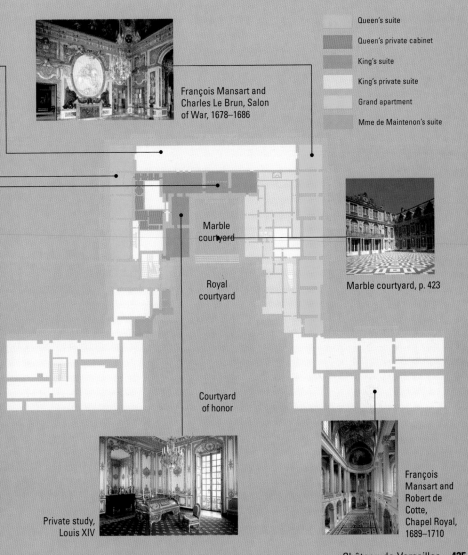

François Mansart and
Charles Le Brun, Salon
of War, 1678–1686

Legend:
Queen's suite
Queen's private cabinet
King's suite
King's private suite
Grand apartment
Mme de Maintenon's suite

Marble
courtyard

Royal
courtyard

Marble courtyard, p. 423

Courtyard
of honor

Private study,
Louis XIV

François
Mansart and
Robert de
Cotte,
Chapel Royal,
1689–1710

Château de Versailles **425**

The king's bedchamber

The king's bedchamber is situated in the middle of the gallery, which is right in the center of the whole palace complex and flanked on each side by the antechamber and the council cabinet. The way it is fitted out today, with the richly decorated alcove and gilded sculpture by Nicolas Coustou above, reflects its condition in 1701. After the Hall of Mirrors was built, the windows on the garden side were lost, so a rearrangement of the bedchamber was necessary. The king died here on September 1, 1715, leaving behind a country deep in debt and burdened by 25 years of war. Exhausted, the dying king is said to have advised his great-grandson and heir to the throne to avoid waging wars and constructing buildings.

Hall of Mirrors

Following the death of Louis Le Vau in 1670, the young architect Jules Hardouin-Mansart took over as director of works. One of his many ingenious ideas was the Hall of Mirrors, which was completed in 1686. It linked the king's suite with that of the queen and was used as a throne room and for grand celebrations, receptions, and royal weddings. The 17 arcade windows overlooking the park are matched by massive mirrors on the opposite side, which reflect the light coming in and give the baffling impression that the room span is extremely wide. In the evening especially, the reflection of the myriad candles must have been even more overwhelming. Charles Le Brun and his workshop were responsible for the magnificent decorative fittings including valuable furnishings, stucco work, and ceiling frescoes portraying the successful war against the allied forces of Germany, Holland, and Spain, as well as the victorious Treaty of Nimwegen (1678). This was a continuation of the iconography of the enfilades, celebrating the military strength of France while at the same time stressing the political will for a peaceful settlement.

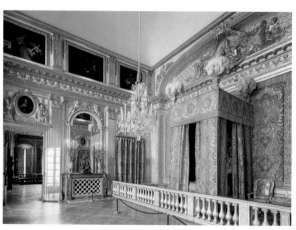

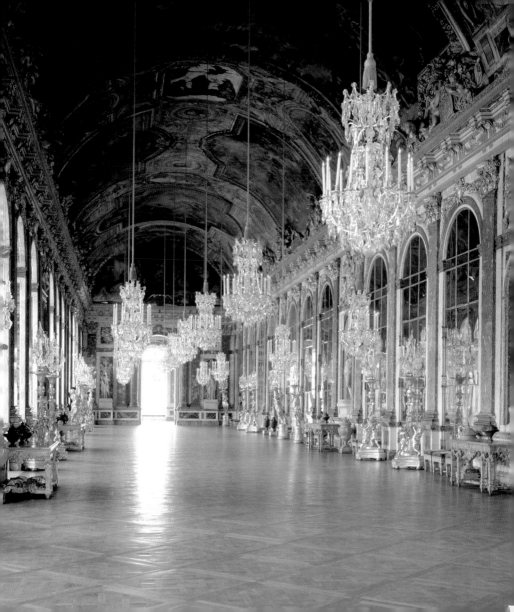

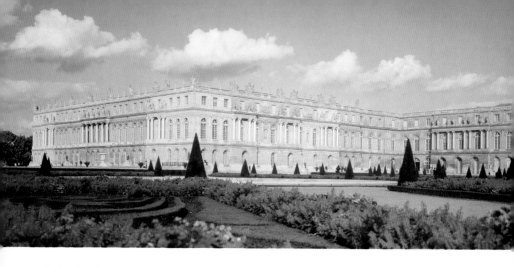

Garden facade

Completed in 1678 by Jules Hardouin-Mansart with a width of 2,200 ft. (670 m), the garden facade of the palace symbolizes the absolute monarchy of Louis XIV, with its monumental scale, solid uniformity, and Imperial ornamentation. As in the case of the Louvre colonnade, a strict French Classicism was applied, perfectly satisfying the king's claims to sovereignty as well as signifying an achievement of French architecture in its own right. The associated gardens, which stretch as far as the eye can see, seem to extend the formal arrangement of the palace architecture into infinity. André Le Nôtre designed a garden layout of straight lines and circles, where even nature appears to subject itself to royal decree. Its completion entailed a feat of unimaginable strength, involving the deployment of up to 30,000 workers, including royal troops, for the laborious earthworks and construction of water supply systems. The main alignment was formed by a symmetrical system of axes and terraces. Numerous water basins, fountains, follies, and arbors also acted as a charming stage for spectacular celebrations, including the premieres of operas by the court composer Jean-Baptiste Lully (1632–1687) and comedies by Molière (1622–1673). Partygoers had never seen the likes of the water and light effects before. The sculptural arrangements in the park were based on themes from Greek and Roman mythology. The representation of Louis XIV as the Sun King was reinforced by the motifs of the sun god Apollo.

The gardens

The extensive gardens were used for the official life of the court, as well as offering the king a retreat from royal protocol. It was for this latter reason that the Grand Trianon was built for Louis XIV; here he enjoyed frequent trysts with his mistress, Madame de Maintenon, whom he took as his second wife in a secret ceremony in 1683. Court life and the king's lifestyle changed as he grew older under the influence of "the uncrowned Queen of Versailles." Madame de Maintenon was not in favor of excessive celebrations or frivolous entertainment, insisting that the king withdraw more to the private sphere of the Trianon. His successor, Louis XV, com-missioned Jacques-Ange Gabriel to build the Petit Trianon for Madame de Pompadour and retreated here frequently, for days at a time, after it was finished in 1768. Marie-Antoinette even built a little village for herself between 1783 and 1785, known as The Hamlet, with twelve peasant cottages and a mill. Following the dictum of Jean-Jacques Rousseau—"back to nature"—a bucolic idyll was staged in the simple wooden dwellings for the entertainment of the queen. The actual hardships of the real world in which peasants lived remained hidden from her in the isolation of Versailles.

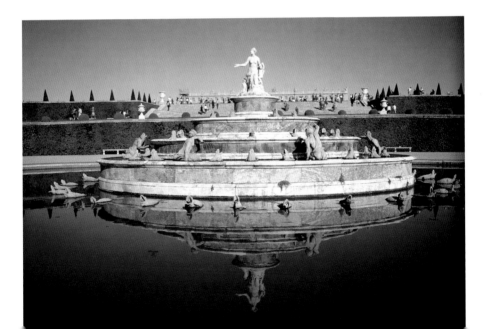

The gardens of Versailles

Jacques-Ange Gabriel, Petit Trianon, 1762–1764, South facade facing the court of honor

Richard Mique, Marie-Antoinette theatre, 1780, Versailles, Petit Trianon

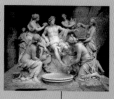

François Girardon, Apollo attended by the Nymphs (Baths of Apollo), 1666–1675, marble and grotto rock, gardens of Versailles

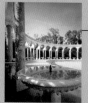

François Girardon, colonnade (detail), 1684, gardens of Versailles

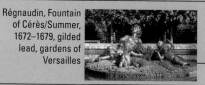

Régnaudin, Fountain of Cérès/Summer, 1672–1679, gilded lead, gardens of Versailles

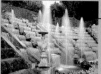

Bosquet des Rocailles, gardens of Versailles

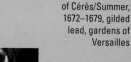

Park facade, p. 428

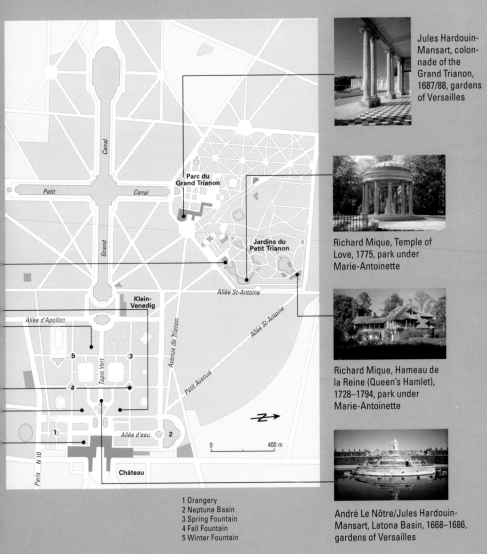

Jules Hardouin-Mansart, colonnade of the Grand Trianon, 1687/88, gardens of Versailles

Richard Mique, Temple of Love, 1775, park under Marie-Antoinette

Richard Mique, Hameau de la Reine (Queen's Hamlet), 1728–1794, park under Marie-Antoinette

André Le Nôtre/Jules Hardouin-Mansart, Latona Basin, 1668–1686, gardens of Versailles

Parc du Grand Trianon

Jardins du Petit Trianon

Allée St-Antoine

Allée St-Antoine

Canal

Petit Canal

Grand

Klein-Venedig

Allée d'Apollon

Avenue de Trianon

Petit Avenue

Tapis Vert

5

3

4

1

2

Allée d'eau

Paris N 10

Château

0 400 m

1 Orangery
2 Neptune Basin
3 Spring Fountain
4 Fall Fountain
5 Winter Fountain

"The King was all etiquette"—a day in the life of Louis XIV

by Oliver Burgard

Dawn over Versailles. Deep in the heart of the palace is the bedchamber of His Majesty Louis XIV, King of France (1643–1715). The control center of power still slumbers. The valet wakes his monarch at precisely eight o'clock, triggering the daily ritual of the court. The king's routine each day provides rhythm and meaning for courtly life. It is an elaborately orchestrated drama, with Louis himself as the director and leading actor.

His stage is the magnificent palace with its vast gardens; his props and costumes are elegant and expensive. The aristocrats living at court act as both his audience and extras in his own production. Yet the courtly ceremonials that surround him are more than just a glamorous piece of theatre. The absolute monarchy has divested the court noblemen of power, binding them into the court rituals through the creation of countless positions as flunkeys. The strict protocol is an effective control mechanism.

Every morning the king performs his extensive

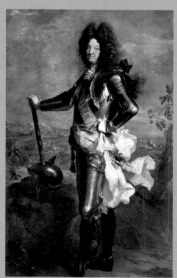

Hyacinthe Rigaud (1659–1743), Portrait of Louis XIV (full length), 1694, Oil on canvas, 277 x 194 cm, Museo del Prado, Madrid

toilette—the ceremonious routine of "le lever," (getting up) is the first official activity of each day. In accordance with court protocol, six different groups of courtiers enter his bedchamber in succession, playing their part in the drama. The hand-picked audience of around 30 or 40 people enjoys the extraordinary privilege of being allowed to see the king even in the morning.

The morning toilette lasts two hours

Immediately upon waking, Louis reaches for his wig, without which he is never seen in public. Only then may the first courtiers appear and watch the king at his morning ablutions. The personal physicians come to rub down his body with cloths. A valet hands him a damp cloth to freshen his hands. Another gives him a basin of holy water and Bible for morning prayers. After the first prayer the king gets out of bed and the tedious process of dressing takes its course. Once dressed, the king retreats to

an alcove to say a second prayer. A reverent hush accompanies the routine of "le lever," which can take up to two hours. No-one speaks, as court protocol forbids it. The only voice to be heard is that of Louis, who talks of trivial things like hunting, and the last party; otherwise, he might direct a friendly word to one of those present. After "le lever" the king receives ministers and foreign delegates in his private cabinet, while also giving out instructions to certain attendants. As the Duc de Saint-Simon wrote in his memoirs: "This is where he issues orders relating to regime for that day, in such minute detail

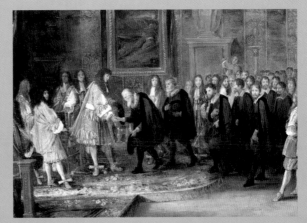

Adam Frans van der Meulen (1632–1690), Louis XIV receiving Swiss envoys on November 11, 1663, 17th c, Oil on canvas, Châteaux of Versailles and the Trianon, Versailles

that it would be clear exactly what the king was doing throughout the day, down to the last quarter of an hour." It was for good reason, therefore, that it was said in France that watches could be set by the king and that life at court functioned like clockwork.

France knows its monarch as a disciplined ruler. He is also a sensual being, however, who sets no boundaries in matters culinary or amorous. "He was chivalrous," wrote his sister-in-law, Liselotte von der Pfalz, "yet often this chivalry touched on excess. He liked them all, but they had to be women—peasants, gardeners' daughters, ladies-in-waiting, women of rank." Louis was in the habit of seeking out his favorites around midday, before going on to enjoy the delicacies of the lunch table in the company of the queen. There he displayed a healthy appetite, as Liselotte noted: "I

saw the king eat four plates of different kinds of soup, a whole pheasant, a partridge, a large plate of salad, two large slices of ham, mutton broth with garlic, a plate crammed with pastries, and then fruit and hard boiled eggs." Even a "très petit couvert," a very small meal, consists of at least three courses and a substantial dessert, for the king loves nothing better than soups and sweets. Exquisite food, fine porcelain, and crystal bestow an air of luxury and opulence on the king. His charisma seems unaffected by the fact that he eats with his fingers and produces an unpleasant smell at the same time. If the king should invite a favorite to the table or ask the person next to him to hold his napkin, these are the highest honors a French aristocrat at Versailles can hope for.

After the midday meal, Louis XIV devotes himself to his official duties. Ministers appear in for meet-

ings in his cabinet in order to inform him of the latest development in their department. His pompous presence may make him look like a king in an operetta, but he is actually an experienced head of state whose astute personnel policies have put a competent bureaucracy at his disposal. This allows him a break from affairs of state most afternoons in times of peace. He then spends the rest of the day walking in the grounds of Versailles, going for coach rides, or hunting.

another two hours, until the king takes himself to bed around midnight. Like his rising, his retiring takes the form of a public spectacle played out before numerous onlookers. Writing about "le coucher," Saint Simon describes it as "almost like reviewing the troops, with the guardian of the royal night commode… playing the part of a sergeant major." The Sun King's day finishes around 1.00 a.m. The valet counts the hours at his feet. He stays awake throughout the night in order to waken his king at 8.00 a.m. precisely.

Evening informality

Every Monday, Wednesday, and Friday Louis opens up his private salon in the late afternoon to receive guests. Known as "jours d'appartement," these soirees always follow exactly the same format. The guests of the king are permitted to watch him playing billiards or cards for a little while in the Diana salon. Then the company moves into the Venus salon, where a ball is taking place. Here, too, etiquette rules the day: Liselotte complained that "those who, like me, do not dance remain seated for hours on end, without leaving the chair, seeing and hearing nothing but an endless minuet." The soiree finishes around 10.00 p.m., but the day does not. The formal dinner takes up

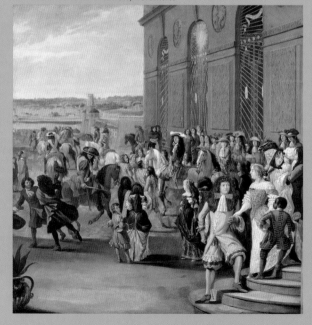

French school, Louis XIV and his heir riding past the Grotto of Thethis in Versailles with retinue, 17th c, 96 x 96 cm, Châteaux de Versailles et de Trianon, Versailles

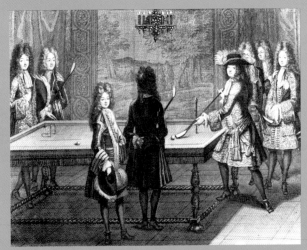

Antoine Trouvain, Billiards, 1696, copper engraving, Bibliothèque Nationale de France, Paris

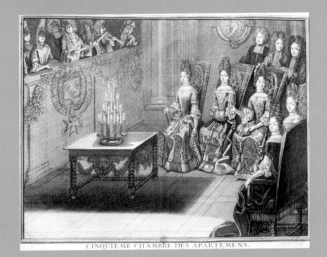

Antoine Trouvain, Musical soirée as part of an "appartement," 1696, copper engraving, Bibliothèque Nationale de France, Paris

CINQUIEME CHAMBRE DES APARTEMENS.

St-Denis

The basilica

St-Denis is said to be the burial place of St. Dionysius, a bishop who was allegedly sent by the Pope to Paris and martyred on Montmartre in the late 3rd century. According to the legend, his body ran from the place he was beheaded to where he wanted to be buried. In 475, St. Genevieve

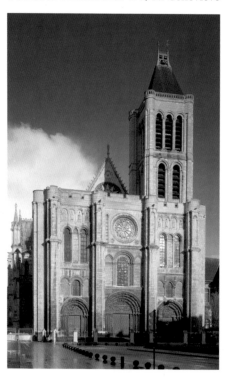

had a small church built in his memory, which was extended in the 7th and 8th centuries and had a Benedictine abbey added. What is left of the Carolingian building has been preserved in the crypt. As early as 639, the Frankish king Dagobert I chose St-Denis as his burial place, beginning a tradition that was cultivated in the 13th century and lasted until the death of Louis XVIII in 1824. As the church where French kings were laid to rest, St-Denis developed into a national shrine of political significance. In terms of art history, the choir and west front of the church represent the founding structures of the French Gothic style. Basic features of Gothic cathedral architecture are in evidence here for the first time: the systematic use of the pointed arch; breaking up solid wall surfaces; and the ambulatory and radiating chapels configured as a single structure. As the spiritual father of the basilica of St-Denis, Abbot Suger (ca. 1080–1151) was anxious to create an imposing building that would represent the power of the French Church and symbolize the incarnation of Jerusalem on high. Thus political and religious symbolism was fused in a powerful rhetorical architectural form. The tripartite division of the facade, which appears probably for the first time in St-Denis, helped to set the style just as much as the configuration of the tympanum in the central portal with a representation of the Last Judgment.

Interior view of the nave and choir

After the west facade was completed and consecrated, Abbot Suger pressed on with the conversion of the choir, which was finished between 1140 and 1144. A friend of the abbot since childhood, Louis VII (1137–1180) was happy to support his ambitious plans. Upgrading the abbey was also convenient for the king; when he set off on a crusade in 1147 he appointed Abbot Suger as his deputy, thus making him the second most powerful man in France. Pioneering innovations in Gothic architecture were achieved for the first time in the choir: the double ambulatory is simply divided by slender columns, thus increasing the spaciousness; the cross-ribbed vault emphasizes the lightness of touch and connects the outer ambulatory to the adjacent chapels; and, finally, huge windows that reach almost to the ground brighten the whole choir area and bathe the church

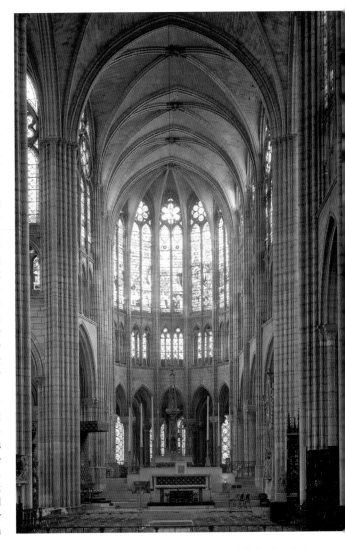

in a shimmering, prismatic light with a near-metaphysical quality. This must have had an inspirational effect on the faithful, who were used to dark, Romanesque church interiors. Following the death of Abbot Suger, there was another episode in the architecture of the building, as the upper sections of the choir were already in danger of collapsing. Refurbishment also seemed absolutely vital in order to secure the abbey's prominent status as both religious monument and royal burial ground. In conjunction with the restoration measures initiated by Eudes-Clément, who was abbot at that time, the nave was also trans-formed as Suger had envisaged. Between 1231 and 1281, windows were installed throughout the triforium, as was a new type of support system using engaged columns, and for the first time a five-bay transept was built, which had rose windows with fine tracery in the Rayonnant Gothic style. This enabled St-Denis to defend its position in perpetuity as the forerunner of a new aesthetic in architecture as well as the burial place for French kings.

Tomb of Louis XII and Anne of Brittany

St-Denis provides an overview of the development of French tomb sculpture. In contrast to the medieval stone sarcophagi with their characteristic gisants (recumbent effigies) from the early Renaissance, tombs also acted as secular memorials on account of their portrait-like qualities. The Florentine sculptor, Giovanni Giusti, found an impressive formulation for the double tomb he created in 1516 for Louis XII (1498–1515) and his wife Anne of Brittany (died 1514), after the design of Guido Mazzoni. Over the sarcophagus with gisants towers an arcade shaped structure, on top of which the royal couple appear in prayer. Relief sculptures and full-size supporting figures deepen the overall impression of grandeur.

Basilica of St-Denis

Giovanni and Antonio Giusti, tomb of Louis XII and Anne of Brittany, 1515–1531, marble

Portal of the north transept, known as "Portail des Valois," mid 12th c.

1122–1140
1140–1144
1170
1231–1281
14th c.

0 10m

Choir stalls from the chapel of Château de Gaillon, wood with colored intarsia inlays, 1508/1509

André Beauneveu, gisant of Charles V, 1364–1366, marble, 180 x 50 x 30 cm

Tomb of King Dagobert, ca. 1250, stone

"Rod of Jesse" window, ca. 1144–1151, stained glass with grisaille painting

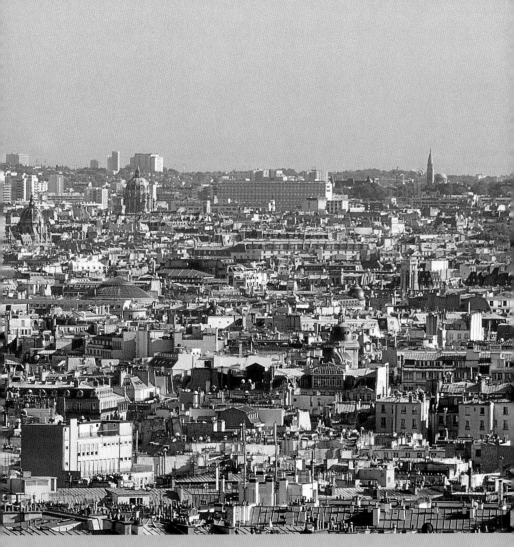

Appendix

Architectural forms from the Middle Ages to 19th century

by Hans-Joachim Kuke

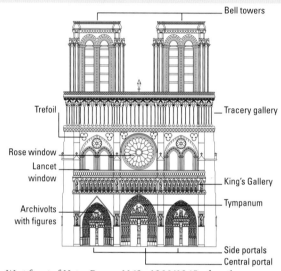

Bell towers

Trefoil

Tracery gallery

Rose window

Lancet window

King's Gallery

Tympanum

Archivolts with figures

Side portals

Central portal

West front of Notre Dame, 1163–1200/1245, elevation

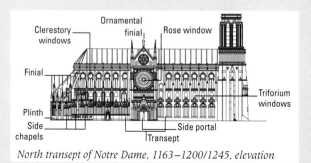

Clerestory windows

Ornamental finial

Rose window

Finial

Triforium windows

Plinth

Side chapels

Side portal

Transept

North transept of Notre Dame, 1163–1200/1245, elevation

Gothic church architecture

Cathedral facades

The cathedral of Notre Dame in Paris, with its tripartite west facade with two towers, became the prototype for many later Gothic cathedrals. Semicircular side portals with pointed arches lead into the interior. The tympani are ornately decorated with figures. Above the portals is the King's Gallery. Light falls into the nave through one of the earliest Gothic rose windows. The two bell towers complete the elevation. The cathedral was one of the first to have a closed radiating chapel, which was inserted between the buttresses. The nave is significantly higher than the two side aisles. The rose window on the transept facade is a typical example of the elegant High Gothic Rayonnant style.

Preceding spread: View over the roofs of Paris to Montmartre

Gothic flying buttresses

Gothic architecture strives for transparency. Wall masses were gradually reduced and broken up with increasing numbers of windows. What was left was a skeleton of essential supporting wall elements. In order to achieve the desired height and lightness, the flying buttress was developed. These supports absorb, stabilize, and distribute the lateral thrusts of a structure, transmitting them securely into the ground.

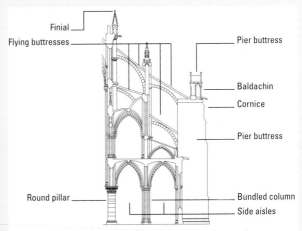

Flying buttress of Notre Dame, after 1230, cross-section

Rayonnant Palace Chapel

In the case of Sainte-Chapelle, built in the High Gothic Rayonnant style, reduction of wall mass was taken a stage further. This two-story double chapel—built to enshrine the Crown of Thorns— resembles a type of glass reliquary, with the supporting elements seemingly no more than neural networks. Verticality is emphasized in all the architectural forms, which extend into extremely slender elements. The ridge turret and ornamentation are reconstructions dating from 1834/1867.

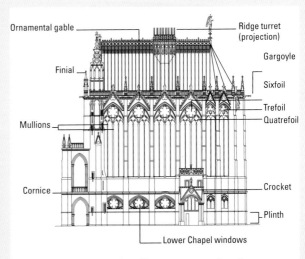

Side facade of Sainte-Chapelle, 1241–1248, elevation

Residential facades

Renaissance

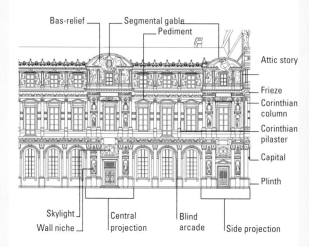

Bas-relief — Segmental gable
Pediment
Attic story
Frieze
Corinthian column
Corinthian pilaster
Capital
Plinth
Skylight
Wall niche
Central projection
Blind arcade
Side projection

Lescot wing, Cour Carrée, the Louvre, 1546–1551, elevation

The two-story Lescot wing with attic had a strong influence on the palace facades of Baroque Classicism in France. The Corinthian pilasters, which were upgraded to columns at the entrances, regulate the rhythm of the elevation. In accordance with the order hierarchy, composite columns are above them. The stronger sculptural work of the supports lends emphasis to the main and side bays. The facade is finished off with a decorative attic story, with segmental gables rising incrementally to the center.

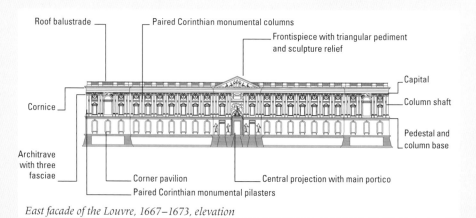

Roof balustrade
Paired Corinthian monumental columns
Frontispiece with triangular pediment and sculpture relief
Capital
Column shaft
Cornice
Pedestal and column base
Architrave with three fasciae
Corner pavilion
Central projection with main portico
Paired Corinthian monumental pilasters

East facade of the Louvre, 1667–1673, elevation

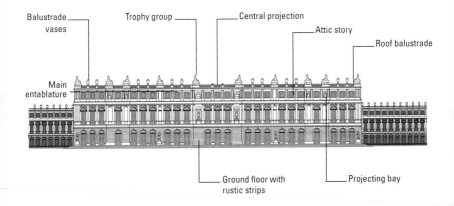

Balustrade vases — Trophy group — Central projection — Attic story — Roof balustrade — Main entablature — Ground floor with rustic strips — Projecting bay

Garden facade of Versailles, 1678–1684, elevation

"Style Classique" (left)

The Louvre colonnade adorns the town palace of French kings, the architecture constituting a visual representation of this elevated rank. In the center is the entrance pavilion crowned by a triangular pediment. Its many reliefs praise the king as leading the Muses. Between the central pavilion and two corner pavilions that flank the facade, the eponymous colonnade stretches out on paired monumental columns standing on a base formed by the ground floor. The building is an exemplary demonstration of the classical geometric precision of French architecture. The distance between the columns was unprecedented and only made possible using innovative techniques.

Palace and garden (top)

The greatest expanse of a Baroque palace facade was achieved in the garden facade of Versailles. The clear, horizontal division of the stories and the Ionic column order corresponds to the "informal" nature of the garden facing side. The scaling of the facade levels and projections emphasizes the central axis. The impression of grandeur is created by the vast breadth and highlighted further still by the clear horizontal line of the attic, which is decorated with trophy groups. The roof line is hidden, making it appear as if the garden side of the palace has a flat roof, an allusion to classical and Italian models.

The "Hôtel"

Early Baroque hôtel

Hôtel Carnavalet is an early example of the numerous town palaces of the aristocracy and wealthy bourgeoisie that were known as "hôtels." The open brickwork at the entrance derives from the 16th century. The building is structured as a central wing flanked by two pavilions. The base of the two-story facade does not have any load bearing architectural "order" (columns, pilasters, or pilaster strips). The main story above it, the bel étage, is articulated by Ionic pilasters. The side pavilions each have only one bay, but are distinguished by their triangular pediments and higher roofs.

Hôtel entre cour et jardin (Hôtel between courtyard and garden)

The Hôtel de Soubise is the prototype of a town palace "between courtyard and garden." An elegant, unified building was developed on an irregular site where old buildings had to be taken into account. Externally the courtyard is composed of rusticated wall strips, while the interior has an airy colonnade oriented toward the stately residence. This renders it a public room in its own right. The hôtel proper has restrained facades and a main entrance decorated with paired columns, as in the Louvre colonnade, and a temple gable. The floor-length French windows provide optimum light for the interior.

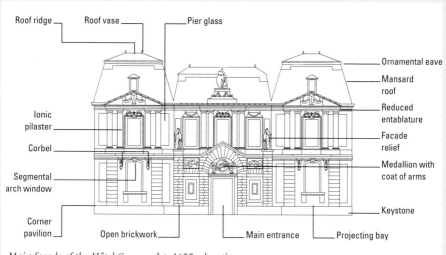

Main facade of the Hôtel Carnavalet, 1655, elevation

The interior decor of the Hôtel de Soubise is the main highlight of the European style known as Rococo. The design is based on irregular "rocaille" (shell-shaped) forms. Their light, curving movements loosen up the heavy symmetrical precision of the earlier Louis XIV style. Stucco, carvings, paneling, gilding, paintings, and furniture are all coordinated to convey the effect of playfulness, lightness, glamour, and an insouciant zest for life.

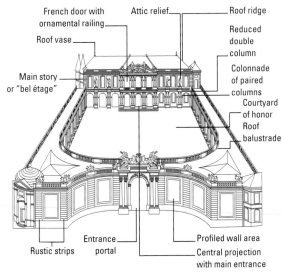

French door with ornamental railing
Roof vase
Main story or "bel étage"
Attic relief
Roof ridge
Reduced double column
Colonnade of paired columns
Courtyard of honor
Roof balustrade
Rustic strips
Entrance portal
Profiled wall area
Central projection with main entrance

Hôtel de Soubise, 1705–1709, elevation

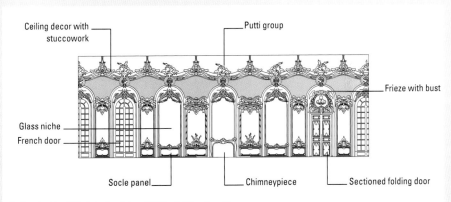

Ceiling decor with stuccowork
Putti group
Frieze with bust
Glass niche
French door
Socle panel
Chimneypiece
Sectioned folding door

Salon in the Hôtel de Soubise, 1736–1739, elevation

The Baroque central structure

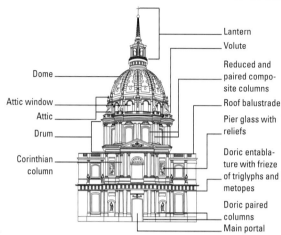

Exterior facade of the Dôme des Invalides, 1677–1715, elevation

Lantern
Volute
Reduced and paired composite columns
Roof balustrade
Pier glass with reliefs
Doric entablature with frieze of triglyphs and metopes
Doric paired columns
Main portal

Dome
Attic window
Attic
Drum
Corinthian column

The Dôme des Invalides is the most important ecclesiastical example of French Baroque Classicism. The complexity of the support elements increases toward the center of the facade. Three wall zones are set in front of the cubic structure, flanking and emphasizing the main entrances. The two-story facade has "royal" Corinthian columns above those of the "masculine, soldierly" Doric order. The drum of the dome is given rhythmic structure by the alternating pattern of pier buttresses with columns in front, while the dome itself is subdivided into 12 gilded sections decorated with bas-reliefs. The dimensions of the Dôme des Invalides are based on the diameter of the dome. The dome of the building has three shells, the outer one of which is constructed in timber. Attic windows allow light into the interior of the dome, which is terminated by a lantern. Its monumental elegance derives from the clever proportions and balanced relationship between the vertical and horizontal architectural forms.

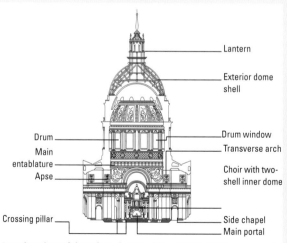

Interior view of the Dôme des Invalides, 1677–1715, cross-section

Lantern
Exterior dome shell
Drum window
Transverse arch
Choir with two-shell inner dome
Side chapel
Main portal

Drum
Main entablature
Apse
Crossing pillar

Ornamental facades of the Belle Époque

The Opéra Garnier stands at the junction of grand boulevards that were built around the same time as the opera house. Above an arcade on the main elevation is a colonnade flanked by projecting bays. A richly sculptured attic terminates the top of the ornamental facade, behind which lie the staircases and foyers. A low dome atop a circular drum vaults the auditorium; the stage area is behind. Oval- and round-domed foyers and restaurants adjoin it to the left and right. The friezes, pediments, and door and window supports are all opulently decorated; the roofscape and external areas are adorned with flagpoles, projections, bands, pommels, lucarnes, and other ornamentation; and the points of articulation are emphasized by the sculptures. All these forms can be traced back to the architecture of antiquity. Yet the Opéra remains a unique edifice.

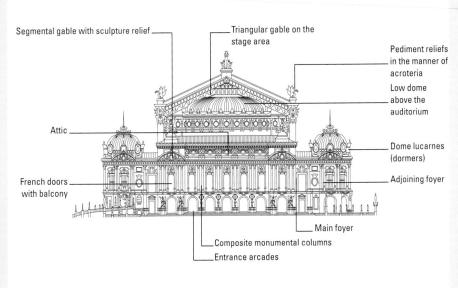

Segmental gable with sculpture relief

Triangular gable on the stage area

Pediment reliefs in the manner of acroteria

Low dome above the auditorium

Attic

Dome lucarnes (dormers)

French doors with balcony

Adjoining foyer

Main foyer

Composite monumental columns

Entrance arcades

Opéra Garnier, 1860–1875, facade

Glossary

Abbey church (from Hebrew abba, "father;" Latin abbatia, "abbey") or monastery church: in architectural terms, the place of common worship within a complex of monastic buildings, which is closed off to its surroundings and houses a community of monks and nuns. The Benedictine layout plan assigns the medieval abbey church with its adjacent cloister a fixed place in the south of the monastery site, following the observance drawn up in the 6th c. in Montecassino by St. Benedict of Nursia (c. 480—no later than 553 AD).

Academy (Latin academia; Greek akademia): facility, institution, or society for the promotion of artistic and scientific studies. The first important academies developed in the style of the Classical schools in Italy during the Renaissance. The concept of the academy only spread throughout Europe during the period of absolutism. The Académie Française (est. 1635 by Richelieu) and Académie Royale de Peinture et de Sculpture (Royal Academy of Painting and Sculpture) took on an exemplary function. The latter was founded by Anne of Austria in 1648 as a state controlled Academy of Art at the suggestion of the French painter Charles Le Brun (1619–1690).

Apartment (from French, appartement): a living area that consists of several rooms. These are often connected to each other as a group or suite of rooms. The size and number of rooms varies depending on the needs and status of the occupants. In palace buildings during the absolute monarchy, the apartments were very elaborately furnished and had many rooms. As in the hôtels in the 16th, 17th, and 18th centuries, there were often several apartments on one floor.

Apollo: Greek and Roman god, son of Jupiter and Leto, twin brother of Diana. Through time, Apollo assimilated many regional gods and their features, with the result that he embodies many religious concepts. Among other things, he is the god of prophecy, music and the arts, light and the sun (Phoebus), as well as being the leader of the muses (Musagetes). For centuries he has represented the classical ideal of beauty.

Apse (Latin apsis, Greek hapsis "connection, curve, vault"): a niche, constructed on a semicircular or polygonal ground plan and vaulted by a semi-dome, which may contain an altar. A cup-shaped apse vault is known as an apse calotte (from French calotte, "skullcap"). Connected to the main body of the church or the part of the choir reserved for the clergy, an apse is also known as an exedra. "Chevet" refers to the eastern end of a Christian church comprising the apse and chapels.

Arcade (French arcade, "candle arch;" Latin arcus, "bow [hunting weapon]"): a row of arches supported on one side by columns.

Arrondissement (French arrondir, "to make round"): generally denotes a sub-district of a French département (borough). The arrondissement is administered by a sub-prefect and council committee. They are mainly responsible for administrative and political tasks. In large cities like Marseille, Lyon or Paris, the individual administrative areas of the communes are also called arrondissements.

Art Deco (French art décoratif, "decorative art"): collective term for the dominant artistic movements in applied arts, interior design, and small sculpture, especially in France, between 1918 and 1932. Originating from French "art nouveau," Art Deco reflects the increasingly technological environment with its geometric structures, symmetrical forms, sharp angles, straight lines, and bright colors. The use of expensive, luxury materials such as polished stones, fine woods, enamel, and chrome often meant that very few pieces were produced. Important figures in Art Deco included the furniture maker Jacques-Émile Ruhlmann (1869–1933), jeweler and glass manufacturer René Lalique (1860–1945), lacquerist Jean Dunand (1877–1942), and silversmith Jean Puiforcat (1897–1945). The term comes from the "Exposition Internationale des

Art Deco: Ivanna Lemaître, André Hebert, Eugène Printz, the salon of the French marshall, Louis Hubert Gonzalve Lyautey (1854–1934), furnished in the Art Deco style; in the background, a mural with spiritual Eastern themes on Buddha, Confucius, and Krishna, Musée des Arts d'Afrique et d'Océanie, Paris

Arts Décoratifs et Industriels Modernes" (International Exhibition of Modern Decorative and Industrial Arts) in Paris in 1925, but has only been in common use since 1966.

Attic (Latin atticus, "from Attica"): low, divided structure above the main cornice of a column or pilaster order, also the area above the ceiling; in Baroque, a mezzanine articulated with a window.

Avant-garde (French avant-garde, "vanguard"): collective name for artists who take on roles as pioneers of new, often radical, artistic ideas and ways of expressing them.

Baroque (from Portuguese, barocco, "uneven, round shaped, small stone"): Stylistic period in Europe between the end of Mannerism ca. 1590 and the beginning of Rococo around 1725. The term derives from the goldsmith's craft, which described an irregular pearl as "barocco."

Bel Étage, or bel-étage (French "beautiful story"): the main story of a stately home, where the reception rooms are located. It is usually above the ground floor. Smaller and more modest buildings define the "beautiful story" as the area above the ground floor. In Italian the public first floor is called "piano nobile."

Belle Époque (French, "beautiful time, beautiful epoch"): an era in French history lasting from around 1890 through 1914, characterized by a general rise in living standards. The prerequisites were absence of foreign wars, technical progress, and a stable currency, leading to an economic boom that also influenced social life. Balls, formal dinners, and soirees took center stage for everyone. Within the bourgeois home, the salon became the most important space.

Buttresses: arches and pillars that give additional external support to the walls of a building to counterbalance the thrust of the vault and roof force.

Cathedral (from Greek kathedra, "seat"): standard term used in France, Spain, and England for the main church in a bishop's diocese, derived from the Greek word for a bishop's seat.

Choir (Greek choros, "round dance"): usually a separate, elevated area in the interior of a church reserved for the common worship of the clergy or singing by the choir. Since Carolingian times, the area extending beyond the nave from the crossing including the adjoining apse that often acts as the terminating point has been called the choir.

Classicism (from French classique and Latin classicus, "classic, first rate"): Stylistic movement in Europe that consciously focused on classical antiquity (5-4th c. BC). It usually describes certain trends in architecture from

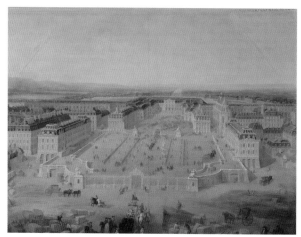

Courtyard of honor: detail from the plan "Le Grand Projet" on the reconstruction of Versailles, ca. 1780/1785, pencil, ink drawing, watercolor, 12.5 x 9.6 cm, architecture department, Versailles

Colonnade (French colonnade): row of pillars with a straight entablature without arches.

Column order: strictly defined Classical system of architecture that specifies precisely the way the column, capital, architrave (beam bearing the weight of the top of the building), and cornice (horizontal protruding wall strip) should be placed. A distinction is drawn between the Doric, Ionic, and Corinthian orders in Greek architecture. They are adopted for the most part in Roman architecture, but variations are found, such as the Tuscan order (with Doric elements) and the Composite Order (with Ionic and Corinthian features).

Corps de logis (French): main building of a Baroque palace, which is higher than the secondary wings and pavilions, and is used for residential and ceremonial purposes.

Cour d'honneur (French, "court of honor"): in French palace architecture, an extended forecourt for formally receiving dignitaries. It differed from the working courtyard that was mostly situated outside, in being integrated into the chateau complex as the courtyard for the masters. The cour d'honneur reached its architectural peak during the Baroque period. The area of the courtyard is normally defined by a main structure flanked by two lower, secondary wings. The fourth side is not closed off, in order to draw the eye to the main building and its embedded portal.

Crossing: area within a church where the nave and transept intersect.

Cubism: common term in use since 1911/12 for an art form created essentially through close collaboration between Pablo Picasso (1881–1973) and Georges Braque (1882–1963). It was developed and reworked by

the 16th to 18th centuries and the period between 1760 and 1830. The formal expression of the style is found in the emphasis on figure and line, cool colors, and strong compositions. The aim of Classicism is to express natural elegance and authority as well as rationalism and veracity.

Clerestory, or clearstory: upper part of the central nave of a basilica containing windows.

Collage (French, coller "to glue, stick"): term used for an artistic technique whereby a picture is made in whole or in part by sticking together everyday materials. Cloth, printed or plain paper, foil, or photographs are just some of the things applied. The principle of collage originated from the "papiers collés" (glued papers) by Georges Braque (1882–1963) and Pablo Picasso (1881–1973). New versions appeared throughout the 20th century (photomontage, assemblage, combine painting). The counterpart to collage is décollage (French décoller, "to take off, separate").

a small group of French, Russian, and Spanish artists and led to a radical dissolution of all visual coherence through abstraction and reduction. Analytic Cubism (1910–1912) is characterized by breaking down the visual subject into small, fragmented shapes that overlap and intersect with each other, representing the subject from different viewpoints. Synthetic Cubism (after 1912) constructed an image from strictly defined areas of color: new contexts of form and meaning develop out of a layering process, and painted lettering is incorporated with bits of newspaper and glued strips of paper or cloth to produce a new relationship to reality.

Donjon (French, from Latin domus dominationis, "house of the masters"): French cultural term for the imposing fortified tower of a castle, also used as living quarters. The donjon originated in northwest France (Loches, Acques, Etampes). Other important examples can be found in England (Tower of London) and southern Italy (Paternò, Aderno). In Germany, the keep took on the role of the donjon, but its fortified tower was not used for permanent living.

Empire (from Latin imperium, "power"): in a general sense, the Empire of Napoleon I (1804–1814/15) and Napoleon III (1852–1870); in cultural history, a decorative style, which developed into a particular form of Classicism under Napoleon I and dominated European art until around 1830. The distinguishing feature of Empire style is the rigor of its representational forms, which is softened by classical ornamentation. The style made its mark on applied arts, interior design and fashion.

Enfilade (French, "succession"): a succession of rooms, the doors of which all lie on one axis, so that when open there is a view through all of the rooms. Developed around 1650 in France, the enfilade is a typical design feature of Baroque palaces and hôtels.

Engaged column: in Gothic architecture, a quarter, half, or three-quarter projecting column that is usually set in a pier or wall as support, taking up transverse arches (separating vaulted areas), ribs (load-bearing structural elements of a vault), or archivolt (arch on exterior). Engaged columns grouped together are called a col-

umn cluster. Piers around which engaged columns are arranged are called composite piers.

Enlightenment: intellectual movement that began in the late 17th c. and extended into the 19th c. It was based on humanism, philosophy, and a world view focusing on the natural sciences, whereby reason (Latin "ratio") is seen as the essence of humanity. Originating in West Europe and supported and disseminated by an emergent, self-assured bourgeoisie, it was the leading intellectual movement of the 18th c, with far-reaching influences on all aspects of cultural life. The main centers of the Enlightenment were the cities and universities.

Fauvism (French fauve, "big cat"): a direction in French painting founded in the first decade of the 20th century by Henri Matisse (1869–1954) and a group of post-Impressionist painters. Three dimensional space is abandoned in favor of pure, brilliant color.

Finial (Greek phiale, "container, urn" or Latin finis, "end"): small, slender turret forming a decorative element in Gothic architecture. The top is usually four or eight cornered and pointed, and found on ornamental gables of windows and portals, or terminating buttresses.

Flamboyant (French, "blazing, flaming"): an ornamental motif reminiscent of licking flames, which dominated late Gothic style in France.

Flâneur (French flâner, "to stroll, wander around"): in a general sense, someone who strolls around aimlessly. The 19th-century English dandy is comparable to the flâneur. A dandy was reputed to be a wanton aristocrat who set great store by his appearance, giving him the label of fop or fashionmonger. The life of the flâneur or dandy consists solely of idleness during the day and entertainment at night.

Fronde (French "sling" used by street urchins in Paris): political opposition of French upper aristocracy and parliament, which fought for estate controlled monarchy. During the first Fronde (1648/49) the court of Louis XIV, who had not yet come of age, had to flee Paris. The second Fronde (1649–53) was supported by Spain and led to military operations. Intrigues and acts of violence soon deprived the opposition movement of any respect

and power. Louis XIV was able to move back to Paris in 1652 and, from then on, he concerned himself with consolidating his absolute rule.

Gallery: a space longer than it is wide and which has windows on one or both side walls. The gallery established itself as a room of ostentatious splendor in French chateaux (Fontainebleau) in the 16th century. Upper corridors in theatres and churches, as well as open hallways and walkways are also called galleries.

Glass and iron structure: new architectural form of huge, glass surfaces with a filigree iron construction. The development of the glass and iron structures was connected to two essential conditions—technological and industrial progress, including the manufacture of malleable ferrous alloys (steel) and the mass production of sheet glass, and the emergence of new applications. World exhibitions, railway stations, passages, and warehouses demanded spacious architecture that was fit for purpose: spanning vast areas became the central task of the architect-engineer. Already tested in bridge building, the technical advantages of iron construction were employed in the early 19th century in glasshouses. Thus the famous Crystal Palace was built in London by Joseph Paxton, the conservatory builder, for the World Exhibition in 1851. The second half of the 19th century saw the rapid spread of glass and iron buildings: railway concourses, libraries, market halls, passages, warehouses, and exhibition pavilions were the preferred buildings for using the delicate iron structures covered in a skin of glass. They were also appreciated from an aesthetic point of view because of the dominant role of light, comparable to its importance in Impressionist painting.

Genre painting (French, genre

"type"): paintings that depict typical scenes and events of everyday life, or of a particular occupational group or social class.

Gothic (Italian gotico, "barbaric, not classical"): European style period of the Middle Ages, originating in northern France around 1150. It ended there by 1400, while elsewhere it lasted until the early 16th century. The term derives from the Germanic tribe of the Goths. Architectural features specifically associated with it are the introduction of the pointed arch (ogive with a break along the centerline), the ribbed vault (two barrel vaults of equal size intersecting at right angles), and the transfer of buttresses (the arches and piers added to the walls to retain the vault thrust and roof force) to the outside. Overall, buildings were characterized by a sense of striving upwards, coupled with an influx of light achieved by breaking up solid wall surfaces. The definitive architectural form was the cathedral, or bishop's church. Sculpture was closely bound to the architecture, and an idealized concept of nature was a

Vault: Gothic nave or ribbed vault, constructed after 1163, Notre Dame cathedral, Paris

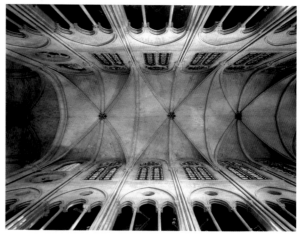

significant feature. The figures and garments, which were mostly represented in an exaggerated elongated manner, were the essential forms of expression. The main activities in painting were panel painting and stained glass.

Historicism (Latin historia, "knowledge, history"): a concept of history that began in 1839 and understood every historical event in the wider context of what had gone before. In terms of art history, historicism refers to an artistic principle prevalent since the 19th century. According to this theory preceding phases in the development of art were consciously adopted in whole or in part and used in new ways. The Neo-Renaissance began in France as early as the Empire period and with the works of Claude-Nicolas Ledoux (1736–1806). From 1830 onward France's own Renaissance was imitated. The best example is the richly ornate town hall in Paris in the style of the early Renaissance.

History paintings (Latin historia, "knowledge, history"): an academic genre held in high esteem since the 17th century, taking themes of human history as its subject matter. Tales from mythology as well as real events (such as Napoleon's Russian campaign) found their way into the paintings. In the succession of genres, history painting took over from Christian themes. Universal principles were deduced from the depiction of historical events, which were also seen as valid for the present day. In the 19th century the break from this academic tradition brought the slow decline of the history picture as the trend moved more toward realism and naturalism. The last great exponents of history paintings in France were Thomas Couture (1815–1879) and Jean Léon Gérôme (1824–1904).

Hôtel (French, from Latin hospitum, "inn"): in the 17th century, this originally referred to a nobleman's house in a French city, especially Paris. Later it was used as a general term for palatial buildings of a private and public nature (hôtel privé, "large residence"; hôtel de ville, "town hall"; hôtel-dieu, "hospital"). Today, a hôtel is understood as a building to accommodate and cater for overnight visitors.

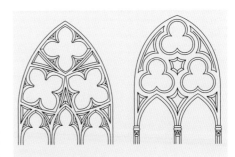

Tracery windows

Impressionism (from French l'impression): form of expression in painting that asserted itself in the last decades of the 19th century in France. It was a reaction to the moribund doctrine of the Academy and studio, history, and genre paintings that focused on content. The name originates from the work by Claude Monet entitled "Impression, soleil levant" (Impression, Sunrise), (Paris, Musée Marmottan, 1872), and was initially used by art critics as a derisive description for a group of painters excluded from the official Salon who had organized their first group exhibition in the salon of the Parisian photographer Nadar in 1874. As a new form of naturalism, Impressionism rejected classical pictorial representation and, on the basis of contemporary scientific theory, interpreted the natural object in a revolutionary way as nothing other than an appearance of color. Supreme importance was attached to open-air painting, through which the artists attempted to capture an unmediated, spontaneous impression of appearances.

International Gothic: movement in European art between 1380/90 and 1420/30, a late Gothic phase during the transition to the early Renaissance. This "soft style" as it was also called, was characterized by a new representational style in sculpture and painting in which the physical weightiness of figures is mainly abandoned in favor of a more graceful, light approach.

Place de la Concorde, Obelisk from Luxor (13th c. BC)

In sculpture more emphasis was given to the texture and three-dimensional qualities of the drapery, and in painting to color quality and the use of light. The "beautiful Madonnas" are typical of this period, and works were commissioned mainly by patricians and royal courts. The early centers for this style were Siena, Avignon, the courts of Paris and Burgundy, and the Middle Rhine including Cologne and Prague.

Mansard roof (French): hip roof, the lower slope of which is steeper than the upper one. This makes it better for extensions, for instance, for homes. It was named after the French architect François Mansart (1646–1708).

Mezzanine (Italian mezzano, Latin medianus, "middle"): a low intermediate floor or entresol where less important rooms are usually located. The mezzanine is above the ground floor, the main floor, or beneath the eaves. The mezzanine is a favorite design element in Baroque and Classical castle architecture that served, where appropriate, to create a functional addition of intermediate floors, which also balanced the structure aesthetically.

Obelisk (Latin obeliscus and Greek obelisko, "small skewer"): four-sided tapering stone pillar crowned with a small pyramid shape. In Ancient Egypt it was originally a cult symbol for the sun god, while since the Renaissance the shape has been used for memorials and ornamentation.

Oeuvre (French "work"): term used to describe an artistic body of work.

Palace (French, from Latin palatium, "royal court"): mainly located in cities, the French palace experienced its heyday in the 17th century. It is the general term for a castle-like building, an official residence (e.g. an embassy), or large, imposing official buildings for different purposes (for justice buildings or exhibitions). It is basically comparable to the hôtel, though the latter is normally more modest in both size and fittings.

Paris Commune (from French commune, "municipality"): originally described the town council of Paris from 1789 through 1795. Term used later by the working class who rose against the newly proclaimed bourgeois republic from March 18 through May 28, 1871. A "proletarian cultural policy" was also established during the Paris Commune: an independent art commission led by Gustave Courbet (1819–1877) set about reorganizing culture along democratic lines and establishing a permanent Arts Commission in the Republic.

Passage (French): in architecture, a walkway normally covered over with glass, said to have originated in Paris. It links streets and squares and as a rule has shops on each side. The upper floors can also accommodate studios, offices, and apartments. With the development of glass and iron structures, the passage acquired a specific architectural meaning during the 19th century (e.g. Galerie d'Orléans, 1828–1830, in Paris; demolished 1935). Covered walkways now also play a significant role in contemporary architecture providing a useful space for

shopping and relaxing in the center of the city.

Pavilion (French "tent, summer house", derived from the French papillon, "butterfly"): originally meant a portable structure: i.e., one that can be quickly put together. Since the 14th century at least, "pavilion" has meant a small, permanent building forming part of a larger architectural context (castle, garden). In the 20th century the term became generally used for smaller buildings according to their purpose e.g. transport or information kiosks.

Pilaster (Italian pilastro, from Latin pila, "pillar"): slightly projecting, rectangular column built into the wall, with a base (bottom), shaft (central section) and capital (top). Used to divide the wall surface, it is often fluted, that is, has a grooved shaft.

Pilaster strip (French lisière, "trim, border"): slightly projecting, vertical wall strip which is used to divide a wall surface and is often overlaid with a blind arch (arch set against the wall) or a frieze (horizontal wall decoration) with a round arch.

Pillar (from Latin pila): vertical supports with round, square, rectangular, or polygonal cross-section. It may be divided into the base (bottom), shaft (central section), and capital (top). Depending on the position and design, there are different types—free-standing, wall, corner pillars, and buttresses (pillars added to the outside of a structure to absorb the vault thrust and roof force). Unlike a column, the round pillar does not taper upwards.

Pointillism (from French pointiller, "to stipple"): artistic movement in France in the late 19th century. Technique used by Neo-Impressionists, applying pure colors next to each other which only blend visually into one shade when seen at a distance by the viewer. Georges Seurat (1859–1891) raised it to an overriding principle, developing it to its ultimate conclusion by applying separate colors next to each other in a strictly schematic formation of dots and commas in his paintings. This new way of painting, called Divisionism by Seurat himself, was shown in public for the first time in 1884 at an exhibition by independent artists.

Portico (Latin porticus, "arcade, gallery") : a structure, usually open, built onto the front entrance of a building. It is supported by columns or pillars and often has a pediment.

Quarter (French "quartier," also "part [of an army camp]"): the standard term in France for the area of a town, and in a military context, accommodation for troops in barracks or private houses (billet).

Rayonnant (French, from rayonner, "to radiate out"): in a general sense a configuration in which the elements radiate out from a central point; in Gothic architecture, chapels which branch off around an apse or ambulatory; or windows subdivided in this radiating configuration (St-Denis, Paris).

Relief (French, from Latin relevare "to raise"): technique in sculpture whereby the representation is modeled out of a flat surface by chiseling or molding work. There are different types depending on the degree of sculptural depth and contours of the work—bas-relief, half-relief and high-relief.

Reliquary (Latin reliquiae, "remains, what is left behind"): physical remains of a saint or

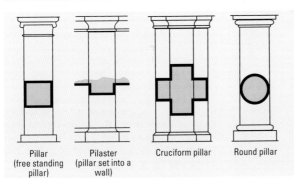

Pillar
(free standing pillar)

Pilaster
(pillar set into a wall)

Cruciform pillar

Round pillar

an item belonging to him which is especially venerated.

Revolutionary architecture: French architectural movement in the late 18th century which got its name from the aspiration to create new forms in architecture, rather than from the French Revolution of 1789. It is characterized by strict austerity, lack of ornamentation and "architecture parlante" (speaking architecture). The aim was to represent the function of buildings (as well as specific topics relating to them such as social reforms, Enlightenment) through their external appearance. Notable examples are plans for a cenotaph to Isaac Newton (1784) by Etienne-Louis Boullée, which would have taken the form of a sphere nearly 500 feet high, or the Royal Saltworks (1774–1779) in Besançon by Claude-Nicolas Ledoux.

Palais de Rohan, relief with horses of the sun god Apollo above the entrance to the stalls, date unknown

Rocaille (French, "loose stones, grotto or shell work"): asymmetrical shell and wave shaped ornamentation associated with Rococo style.

Rococo (from French rocaille, "pebble, grotto, or shell work"): period in European art between 1720/30 and 1770/80, characterized by decorative style that preferred lightness of touch, playfulness, and elaborate ornamentation. In painting, this is emphasized by the use of a brighter color palette.

Romanesque (from Latin, "Roman"): a term—introduced in France in the first three decades of the 19th century—to describe Western architecture of the early Middle Ages that was based on forms of Roman architecture (round arch, pillars, columns, vaults). It ran from around 1000 to the mid-13th century and developed national types and style characteristics in individual regions. A defining feature was the addition of individual sculptural elements as well as the interplay between cylindrical and square forms. In central France it ceded to early Gothic style as early as the mid-12th century.

Romanticism (from Old French romanz "speech of the people". Came to mean "exaggerated, wild, or fanciful tale"): used to designate an epoch between 1790 and 1830 for all manifestations in literature, visual arts and music. Characterized by a departure from classical and Enlightenment tendencies, it featured a revival of medieval literature and (folk) art, as well as religion: rational thought was to be developed through the subconscious and individual emotions. The stylistic movement in the visual arts expressed itself in painting in particular, but was also closely associated with poetry: the close connection between man and surrounding nature was depicted, along with scenes from everyday life and fairy tales and religious events. The last category was mainly represented by the Pre-Raphaelites. The best known French Romantics are Théodore Rousseau and Eugène Delacroix.

Rotunda (Italian rotonda): round building, or central structure built on a circular ground plan, or the round room inside a building.

Rustica (Latin rusticus, "rural, peasant"): masonry constructed on the outside from rough hewn stone blocks.

Salon (French, and Italian salone, originally meaning "large hall"): in the common parlance of 18th- and 19th-century France, the term for an exhibition hall, and for the Academy's art exhibitions held in the Salon d'Apollon of the Louvre from 1667 onward. From 1737, the exhibitions took place twice a year (annually after the French Revolution) in the Salon Carré of the Louvre. Toward the end of the 19th century the official Salon jury bowed out to make way for a committee made up of state approved members of the Société des Artistes Français—that is, former Salon artists.

Salon des Indépendants (French, "Salon of Independent Artists"): association of "unknown and rejected artists" founded in 1884 following a dispute with the official May Salon in Paris. It later became the model for the Secession artists in the artistic capitals of Europe. Unlike the Salon des Refusés, it was an organization independent of the state.

Salon des Refusés (French, "Salon of the Rejected"): exhibition held in 1863/64 and 1873 in protest at the conservative cultural policy of the official Paris Salon, showing pictures that had been turned down by the Salon. The Salon des Refusés was organized by Napoleon III, and among those taking part were Édouard Manet, Paul Cézanne, Henri Fantin-Latour, Camille Pisarro, and James MacNeill Whistler.

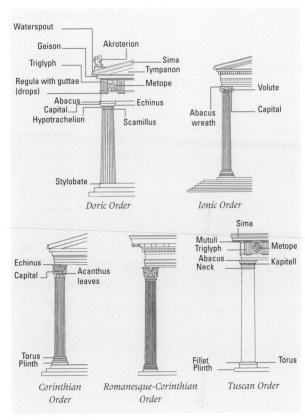

Doric Order

Ionic Order

Corinthian Order

Romanesque-Corinthian Order

Tuscan Order

Classical Column Order

Sansculottes (French, from sans-culottes, "without knee breeches"): during the French revolution, originally the nickname for insurgents who wore long breeches, as opposed to the knee-breeches of the aristocracy. Sansculottes in contemporary terms means a group of revolutionaries, who increasingly resort to military means in the fight for political, civil or social justice.

Sarcophagus (Greek sarcophagos, "flesh-eating"): decorative coffin made of wood, metal, concrete or stone.

Spoils (from Latin spolium, "booty" and from spoliare, "to rob, plunder"): spoils of war; also repurposed parts of a work of art or building.

Still-life painting (Dutch, still-leven; from still, "immobile," and leven, "model") also known as nature morte or natura morte (French and Italian, "dying nature, lifeless creation"): a genre that became particularly important in Dutch painting during the 17th century, which was dedicated to the realistic representation of "still" objects that did not move. Depending on the emphasis assigned to the object, these paintings were called either fruit and flower still lifes, or hunting, kitchen, and market pieces. Categorized as a lower genre in the academic painting of the 18th century, it was rediscovered by the Impressionists. Their interest in the genre was not focused on the illusion of the object, but was rather an expression of the search for reproducing color and artistic quality in apparently insignificant objects.

Symbolism: artistic movement in late 19th-century France, mainly in literature, which opposed Realism and Impressionism. Instead, it demanded deeper meaning from a work of art, attempting to express ideas and subjectivity through widely understood symbols or suggestive allusions. It was not a question of the objective portrayal of something, but the underlying concept; thus, mythical figures and dreamlike forms became subjects for the paintings. Along with Gustave Moreau (1826–1898), whose enigmatic "Salomé" paintings can be seen as the epitome of symbolism, Odilon Redon (1840–1916) and Pierre Puvis de Chavannes (1824–1898) are some of the best known representatives of symbolism in France.

Tapestry (from French tapisserie): term used for woven, embroidered, or knitted wall hangings or furniture fabrics carrying pictorial representations. Tapestry weaving flourished in the great Gobelin and carpet factories in France under Louis XIV (1638–1715) and Louis XV (1710–1774).

Tracery: ornamental patterning in Gothic architecture based on circular forms, used for segmenting pointed arches of large windows, and later for subdividing gables, walls, and other surfaces. (ill. p. 455)

Triumphal arch: originally an arch built in honor of a Roman emperor or general in the form of a free-standing archway with either one or three passageways. The occasion of the celebration is indicated by the relief ornamentation and sculpture on the structure, and by inscriptions. Famous examples are the Arches of Titus, Septimius Severus, and Constantine in Rome. It was resurrected as an architectural form during the epochs of Baroque and Classicism in France, often in conjunction with ceremonial boulevards. The prime example is the Arc de Triomphe in Paris, begun during the reign of Napoleon I and completed in 1836.

Trophy (French trophée, from Greek tropaion, "sign of victory"): symbol of victory, especially in the form of plundered weapons or flags (Church of Les Invalides, Paris). During victory celebrations, trophies were often put on display or incorporated into triumphal monuments. Later it became customary to recast the trophies in durable materials and adopt them in heraldry. Nowadays references to trophies are mainly associated with hunting.

Tympanum (Greek, tympanon "eardrum, kettledrum"): area within an archway above a portal or within a pediment.

Vault: arched ceiling over a space, constructed mainly from wedge shaped masonry stones. Unlike a dome, it is also found above longitudinal spaces. The abutments, e.g. walls or pillars, absorb the stress and thrust of the vault. There are many variations on the vault form, such as the groin vault or barrel vault.

Volute (Latin voluta, "spiral scroll"): spiral, scroll-shaped ornament originally part of the Ionic capital, but also used on pediments and as transitions between vertical and horizontal structural elements.

World Exhibition: exhibition staged for the first time in London as a universal exposition, repeated at intervals of one to eight years since 1851 in various cities where

International Exhibition of 1900: sculptures created specially for this exhibition were on display in the Grand Palais, 1900

countries from all over the world competed in the areas of technology, science, and culture. The different exhibition buildings and pavilions reflect the prevailing status of architectural design, e.g. the Eiffel Tower for the International Exhibition of 1889, designed by Gustave Eiffel.

Wimperg (Old High German winthberga, "draft shield"): in Gothic architecture, the German and Dutch term for an ornamental gable over windows and portals, often with tracery (Gothic decorative rib pattern) or other ornamentation.

Biographies

Alphand, Adolphe (1817 Grenoble–1891 Paris) was one of the most important French landscape architects in the second half of the 19th century. When Napoleon III came to power in 1852, the urban planner Georges-Eugène Haussmann was given the task of transforming Paris into a modern metropolis. He engaged the services of Alphand for the remodeling of the Bois de Boulogne. Alphand also developed numerous parks, squares, and avenues, which continue to mark the cityscape of Paris today.

Baltard, Victor (1805 Paris–1874 Paris) began his apprenticeship in Paris in 1823 with his father, the architect Louis-Pierre Baltard. In 1833 he was awarded the Rome prize for his design for a military school. On his return from Italy, the design for the tomb of Napoleon I (1839) resulted in early recognition of his artistic skills. His main works—the market halls built between 1852 and 1859 of glass and iron (demolished 1971/1973) and the St. Augustin church (1860–1868), a central structure with a vaulted dome and a bold iron construction inside—are bravura achievements of historical architecture in 19th-century Paris.

Benjamin, Walter (1892 Berlin–1940 Port Bou), a reviewer and author of works on art theory, found himself in difficult financial circumstances throughout his life. On completing his dissertation on art criticism in the Romantic period (1919) he tried unsuccessfully to pursue a university career. During the 1920s he turned towards Communism. In 1933 he emigrated to Paris and between 1936 and 1939 wrote the essay "The Work of Art in the Age of Mechanical Reproduction" as well as a treatise on the Paris "passages." Fleeing from the Nazis, he committed suicide on September 27, 1940, in Spain.

Bernini, Gianlorenzo (1598 Naples–1680 Rome) is seen as the most influential master of Italian Baroque. He worked as a sculptor in Rome from 1606. His fame was established by free sculptural groups of biblical and mythological themes and fountain projects in Rome, which were completed in 1615/16 at the behest of several cardinals and popes. During the second half of his life he worked more intensively as an architect, thus coming into competition with Borromini. Between 1624 and 1670, Bernini directed the construction and design of St. Peter's. In 1665 he was invited to France by Louis XIV to complete designs for the extension of the Louvre, but these were never realized. Bernini's work is characterized by virtuoso workmanship in marble, skillful use of light, and dramatic staging in terms of interior design. The dynamic strength and proportionality of the buildings and architectural and sculptural unity are typical of his work.

Boffrand, Gabriel-Germain (1667 Nantes–1754 Paris) left behind a comprehensive body of work as a court architect in France. He initially worked under Jules Hardouin-Mansart, but was soon able to set himself up independently. Boffrand received numerous commissions from the aristocracy, especially to build "hôtels particuliers" (including the redesign of the Hôtel de Soubise).

Boucher, François (1703 Paris–1770 Paris) was one of the main exponents of the Rococo style in France. His teachers, Lemoyer and Watteau, had a decisive influence on his work. His glittering career began following a trip to Italy between 1727 and 1731; from acceptance into the Academy, which he later directed, he went on to an appointment as official court painter in 1765. His decorative works with mythological and social themes and his erotic images exude a charming joie de vivre; they suited courtly taste, but attracted censure from the enlightened bourgeoisie.

Bruant, Libéral (ca. 1637–1697 Paris) was one of the foremost architects during the reign of Louis XIV. His buildings include the church of Petits-Pères (today known as Notre-Dame-des-Victoires) and chapel of the Hôpital de la Salpêtrière. In 1670 he designed a struc-

Pierre Petit, The Painter Gustave Courbet, 1865,
Archive for Art and History, Paris

tural complex for the care of 5,000 elderly and sick soldiers. Completed in 1691, the Hôtel des Invalides was the second largest building project after the chateau of Versailles under Louis XIV. In the architect's own house, Hôtel Libéral Bruant (1685), there is now a famous collection of locks and keys in the Musée de la Serrurerie.

Carpeaux, Jean-Baptiste (1827 Valenciennes–1875 chateau Bécon in Courbevoie/Seine) began to learn the art of sculpture in the studio of François Rude in 1844. Winning the Rome prize in 1854 enabled him to travel to the Eternal City from 1856 through 1863, where he became acquainted with the oeuvre of Michelangelo and Bernini, which would prove significant for his own work. The unveiling of his *pièce de résistance*, "The Dance" (1869) at the Paris Opéra created a scandal as he was accused of being guilty of realism and unsuitable modernism. Carpeaux combined innovative formal language in his artistic molding of surfaces and inte-

gration of light effects with traditional elements; he was one of the most important sculptors of the second half of the century.

Chardin, Jean-Baptiste Siméon (1699 Paris–1779 Paris) was a pupil of various history painters from 1720 onward. In 1724 he became a member of the Parisian guild, the Académie de Saint-Luc, and of the royal Academy in 1728, where he held important positions until 1774. Chardin favored still lifes and genre paintings, both unrecognized genres in art at that time, which he helped to give more prominence. Subtle gradations in color and sparse compositions distinguish his style.

Colbert, Jean-Baptiste, Marquis de Seignelay (1619 Reims–1683 Paris) advocated the doctrine of mercantilism in his capacity as statesman and economic reformer. As Controller-General of Finances and Minister of Commerce under Louis XIV he promoted centralization in France by expanding the transport infrastructure and focusing it on Paris as the center. Colbert, who became known as the "father of roads," laid a network of surfaced highways as well as canals and harbors. He stimulated the economy by abolishing domestic tariffs and reforming the tax system.

Courbet, Gustave (1819 Ornans by Besançon–1877 La Tour-de-Peilz by Vevey, Switzerland) began to teach himself the art of painting in 1840, copying works by Velàzquez, Hals, and Rembrandt and painting from nature. Influenced by his socialist friend Pierre-Joseph Proudhon, Courbet aspired to a realistic form of representation that reflected the spirit of the times. He painted subjects involving the everyday lives of peasants and workers in an objective and unsentimental way, something that was hitherto unknown. This direction led him away from the Academy and "official" history painting, and he became one of the founders of Realism. Despite the critics he began to enjoy success around 1850, especially in Germany, where he often visited. In 1871 he joined the Paris commune, but was imprisoned when it was defeated and forced to flee to Switzerland.

Coysevox, Antoine (1640 Lyon–1720 Paris), was, along with François Girardon, one of the masters of French monumental sculpture. He won early acclaim with his numerous busts of famous personalities and, from 1679, began to work for Louis XIV (reign 1643–1715). Among his most important works are the monumental sculptural groups for Chateau Marly, which now stand in the Louvre.

David, Jacques-Louis (1748 Paris –1825 Brussels) was the leading exponent of French Neo-Classicism. On the advice of his friend Boucher, he became a pupil of Joseph-Marie Viens in 1766. Studying Roman antiquity during a stay in Italy from 1775 through 1780 proved to be his greatest inspiration. David became politically active and as a leading Jacobin was the foremost painter of the French Revolution. Later he aligned himself with Napoleon I, who appointed him official court painter. After the fall of the Emperor he went into exile in Belgium in 1816.

Degas, Edgar (1834 Paris–1917 Paris), real name Hilaire Germain-Edgar de Gas, came from a wealthy banking family. He studied from 1853 through 1855 in Paris with Louis Lamothe and Hippolyte Flandrin, followers of Ingres who introduced him to this artist, which proved important for his own work. Degas cultivated friendships with Monet and Renoir and participated in Impressionist exhibitions. His main concern, however, was the human body, especially the female one; he saw in the poses and movements of women the epitome of perfection and harmony. The use of space and light in his portrayals of jockeys, dancers, and washerwomen, which he chiefly completed in pastels at the end of the 1870s, differentiates him from classical models and indicates his close affinity with Impressionism. The wax figures, mostly of dancers, he created after 1865 were not produced for the public, and only cast in bronze after his death.

Delacroix, Eugène (1798 St-Maurice-Charenton by Paris–1863 Paris) studied Rubens and Veronese in particular during his training in Paris, and was also inspired by Constable. He stayed in London in 1825 and in 1832 traveled in North Africa and southern Spain. Delacroix was the leading painter of French Romanticism. His compositions, based wholly on the vibrant use of color, took him away from "official" Classicism and would lead the way for Impressionist painting.

Delaunay, Robert (1885 Paris–1941 Montpellier) occupied a special place within Analytic Cubism. Unlike the fragmentation of objects in the work of Georges Braque and Pablo Picasso, Delaunay insisted on constructing the image by using contrasting color and light, which produced a rhythmic movement. His subject matter of preference was not still life, but the city, sport, and technology. The musical and poetic nature of his pictures led the poet Apollinaire in 1912 to describe for the first time the style of Cubism adopted by Sonia and

Louis Michel van Loo (1707–1771), Portrait of Denis Diderot, Oil on canvas, 81 x 65 cm, Musée du Louvre, Paris

Delaunay as Orphism, an allusion to Orpheus, the musician of Greek mythology.

Delorme, Philibert (ca. 1512 Lyon–1570 Ivry) was one of the most influential French architects of the 16th century, even though many of his works have now been destroyed. In 1547 he became responsible for building works under Henri II, but after the death of the king in 1559 he was unexpectedly relieved of his duties. In 1563 Catherine de' Medici brought him back into royal service and entrusted him with his greatest commission, the construction of the Tuileries Palace. Only the extensive park now remains of the building, which burnt down in 1871.

Diderot, Denis (1713 Langres–1784 Paris) expanded the intellectual parameters of the Enlightenment in his philosophical treatises by introducing dreams, madness, and the subconscious. Along with d'Alembert, he founded and edited the "Encyclopédie," which compiled the collective knowledge of science, philosophy, and art in the form of a dictionary. Between 1751 and 1772, 28 volumes of the "Encyclopédie" were published, though the work was banned by the church because of its anthropocentric philosophy.

Eiffel, Alexandre-Gustave (1832 Dijon–1923 Paris), a modern engineer and architect, favored working with steel constructions. He designed the 984-ft. (300-m)-high Tour Eiffel (Eiffel Tower) for the International Exhibition in Paris in 1889, which was also the centenary of the French Revolution. Its steel frame construction, left visible, reduces it to purely functional elements. The use of prefabricated parts, which could just be assembled on site, allowed the tower to be built in less than 26 months with only 250 construction workers. The tower, which attracted much criticism from contemporaries, has remained the true symbol of Paris until today, and a monument to the French Revolution.

Fragonard, Jean-Honoré (1732 Grasse–1806 Paris), a painter, illustrator, and graphic artist, was one of the leading figures of French Rococo. He began as a pupil of Chardin, before Boucher took him on in his workshop. Following a stay in Rome from 1756 through 1761, he

Aimé Morot (1850–1913), The engineer Gustave Eiffel, 1905, Oil on canvas, 140.5 x 98 cm, Châteaux of Versailles and the Trianon, Versailles

was accepted four years later into the Royal Academy. Yet he preferred to work for private patrons, for whom he also created monumental interior designs. His work is characterized by mythological themes, landscapes, and mildly erotic portraits of the upper classes. He is buried in Montmartre.

Gabriel, Jacques-Ange (1698 Paris–1782 Paris) worked as court architect to Louis XV during the transition from Rococo to early Classicism. Among his greatest projects in Paris were the École Militaire and the redesign of Place de la Concorde. The latter, with its original asymmetrical layout as a square, was significant in terms of urban planning; flanked on only one side by

two monumental formal buildings (Hôtel Crillon and the Gardemeuble, now the French Naval Ministry), the three other sides remain open, forming a connection with the surrounding natural environment.

Garnier, Charles (1825 Paris–1898 Paris) studied architecture at the École des Beaux-Arts. He suddenly gained recognition when he won the competition to design the Opéra building, the largest construction project in France at that time. Its magnificent Neo-Baroque style embodied the spirit of the Second Empire under Napoleon III. As Garnier personally supervised the works down to the last detail, he had little time for any other projects. With his monograph above the Opéra building, in 1881 he published one of the most comprehensive descriptions of a building during the 19th century.

Gogh, Vincent van (1853 Groot-Zundert–1890 Auverssur-Oise) worked as a lay preacher in the Belgian coal-mining district of Borinage following his studies in theology. He began to study painting in 1880 in Brussels and Antwerp, and then in Paris with Fernand Cormon between 1886 and 1888. His early work was influenced by the realism of the Haag School. The landscapes, portraits, and still lifes he produced in a feverish creative burst first in Paris, influenced by the Impressionists and Pointillists, and then in Arles from 1888, reveal his distinctive style, which used color increasingly as a powerful form of expression. In 1889 Van Gogh was admitted to the Saint-Rémy sanatorium, where he took his own life.

Goujon, Jean (ca. 1510 Normandy–ca. 1565 Bologna) was one of the leading French sculptors of the 16th century. After Henri II came to power in 1547, he worked in the royal service with the architect Pierre Lescot. His main works include the sculptural decoration on the Fontaine des Innocents, the Hôtel Carnavalet, and the reconstructed Louvre (Cour Carrée) with the Salle des Caryatides. The first complete French translation of the treatise "De architectura" by Vitruvius, published in 1547, is illustrated with woodcuts by Goujon and demonstrates his knowledge of antiquity.

Green, Julien (1900 Paris–1998 Paris) grew up as the son of American immigrants in Paris. In his novels and plays, Green deals with the theme of the struggle between Catholic moral values and sexual desire. His protagonists often end up committing terrible crimes, becoming obsessive, or going mad. A member of the Académie Française since 1971, his resignation from it caused a scandal in 1996. His most important works include "Adrienne Mesurat," "Moira," "Leviathan," and his diaries.

Guimard, Hector (1867 Lyon–1942 New York) was a student at the École des Arts Décoratifs from 1882, then went on to study architecture at the École des Beaux-Arts from 1889 through 1893. Very successful in the field of applied arts with furniture, glass, and ceramics, Guimard was particularly inspired by the Belgian architect Victor Horta. His principal work is the apartment building known as "Castel Béranger" (1894–1898) which has a conventional exterior, but reveals a bold use of metal, fayence, and glass inside. He became famous, however, with his Métro entrances (1899–1904), which still define the cityscape today.

Hardouin-Mansart, Jules-Michel (1646 Paris–1708 Marly) was involved in numerous building projects as principal court architect to Louis XIV. His designs for Place des Victoires and Place Vendôme were significant in terms of public town planning. His most important example of church architecture was the Dome des Invalides. At the same time, as successor to Le Vau, he spent most of his time directing the building works at Versailles. Hardouin-Mansart was one of the main exponents of a Classical Baroque style that abandoned decorative detail for the effect of sweeping expanses.

Haussmann, Georges-Eugène, Baron (1809 Paris–1891 Paris) was given the task as urban developer under Napoleon III of turning Paris into a modern metropolis. He created a new system of roads with wide avenues and boulevards, the main axes of which converge in squares configured in the shape of a star. Part of his vision was the design of public green spaces. Many of the historical quarters of the city with rambling, densely built housing were demolished in the course of the

works. Haussmannism has left its stamp on the face of the city even today.

Hittorff, Jakob Ignaz (1792 Cologne–1867 Paris) worked as an architect in France. He began his apprenticeship in his home town with the canon of the cathedral chapter, the university professor Wallraf, and then went on to study at the École des Beaux-Arts in Paris. His talent is evident in the many designs he created as a town planner, yet few projects were realized as he could not compete with Haussmann. The fountains on Place de la Concorde flanking the central obelisk were built according to Hittorff's designs.

Ingres, Jean-Auguste-Dominique (1780 Montauban–

Baron Georges Eugene Haussmann (1809–91), Musée Carnavalet, Paris

1867 Paris) initially studied in Paris with Jacques-Louis David. From 1806 through 1824 he lived in Florence and Rome, and then returned to Paris. In 1835 he accepted a chair at the Academy in Rome and taught there until 1841. Heavily influenced at first by David's painting, Ingres gradually turned more toward Renaissance art. His style reflects his attempt to harmonize the ideal form and naturalness. Support for late Classicism made him an adversary of Delacroix, who was vehemently opposed to this "official" art.

Le Brun, Charles (1619 Paris–1690 Paris) the son of a sculptor, was one of the most influential artists of his generation. At the age of 13 he was apprenticed to François Perrier and then in 1635 to the court painter Simon Vouet. His trip to Rome with Poussin from 1642 through 1646 provided him with decisive inspiration. There he studied the works of Annabile Carracci and Raphael. In 1648, he became a founder member of the Académie Royale, which became the leading art school in France under him. He undertook many projects for the royal court from 1660 and was appointed official court artist and director of the royal Gobelin and furniture factory. His creativity in many fields made Le Brun a significant contributor to the development of the ceremonial and ornamental Louis XIV style.

Le Corbusier (1887 La Chaux-de-Fonds–1965 Roquebrune-Cap-Martin), real name Charles-Édouard Jeanneret, was a Swiss architect who worked in Paris in the 1920s and 1930s and was important in terms of architectural theory. In 1914, he developed the industrially manufactured steel frame construction system to use as a functional building method. His works are defined by basic geometric forms that are adapted to a human scale. He built a villa for the banker La Roche that now houses the "Fondation Le Corbusier" with architectural drawings and paintings by him on display as well as furniture designed by him.

Le Nôtre, André (1613 Paris–1700 Paris) came to prominence as a landscape gardener under Louis XIV and was reputed to be the original creator of the formal French garden style, which was *de rigueur* throughout

Europe until the 18th century. By 1637 he had succeeded his father as the director of the Tuileries Gardens. The gardens at Versailles were one of his major works; controlling the forces of nature with its system of main axes of central squares and parallel or radiating allées and paths, the park can be seen as the direct expression of absolutism.

Lescot, Pierre (1500/1510 Paris–1578 Paris) was a leading French architect during the Renaissance who served under François I and Henri II. He built the Hôtel Carnavalet with Jean Bullant. The contemporaneous Louvre reconstruction (Cour Carrée) and the Fontaine des Innocents were among his major achievements. He worked closely with the sculptor Jean Goujon in designing the sculptural ornamentation. Lescot made his mark with a specifically French architectural style, which combined the characteristic cultural forms of Roman antiquity with rich ornamentation that became more elaborate towards the top of the structure.

Le Vau, Louis (1612 Paris–1670 Paris) was, along with François Mansart, one of the most important architects under Louis XIV. Hôtel Lambert was one of his first projects. His close connections to the circle around Cardinal Mazarin led to Le Vau's promotion to the position of "first architect" at court after Mazarin's appointment as a minister in 1654. He was put in charge of the Louvre building works and was later responsible for the construction of the chateau at Versailles. The Collège Mazarin, now the Institut de France, was yet another of his important designs. His Baroque buildings stand out by virtue of their dynamic spatial proportions.

Maillol, Aristide (1861 Banyuls-sur-Mer–1944 Banyuls-sur-Mer) studied painting with Jean-Léon Gérôme and Alexandre Cabanel and influenced by Gauguin developed his own style, which emphasized surface and line. In 1893 he began to associate with "Les Nabis," a group of Parisian artists. He produced tapestries, woodcuts for book illustrations, and small sculptures in wood and clay. A self-taught sculptor, Maillol then produced large figures in stone and bronze. The self-contained figures are heavy and voluminous, with strict formal lines and the

François Mitterrand, 1994

simple movement characteristic of Classical antiquity. They typify the new direction taken by the most important sculptor of modernity at the turn of the century.

Manet, Édouard (1832 Paris–1883 Paris) trained in the workshop of Thomas Couture from 1850 to 1856. Like Fantin-Latour, he avidly studied the old Masters in the Louvre, while on his journeys across Europe he copied Titian in particular and also Tintoretto, Rembrandt, and Velázquez. Manet caused an outcry in 1863 and 1865 with his works "Le déjeuner sur l'herbe" and "Olympia," which made deliberate reference to famous predecessors. He was seen as a realist influenced by Spanish painting. In his later works, which comprised portraits, landscapes, and still lifes, he emphasized the surface of the picture plane and reduced the color shades, creating a spontaneous and consistent brightness in his

painting and with it a pioneering contribution to Impressionism.

Mansart, François (1598 Paris–1666 Paris) was a French architect who was one of the leading exponents of early Classical Baroque. From 1636 he was in royal service, responsible for many building projects and reconstructions of chateaus, churches, and palaces. His most important works in Paris included the church and abbey of Val-de-Grâce, while the rebuilding of Hôtel Carnavalet was based on his designs. The Mansard roof that became popular in the 17th century was named after him. Allowing better use of the attic, it was the roof type of choice of François Mansart.

Marcel, Étienne (ca. 1316 Paris–1358 Paris) was the provost of merchants (prévôt des marchands) in Paris. He tried in vain to restrict the power of the French throne by introducing joint governance of the estates. In order to maintain his own position in Paris' city administration vis-à-vis the Dauphin (later Charles V) he forged an alliance with the rebellious peasants in northern France (the so-called Jacquérie) and with Charles the Bad of Navarre. During a people's revolt against the royal troops, he was killed by a supporter of the Dauphin in 1358.

Matisse, Henri (1869 Le Cateau–1954 Nice) was an expressive painter who was part of the Fauvist avant-garde during the early 20th century. The recognition of the intrinsic value of color is fundamental to his style. The decoratively structured images emphasize the two-dimensional nature of the canvas and show the pure colors, juxtaposed in contrast to each other, to full effect. He was also a sculptor, active in different branches of arts and crafts. His creativity also found expression in experimentation with new materials.

Mazarin, Jules, Duc de Nevers (1602 Pescina–1661 Vincennes) acted as an advisor to the French court from 1640 and became cardinal the following year. After the death of Richelieu in 1642, Louis XIII promoted him to first minister. With the agreement of Anne of Austria, the mother of Louis XIV, Mazarin ruled in place of the underage king, and won supremacy in Europe for France through the Treaty of Westphalia in 1648 and the Peace of the Pyrenees in 1659. With the suppression of the Fronde, a revolt of the aristocracy and the courts, Mazarin also secured French absolutism on the domestic front.

Mitterrand, François (1916 Jarnac–1996 Paris) took on various ministerial posts under Charles de Gaulle between 1947 and 1957. After the creation of the Fifth Republic (1958) he rallied the forces of left and in 1965 became the president of the Fédération de la Gauche Démocrate et Socialiste (Federation of the Democratic and Socialist Left). In 1971 he was elected first secretary of the newly formed Parti Socialist, the Socialist Party. As President of the Republic (1981–1995) he commissioned costly and prestigious buildings which rapidly became symbols of the city: the Bastille Opéra, the Louvre glass pyramid, the triumphal arch at La Défense, and the new National Library.

Monet, Claude (1840 Paris–1926 Giverny) grew up in Le Havre, where he was inspired by the plein air painting of Boudin. From 1859 he studied at the Académie Suisse in Paris, where he met Pissarro, and then at the École des Beaux-Arts. As with Bazille, Renoir, and Sisley, his paintings were mainly of nature. On a trip to London during the war years (1870/71) he became familiar with the work of Turner. He lived in Argenteuil from 1872 to 1878, then in Vétheuil, Poissy near Paris, and finally in Giverny from 1883. His oeuvre represents the epitome of Impressionism.

Moreau, Gustave (1826 Paris–1898 Paris) learned his trade in the studios of François-Edouard Picot and Théodore Chassériau. Of independent financial means, Moreau traveled in Italy from 1857 through 1859. He exhibited in the Salon intermittently from 1852 to 1880 and for the last time in the Galerie Goupil in 1886. In his mystical, dreamlike, fantastic visions, which were filled with exotic drapery and Oriental decor, he gave form to mythological and religious themes as symbols of the irrational and inexplicable. Influenced by the English Pre-Raphaelites and the quattrocento masters in Italy, Moreau is seen as one of the leading exponents of

Symbolism. Henri Matisse and Georges Rouault trained in his studio.

Napoleon I. (1769 Ajaccio–1821 St. Helena) appointed himself First Consul of France in a coup d'état in 1799. His constitution for the consulate created a centralized system of government. In 1804, he crowned himself Emperor. The same year he reformed the French civil code. Following a defeat in the Russian campaign, French supremacy in Europe came to an end in 1812. In 1814, he was exiled to the island of Elba, but a year later took power again. He was finally defeated at Waterloo and exiled to the British island of St. Helena for the rest of his life.

Nouvel, Jean (born 1946 Fumel, Lot et Garonne) is one of the most successful French architects of our time and is represented in Paris by a number of large projects. In 1980 his career took off when he won the competition for the Institut du Monde Arabe. The Cartier exhibition hall is worth a look. The Musée du Quai Branly opened in 2006. The glass buildings and translucent constructions of Nouvel are based on the theory of immateriality in architecture.

Pei, Ieoh Ming (born 1917, Guangzhou, China) left China in 1935 to study architecture in America. After graduating from Harvard, he led the large architectural firm of Webb & Knapp and then went into business for himself in New York. He completed numerous large-scale international projects along with his partners Henry Nichols Cobb and James Ingo Freed and hundreds of employees. In Paris he won the competition for the design of the entrance to the Louvre. Completed in 1993, the glass pyramid forms a contrast to the historical structure, without deflecting attention from it.

Picasso, Pablo (1881 Málaga–1973 Mougins) was a Spanish painter, illustrator, graphic designer, and sculptor who was one of the most prolific and diverse artists of the 20th century. Blue and Rose Periods, Cubism, object constructions, figure painting, collages, assemblages, and ceramics—all catch phrases for the individual aspects of his creative output, like the experimentation with different types of material. His work is suffused with thorny questions about art theory, politics, sexuality, and personal issues. The Musée Picasso in Paris provides an overview of his oeuvre.

Poussin, Nicolas (1594 Les Andelys–1665 Rome) lived in Rome from 1624. He spent only a short period at court in Paris (1640–1642), where Louis XIII appointed him official court painter. Rooted in the art of antiquity and the Italian Renaissance, Poussin painted religious and mythological history pictures, portraits, and landscapes, all of them subject to a strict principle of arrangement aimed at the highest perfection. With his classically oriented paintings his main influence was on the Paris Academy and its artists.

Rembrandt (1606 Leiden –1669 Amsterdam), real name R. Harmensz von Rijn, was a student of Pieter Lastman in Amsterdam. He moved there in 1631 after his first job in Leiden. In spite of being a sought-after painter and etcher, he suffered severe financial difficulties. Rembrandt came to prominence especially with his reli-

Nicolas Poussin, Self Portrait, 1650, Oil on canvas, 78 x 94 cm, Musée du Louvre, Paris

gious history paintings and portraits, in which he departed from the traditional composition of the subject matter. In his subtle chiaroscuro work he sympathetically conveys the spiritual feelings of the individual.

Renoir, Auguste (1841 Limoges–1919 Cagnes-sur-Mer, Nice) began his career as a porcelain painter and decorator of fans and curtains. From 1861 he studied with Bazille, Monet, and Sisley in the studio of Charles Gleyre. After a period painting figures and portraits in the Impressionist style, his technique was heavily influenced by a trip to Algeria and Italy in 1881/2. Inspired by the paintings of Ingres, Raphael, and the Italian quattrocento, his figures became more classical and monumental. A looser creative style, more mellow and sensual in quality, dominates his later works, which mainly consist of nudes and figure painting.

Richelieu, Louis-François-Armand du Plessis (1585 Luçon–1642 Paris) was the founder of French absolutism. Originally a cardinal, he was appointed first minister by Louis XIII in 1624. He strengthened the monarchy by removing power from the aristocracy and special privileges from the Huguenots. In foreign policy he consolidated the position of France in relation to the power of Spain and the Habsburgs by forging an alliance with Gustav Adolf, King of Sweden. In 1641 he paved the way for the Treaty of Westphalia, which ensured the primacy of France in Europe. In 1635 he founded the Académie Française.

Robert, Hubert (1733 Paris–1808 Paris) initially attended the Collège de Navarre and was instructed in drawing at the studio of the sculptor M. Slodtz. In 1754, he went to Rome for over 10 years, where he received the official scholarship of the Académie de France from 1759 through 1762. In 1760 he traveled to Naples to visit classical excavations. While in Italy, Robert's painting was greatly inspired by Giovanni Battista Piranesi and Giovanni Paolo Pannini. In 1765, Robert returned to Paris, where he became a member of the Academy in 1766 as an architectural artist. After a brief incarceration during the Revolution, he joined the Commission that supervised the transformation of the Louvre into a

Rembrandt van Rijn, Portrait of the Artist at his Easel, 1660, Oil on canvas, 111 x 90 cm, Musée du Louvre, Paris

new national museum. Robert is seen as an important forerunner of 19th-century French landscape painting.

Robespierre, Maximilien de (1758 Arras–1794 Paris) was appointed a member of the Estates-General in 1789. A lawyer from northern France, he led the radical "Montagnards" and was part of the ruling Convention in 1792. As chairman of the Committee of Public Safety he set up the Reign of Terror in 1793/4 that saw around 30 people being executed every day in Paris. Robespierre justified the totalitarian nature of the Revolution by equating his political aims with the "Volonté générale" (general will). He was removed from power on 9 Thermidor (July 27) 1794 and guillotined the next day.

Rodin, Auguste (1840 Paris–1917 Meudon) is regarded as the leading sculptor of the 19th century. Turned down several times by the École des Beaux-Arts, he became

Giovanni Lorenzo Bernini (1598–1680), Cardinal
Richelieu, Marble bust, Musée du Louvre, Paris

a colleague of Albert-Ernest Carrier-Belleuse working in the Sèvre porcelain factory from 1864 through 1870. A trip to Rome and Florence in 1875 acquainted him with the art of Michelangelo and Donatello, and led to the development of a revolutionary style. With his masterpiece "The Burghers of Calais" (1884–1886) Rodin created a new type of monument without heroic glorification in the traditional sense. In his portraits, groups, and other sculptures he achieves an unprecedented level of expressivity, creating a psychological impact and spiritual elation through his free treatment of surfaces and the emphasis on light and shadow.

Saint-Phalle, Niki de (1930 Neuilly-sur-Seine—2002 San Diego) was an internationally successful sculptor and painter. She first attracted attention around 1960 with her "shooting" paintings. Under the surface of these gypsum reliefs are pockets of hidden paint which burst onto the surface when shot with a gun. She became famous for her "Nanas"—huge, curvaceous, female figures in gaudy colors, whose warmth is missing in the pin-up subjects of Pop Art. Many projects were completed in collaboration with her husband, Jean Tinguely: for example, the Fontaine Stravinsky in front of the Pompidou Center.

Soufflot, Jacques-Germain (1713 Irancy–1780 Paris) was the most significant architect of French Neo-Classicism. Following his schooling in Lyon, he went to Rome in 1731, where he tackled the art of antiquity and Italy with intensity and studied at the Academy there for three years. On his return in 1738 he obtained numerous commissions in Lyon. From 1755 in Paris he was mainly involved in public projects. His masterpiece was the church of St. Geneviève, completed after his death and now known as the Panthéon, the burial place of famous people.

Suger (ca. 1081 Paris–1151 St-Denis) was the abbot of St-Denis who had the abbey reconstructed in 1122 as an early Gothic masterpiece. Louis VI called him to service in the royal court as an advisor in religious matters. From 1147 to 1149 Suger was appointed regent by Louis VII while the king himself was out of the country on crusades. As a chronicler Suger compiled a biography of Louis VII as well as various political portrayals that form the basis of the history of St-Denis.

Tinguely, Jean (1925 Fribourg–1991 Bern) is an important Swiss sculptor of the 20th century. Dada and Constructivism formed a significant basis for his work. He became famous in the 1960s with his machines constructed out of scrap, which he animated mechanically with the press of a button or computer control and sometimes combined with sound, light, and even smell. These mechanisms without purpose are to some extent ironic paraphrases and partly playfully humorous, like the Fontaine Stravinsky, designed with his wife Niki de Saint-Phalle, which is located in front of the Pompidou Center.

Toulouse-Lautrec, Henri de (1864 Albi–1901 Château

Jean Antoine Houdon (1741–1828), François-Marie Arouet, known as Voltaire (1694–1778), 18th c, Bronze bust, 45 x 20.8 x 21.2 cm, Musée du Louvre, Paris

Malromé, Gironde) came from the house of the Counts of Toulouse. A hereditary condition and many childhood accidents led to his stunted growth. From 1882/3 he studied with Léon Bonnat and Fernand Cormon in Paris and in 1885 he discovered the demimonde of Montmartre as the subject matter for his art. He produced unconventional portraits of friends, artists, dancers, and prostitutes. With his two-dimensional decor and animated lines he revealed the typical in gesture, movement, and facial expression, with a concise style that would become groundbreaking for modern poster art. Heavily influenced by the English Art Nouveau artist Aubrey Beardsley, this painter's works include book illustrations and etched color lithographs.

Voltaire, (1694 Paris–1778 Paris), real name François-Marie Arouet, became the outstanding thinker of the Enlightenment with his satirical dramas and novels. Voltaire reworked classical heroic themes in his popular works, advocating tolerance and humanity. As a philosopher he turned against the Church and all forms of dogma, but professed a general belief in God based on a natural form of religion. He lived at the court of Frederick the Great of Prussia from 1750 through 1753, conducting a philosophical discourse with him.

Watteau, Antoine (1684 Valenciennes–1721 Nogent-sur-Marne) was a student of Jacques-Albert Gérin in Valenciennes. Around 1702 he went to Paris and continued his apprenticeship with Claude Gillot and Claude Audran III. These masters introduced him to the symbolic world of the commedia dell'arte and the free technique of arabesque painting. In 1717 he was accepted into the Académie Royale de Peinture et Sculpture as a painter of "fêtes galantes" (elegant festivities). Between 1719 and 1720 he worked in London as a much sought-after painter. Watteau is one of the leading French artists of the 18th century.

Zola, Émile (1840 Paris–1902 Paris) unmasks the superficial glamour of city life in his socially critical novels and reveals the darker side of industrial society—poverty, illness, prostitution, and alcoholism. His masterpiece, the 20-volume Rougon-Macquart cycle, portrays the decline of a family during the Second Empire. The novels in it—including "Germinal," "Nana," "The Beast in Man," "Money," and "The Downfall"—are some of his best known works. In 1897 Zola also played a high-profile role as a political commentator during the Dreyfus affair, and was forced briefly into exile in England.

Further reading

Bartz, Gabriele, and König, Eberhard: Louvre, Königswinter 2005

Beach, Sylvia: Shakespeare and Company, Frankfurt am Main 1982

Benjamin, Walter: Das Passagen-Werk (Arcades Project), Frankfurt am Main 1983

Beutler, Christian: Paris und Versailles, Reclam art guide, France Vol 1, Stuttgart 1972

Campbell, Barbara-Ann: Paris. A Guide to Recent Architecture, Cologne 1997

Ehlers, Joachim et al.: Die Französischen Könige des Mittelalters—von Odo bis Karl VIII., Munich 1996

Fitch, Noel Riley: Literary Cafés of Paris, Washington 1989

Gärtner, Peter J.: Musée d'Orsay, Königswinter 2007

Goncourt, Edmond and Jules de: Pages from the Goncourt Journal, Oxford 1978

Green, Julian: Paris, Munich 1989

Gretter, Sabine (ed.): Paris liegt an der Seine. Bilder einer Stadt, Frankfurt am Main 1999

Grimm, Jürgen (ed.): Französische Literaturgeschichte, Stuttgart, Weimar 1994

Gruber, Anna, and Schäfer, Bettina: Spaziergänge über den Père-Lachaise in Paris, Zurich, Munich 1995

Hartmann, Peter C. (ed.): Französische Könige und Kaiser der Neuzeit. Von Ludwig XII. bis Napoleon III. 1498–1870, Munich 1994

Hemingway, Ernest: Paris—ein Fest fürs Leben (1960) [Paris—A Moveable Feast (1965)], New edition 1999

Harvey, David: Paris. Capital of Modernity, London, New York 2003

Jordan, David: Transforming Paris: The Life and Labors of Baron Haussmann, New York 1995

Kathe, Heinz: Der Sonnenkönig. Ludwig XIV., König von Frankreich, und seine Zeit, 1683–1715, Berlin 1981 (Akademie Verlag)

Kimpel, Dieter: Paris—ein Führer durch die Stadtbaugeschichte, Munich 1982

Kimpel, Dieter, and Suckale, Robert: Die gotische Architektur in Frankreich 1130–1270, Munich 1995

Metelmann, Volker: Paris von Aragon bis Zola. Acht literarische Spaziergänge, Gießen 1995

Murat, Laure (ed.): Paris—Stadt der Dichter, Munich 1997

Paris—Belle Époque. Faszination einer Weltstadt, Exhibition catalogue, Villa Hügel, Essen 1994

Pérouse de Montclos, Jean-Marie: Paris. Kunstmetropole und Kulturstadt, Cologne 2000

Peters, Paulhans: Paris, die großen Projekte, Berlin 1992

Piaf, Edith: My Life, London 2000 (First published in France 1954)

Picon, Antoine and Robert, Jean-Paul (ed.). Le dessus des cartes—un atlas parisien. Exhibition catalogue, Pavillion de l'Arsenal, Paris 1999

Ross, Werner: Baudelaire und die Moderne. Porträt einer Wendezeit, Munich, Zurich 1993

Sauerländer, Willibald: Das Jahrhundert der großen Kathedralen, Munich 1990

Sieburg, Heinz Otto: Grundzüge der französischen Geschichte, Darmstadt 1973

Stierle, Karlheinz: Der Mythos von Paris. Zeichen und Bewußtsein einer Stadt, Munich, Vienna 1993

Thiebault, Philippe (Hg.), 1900. Ausst.-Kat. Grand Palais, Paris 2000

Valèry, Paul: Paris—Funktion einer Stadt, in Regards sur la France—Gedanken über Frankreich, Munich 1973

Viollet-Le-Duc, Eugéne: Dictionnaire Raisonné de l'architecture française du Xie au XVIe siècle, 10 Vols, Paris 1859–68

Weiss, Andrea: Paris war eine Frau. Die Frauen von der Left Bank, Reinbek bei Hamburg 1998

Willms, Johannes: Paris. Hauptstadt Europas 1789–1914, Munich 1988

Zola, Emile: Die Rougon-Macquart, Natur- und Sozialgeschichte einer Familie unter dem Zweiten Kaiserreich (Natural and Social History of a Family under the Second Empire), ed. Rita Schober, Gütersloh 1975–78

Index of places

Image and Map Credits

The publisher would like to thank the museums, archives, and photographers for their support and permission to use reproductions in this book. Up to the publication stage, the publisher has taken every step possible to trace the rights owners for other images. Individuals and institutions who may not have been contacted and wish to exert rights for reproductions used are kindly requested to contact the publisher.

National du Chateau de Malmaison, Rueil-Malmaison 203 1.Reg.1.Abb.; Musee National du Chateau de Malmaison, Rueil-Malmaison, Lauros-Giraudon 356; Musee National du Moyen Age et des Thermes de Cluny, Paris, Lauros-Giraudon 201 3.Reg.4.Abb., 201 4.Reg.1.Abb., 271, 272/73; Musee National du Moyen Age et des Thermes de Cluny, Paris / J.P. Zenobel 201 3.Reg.1.Abb.; Musee de l'Orangerie, Paris / Lauros-Giraudon 151; Musee d'Orsay, Paris 72 l, 74 tr, 75, 84, 203 3.Reg.2.Abb, 365 u; Musee d'Orsay, Paris / DACS / Lauros-Giraudon / 203 1.Reg.3.Abb.; Musee d'Orsay, Paris / Giraudon 74 cl, 74 bl, 78, 80, 82, 203 3.Reg.3.Abb., 203 3.Reg.4.Abb., 203 3.Reg.5.Abb.; Musee d'Orsay, Paris / Lauros-Giraudon 74 br, 81 l, 83, 85; Musee d'Orsay, Paris / Peter Willi 81 r; Musee Picasso, Paris / DACS /Giraudon / 204 3.Reg.1.Abb., 234, 235, 236, 237, 238; Musee Rodin, Paris 321 tr; Musee Rodin, Paris / Philippe Galard 320 tc, 322; Musee Rodin, Paris / Peter Willi 320 tr, 320 bl; Musee de la Ville de Paris / Musee Carnavalet, Paris 16, 182, 202 1.Reg.6.Abb., 255; Musee de la Ville de Paris / Musee Carnavalet, Paris / Archives Charmet 63, 201 2 Reg.5.Abb., 467; Musee de la Ville de Paris / Musee Carnavalet, Paris / Lauros-Giraudon 14, 17, 241, 242; Musee de la Ville de Paris / Musee Carnavalet, Paris / J.P. Zenobe 15; Musee de la Ville de Paris / Maison de Victor Hugo / Lauros-Giraudon 57, 203 5.Reg.4.Abb.; National Gallery, London 276; Private Collection 330 r; Private Collection / Archives Charmet 121, 209; Private Collection / Archives Charmet 377; Private Collection / Giraudon 435 t; Topkapi Palace Museum, Istanbul / Giraudon 99 bl; Musee Rodin, Paris / DACS / Philippe Galard 321 tl), © Christophe Fouin (166, 167, 220; MAHJ, Paris 245), © The Kobal Collection Universal (123, 124), © Laif, Paris (Hemisphères 310 tr, 342; Hoa-Qui 34 tl, 71, 203 4.Reg.2.Abb; Krinitz 174/75; Volz /© CHRISTO 1985 47, 204 5.Reg.5.Abb.), © Musee national de l'histoire naturelle (411), © Caroline Rose, Paris (5 b, 8, 52 bl, 52 tr, 52 c, 53 t, 55, 56, 86/87, 95, 178 b, 196/97, 198, 201 3.Reg.2.Abb., 202 1.Reg.4.Abb., 202 2.Reg.4.Abb., 283, 358, 395 br, 454), © Bilderberg (Dorothea Schmid 181 r), © Tandem Verlag GmbH, Königswinter (Photo Achim Bednorz 7 b, 34 br, 38, 39, 50/51, 52 tl, 158, 169, 170 b, 201 5.Reg.2.Abb., 202 2.Reg.5.Abb., 202 2.Reg.6.Abb., 203 2.Reg.2.Abb., 226 l, 228, 229, 230 t, 267 bl, 267 cr, 277, 279, 297, 302, 311 l, 420/21, 422/23, 424 b, 425 br, 425 c, 426, 430 bcr, 430 tr, 430 cl, 431 2nd from t, 431 2nd from b, 431 t, 436), © Tandem Verlag GmbH, Königswinter (Photo Caroline Rose 5 t, 6 t, 6 b, 7 c, 7 t, 19, 21, 30/31, 33, 34 tr, 34 bl, 35 tl, 35 tr, 35 b, 36, 42 r, 43, 46, 48, 49, 52 br, 60, 61 l, 61 r, 62, 64, 65, 70, 90 bl, 91 tl, 91 tr, 91 br, 93, 94, 145, 152, 156, 157, 164, 170 t, 171 t, 171 br, 172/73, 177, 178 t, 179 tl, 179 r, 179 b, 179 cl, 180, 188, 189, 190 tl, 190 bl, 190 br, 191 tl, 191 tc, 191 tr, 191 bl, 191 br, 199 l, 199 r, 201 2.Reg.2.-3.Abb, 202 1.Reg.3. Abb., 202 2.Reg.1.-3.Abb., 202 4.Reg.3.,6.Abb., 203 2.Reg.1.,5.,6.Abb., 203 5.Reg.1.,3.Abb., 204 2.Reg.2.-6.Abb., 204 5.Reg.4.Abb., 206, 208, 211, 219, 224 b, 225, 226 t, 226 b, 227 bl, 227 br, 230 b, 231 c, 231 tl, 231 tr, 231 bl, 231 br, 240, 244, 250/51, 252, 253, 254, 262/63, 264, 265, 266 bl, 266 br, 267 tl, 267 tr, 268, 270, 286/87, 288, 292, 294 l, 294 r, 301, 304/05, 306/07, 308, 310 br, 311 r, 312, 313, 316, 318, 320 br, 325, 326, 328, 329, 346 tl, 346 tr, 346 br, 348, 354, 355, 356/57, 360 l, 361 t, 361 c, 361 b, 362, 368, 369, 370, 372, 374, 378, 379, 380/81, 382, 383, 384 cl, 384 t, 384 b, 385 t, 385 b, 386 t, 386 b, 387 c, 387 t, 387 bl, 387 br, 388, 389, 390/91, 391, 394, 395 tr, 395 bl, 396, 398/99, 400, 401, 403 cl, 403 cr, 403 tl, 403 tr, 403 bl, 403 br, 404 l, 405, 406, 408, 409, 416, 417, 418, 419, 440/41, 456, 458), © Archives ADAGP-Image Bank (161) © Fondation Le Corbusier 2007 (351 r, Olivier Martin-Gambier 346 bl), © Staatliche Kunstsammlungen Dresden (Josef-Hegenbarth-Archiv / H. Boswank 141), © Roger Viollet (12, 102, 155, 163, 183, 184, 185, 186, 201 1.Reg.1.Abb., 203 5.Reg.2.Abb., 204 1.Reg.3.Abb., 204 2.Reg.1.Abb., 204 4.Reg.4.Abb., 204 5.Reg.1.Abb., 243, 330 l, 331, 339, 360 r, 366, 376, 451, 468; Jacques Boyer 160; Carnevalet 24; Albert Harlingue 37, 290, 338, 363; LAPI 340; LL 203 2.Reg.3.Abb., 365 t, 461; Henri Martinie 291; Ullstein Bild 392)

For reproductions of artists' works: